The Painter's Handbook

The Painter's Handbook

Mark D. Gottsegen

Watson-Guptill Publications/New York

First published in 1993 in the United States
by Watson-Guptill Publications,
a division of BPI Communications, Inc.,
1515 Broadway, New York, N.Y. 10036.

Library of Congress Cataloging-in-Publication Data

Gottsegen, Mark David.
 The painter's handbook : a complete reference / Mark D. Gottsegen.
 p. cm.
 A rev. ed. of: A manual of painting materials and techniques.
 1987.
 Includes bibliographical references and index.
 ISBN 0-8230-3003-2
 1. Painting—Handbooks, manuals, etc. I. Gottsegen, Mark David.
 A manual of painting materials and techniques. II. Title.
 ND1500.G6155 1993 93-14996
 751—dc20 CIP

Distributed in Europe, the Far East, Southeast and Central Asia, and South
America by RotoVision S.A., 9 Route Suisse, CH-1295 Mies, Switzerland.

Distributed in the United Kingdom by Phaidon Press Ltd., 140 Kensington
Church Street, London W8 4BN, England.

Manufactured in the United States of America

First printing, 1993

5 6 7 8 9/04 03 02 01 00

ACKNOWLEDGMENTS

This book could not have been written without the help and enthusiasm of a large number of people.

I am first indebted to my teachers, all of whom contributed to my early development as a painter and to my interest in painting materials: David Aronson, Philip Guston, James Weeks, and most especially Reed Kay.

My thanks also go to those who have at one time or another commented on various parts of the manuscript, answered questions, or made suggestions or corrections. These include my colleagues in the American Society for Testing and Materials, National Artists Equity Association, and the Inter-Society Color Council. I am especially grateful to Joy Turner Luke for her encouragement and support, and to Hilton Brown, Robert L. Feller, Robert Gamblin, Ben Gavett, Mark Golden, Charles Jacobson, Zora Sweet Pinney, Al Spizzo, Peter Staples, Woodhall Stopford, M.D., Michael Wilcox, Russell Woody, and Tom Vonderbrink. Naturally, any errors or omissions are mine, not theirs.

Numerous manufacturers and distributors willingly answered my many questions and provided volumes of information, and for that I also give my thanks.

I wish also to acknowledge with thanks the correspondence and personal contacts with staff members at the following institutions: The Art Institute of Chicago, the Art Conservation Program at the University of Delaware, Boston's Museum of Fine Arts, the Conservation Center of the Institute of Fine Arts of New York University, the Cooperstown Art Conservation Program at SUNY Buffalo, the Courtauld Institute of Art of the University of London, the Fogg Art Museum, the Library of Congress, the Metropolitan Museum of Art, The Museum of Modern Art, the North Carolina Museum of Art.

I am grateful to my colleagues at UNC Greensboro for their support of my work. Of course, I could never have done this without the enthusiasm and cooperation of my students, from whom I learn constantly.

I owe many thanks to Jane Cullen for her original encouragement and confidence in me. Thanks to Candace Raney at Watson-Guptill. Also at Watson-Guptill, I am indebted to Janet Frick for her sensitive, accurate, and sympathetic editing; and to Ginny Croft, Areta Buk, and Hector Campbell for all their good work on this book.

Finally, I express my profound love and admiration for my friend and wife, Emilie, who cheerfully tolerated my strange working hours during the development of this project and whose devotion, encouragement, and great sense of humor made it all easier.

Mark D. Gottsegen

Contents

Introduction:
What to Get Out of This Book
Before You Go into the Studio

To express your ideas clearly, you must be in control of your medium. A brief encounter with a variety of materials while you are a student, and a firm grounding in the technical and procedural aspects of the craft of painting, can help you choose the most appropriate medium and use it most effectively as you continue to grow during your lifetime as a creative artist.

Despite this, learning about the materials of painting remains a neglected aspect of the education of many young artists. There has been a revival of interest in craftsmanship, yet in much good painting today we see evidence of early deterioration and physical failure—the absence of good craftsmanship.

Artists must be able to choose painting materials that, when properly assembled, result in durable works. Most artists today realize that pictures made with inferior materials will deteriorate rapidly even in the best of storage conditions. Fewer artists, perhaps, are aware that pictures made with even the best materials can suffer premature deterioration if they are constructed without regard for the rules that limit the use of those materials.

There is now a vast range of ready-made products within easy reach of most artists, and selecting what to use is no longer a simple affair. Few of you will want to prepare all your materials from scratch after your student days, but if you understand what is involved, you will have a solid basis for selecting quality ready-made products. This book will help you purchase and apply your materials intelligently—or continue to make some of your own, if you prefer them.

The Painter's Handbook is first of all a reference work designed for practical studio use at the basic level. It can also be used as a text to guide those who teach and study basic painting. Third, it might be interesting for collectors who wish to know more about how paintings are made. This book is both a starting point for development as an individual artist and a helpful addition to the mature artist's library.

One special feature I've included is the cautions about health hazards, which are highlighted in italics with a symbol of a pointing hand. These direct your attention to specific dangers.

The boxes in this book are like recipes: They give specific instructions about how to prepare various art materials or do various projects. Read the entire box before you start, just as you would with a kitchen recipe or a chemistry experiment, and make sure you understand any cautions. In fact, it's a good idea to read that entire chapter.

Make notes about the various processes and materials you encounter in your studio. Refer to them later; add to them as you acquire experience. Your direct experience will be your most effective teacher. You will learn to answer such questions as "What's the best paint to use?" or "Can I do this?" without relying on anyone else's opinion. When choosing materials, however, do not hesitate to ask the advice of a knowledgeable salesperson at an art supply store.

This book, then, is intended to be a guide through the maze of basic information about some of the traditional and nontraditional painting materials and processes. I have not attempted to suggest aesthetic approaches to

painting, although I believe that successful artistic expression is greatly enhanced by a full command of technique. Rather, artists who use handbook should come away with a better idea of the practical whys and hows of selecting and using painting materials.

GENERAL HEALTH AND SAFETY NOTICE

I have made every effort in this book to provide sufficient and up-to-date cautions about specific, recognized hazards. You'll see them highlighted in italics with a symbol of a pointing hand. Nevertheless, the book suggests using some materials, methods, and equipment that can be hazardous to your personal safety or health. Since there is little conclusive evidence about the potential chronic hazards of some art or craft materials—especially regarding how you choose to use the materials—it is your individual responsibility to establish necessary safe studio practices and to determine whether you should use that material or method. *Neither I nor the publisher can be held responsible for the use, misuse, or abuse of a particular material.*

Here is some general advice to follow as you work in your studio, no matter what medium or method you are using.

SMART WORKING PRACTICE IN THE STUDIO

- *Read all labels.* If the material is harmful, follow label instructions to the letter. Do not hesitate to call the manufacturer if you are in doubt about label instructions or the contents of the material.
- Keep the telephone number of your local poison control center handy. Do *not* call the manufacturer with health-related questions. Manufacturers do not give medical advice: your doctor, or a toxicologist, can help.
- Do not eat, drink, or smoke while you are working in your studio. Wash your hands thoroughly after working, and before eating.
- Provide good ventilation and circulation of fresh air in your studio. If necessary, use an exhaust fan vented to the outside. Adequate ventilation of a room is about ten complete air changes per hour, and some toxic materials require special ventilation systems that protect you from breathing any vapors. (See Chapter 5 for more on ventilation.)

- Keep your materials out of the reach of children! Keep children out of your studio altogether.
- Be sure your materials are labeled and in safe containers.
- Keep all materials, especially solvents, tightly covered when not in use. Pour out only as much solvent as you immediately need, and safely store the rest.
- If irritating materials, especially solvents, get on your skin, wash thoroughly right away using soap and water. Do not use solvents to clean your hands. Do not apply paint with your bare fingers; wear rubber gloves.
- Never put brushes or other paint-applying implements in your mouth. Learn to "point" a watercolor brush against a tissue instead of using your lips.
- Avoid inhaling any solvent vapors for even short periods of time, even if your studio is adequately ventilated.
- Do not sleep in your studio unless you first remove all painting materials to a safe storage place and properly dispose of solvents.
- Clean up all spills promptly. Do not store solvent-soaked rags in your studio; dispose of them in an environmentally safe manner (call your local government for instructions). A fire-suppressing metal can should be used for rag disposal.
- Do not expose solvents to heat or other sources of ignition. Keep a fire extinguisher in your studio, preferably near the exit.
- If you are using powders (dry pigments) or spraying anything, wear a respirator mask with a filter cartridge rated for the material you're working with. The mask should be approved by the National Institute for Occupational Safety and Health (NIOSH). Wear goggles to protect your eyes.

Again, be aware that it is impossible for me to foresee all the ways in which you can use, or abuse, art materials. Use common sense and follow the cautions and warnings for each material discussed in the following chapters.

Part One
The
Basics

If you want your work to last, you should know the basic physical properties, advantages, and disadvantages of what you use to support, build, and preserve a painting. ✍ In Chapter 1 we will look at the painter's basic studio equipment and drawing media. ✍ Chapters 2 through 6 discuss supports, sizes and grounds, binders, solvents and thinners, varnishes, and preservatives that may become part of the painting itself. ✍ These essentials, often invisible to our audience, play a crucial role in how well and for how long those viewers will be able to enjoy the painting and see it as we intend it to be seen. ✍ Chapter 7 is about pigments, the coloring materials that bring a painter's ideas to life.

I Basic Tools and Equipment for the Artist

This chapter covers the auxiliary materials you will use when painting—the tools that do not become part of the painting itself. It also discusses drawing papers and dry and wet drawing media.

PALETTES

The word "palette" has a double meaning: It is the selection or range of hues employed in a painting, and the surface on which you mix colors. Ranges of hues will be discussed in Chapter 7. For now let's focus on the physical mixing surface.

There are several kinds of palettes: wooden, porcelain-coated steel, glass, or tear-off-and-throw-away paper, among others.

Wooden palettes, especially the arm-held kind, are the traditional favorite. They are usually stained a dark reddish color so that you can see relative color mixtures better. Arrange the colors in an organized fashion and leave the center clear for mixing. Instead of cleaning the paint off entirely at the end of a session, use a rag to rub some of it into the wood. In time the palette will develop a neutral gray patina that is excellent for making comparative color mixtures. An alternative to buying an expensive wooden palette is to make one from a well-sanded piece of plywood 9 mm (³/₈ inch) thick; shellac both sides to prevent warping.

Porcelain-coated steel palettes are expensive but can be found as food-service trays in restaurant supply houses. The porcelain should be white. These palettes are easy to clean, but you must be careful not to chip the porcelain.

Glass palettes, made of tempered plate glass at least 6 mm (¹/₄ inch) thick, are a favorite because they are easy to keep clean. Dried paint is quickly and efficiently stripped away with a single-edged razor blade. This kind of palette should be securely fastened to a sturdy tabletop, not held in your hand. Place a piece of white paper beneath the glass in order to see the colors; better yet, paint the tabletop with an acrylic emulsion artists' paint mixed to a neutral gray. Against a hueless neutral gray, the most subtle color mixtures are easily seen.

Tear-off paper palettes are convenient. At the end of the day the used paper is torn off, exposing a fresh surface on which to mix the next day's paints. However, these palettes are a waste of money; with very little effort, you can make a far better, bigger, and more durable surface on which to work.

A palette made in England by Rowney called the Stay-Wet palette is good for acrylic emulsion paints, though the largest one is still rather small. It consists of a two-compartment tray, one compartment being smaller and to be filled with water to keep your brushes wet. The other is the color-mixing surface. Into it you insert a membrane that absorbs water, and over that you put a semipermeable membrane that allows the water beneath to migrate up to the colors, thus keeping them wet. The palette has a cover that prevents evaporation and thus keeps your piles of acrylic emulsion paint wet for quite a long time. This palette is a boon to those painters who work for a long time on their paintings.

BRUSHES

These long-handled implements are probably the most important tool you can purchase. It is therefore smart to buy the best brushes, since only the best will stand up to daily use and maintain their performance over the years.

A cheap brush is not inexpensive—it is cheap. Buying cheap brushes is one of the most common mistakes of too many beginning painters.

BRISTLE BRUSHES

Fine bristle brushes come in many shapes and sizes, though this huge variety is a twentieth-century development. The bristle comes from hogs and boars raised in Switzerland, China, India, France, Russia, and the Balkan mountains of eastern Europe. The best bristle is from a strip of hair 8 cm (3 inch) wide, running down the spine of the animal from neck to tail, where it is long and springy. The length of the bristle may vary from 2.5 to 25 cm (1 to 10 inches) and can be black, brown, gray, or white. The kind used in the finest artists' bristle brushes are natural white. They are not bleached because bleaching can weaken the bristle.

The significant feature of a good bristle is that its tip does not come to a point, like a hair, but rather has two or three points called flags. The flags enable the bristle to hold more paint than a plain point. Bristle brushes that do not have flags may have been trimmed by the manufacturer. This is a sign of a cheap brush.

The bristles are bundled, cleaned, wrapped in a form, sterilized, sorted by length, and hand-tied into separate bundles for each brush. The various shapes of brushes (Figure 1.1) are achieved by hand-tying the bundles, not by trimming the bristles. The bundles are then "cupped" into shape and set in a ferrule using a vinyl or epoxy resin adhesive. The size and shape of the ferrule, the best of which are made of seamless nickel-plated copper, contribute to the shape and size of the brush.

Unlike rubber-based, heat-cured compounds used to set the hairs or bristles of other brushes, the compounds used to set artists' white bristle brushes can be soluble in aromatic solvents. Take care to avoid using these solvents with the best brushes: Use only water, mineral spirits, gum turpentine, or alcohol.

The bristles, set in the ferrule, are crimped to a hardwood handle. There are three crimps in the best brushes, two in the less expensive kind, and one (or none—just small brads) in the cheapest kind. The more crimps, the sturdier the attachment. The handles can be hardwood of any variety, but they must be straight-grained and free of defects.

Brushes are sized by number, with small numbers indicating small brushes and large numbers indicating large brushes. The sizing of brushes is not standardized: One company's #6 can be quite a bit smaller than another's.

A good beginning selection of bristle brushes is a small round, a medium-size round, a medium-size flat, and a large flat.

HAIR BRUSHES

Sable brushes can also be used in oil painting, mainly for glazing and applying fine details. The word "sable" is not a standard term, but refers to a class of which weasels, minks, ermines, martens, and kolinskies are all members. Some brushes labeled "sable" are even made of camel hair, squirrel hair, dyed white ox hair, Russian fitch hair, goat hair, badger hair, or American skunk hair. The most reputable brushmakers are not so devious as to label all these as sables; some are labeled "sabeline," and some, believe it or not, are even labeled with their actual names!

The finest watercolor brushes are made of "100 percent Russian kolinsky sable," collected from the tip of the tail where the hairs are the longest. Russian kolinskies are favored because

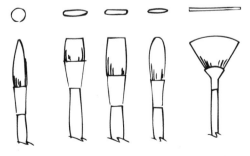

FIGURE 1.1. Types of bristle brushes. *Bottom, left to right,* round, bright, flat, filbert, fan blender. *Top,* the same brushes shown in cross section.

the wild animal has survived a cold northern climate and therefore has produced very long hairs. Domestic martens and other sables that have been raised in captivity produce shorter hairs because heavy coats are not needed for survival. This is a fine distinction, but when you consider the price of true Russian kolinsky hairs, several thousands of dollars per pound, and how the hair length can affect both the prestige and reputation of the brushmaker and the price of the brushes, the distinction becomes clearer. Unfortunately, because of the difficulty of obtaining the hairs, *no* manufacturer is willing to guarantee in writing that its brushes are 100 percent Russian kolinsky 100 percent of the time—they are usually mixes of Russian and other kolinsky sables, but are always kolinskies, never other sable types.

Real sable hairs taper from the base, swelling into a belly, and then to a fine, microscopic point. When they are set into a ferrule after the usual washing and bundling, their natural curve brings them together in a point. The top edge of the ferrule must be correctly placed to contact the bundle of hairs at about where the belly of each hair occurs. This placement is crucial if the brush is to have and retain its characteristic spring.

When you are buying a sable brush, ask the dealer for a glass of water. Flick the hairs against your wrist to loosen the glue used to protect the brush when it is shipped from the maker, swirl the brush about in the water until it is thoroughly soaked, and then sharply snap your wrist to discharge the water. The brush should come to a perfect point, and the hairs should spring into position without flopping over. Considering the expense of a sable brush, it is worth doing this test to demonstrate the quality—good or bad—of the product.

For glazing and detail work in oil or other heavy-bodied paints, do not buy the expensive sable watercolor brushes—they might not be ruined, but they may not perform as desired in watercolor after being washed in active solvents. Buy the long-handled hair flats, brights, or rounds, and do not pay too much for them. One or two will suffice for most purposes. For general information about other kinds of brushes, visit a good art supply store or consult a comprehensive catalog.

SYNTHETIC BRISTLE AND HAIR BRUSHES

Brushes made of synthetic fibers like nylon and polyester have become more popular with painters who use water-based media like the acrylic emulsion paints. In recent years, technological improvements have been made in the ability of these brushes to carry a heavy load of paint, although they still do not equal the capacity of the natural fibers. Some high-quality white synthetics imitate the spring and flags of natural bristle, and some high-quality colored synthetics imitate the shape of fine hair brushes; they also use microscopic scales on the fibers to increase the color-carrying capacity of the hairs.

If you are interested in using these brushes, by all means give them a try. Particularly in the water-based paints, they can stand up to soaking in the thinner without losing their spring. But remember that they are imitations of the real thing, and that the best imitations can be as expensive as the real hair and bristle brushes.

CARE OF BRUSHES

Even if you buy brushes of the very best quality, you can quickly ruin them if you do not take care of them properly. Brushes should be cleaned after each day's painting, using the following procedure:

1. Use the correct solvent for the paint and remove as much of the color as possible.
2. Wipe the brush on a cloth rag.
3. Using a mild soap and lukewarm water, lather up the brush and swirl it in your palm. Rinse the brush well.
4. Repeat Step 3 until no trace of color remains in the brush. Some of the particularly powerful organic pigments will stain the bristles or hairs. This is not serious—just be sure to get all traces of paint out of the brush, especially at the heel where the brush is inserted into the ferrule.
5. Rinse the brush, shape it, and put it away to dry.

Do not store brushes upright in a pot. Because the handles are usually lacquered, water used in cleanup can seep down inside the ferrule and spread the hairs or bristles, or down between the wood and the lacquer. Eventually the lacquer will crack because the wood swells with moisture, and the ferrule can loosen; the ferrule, with its precious cargo of fine bristles, can then fall off the handle. To avoid this problem, do not store your brushes upright in a pot. Store the brushes flat, in a drawer or covered box, to keep dust from getting into them. This way the water will evaporate from the bristles rather than being drawn into ferrule or handle by gravity. Sable and other hair brushes can be stored in a box with mothballs, to keep moths from eating those expensive hairs.

Brushes that are stored carefully should retain their shape. If the bristles or hairs become splayed out or bent from careless storage, it may be possible to recover the original brush shape by the following method:

1. Wash the brush in hot, soapy water until the hairs or bristles soften.
2. Shape the brush—if the hairs or bristles are soft enough, they may retain this shape.
3. Dip the brush into baby shampoo or cream rinse; allow it to soak for a minute.
4. Wrap the brush in a paper or waxed paper sleeve so it will hold its shape as it dries.
5. When the brush is dry, rinse out the soap or cream rinse.

A cheap brush will not last long, even if scrupulously cleaned daily. A good-quality brush, if properly cared for, should last many years, even with daily use. Buy the best brushes possible, even if you are just beginning to learn to paint.

KNIVES

Painting knives are for applying paint, particularly impasto effects, and for scraping paint off paintings in progress. Palette knives are for cleaning your palette. Spatulas and scrapers are for mixing pastes and scraping paint in large volumes. All these tools can be used interchangeably, of course.

Painting knives come in myriad shapes and sizes (Figure 1.2) and are distinguished from their cousins by the wire extension that projects from the handle. The wire makes the knives flexible and light. The blade should be tempered steel, so that it is both stiff and flexible down its entire length. It should not be too sharp, lest it cut the fabric when scraping paint from a flexible support. You can dull a knife with fine sandpaper, if necessary.

Palette knives have handles and a flat blade that extends out from the ferrule and then bends down and out to keep your knuckles from getting in the paint. One palette knife is all you need, though most painters have several—no one can resist buying new tools when browsing in an art supply shop.

Spatulas and scrapers can be used in large-scale works or whenever a large volume of paint is to be moved around. Buy quality spatulas and scrapers in restaurant supply houses or hardware stores; the best have tempered carbon or stainless steel blades and a bolster where the blade emerges from the handle. The tang should extend completely through the handle and be held in place by through riveting. One good spatula and one good scraper will last a lifetime.

Don't buy too many knives. It is easy to become seduced by the thick, luscious slabs of impasto, and by the tricky effects some knives give. There is a place for knife painting, certainly, but you must always decide whether your technical manipulations serve the concept of the picture.

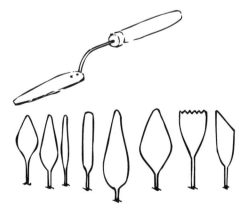

FIGURE 1.2. Painting knife, with various shapes for different effects.

EASELS

A large variety of easels can be purchased for studio or field use. A French easel folds up into a box for use outdoors. A studio easel should be sturdily built of hardwood, steel, or aluminum, with heavy metal fasteners, and be versatile enough to handle a variety of sizes and weights of picture supports. Field easels, like the so-called French landscape easels, must also be sturdy, for the price you will pay. The metal attachments on wooden easels should be high-quality steel or brass, not soft aluminum. The wooden parts should be made of hardwood, such as maple or oak, not soft pine. Disregard the colored stains; just press your fingernail into the wood. If you can scratch the wood with your fingernail, it's too soft.

However, it is a mistake to assume that you need the best easel made, if you are just starting out as a painter. You can avoid the whole issue of an easel if you have a studio. Some nails or dowels in a wall will hold a painting quite well. You can also attach fire-rated Homosote to the wall, over a stud framework, and use that.

LIGHTING

The section on color in Chapter 7 explains why cool north light is useful for lighting setups in the studio: It is a relatively steady light, albeit at a low level, that does not cast strong, constantly changing shadows. But it is generally not a great kind of light to have falling on your painting in progress, because most galleries now light their shows with incandescent spotlights. You can make adjustments in your studio lighting using a combination of fluorescent lights, incandescent spotlights, and colored theatrical gels, to suit most needs. One bit of advice—the lighting in your studio should be good, bright when needed, and adjustable.

ACCESSORIES

Palette cups attach to the palette and are used for holding small quantities of thinner or solvent, or mediums.

Cans hold solvent for washing brushes. You can spend money on a fancy brush washer, or make one for virtually nothing out of three empty cans of different sizes. Use nails to punch holes, all from the same direction, in the smallest-diameter can. Then place it inside the middle-diameter can (which should also be the tallest). Make sure the jagged edges point downward so that they won't damage your brush hairs. Next add thinner. The paint sludge will sink to the bottom, and the third can serves as a lid.

Glass bottles hold mediums, varnishes, and so on. They should be carefully labeled with the contents and dates of manufacture, and stored to avoid fire or health hazards. Colored wine bottles work well here—corks make good stoppers if they do not dry out.

Paper towels are no substitute for fabric rags, and synthetic fibers are no substitute for absorbent cotton. Rough paper or synthetic can wear the bristles or hairs of a good brush. Buy clean used cotton diapers from a baby diaper service, or use worn-out cotton undershirts, sheets, or towels.

Tables can be large or small, but they should be sturdily built; it helps when rearranging your studio (a frequent occurrence, it seems) if the table legs are fitted with casters.

DRAWING MATERIALS

Drawing materials are often used together with painting processes, and have as long and involved a history as painting materials. Using contemporary terms it is practically impossible to separate drawing from painting, nor is it possible to give an entirely satisfactory explanation of just what "drawing" is.

Simply, however, drawing is "a mark made on a surface." Since there has been so much recent interest in the use of alternative nontraditional mediums, such as colored pencils and oil pastels, it is necessary briefly to survey the materials we use for drawing. The support most often used for drawing, paper, is also considered.

PAPERS

Light, portable, and flexible supports for drawing have always been a concern of artists. The first such support was probably made of

beaten and flattened plant fibers (papyrus) or woven fibers (silk).

The first mention of true paper as we know it is in the first century A.D. in China, during the first year of the Han dynasty. This paper is described as being made of "hemp waste, old rags, and fish nets" (Dard Hunter, *Papermaking: The History and Technique of an Ancient Craft* [New York: Knopf, 1947], p. 52). These materials proved strong and durable, and in the ensuing centuries rag papers were the only ones artists found acceptable for their work.

Until the end of the eighteenth century, linen and cotton rags were the only materials used in papermaking. But by the beginning of the 1700s the demand for rags for fine artists' papers, coupled with the increasing use of paper for commercial printing applications, had quite exhausted the available supplies of raw materials.

In the early 1800s a process was described whereby paper could be made from wood pulp. By 1803 Henry and Sealy Fourdrinier had refined an efficient and economical papermaking machine—originally invented by Nicholas-Louis Robert but called a Fourdrinier machine to this day—that increased the large-scale production of pulp papers. By then, fine rag papers had become as relatively expensive as they are now.

heated weights and have a smooth surface. *Cold-pressed* papers are finished under cold weights, which leave a medium-rough surface (sometimes called "not"). For a paper with a *rough* surface finish, the sheets are not pressed (sometimes also called "not").

Commercial papers are still sometimes referred to by traditional names, and it is worth knowing them so that you can talk to the old-time papermakers or traditional paper-sellers who still use them.

Proprietary Name	Size
Antiquarian	78 × 135 cm (31 × 53")
Double elephant	66 × 101 cm (26 1/2 × 40")
Elephant	58 × 70 cm (23 × 28")
Imperial	55.5 × 76 cm (22 × 30")
Super royal	49 × 66 cm (19 1/4 × 27")
Royal	48 × 61 cm (19 × 24")
Medium	44 × 60 cm (17 1/2 × 22")
Demy	39 × 51 cm (15 1/2 × 20")

Perhaps the only difference between handmade and machine-made papers of equal material quality is a certain feel to the slightly irregular surface of the handmade paper—and, of course, the aesthetic freight we are apt to attach to the concept of something that is handmade.

PAPERMAKING

Whether the paper is made by hand from rag fibers or by machine from ground wood pulp, the process is essentially the same. A slurry of rag or wood pulp and water is cast onto a screen and agitated, and the water is allowed to drain out. The agitation causes the fibers to felt together to form a sheet, which is then removed from the screen and dried.

A bewildering assortment of papers is available for today's artist. It is well worth experimenting with different kinds to discover the effects they yield. A few key factors to keep in mind include surface texture, weight, and permanence.

How the pulp is made, and from what materials, determines the paper's durability and strength. *Hot-pressed* papers are pressed under

PERMANENCE OF PAPERS

The durability of a paper has nothing to do with how it is made, but with the materials used. With the beginning of the wood pulp industry and the invention of the Fourdrinier process, wood pulp papers became very popular and their use spread. Unfortunately, the cellulose in wood pulp is not pure. It contains ingredients such as lignin, which react with oxygen in the air to cause the formation of acids. These ingredients can lead to the rapid deterioration of the paper. The very short life of newsprint, which is almost entirely low-alpha cellulose wood pulp, is a good example of how poorly this kind of paper lasts.

Linen and cotton fibers are still the most favored of the natural ingredients used in art papers; the longer, and therefore stronger, linen

fibers are somewhat preferred over cotton. The so-called rice papers of the Far East, made predominantly of mulberry and other vegetable fibers, have very long fibers, which gives them great wet strength.

The archival papers are popular for use in printmaking and conservation. If the pulp made from the natural fibers is prepared by careful and repeated washing, it will contain no acids or other ingredients that might react with the atmosphere. Many papers are made with an alkaline buffer added to the pulp to counter any absorption of acidity that could occur in the course of normal exposure to our increasingly acidic environment.

Papers that contain 100 percent rag fibers are necessarily quite expensive, since there is a large demand for cotton and linen for other uses. Some papers are therefore only 75, 50, or 25 percent rag, the balance being cellulose or some other natural or synthetic material. These "rag content" papers may contain filler ingredients like chalk or kaolin to produce a surface similar to that of 100 percent rag papers. Furthermore, some art papers made today do not have any rag content; they are composed of synthetic materials like fiberglass or natural but impermanent materials that have been chemically stabilized.

Besides fillers and buffers, the other ingredients that can be added to the pulp include pigments for color (dyes are not used in permanent papers unless they have passed lightfastness testing), and sizes to control the bleeding or spreading of liquid painting or drawing mediums. Neither rosin nor alum should be used in fine art papers. Rosin is a naturally occurring resin found in paper pulp made from ground-wood pulp that has not been thoroughly washed. It inevitably yellows and grows brittle, as does lignin, a natural adhesive in wood-pulp papers. Alum, a size, is used in some commercial and book papers. Both are now the source of many an archivist's nightmare: Books made with papers containing rosin or lignin, or sized with alum, are now crumbling by the millions.

With all the possible materials a papermaker can add to the product, the issue of permanence—and how to predict it—has

become very confused. (A few of the older manufacturers, especially the European houses, rest comfortably on their centuries of excellent repute.) Watermarks in the paper sometimes indicate the rag content, but this is not always a reliable guide. A significant indicator of a paper's expected life, its pH, can be tested using the method outlined below. (This pH test used by permission of Dr. Richard D Smith, President, Wei T'o® Associates, Inc., Matteson, IL 60443.)

PAPER pH

The potential of hydrogen, or pH, is measured with papers such as litmus paper that indicate pH by means of a color change. A pH measurement can be acid, 0 on the scale, or basic (alkaline), 14 on the scale. A reading of 7 is neutral, neither acidic nor alkaline. You can measure a paper's pH yourself by following the procedure outlined in Box 1.1.

Artists' papers with pH values between 8 and 10.5 are slightly alkaline; although they may absorb some acidity as they age, they are buffered against becoming too acid. A draft of a current American Society for Testing and Materials (ASTM) standard for artists' papers calls an "archival" paper one that has a minimum pH of 7.5 to 9.5, and those that are deemed "acid free" to have a minimum pH of 7.0 or above. "Archival" is better for the artist than "acid free." "Buffered papers" have an *internal* buffer of calcium carbonate or other absorbant chalk that can absorb atmospheric acidity; "surface buffered" papers perform less well in this respect. Papers with pH values below 8 will become acidic as they age. Papers with a pH below 7 are already acidic and are deteriorating.

Even with this in mind, judging the quality of papers is difficult, since you will often buy single sheets that are unlabeled. You must buy from a reliable supplier who can tell you about the source. You can also write or call the manufacturer for technical details. "Archival," "permanent," "pH neutral," and so on are phrases that have become so overused as to have lost their original meaning. You must know what they mean to you—and to that

particular manufacturer—if you wish to buy paper that will not yellow or crumble in less than 100 years.

WEIGHTS OF PAPERS

Weights of paper are determined by weighing 500 sheets (a ream) of the same kind of paper (that is, say, 500 sheets of 55.5 × 76 cm watercolor paper). If a ream of cold-pressed watercolor paper weighs 300 pounds, the paper is referred to as a "300-pound cold-pressed watercolor paper." The more substantial papers, with weights above 170 pounds, are generally better suited for wet drawing or painting media, while those below 170 pounds work well for dry drawing media. But there is no reason why any good paper cannot be used for any technique.

Some manufacturers now refer to a paper's weight by grams per square meter: g/m^2.

USES OF PAPERS

For dry drawing techniques any kind of paper, with any kind of surface, can be appropriate. Usually, finely detailed drawing techniques require that the paper have a smooth surface, and harder-surfaced papers will stand up to erasing. For wet mediums, the heavier papers will be able to stand repeated wetting without much distortion.

Surface preparation is unnecessary when most dry drawing techniques are used. You just start drawing on the paper, which can be in pad form or as single sheets pinned to a board. For a more resistant support, mount the paper on hardboard 6 mm ($^1/_4$ inch) thick. A watercolor

BOX 1.1. HOW TO MEASURE THE PH OF PAPER

MATERIALS

- ColorpHast Indicator Strips (see List of Suppliers). ColorpHast strips do not bleed and will not stain the paper being tested. They can be obtained in a variety of measuring ranges, but get the widest range—0 to 14.
- Plastic film, such as kitchen plastic wrap.
- Distilled water.
- The paper being tested.
- Light weight.

METHOD

1. Lay a piece of plastic film under the paper.
2. Place a drop of distilled water on the paper.
3. Lay the sensitive end of the ColorpHast Indicator Strip (a plastic strip with the indicating pad at one end) on the drop of water and move it around a bit to make sure it is completely wet.
4. Place another piece of plastic film on top of the pH strip.
5. Put a light weight on the film to make a firm contact between the pH strip and

the paper. (All these steps are illustrated in Figure 1.3.)

6. After 5 minutes, remove the weight, top sheet of plastic film, and pH strip. Read the pH of the paper by matching the color of the wet pH strip with the color chart on the ColorpHast Indicator Strip container.

FIGURE 1.3. Arrangements of materials for testing paper pH. *Clockwise, beginning at top right, arrows point to:* weight, plastic film, paper sample, plastic film beneath sample, distilled water, pH indicator strip with sensitive end and side down in contact with damp paper. (Used by permission of Dr. Richard Smith, President, Wei T'o® Associates, Inc., Matteson, IL 60443.)

wash can be applied to the paper to give a colored surface on which to begin the work.

Papers used for wet techniques do not have to be stretched if they are sufficiently thick. Thin papers often buckle and wrinkle in an unpleasant or uncontrolled way, and can be stretched on a board following the method outlined in the chapter on watercolor painting.

Rag papers can be used for collage techniques, and are far more durable and stable than the usual castoff scraps of labels and newsprint that one sees in this medium. Colored rag paper, or painted paper, also works well.

DRY MEDIUMS

There is a huge variety of drawing materials available in supply shops, but comparatively few are reliably durable. Because ingredients and manufacturing methods for materials like colored pencils and colored markers are not standardized and are constantly changing, it is very wise—if you are concerned with the permanence of your work—to test them for lightfastness using the methods given in Chapter 7.

GRAPHITE PENCILS

Although the term "lead pencil" is the popular name for this instrument, a graphite pencil is made not of lead but of graphite, a crystallized form of carbon. (The term "lead" is used by manufacturers to differentiate between diameters of drawing materials. A "lead" is smaller than a "crayon.") Graphite has been used for drawing or polishing since at least 2500 B.C., but the first wood-encased graphite pencil was developed in England in the mid-sixteenth century. By the end of the eighteenth century, Nicholas Jacques Conté had developed the forerunner of the modern lead pencil by mixing ground clay and ground graphite into a dough with water, pressing the mixture into grooves, baking the dried sticks, and impregnating them with wax.

Today graphite pencils are still made by mixing clays and natural graphite with a small amount of water and extruding the dough through a press to form the leads. The leads are cut into strands and fired in kilns at high temperatures. The fired leads are impregnated with wax and glued into cedar casings. The hardness of the lead is controlled by the proportion of graphite to clay in the dough: More clay and less graphite make a harder pencil.

Drawing pencils are available in hardnesses ranging from 6H (the hardest) to 6B (the softest). Since the paper fibers shave the lead, and hard pencils contain clay to make them more resistant to the shaving, it is impossible to get a black mark with a 6H pencil. But a 6B pencil is not resistant to shaving, which makes it possible to make a very black mark with this soft lead. (Incidentally, the term "pencil" is actually the archaic word for "brush.")

GRAPHITE STICKS

The same materials that go into graphite pencils are used to formulate graphite sticks, except that there are no wooden sleeves. The sticks are generally bulkier and capable of producing broad strokes of tone quickly. Graphite sticks can also be powdered by crushing, mixed with a little mineral spirits, and used as a rather greasy black inky drawing material; you can also draw with the dry powder.

☞ *CAUTION: **Do not breathe the dust.***

Pentalic Corporation is now marketing a European-made variety of graphite stick that is lacquered and can be sharpened like a large pencil. The lacquer coating keeps your hands clean.

VINE CHARCOAL

This kind of charcoal is made by slowly baking willow dowels (or other types of wood—formerly grapevines) until they are reduced to almost pure carbon. The sticks will produce lines and tones of infinite subtlety, as well as robust painterly effects. Vine charcoal sticks come in a variety of diameters and can also be obtained as rectangular sticks and blocks; the hardness of the sticks also varies. Vine charcoal can be powdered like graphite.

☞ *CAUTION: **Do not breathe the dust.***

COMPRESSED CHARCOAL

This is compressed vine charcoal, available in pencil form as well as in sticks of different shapes, sizes, and hardnesses. The pencil form of compressed charcoal can be sharpened to a very fine point and is particularly suited to drawing meticulous detail. Compressed charcoal can produce very dense blacks.

CHALK

The word "chalk" is derived from the Latin "creta," and so are the French words "craie" and "crayon." Perhaps this is why Conté crayon is today sometimes called chalk. Conté crayon is a slightly greasy or oily kind of chalk, made with carbon black, various shades of earth reds or browns, or titanium white as the colorants. The crayons come in short sticks of various hardnesses that can be sharpened like charcoal sticks—by rubbing them against a sheet of fine sandpaper. Conté crayon marks are somewhat difficult to erase and can make a wide range of marks of varying delicacy.

PASTEL CHALK

Although considered a paint, this chalk makes an excellent, fine, soft drawing material.

BLACKBOARD CHALK

There are a great many ways of making this kind of chalk, from extruding natural calcium carbonate mixed with a small amount of gum, to molding calcium sulfate (plaster of Paris) into a stick form. Some blackboard chalks contain small amounts of clay (which can make them too hard to use on a fine paper) or petroleum jelly (which can make them less permanent) for making "dustless" chalks.

FRENCH CHALK

The so-called French chalk is not chalk, but talc; it is used to make tailor's chalks.
☞ *CAUTION: Do not use French chalk for drawing, since the talc dust can be hazardous if inhaled.*

CRAYONS

If the Egyptians or Greeks are presumed to have developed the encaustic painting technique, then they may have also been responsible for making the first crayon, since the hardened encaustic mixture is very much like our modern crayons. In fact, a simple mixture of beeswax and pigment can make an effective, though somewhat soft or potentially brittle, drawing material.

WAX CRAYONS

Ordinary children's wax crayons are made of paraffin and stearic acid, melted and mixed with pigments or dyes (none of the ingredients can be harmful, by law), and molded. None of the children's crayons tested for lightfastness use permanent colorants.

OIL CRAYONS

A Conté crayon can be considered an oil crayon, but normally the more colorful oil crayons, oil pastels, and oil paint sticks fall into this category. Oil crayons and oil pastels are small, soft, pigmented, oil-impregnated sticks. Paint sticks are similar but much larger. Oil crayons can be built up to an appreciable thickness, scraped, thinned with mineral spirits, brushed, and generally manipulated to a far greater degree than can wax crayons. The only drawback to these materials is that some of the colorants are extremely fugitive—some will fade, or disappear entirely, within a week of exposure to sunlight.

Furthermore, the formulas used to make oil crayons can change from batch to batch. You should test these products. Test each new box, since it can be different from the previous box from the same manufacturer. Those that are labeled with generic pigment names for the colorants, and are offered in a much more restricted color range than the crayons and pastels, may be more reliable products.

LITHOGRAPHIC CRAYONS

A lithographic crayon is a carbon pigment impregnated with an oily and/or greasy vehicle.

These come in pencil form as well as sticks, in both hard and soft textures, and are used for lithographic printing techniques—hence the name—although they can be used successfully for drawing.

METALLIC POINTS

Gold, silver, or aluminum wire can be inserted into a mechanical pencil holder and filed against a slightly rough surface to produce an image. *Silver point* is the traditional technique; gold and aluminum are less common. When the metal tarnishes (oxidizes), the image becomes darker. This is an extremely delicate medium. The range of values is particularly narrow, and the possibilities for erasure and redrawing are limited.

A base for drawing in metal point can easily be made by coating a sheet of smooth drawing paper with a thin, evenly applied wash of zinc white (Chinese white) watercolor. The pigment particles are very fine and provide just the right sort of smooth but toothy and abrasive surface needed for this technique.

COLORED PENCILS

There are a tremendous number of different kinds of colored pencils in art supply stores. Many of them are made for temporary reproduction techniques, which is a clue to their questionable permanence.

With all types of colored pencils, it is essential to test each new box of colored pencils for lightfastness, because composition and formulas change constantly. The ASTM Subcommittee on Artists' Materials is working on a lightfastness test method for colored pencils, and there are two methods for testing lightfastness using the ISO Blue Wools that artists are capable of using. See Chapter 7.

Also beware of proprietary color names. These are usually the manufacturer's name for the hue, not necessarily the actual name of the colored pigment or pigments used. Look for generic pigment names, such as burnt sienna, to be more reliably assured of the product's lightfastness.

Traditional Colored Pencils

Ordinarily these are made by impregnating the leads with a waxy binder, although some are bound with a thermosetting (heat-curing) resin. The leads are composed of pigments, toners, or metallic flakes—for "silver" and "gold"—and a little clay for hardness. The value range is rather narrow because of the hardness of some of the binders. Some brands offer better value ranges.

Pastel Pencils

These pencils are somewhat like pastels, except that the pigmented sticks are encased in a wooden sleeve; they can be more easily sharpened and tend to crumble less than regular pastel sticks. Usually pastel pencils offer a much greater range of values than regular colored pencils, mainly because they are softer.

Watercolor Pencils

Bound in either a water-gum binder or a water-soluble dispersion of oil, soluble soaps, and fatty acids, these pigmented leads are encased in a wooden sleeve. They can be used like a regular pencil, then brushed over with water to create washes.

MISCELLANEOUS

There are certainly many other dry drawing materials that can be used for making pictures, among them grease pencils, industrial crayons, and lumber marking pencils.

Be sure to check the lightfastness of these products—and recheck new purchases—if you use them for permanent work.

☞ *CAUTION: Be aware that some industrial crayons use toxic lead chromate pigments.*

WET MEDIUMS

Certainly any paint can be used as a drawing medium, but we normally think of the inks when referring to liquid drawing mediums.

INDIA INK

Actually, india ink was invented in China, but the source of the carbon pigment was

India—thus the name. Traditional Chinese ink can be made simply by grinding with a mortar and pestle a small amount of normal-strength hot hide glue (see Chapter 3) with a proportion of carbon black, lampblack, or bone black pigment. Lampblack is the finest textured. The proportions are approximately 1 part pigment to 2 or 3 parts vehicle, by volume. Grind the mixture until it is smooth, pour it into a shallow ceramic dish, and let it dry. To use the dry ink, brush it with water until its surface reliquifies.

You can also stir the mixture in the mortar until most of the water has evaporated and the ink is thick and stiff; mold it into a stick and wrap it with waxed paper so that it can dry slowly without cracking. To use ink in this form, rub the stick in water on a slate ink slab.

Manufactured india inks are made of carbon black pigment ground in water with a little shellac—or other water-dispersed resin—to make them water-resistant. Most india inks can be considered reliably permanent in light. Do not confuse india ink with the other black inks made for technical or fountain pens. These inks are generally *not* water-resistant. Worse, they may not be lightfast.

India inks can be applied in washes with a brush or with a very large variety of pens, including steel pens, crow-quill steel pens, lettering pens, bamboo pens, and reed and natural quill pens. Each type of pen gives a different characteristic line. It is worth experimenting with all of them to see the possibilities.

COLORED INKS

There are two kinds of colored drawing inks that come in bottles. Both dye-based and pigmented inks can be used in drawing pens, airbrushes, or with brushes and water. Dye-based inks can be also used in technical pens.

Dye-Based Inks

These colored inks form clear, transparent films suitable for glazing. Many of them use fugitive dyes, so it is necessary to test each new ink for lightfastness. One well-known brand advises that the colored inks in its line may

not be permanent in light, but this warning appears only on the box of permanent black ink that accompanies the set. Ironically, in a lightfastness test, all *but* the black ink made by this company faded to white.

Pigmented Inks

Pigmented inks resemble watercolor paints in that a water-based binder holds a very fine pigment dispersion, except that the binder is more water-resistant than the gum used in transparent watercolors. These inks can be more lightfast than most colored inks, but it is still wise to test each new purchase.

COLORED MARKERS

These are the familiar felt-tipped pens, in colored and black ink, that dry very quickly by the evaporation of the solvent that carries the colorant. Some are water- or alcohol-based, but the quickest-drying ones use volatile solvents like xylene or toluene and dry water-resistant. To get a fine enough dispersion that will flow through the fibrous pen tip, fugitive dyes are used for many of the products. Some companies do use permanent carbon for their black markers.

Test markers for lightfastness. Most are not intended for permanent artistic use.
☞ *CAUTION: Some felt-tip markers are hazardous because of their solvent content. Read precautionary labels, and avoid breathing vapors.*

There are a couple of new products that may meet the requirements of permanency: Golden Artist Colors' Fluid Acrylic Markers, which use acrylic emulsion paint in small plastic squeeze-bottles with mohair tips; and Hunt's Speedball Painters Opaque Paint Markers, which are the more familiar metal tubes with fibrous tips. Both companies claim that the colorants are lightfast and the vehicles are nontoxic. Golden's product has the generic colorant name on the label.

Newly on the market are Sakura's Pigma pens and Staedtler's Marsgraphic Pigment Liners, which come in black and several colors and are fiber-tipped. They may be mainly for technical drawing, but Sakura also sells a

brushlike product for broader strokes of color. The interesting thing about these pens and markers is that they claim to be waterproof and fadeproof, although Sakura has not yet forwarded technical data to support this claim. If the colorants pass exposure tests, then the claims may be true; for now, treat these products with hopeful skepticism. If the colors are truly lightfast, then we have another technological breakthrough that will benefit those who wish to use markers—most of which are unreliable products.

BALLPOINT PENS

Ballpoint pens use dyes for the colorant, so it is important to test them for lightfastness. One undeniable advantage of a ballpoint pen is that you can draw for days without ever having to refill the pen point. This may be of no use, however, if the drawing disappears in a year or two. Test for lightfastness.

Sakura, again, has put its black "fadeproof" marker ink in a gel base and produced its "Gellyroll" pen—a permanent ballpoint pen. Alvin manufactures Graphic Pen and assures the user that the ink used in this revolutionary ballpoint pen is true pigmented india ink. The points are removable for cleaning in hot water, and the ink comes in cartridges for easy refilling.

The ink is so gritty, though, that the points, which are relatively expensive, wear out very quickly. This pen may not survive its marketing hype for this reason.

Be wary of such labeling as "india ink," or "india ink density." The quotation marks are a clear signal that the real pigment is not being used.

A FINAL NOTE

With all the recommendations in this chapter to test for lightfastness, you might get the impression that the materials I am warning you to test should not be used for artwork. Not so. They should be used with caution if you are concerned about permanence.

A work of art that is sold for money carries with it an implied warranty about its fitness. A professional artist with integrity will certainly be concerned that the client—collector, dealer, agent, museum, gallery—should be able to look at and enjoy the work for a long, long time.

You must know what you are buying if you are concerned about durability. There are no quality standards for artists' inks, markers, colored pencils, and the other materials discussed in this chapter. You might wish to write the respective manufacturers and politely ask why.

2 Supports

The basic substrate that carries the painted image is called a support. The support is the most important structural element in a painting, because if it fails the painting probably will not survive. Over the centuries, artists have used a whole range of supports—walls, wooden panels, stretched canvas, glass, metal sheets, and paper, to name just a few. Each of the variety of support materials imparts a character to the surface of the picture. If the support is smoothly finished, the picture will exhibit a smooth surface; if the support has a pronounced texture, the picture will show some of this texture.

Many supports for easel painting can be purchased already prepared. In stores you will see extreme variation in the quality and durability of these products, and the most expensive materials are often on display right next to the cheapest.

Putting together your own supports is neither expensive nor difficult. You can exercise a degree of quality control, and you can develop combinations of supports and grounds that meet your own needs. Use as wide a variety of supports and support/ground combinations as you can afford in your early days as a painter. You will gain invaluable experience.

You may wish to try the same paint, used in the same way, on a selection of supports appropriate for that paint. You can easily set up a little production system. Line up some supports and go down the row applying daubs of paint in two or three different ways—thick, thin, scrubbed on, mixed with a glaze medium, and so on. Leave a space on each support to note the type of paint and your reactions to its performance.

Do not think of economy when learning about your supports: The least expensive preprimed supports, on which you will do your first paintings, are also the flimsiest. You may be seduced by the surface qualities of these materials, and end up doing some good work on them—only to have them fall apart ten years down the road.

Whatever kind of support you choose, whether ready-made or homemade, it should satisfy these minimum requirements:

- It should age without becoming so brittle or fragile that it will suffer from exhibition, handling, or proper storage.
- It should be able to withstand the effects of atmospheric changes. Under reasonably variable conditions of relative humidity (RH) and temperature, the support should expand, contract, or warp as little as possible.
- It should have enough absorbency and tooth to provide a good key for the kinds of paints and grounds applied to it.

RIGID SUPPORTS

In the history of Western painting, rigid supports (such as cave walls) were used long before the adoption of flexible fabric supports. By many accounts, one of the earliest uses of a rigid support separate from a wall is in the portraits that decorated the coffins of Egyptians in the Fayum era, between the first and third centuries A.D. Since then, artists have endeavored to find a variety of supports for their paintings.

Let's examine several major types of rigid supports, including the methods used for bracing and for surface preparation.

SOLID PANELS

Painters in the Renaissance developed the use of wooden panels for painting into a special craft. Thick, solid hardwoods and semihardwoods such as oak, mahogany, and poplar were used for altarpieces. Sophisticated joinery, heavy framing, and continual treatment by conservators through the centuries have combined to ensure the physical survival of many of these works. Panels made of solid wood, however, present complicated problems.

Wood is a cellular material. In the central core of a tree, these cells store water. When the wood is cut into boards and allowed to dry for a long period of time, the cells eventually give up most of their moisture. However, the cell walls and cavities remain capable of absorption and are constantly expanding and contracting according to the moisture content of the surrounding atmosphere. After many years of gradual drying, the cells become more or less stable.

If wood planks are cut radially from a log (Figure 2.1), the stresses of expansion and contraction are more or less equalized between the two faces of the panel. Tangentially sawn planks impose unequal tension on the faces, because of the arrangement of the grain, and this can lead to defects such as warping, twisting, cupping, splitting, and cracking—all potentially disastrous to a painting. Even radially sawn planks can be affected this way. Tangential sawing is by far the most economical way to obtain the greatest number of boards from a log; it is rare to find radially sawn planks at the average lumberyard. Even when they can be found, radially sawn boards must be seasoned for several years in a stable environment. The modern kiln-drying

seasoning method employed today does not produce completely seasoned wood.

Well-seasoned hardwoods such as mahogany or white oak are preferred for easel painting panels. Do not make the mistake of buying insufficiently seasoned wood. Semihardwoods and softwoods like poplar or pine should also be avoided. The board should be at least 2.5 cm (1 inch) thick; thinner boards will not resist structural deformation over a long period of time.

The panel should be sealed against moisture penetration by applying a size and ground to all edges and both sides. To slow the expansion and contraction of the wood even further, apply a layer of the paint used in the picture to the back of the panel. This layer will help to equalize the tensions on the faces of the panel.

Because few large hardwood trees are now harvested, and the width of a board is limited by the size of a tree, it will probably be difficult to find boards of substantial width. Several boards can be glued together at the edges, with tongue-and-groove joints, to form a larger panel. But if the joints are not perfectly made, they will certainly split or crack. Bracing systems (also known as cradles) applied to the rear of solid wood panels invariably lead to cracking, because the braces hold the panel far too rigidly against the stresses in the wood's grain.

LAMINATED PANELS

Laminated panels are a useful alternative to the inconvenience, expense, and risk of preparing and using solid woods. First we will consider consider plywood, a laminated wood product, and then laminated paper boards.

PLYWOOD

Plywood is the most common of the laminated woods. These boards are available in large sizes

FIGURE 2.1. *Top,* end views of a *(left)* radially sawn plank and a *(right)* tangentially sawn plank. *Bottom,* the defects of solid wood panels, *left to right,* warping, checking, splitting.

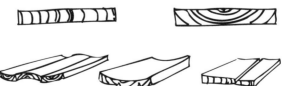

and varying thicknesses, and are made of both softwoods and hardwoods.

Plywood is put together so that the stresses caused by moisture and grain are lessened, if not eliminated. Thin layers of wood veneer, peeled from a tree by rotating the log against a sharp knife, are glued into a sandwich that has the grain of each layer at right angles to the grain of those adjacent to it. The number of layers vary according to the thickness of the board, but the minimum is three; this arrangement of the layers works to reduce warping and shrinking.

The inner layers of most plywoods are thicker and sometimes composed of a different wood from the outside layers. This is particularly true when the outer veneers are expensive hardwoods. In addition, different types of glue are used to laminate the plies, depending on whether the plywood is for interior or exterior use. Exterior-grade plywood is superior for its resistance to moisture, but the smoothest surface finishes are found on interior grades. If you want to try a plywood that has hardwood core layers, look for die boards: five-ply boards of hardwood, with all the layers composed of the same wood and of equal thickness, used for making punch dies (see List of Suppliers).

The most accessible and least expensive plywood has a pine veneer. If at least one side is perfectly smooth—free of seams, plugs, fillers, and knots—it can be a satisfactory surface for a painting. Softwood grains do have an eventual tendency to show through thinly applied paint layers; hardwood veneers of birch, maple, walnut, or mahogany are less likely to show this fault.

The necessary thickness of a plywood panel can be determined by the size of the proposed picture. A small painting might require a panel only 6 mm ($^1/_4$ inch) thick, whereas a large one might require a panel of up to 2.5 cm (1 inch) thick. A thin panel for a picture larger than about 61 cm (24 inches) on one side will need to be braced against warping. (Bracing plywood does not cause the problems associated with bracing solid wood panels because of the multidirectional grain in the panel.) The bracing is done by gluing 2.5 × 5 cm (1- by 2-inch) strips of wood around the outside edges of the back of the panel, using a strong carpenter's glue and C-clamps. Cross-bracing the middle of the longer side may also be advisable. Nails and screws cannot be used, since they must be put through the face side of the panel to work effectively—they will eventually rust or pop through the ground and paint layers. The best method is to assemble the bracing as a separate unit and then glue it to the rear of the panel.

The exposed edges of the plywood should also be treated against moisture penetration, which could cause the delamination of the layers. Sand the edges and seal them with a size, the ground, and paint, just as you might treat the edges of a solid wood panel.

LAMINATED PAPER BOARDS

Paper boards are made from wood waste or wood pulp. They are thick, somewhat dense, and lack the distinct layering of plywood. Laminated boards are sold under a variety of trade names, such as Upson Board or Beaver Board. Illustration board and the commercial framer's inexpensive mat board are more common types that have paper layers glued to the face surfaces. Paper boards should be considered temporary supports. Because of their high acidity and weak physical structure, they will deteriorate quickly; no amount of preservation or stabilization will prevent this. Do not use them for permanent work.

Laminated paper boards should not be used as supports, nor should they be used as collage materials. The discoloration and brittle appearance of added papers and paper boards in much twentieth-century painting is evidence of how poorly the materials survive. Furthermore, it is not a even a good idea to use these products for studies or sketches; you could easily be seduced by the surface quality or absorbency of the material and end up doing work that you want to preserve. If you want to do throwaway studies on these surfaces, then be sure to throw them away!

MUSEUM BOARDS

Technically speaking, museum boards are a type of laminated paper boards, but they deserve to be considered separately because they are of much higher quality. A museum board is a mat board

made from 100 percent linen or cotton rags, or from deacidified and buffered paper pulp. This material is usually an off-white or cream color, although other colors are now available. Each board has distinct layers (two, four, six, or eight layers)—the same coloration throughout all the layers—and no paper facing on the surfaces. These laminated boards can be used successfully with a number of painting techniques and are an excellent support. Museum board does not have much structural strength, however, so the two-ply boards should be matted and displayed like works done on paper. The four-, six-, or eight-ply boards can be displayed the same way or mounted on a wooden panel for rigidity.

CHIPBOARDS

These heavyweight boards are made of ground wood chips, pressed and glued together into large panels about the same size as standard plywood panels. Although chipboards are structurally sound, panels of any significant size are disproportionately heavier than other rigid supports. The transportation, exhibition, and storage problems of using such a heavy support should be taken into account. One product, with the trade name Aspenite, has much larger chips in its matrix, which allow for sufficient structural strength and a much thinner panel. This type of chipboard is also known as wafer board, flake board, or oriented strand board.

Medium-density overlay and high-density overlay (MDO and HDO) boards are high-grade chipboards made for the furniture industry and used under countertops and cabinet carcasses that will have veneers or other surface treatments laid over them. They are heavy and come in limited sizes but are well-made.

You should remember that chipboards were designed for construction and industrial use, not for artists. You should have some doubt about the permanence of the products. It may be wiser to avoid their use until their reliability as artists' materials can be verified.

POROUS BOARDS

Boards such as Homosote or Cellotex superficially resemble chipboards and are made of materials similar to those found in the inferior laminated paper boards—paper or wood pulp. These materials also deteriorate rapidly and cannot be considered suitable for permanent works. They are also structurally weak, too porous, loosely textured, and offer little in the way of physical support for a painting. I can't recommend them for any use in your studio except as a bulletin board.

HARDBOARDS

Hardboard panels are made of shredded, compacted, and compressed wood fibers. The fibers are burst apart under steam pressure, and the resulting pulp is formed into sheets. Only the natural adhesive found in the wood—lignin—holds the mass together. The method of manufacture produces a dense, one-layer substitute for solid wood that does not have a pronounced grain. The panels are therefore less likely to warp and are resistant to penetration by atmospheric moisture. A widely available brand called Presdwood is made by the Masonite Corporation. Two finishes, tempered and untempered, are of interest to the artist.

Tempered Presdwood is impregnated with an oily or resinous substance to make it more moisture-resistant, and can be recognized by its dark brown color and hard surface. Untempered Presdwood is light brown in color and considerably less dense than the tempered variety, since it lacks the oily addition.

Either type of hardboard panel can be successfully used as a painting support. Because the tempered Presdwood has an especially hard and nonabsorbent surface, it must be sanded vigorously to provide a good mechanical key for a painting ground. Untempered Presdwood should be lightly sanded to break up its surface fibers; because it is less dense and more absorbent than tempered Presdwood, it is more susceptible to moisture penetration and mechanical damage.

Both these general types of hardboard are made by other companies under different trade names, using more or less similar manufacturing processes. The panels come in varying thicknesses, but are more readily found in 4 mm ($^1/_8$-inch) and 6 mm ($^1/_4$-inch) sizes. The

standard width is 126 cm (4 feet). The length of a panel can be 241, 304, or 365 cm (8 feet, 10 feet, or 12 feet). Small panels can be used without an auxiliary support, but all panels may warp if uneven tension is exerted by a painted layer on only one side, and larger panels will bend and deform from their own weight. Bracing will easily diminish this problem.

CORED BOARDS

The principal disadvantage of panels, especially large ones, is their weight. Boards with a lightweight core between two permanent surfaces offer a way of overcoming this disadvantage.

One type of cored board, which has a plastic foam core with white paper surfaces, is used extensively as a backing for framed pictures. The board itself is not very rigid and warps easily. Archival-quality foam-cored boards are now available, suitable for permanent use, but the usual type is of questionable durability.

A hollow-core door, cored with a honeycomb of treated cardboard and faced with clear hardwoods, can be useful if there are no seams on at least one side. Custom services can provide panels like this made with a variety of surfaces: hardwood, hardboard, and even museum board. The one difficulty with this kind of structure is altering the size. If a hollow-core door is cut to a special size, the exposed edge will lose the support of the surrounding framework and be susceptible to damage. You must replace the missing part of the framework with a new member—a simple enough matter.

A new material in the construction trade is Alucobond panels (from the Fomebords division of Monsanto), which have painted aluminum surfaces with polyester cores and which are used as exterior cladding for buildings. These products are very expensive, but lightweight and stiff. They may prove to be a new generation of acceptably durable rigid supports.

METALS AND GLASS

Both metal and glass surfaces have been used for painting, but the practice is less common now. In Holland during the sixteenth and seventeenth centuries, artists sometimes did small paintings on copper or other metals; in the twentieth century, Jackson Pollock painted on glass and Frank Stella uses metal. Examples such as these survive because of extensive restoration or continued conservation measures.

The problem with these nonabsorbent supports is that the surfaces must be given a key for the following layers of paint, or the paint will not adhere properly. Glass has to be etched with acid or sandblasted to give it a tooth—even then getting a good key between the support and ground is difficult. Metals can rust or corrode beneath the priming layer, even if the surface is sufficiently roughened.

Aluminum is one metal that seems so far to be a good substrate for the acrylic emulsion paints—the metal and the paint have similar reactions to changes in temperature, and a paint-aluminum reaction provides for very good adhesion. If an aluminum panel is thoroughly sanded and degreased, it can be primed with an acrylic emulsion ground and painted with acrylic emulsion paints. Process Materials Corporation sells a cored support that has a honeycombed interior with aluminum skins; Fine Arts Stretchers and Services sells aluminum honeycombed panels with either aluminum or polyester skins. (See List of Suppliers.) As you might guess, the prices for these types of supports are very high.

BRACING A RIGID SUPPORT

Panels of plywood or hardboard should be braced on the back side. This will help prevent bending or warping caused by the weight of the panel, or uneven tension between the painted and the unpainted sides. Bracing can also help keep the panel edges from shredding or denting. The two primary types of bracing are simple and lap-joint (Box 2.1).

In *simple bracing*, the bracing parts are cut to fit the outside dimensions of the panel. The joints of the bracing are not attached to each other, but are glued separately to the panel. This type of bracing is only adequate. Its disadvantage is that the joints between the members of the bracing are not rigidly connected. The butt joints can be strengthened by using corner and T-irons, or plywood triangles called gussets.

Lap-joint bracing, which calls for a bit more carpentry skill, produces stronger joints and a better independent structure for the bracing. The bracing is built as a separate unit with lap joints and glued to the rear of the panel.

The wood for either type of bracing should be straight-grained and free from knots, twists, or warps. The boards can be softwoods like white pine, fir, or redwood, or a harder wood like yellow pine. You can use 2.5 × 5 cm or 2.5 × 7.5 cm (1 × 2 inch or 1 × 3 inch) boards. Remember that these are nominal measurements, based on the industry designations for the roughly hewn sticks. After planing and drying, they are smaller: The actual size of a 2.5 × 5 cm board is only 1.9 × 3.8 cm ($^3/_4$ × $1^1/_2$ inch).

BOX 2.1. HOW TO BRACE A RIGID SUPPORT

MATERIALS
- Panel to be braced.
- Bracing strips, 2.5 × 5 cm (1- by 2-inch).
- Corner and T-irons, with flathead wood screws.
- Hammer and screwdriver.
- Backsaw and miter box.
- Sharp, wide chisel.
- Carpenter's square.
- Weights or (better) C-clamps.
- Corner clamps.
- Good-quality, strong carpenter's glue. The yellow glues are stronger and more moisture-resistant than the white glues. Contact cement can also be used, but use the water-based kind.
 ☞ *CAUTION: Solvent-based contact cements contain toxic solvents.*

METHOD A: SIMPLE BRACING
1. Measure the dimensions of the panel.
2. Cut the bracing to the measured lengths with the backsaw and miter box. Check the cut ends with the carpenter's square to be sure that they are perfectly square. If the panel is large, cut extra pieces for cross-bracing.
3. Lay the panel face down on a table or the floor and assemble the bracing on it to see that it fits. All the butt joints should be snug and square.
4. Spread the glue evenly and thinly on each piece of the bracing and reposition them on the back of the panel.
5. Pile weights on the bracing. Better yet, clamp them with the C-clamps. Allow the assembly to dry overnight. If contact cement is used, clamping will be necessary for only a short period of time—perhaps an hour.

METHOD B: LAP-JOINT BRACING
1. Measure the dimensions of the panel and cut the bracing members to these lengths. Notice that the strips overlap.
2. Cut the laps, also known as dados, for all the joints by sawing halfway through the end of each overlapping piece and chiseling away the scrap. Each joint will now be a lap joint—stronger than a butt joint.
3. Assemble the bracing and glue it to the panel as in Steps 4 and 5 above. The joints can be glued and screwed together, attached with the corner and T-irons (Figure 2.2), or attached with gussets. You can see the lap joints in this illustration.

FIGURE 2.2. Lap-joint bracing for a rigid support, with all joints to be screwed and glued.

SURFACE PREPARATION

Before receiving a size and ground, the surface of the panel should be roughened by sanding lightly with fine sandpaper. The edges of the panel should also be slightly beveled with a file, or rounded with sandpaper, to prevent a stiff ground layer from chipping off. Thoroughly dust the sanded panel before applying any coatings.

Aluminum panels are also easily sanded. Take care to rough up the surface thoroughly and evenly—an electric orbital sander is a great help. Gently file the panel's edges to remove burrs.

Wood and aluminum panels should be wiped with a cloth dampened in denatured ethyl alcohol or mineral spirits to remove residual grease or oils.

☞ *CAUTION: Alcohol and mineral spirits are health and fire hazards, alcohol more so. Use either of them with plenty of ventilation.*

FLEXIBLE SUPPORTS

Supports made of textiles or paper—flexible supports—have advantages over rigid supports. They are lightweight and portable. They can be put together in a much greater variety of sizes. And these supports are generally more easily treated if they need to be repaired.

But because flexible supports are also much thinner than panels, they are more susceptible to atmospheric and mechanical damage. Depending on the specific material, most textiles and papers are unstable in response to atmospheric changes. Constant movement resulting from changes in temperature and humidity can contribute to the physical deterioration of a relatively rigid painted layer. You can counteract the instability of fabrics by supporting them on a chassis (a strainer or a stretcher) or mounting them on a rigid panel substrate. Both techniques are described later in this section.

PAPER AS A SUPPORT FOR PAINTINGS

When properly prepared, paper can be an excellent support for a variety of mediums. The paper should be made of 100 percent cotton or linen rag fibers, or one of the newer cellulose pulp papers that are buffered against atmospheric acid. These conditions must be met if the papers are to resist yellowing and embrittlement. Certainly, cheap newsprint and the various plain white drawing bond papers are not permanent materials unless they can be certified to contain no wood pulp or acids. (A simple test for the acidity of papers can be found in Chapter 1).

Papers are useful as sketching supports for oil painting, but they should not be considered permanent. A boardlike 400-pound watercolor paper might prove durable for a while, but even such a strong support will eventually be stained and damaged when the oil penetrates its fibers. Papers can be primed with a ground such as an acrylic polymer emulsion gesso to protect them against the oil, but the priming will so obscure the surface quality of the paper—which is the reason for using it in the first place—that you might as well use a different support or a different paint. Permanent papers are fine supports for the acrylic emulsion paints, for instance.

The advantages of paper are that it is accessible and inexpensive. But it is physically fragile. Paintings done on paper should be carefully handled and stored. (See Chapter 16.)

CANVAS BOARDS

Art supply shops sell canvas boards and primed paper as supports for painting, but these products are of doubtful quality and you, a serious artist, should avoid them. Inexpensive primed paper is sold in tear-off tablets and has a cloth weavelike texture imprinted on its surface. It is both cheaply made and impermanent. Canvas boards use thin cotton or muslin glued to cheap pulp cardboard, primed with an acrylic emulsion that also fills the gaps in the fabric's thin weave.

These materials are technical disasters. It is possible to find well-constructed custom canvas boards made of permanent materials, but you can easily make your own at less expense and be equally assured of a durable product.

TEXTILES

Fabrics such as silk have been used in the Orient since ancient times as supports for paintings in ink and watercolor. Linen and cotton came into general use in Europe during the Middle Ages. Other sorts of woven fabric have been used as a basis for painting at one time or another. Today, artists chiefly use cotton, linen, and a few of the synthetic fabrics. Canvas is a term often applied to cotton materials, or even as a designation for a finished picture (whether on cotton, linen, or synthetic), though its true definition is much more general: a firm, closely woven cloth.

COTTON DUCK

Cotton duck is made of the fibers of the fruit of the cotton plant. It is widely available and a popular support for painting, although it has definite disadvantages. For example, cotton fibers are quite short and resistant to stretching. They suffer rapid degradation when subjected to atmospheric stresses, especially when the fabric made from them is stretched tightly on a frame, as in a painting. Finally, the fibers, no matter how white and pure, show a measurable color change after relatively little exposure to light—less than ten years.

However, many forms of cotton are currently used in painting. The medium to heavy weights—on the order of 284 gm/m^2 (10 ounces per square yard) and tightly woven—are used in artistic paintings. Theoretically, the raw cotton duck should be washed before using (to get rid of the mill-applied sizings), and should be prestretched before attaching it to an auxiliary stretcher system (to remove the crimp in the weave). This is such a bother that few artists do it.

Thin cotton, such as bed sheeting or muslin, is also sometimes used as a support—especially by those who are thinking of economy. But this cotton is not economical in the long run, because it is much too structurally weak to support a paint film. You can, however, back the fabric with a rigid panel substrate to solve this problem.

Some artists object to the mechanical appearance of the cotton weave, although this objection is largely aesthetic; some styles of painting may demand that the fabric's texture be unassertive. Regardless of aesthetic concerns, cotton should be considered an inferior material in comparison to linen.

LINEN

Linen is made from the woven fibers of the flax plant and is distinguished from cotton by its color—a dull brownish-green—and its usually pronounced and irregular texture. Individual linen fibers are considerably longer and springier than cotton fibers; the material is therefore somewhat more durable and has a livelier feel when it is stretched on a frame.

The physical problems of linen have long been discounted because of its relatively better performance when compared to cotton. However, studies on the mechanical properties of linen and cotton when combined with sizings and primings show them both to be equally poor supports for oil painting. Nonetheless, linen is the most favored support today, and when properly supported by an auxiliary system and used with the right kind of paint, it is a valuable and useful material.

There is considerable variety of weave texture and weight available in linen, from very coarse and heavy to fine and light. Usually the heavier grades are chosen for large pictures, while the lightweight linens are satisfactory for small works or for mounting on a panel. Whichever grade you choose, select a linen made for artists' use. (See the List of Suppliers for sources of good-quality linen.)

Look for a close weave, where the threads of warp and fill (weft) are of equal weight, and avoid blends of linen and other materials such as cotton or the synthetics. Different threads will have uneven tension when stretched and will show unequal reactions to environmental changes. If the blend is in the thread, and exists in equal weight ratio in the warp and fill, blends can be satisfactory. You must rely on the manufacturer's word about whether the blend was made in this way. Practically speaking, most blended textiles are too thin for general artistic use.

SYNTHETIC FABRICS

The major disadvantage of most fabric supports is their continual movement in response to atmospheric change. Some manufacturers of artists' and conservators' materials are investigating the use of synthetic fabrics to replace the natural ones. Some of these fabrics offer promising possibilities and should not be dismissed.

Polyester fabrics seem to be the best alternative, since they are nonabsorbent (and therefore don't react to humidity) and stable at normal temperatures—although they do have a tendency to sag at higher than normal temperatures. Fredrix Artist Canvas (Tara Materials), an American manufacturer, markets a preprimed polyester support called Polyflax. It also produces a cotton and polyester blend— a blend in the thread. Both are primed with a heat-set acrylic polymer emulsion ground which is tightly keyed to the nonabsorbent support. Fredrix also markets a dyed polypropylene fabric (preprimed with a thermoset acrylic emulsion ground) which, in color at least, resembles linen. (See List of Suppliers).

Fiberglass fabrics, both the chopped strand mat and the woven cloth types, might provide another alternative to the natural fabrics, though neither has been fully tested in conditions under which artists would use it. Neither stretches very well. The other synthetics (acrylics, nylons, acetates, sarans) show rapid deterioration on exposure to light and so are probably unsuitable.

OTHER FABRICS

Burlap, jute, and hemp are coarse-textured, heavy, short-fibered textiles that have been used for painting. Works done on these fabrics usually deteriorate very quickly, for the materials are too absorbent, brittle, and short-lived. For a rough-textured support, it is better to choose a rough linen.

PREPRIMED TEXTILES

Many fabrics can be bought already prepared with a size and/or a ground. This is convenient and economical. Since there is wide variation in the quality of preprimed supports, however, pay particular attention to choosing the best quality. Using cheap preprimed textiles is a mistake.

You will most commonly find cotton duck preprimed with an air-dried or thermoset (heat-cured) acrylic or vinyl emulsion ground. Look at the backs of these products and inspect the fabric. If it is white or cream-colored, it is cotton. It should be of substantial weight and have a tight, close weave. You might find during such an inspection that the ground is actually holding together a thin, insubstantial fabric. This is an indication of poor quality.

Single- or double-primed linen, with a glue size and an oil ground, is also on the market. The basic expense of the ingredients and labor in the preparation of the materials generally ensures that the manufacturer has made a better-quality support (but see pages 41–42 in Chapter 3 for an admonition about glues). Here again, check the back of the support to see that the fabric is closely woven and substantial. If it is light brownish-green or dark brownish-green, it is most likely linen. You can also check the adherence and flexibility of the ground by rolling a corner of the material, ground side out, between your forefinger and thumb. An oil ground will usually crack under such an extreme test. If it does not powder or separate from the support it should be satisfactory. You can tell if this material has been sized with a glue size by wetting your finger and rubbing the back of the support: If, after a minute or two, you feel a slipperiness, the sizing is probably glue. Otherwise, there is no simple way to know what the sizing is.

Note that many textiles preprimed with an oil ground, especially a lead-in-oil ground, have a grayish color instead of the brilliant white you expect in a ground coating. This is because oil grounds turn yellowish with age, so manufacturers add a tint to hide this defect. Lead-in-oil grounds suffer even more because the lead pigment can turn yellowish when stored in dark or humid conditions, and since preprimed textiles are stored in rolls this frequently happens. An untinted ground that has yellowed will regain its former whiteness once it is stretched and exposed to daylight for a few days. A ground that has been tinted during manufacture will remain gray.

If you are using a cheap preprimed support, you may think you will save money and increase its durability by priming the already-primed fabric, but you will not: You will have a high-quality priming on a cheap support. Likewise, high-quality preprimed fabrics need no further attention other than prestretching and exposure to light. Priming them is a waste of effort and money.

Preprimed supports with oil grounds should be stretched before being stored in the studio. Storing these supports in rolls allows the ground layer to grow brittle—a natural tendency of the oil in the ground. Subsequent stretching of a preprimed fabric that has been stored rolled up may crack the ground, especially where it is bent over the chassis. Cracking exposes the fabric to stress from paint layers and atmospheric conditions, and can lead to future separation of the ground and paint from the support.

CHASSIS FOR STRETCHING TEXTILE SUPPORTS

To lessen the movement of the support in response to atmospheric changes, fabrics used for painting are stretched on an auxiliary chassis.

It is possible to paint on a flexible support without stretching it first. Tack it to your painting wall or a large piece of plywood, size and prime it, and paint away. If you like the painting, then stretch it—before it dries, if possible. If it is an oil painting, give it a week or two to dry and then stretch it; if you allow an oil painting to dry completely, you may crack it when you stretch it. If you like the painting, then stretch it before it is fully dry. Depending on the thickness of paint, an acrylic emulsion painting may dry in an hour. You can let an oil painting dry a week or two before stretching it. Just don't let it dry completely, or you may crack it when you stretch it.

There are two types of chassis: the strainer and the stretcher.

Strainers

The homemade strainers described below are convenient, inexpensive, and easy to make. Because their rigid corners restrain the movement of the mounted textile, and because this can sometimes lead to the cracking or flaking of oil paint, strainers have not enjoyed a good reputation. But plenty of oil paintings on linen (sized with glue, primed with lead white

BOX 2.2. HOW TO MAKE A SAWED-BEVEL STRAINER

MATERIALS
- 2.5 × 5 cm (1- by 2-inch) or 2.5 × 7.5 cm (1- by 3-inch) pine, fir, or other straight softwood, free of twists, warps, or knots, long enough to go around all four sides of the picture.
- Table saw.
- Miter box and backsaw.
- Corner irons, with screws.
- Hammer.
- Screwdriver.
- Carpenter's square.
- Corner clamps.
- Carpenter's glue.

METHOD
1. Use the table saw to cut a bevel into the face side of the boards. Leave a lip about 1.3 cm ($\frac{1}{2}$-inch) wide exposed on the face of the board. This lip will be the area of contact for the fabric.
 ☞ *CAUTION: Table saws are dangerous. If you do not have experience with them, get instruction.*
2. Cut the boards to length, and miter their ends to 45° angles with the miter box and backsaw.
3. Assemble the chassis using the corner clamps to get 90° angle corners. Glue the joints and use the corner irons to hold them rigid. Add cross-bracing to the back of the chassis if any side is over 61 cm (24 inches) long. Cross-bracing is necessary to prevent the bowing-in of the chassis as the textile is stretched on it.

in linseed oil, and stretched on strainers) have survived for well over a hundred years without significant damage to the paint. Strainers can pose a threat to oil paintings, but they can be used successfully if the paintings receive proper care, and they are more than satisfactory for other types of flexible paints.

You can easily build a sturdy strainer in your studio. (See Boxes 2.2 and 2.3.) It is usually made using 2.5 × 5 cm (1- by 2-inch) or 2.5 × 7.5 cm (1- by 3-inch) clear lumber in the same manner used for building a panel bracing on page 32, with one important difference: A lip, or bevel, must be added to the front edge of the chassis to hold the textile away from the frame. If the fabric were to remain in contact with the full width of the strainer frame during the painting process, an annoying or even damaging line would appear on the painting. The bevel can be made by sawing it into the chassis edges with a table saw, or by adding it as a separate component using quarter-round molding.

Stretchers

A stretcher is a set of machine-made wooden rails, with beveling at the edges and mitered, mortise-and-tenoned corners. The mortise-and-tenoned corners allow a set of four bars to be fitted together without glue or screwed-on supports. The stretcher system can therefore expand and contract with the movement of the mounted fabric. Most stretcher systems have small slots in the inside corners of the chassis into which keys can be inserted (two keys for each corner). These keys provide a means for retensioning the fabric if it sags.

Keys should not be overused. Most fabrics will sag in conditions of high humidity and will shrink when the humidity goes down. If you "key out" a sagging picture when the humidity is high—so that the picture is drum-tight in high humidity—it can be exposed to great stress when the humidity goes down. This can place a strain on a relatively rigid paint film, especially after many cycles of high and low humidity. The strain causes cracking, loss of adhesion, and the like. Keying out should therefore be avoided if possible. If the picture is sagging too much, do the keying out when the humidity is low.

Despite these drawbacks, stretcher systems are popular. They are easily disassembled, rearranged, and reused, and they are convenient and relatively inexpensive.

BOX 2.3. HOW TO MAKE A STRAINER WITH QUARTER-ROUND MOLDING	
MATERIALS	**METHOD**
• 2.5 × 5 cm (1- by 2-inch) or 2.5 × 7.5 cm (1- by 3-inch) pine, fir, or other straight softwood, free of twists, warps, or knots, long enough to go around all four sides of the picture. • Miter box and backsaw. • Corner irons, with screws. • Hammer. • Screwdriver. • Carpenter's try square. • Corner clamps. • Carpenter's glue. • 1.3 cm ($^1/_2$-inch) quarter-round wooden molding. • 1.9 cm ($^3/_4$-inch) brads or finishing nails.	1. Build the strainer as though you will be bracing the back of a panel. Miter the corners or make lap joints; glue them together and use the corner irons on the back for rigidity. Use the corner clamps to be sure that the corners are 90° angles. Construct cross-bracing, using half-lap joints, if the size of the strainer warrants it. 2. On the face side of the strainer, measure for and cut the quarter-round molding. Lay the molding around the outside edges of the strainer so the rounded profile of the molding faces the inside of the strainer. Miter the ends of the quarter-round for a flush, square fit. 3. Put glue on the bottom of each of the molding strips and nail them into place.

Ready-made stretcher bars come in two sizes. The smaller and most common is about 1.9 cm thick and 3.9 cm wide ($^3/_4$-inch × $1^1/_2$ inches), with beveling on both front and back. Sometimes these bars can be found with a keyable cross-brace for the middle of the long side of a chassis.

The larger bars are not as readily available at most retail stores, but can be had through various mail-order suppliers (see List of Suppliers). These are about 3.9 cm thick × 6.9 cm wide ($1^1/_2$ inches × $2^1/_2$ inches) and have the bevel only on one side; they also come with corner keys. This size is excellent for large pictures, where the greater expanse of fabric needs a stronger support. Both sizes are usually well made, but before you buy them, it is wise to inspect individual bars for defects such as warping, twisting, or cracks in the joints.

Custom-made stretcher bar systems can be purchased from several companies that will make up a chassis to your exact dimensions (see List of Suppliers). These systems feature high-quality hardwood in their construction, and ingenious mechanical devices at the corner and cross-bar attachments that can maintain precise tension on the fabric support. The expense of these custom systems usually prohibits their use by the average artist, but they are widely used by conservators and museums.

One manufacturer of artists' supplies, M. Grumbacher, makes Stretcher Cleats and Cross-Bar Cleats that can be used to simulate the action of keyable bars on a homemade strainer. The cleats are aluminum wedges that slide on screws fastened to the mitered corners of a strainer. They spread the corners of the strainer and angle the face of the fabric away from the inside edges of the bars. The cleats allow an artist to build an acceptable stretcher from plain wood instead of buying machine-made stretchers.

Stretching Textiles

There are a number of ways to stretch fabric onto a chassis. Any system that produces a flat, smooth, taut surface will do. Stretching a preprimed fabric requires slightly more effort than stretching raw fabric because priming stiffens the fabric's surface. If you find it difficult to stretch stiff fabric, use upholsterer's stretching pliers. A textile that will later have an acrylic emulsion ground applied also needs to be stretched tightly, because the acrylic primer will not shrink the fabric as much as a glue size. Linen or cotton duck that will be sized before the ground is applied should not be tightly stretched (it is sometimes better to do it without using the pliers) because the size will shrink the fabric. If the fabric is too tightly stretched, the shrinking action can break the joints of the chassis.

Methods used to fasten the material also vary. Some artists prefer to use No. 4 or No. 6 blue steel carpet tacks and a magnetic tack hammer. The tacks hold very well even when they begin to rust, and are the traditional fasteners. (See Box 2.4.) Other artists prefer to use staples because a staple gun is faster and can be used with one hand. If you use staples, choose a gun that can shoot heavy-duty fasteners.

Some artists find it more convenient to drive the tacks or staples into the rear of the stretcher instead of the edges—it's much easier than standing the stretcher on its edge. This is an acceptable practice, provided you realize that extra strain is put on the material by stretching it over two edges instead of one.

Whatever system you use, a properly stretched fabric should lie flat when placed face up on the floor. If you try this and find that one of the four corners does not touch the floor, it indicates that the support is warped—usually the result of uneven stretching tension.

Put the keys in the slots at the rear corners of the chassis. They can be held in place with small brads. Remember that overusing them can be harmful for the picture.

Mounting Textiles to a Panel

The homemade version of those cheap canvas boards described earlier combines a rigid panel substrate with the desirable surface qualities of a flexible material. Since painting with oil on flexible fabrics can be risky, this laminated arrangement might be the best support for easel painting on fabric.

The disadvantages of mounting a textile to a panel include the difficulties of making repairs to the back of the textile, the potential

BOX 2.4. HOW TO STRETCH LINEN ONTO STRETCHER BARS

MATERIALS

- Four ready-made stretcher bars with keys.
- Raw, unprimed linen, cut so that it is a piece about 5 cm (2 inches) larger on each side than the assembled chassis.
- Carpenter's square.
- Tack hammer with one magnetic head and one plain head.
- No. 4 or No. 6 blue steel carpet tacks.
- Stretching pliers.

METHOD

1. Assemble the chassis. Make sure the corners are 90° by checking them with the square, or measure the length of the two diagonals to see that they are equal. Secure the corners of the chassis by driving a tack through the joints, or use some scrap wood as a temporary brace. (Be sure to remove the tacks or bracing after stretching the fabric.) If the size of the chassis requires it, attach a cross-brace between the centers of the longer sides.

2. Place the linen on the floor or a table and smooth it out. Center the chassis on the linen so that there is an equal amount of excess material on all sides. The weave of the linen should be parallel to the sides of the chassis.

3. Find the center of each bar, by eye or by measuring. Fold the linen over the bar on one side and tack it to the center of the outside edge of the bar. Drive this and all the rest of the tacks about halfway in, so they can be removed later if necessary.

4. Tack the linen to the center of the opposite bar. Follow the same procedure with the other two sides.

5. Stand the chassis on one edge and remove the center tack. With the pliers, grasp the excess linen and stretch it across the edge of the bar. Replace the tack, using the magnetic head of the hammer to hold the tack for the first

blow. Do the same to the adjacent side. Notice the diamond-shaped wrinkle in the surface of the fabric.

6. About 5 cm (2 inches) on either side of the first tack, drive two more tacks. Do the same on the opposite side, stretching the linen taut before placing the tacks and using the same tension to keep the weave parallel to the bars. Estimate the distance between the tacks by using half the width of the plier jaws.

7. Do the same with the adjacent sides, being sure to place the tacks directly opposite their counterparts. This will ensure even tension. Pull slightly away from the center, toward the corners, when stretching the material. Continue in this manner, placing the tacks at even intervals but driving them only halfway in, until the linen is stretched onto the chassis up to the corners.

8. Neatly fold the corners and tack the linen into the heavier part of the joint. If you are facing the rear of the chassis, the heavier part of the joint will be the edge nearest you on the right and the edge farthest from you on the left. A neat corner fold not only looks best, but is an advantage when the picture is inserted into a frame. Bulging excess material at the corners can complicate framing.

9. If you are satisfied that the linen is properly stretched, without wrinkles, sags, ripples in the weave, or warps in the chassis, drive the tacks in completely. If there are defects, remove the tacks at that point and restretch.

10. Tack the excess linen to the back of the chassis—don't trim it off at the edges of the bars. If you have to restretch the painting in the future, you'll want to be sure to have enough material to grasp with the stretching pliers.

for the lamination to separate due to air bubbles or moisture penetration between the layers, and the weight of the combination. But good technique can at least prevent delamination.

One recommended method uses the common and easily obtained hide glue adhesive, also called a size. (See Box 2.5.) The hide glue method is best for general use and is the easiest to make and apply, but the fabric may eventually come loose from the panel if moisture penetrates.

To prevent this, you can substitute a commercial acrylic emulsion gloss medium for the hide glue. Use any artist's paint manufacturer's gloss medium. This material can be used straight from the jar, or very slightly thinned with water. However, be aware that this method—unlike the others—uses a glue that cannot be dissolved using weak solvents. If the fabric ever has to be removed from the panel for restorative treatment, special solvents will have to be used.

BOX 2.5. HOW TO MOUNT A TEXTILE TO A PANEL WITH HIDE GLUE OR ACRYLIC MEDIUM

MATERIALS

- Panel substrate. (If it is hardboard, sand it, bevel the edges, and brace it if necessary.)
- Fabric (linen or cotton) cut to a size about 5 cm (2 inches) larger on all sides than the panel.
- Strong hide glue, as prepared in Box 3.1 (for Method A).
- Acrylic gloss medium (for Method B).
- Bowl.
- Large housepainter's brush.
- Hard rubber brayer.

METHOD A: HIDE GLUE

1. Make the glue and put it into the bowl.
2. Brush the glue onto the panel, covering it generously.
3. Dip the fabric into the glue so that it is thoroughly wet. Wring out the excess glue.

4. Position the fabric on the panel. Fold the flaps over the panel's edges and onto the back.
5. Use the brayer to roll the surface and edges of the panel to be sure the fabric is completely adhered. Start at the center of the panel and work toward the edges, forcing out any trapped air bubbles.
6. Put a coating of the glue on the back of the panel.
7. Stand the panel on edge and lean it against a wall. Allow the panel to dry overnight. It will need no further preparation except priming.

METHOD B: ACRYLIC GLOSS MEDIUM

1. Proceed as outlined in the hide glue method, but skip Step 1.
2. In Step 3, brush the gloss medium onto the fabric instead of dipping it.
3. Continue as instructed.

3 Sizes and Grounds

Most painting supports need further surface treatment before they can be used. Preprimed textiles already have a prepared surface and need only be mounted on an auxiliary support. Papers being used for aqueous techniques generally do not need further attention. But untreated supports, flexible and rigid, are usually too absorbent to allow the controlled application of paint. Therefore intermediate layers, called a size and a ground, are first applied. A size sinks into the surface support without forming a separate layer, whereas a ground is a distinct layer that gives the paint a toothy coating to grip and makes the support more evenly absorbent.

It is most efficient to prepare six month's or a year's worth of supports once or twice a year. Stretch, size, mount, sand, and otherwise prime 25 or 50 supports of various sizes all at once, over a 2- or 3-day period. You will have lots of ready-made surfaces to use, and you will be sure of their quality.

SIZES

A size is a thin solution, often a weak glue but sometimes a resinous mixture, that is brushed directly onto the support. A correctly made and applied size will permeate the support surface without coating it. There are several good sizes available, and it is worth experimenting with them to discover their advantages and disadvantages.

The incorrect application of a size can cause damage to the picture. A thick, glossy film of size may prevent a good mechanical bond between the support and subsequent coatings, such as paint, and this problem may lead to cracking and loss of the paint film. A size that is too weak, on the other hand, will allow the paint binder to be absorbed into the support, and weakly bound paint may crumble or powder off the support.

A size is essential if the grounds or paints are based on linseed oil. Linseed oil dries by oxidizing (in effect, doing a "slow burn"), and can disintegrate or embrittle an unprotected paper or fabric support.

As the term implies, sizes also shrink a stretched fabric support so that it fits tightly on the chassis. Some sizes do this better than others, and some, like hide glue, are so powerful that they have a tendency to overwhelm the other physical components of a painting. Of course, this depends on the conditions under which they are used.

HIDE GLUE

Made from animal skins and bones, hide glue has the popular name of rabbitskin glue. It comes in the form of tough, leathery sheets, roughly ground granules, or finely ground powder. The dry glue is mixed with hot water to make a powerful adhesive, a binder for paints, or a size, depending on the strength of the mixture.

Hide glue is now known to be far stronger than any other component in an oil painting on fabric (the other components are the paint and the fabric). Hide glue is hygroscopic— it tends to absorb and expel atmospheric

moisture, even when apparently dry—and its response to changes in relative humidity can be extreme. It shrinks greatly when humidity is low, and sags considerably when the humidity is high. Both responses put undue stress on a relatively rigid and brittle dried oil paint layer, especially when it has been painted on a flexible support and stretched on a chassis. The oil paint has little choice but to crack under these conditions, and the obvious result is the slow and inevitable destruction of the picture.

For these reasons, hide glue is generally denigrated as a size and is not recommended for a textile that is to be primed and painted with oil-based paints. Still, I have included instructions on how to apply hide glue to a stretched textile support since it remains a widely used procedure. If you are going to size fabric with hide glue, you should do it correctly.

BOX 3.1. HOW TO MAKE HIDE GLUE TO SIZE A SUPPORT

MATERIALS

- Dry hide glue.
- Cold tap water.
- Double boiler or clean metal container.
- Electric hot plate with a rheostat so that the temperature can be controlled, and a metal cover over the heating element to lessen the danger of fire.
- Wooden spoon or stick for stirring.

METHOD

1. Place about 1 part by volume powdered glue into 10 parts cold tap water.

2. Soak the glue until it has absorbed water and swollen; three hours should be enough. Stir the mixture occasionally to keep it from sticking together in a lump.

3. Place the mixture in the top of the double boiler. Put water in the bottom pot—the hot water will melt the glue and insulate it from direct application of heat.

4. Heat the mixture gently on the hot plate. Do not allow it to boil because glue that boils loses its adhesiveness and must be discarded. Remove it from the heat when it has melted completely, and use while hot.

BOX 3.2. HOW TO APPLY HIDE GLUE TO A STRETCHED FABRIC

MATERIALS

- Hot hide glue, as prepared in Box 3.1.
- Fabric stretched on a chassis.
- Housepainter's brush.
- Blunt knife or stiff paper card.

METHOD

1. Be sure the fabric is clean and not too tightly stretched.

2. Brush the warm glue onto the fabric. Begin in the center and work toward the edges. Apply the glue thinly and uniformly so that it appears to sink into the weave. Brush the size onto the edges of the support and around to the back of the chassis. This will glue the fabric to the back of the bars and keep frayed edges from raveling.

3. A single coat of glue may leave a number of pinholes through which subsequent applications of paint can seep. You can apply a second, very thin coat of size when the first is dry.

4. If the fabric sticks to the front of the stretchers, release it by running a blunt knife or stiff card along the back of the support, between the bars and the fabric.

5. Allow the size to dry naturally. Do not force it to dry by applying heat, direct sunlight, or forced air; forced drying might result in a warped chassis or broken stretcher bar corners.

Hide glue is a valuable adhesive for certain applications. Very diluted, it will weakly size a strong paper. When formulated properly, it can be used to mount a fabric support on a panel. It has been used as the binder for pigments in size paint, also known as distemper.

HIDE GLUE SIZE FOR A SUPPORT

To make a size, you can prepare hide glue according to the method outlined in Box 3.1. You can then apply the prepared glue to a stretched fabric (Box 3.2) or to a panel (Box 3.3).

Whichever support you use, check to make sure that the glue has been applied properly. To do so, hold the support at an angle to a strong light and look at the dried surface. It may have an overall sparkle, but it should not show any shiny, reflecting spots—these indicate that you've applied the glue too thickly. Remove the shiny spots by wiping them with a rag dampened in warm water. Insufficient coverage can also be noticed if the support is held up in front of a strong light. Pinholes indicate that a second thin coat of size is needed.

You can store leftover glue in a clean, covered glass jar in a refrigerator. It will decompose after about two weeks; its odor becomes stunningly unpleasant, and it must be discarded.

Glue that has cooled will jell. In most instances it is necessary to melt the gel by gentle heating in order to use it again—but be careful not to let it boil, or to heat it too long. Reheating will drive off some of the water and increase the strength of the glue, so add a little hot water to the solution to return it to its proper concentration. Softly jelled glue can be applied to fabric without reheating it by using the edge of a large spatula to spread the size thinly over the support. Be sure to use enough pressure to force the gel into the weave.

A thin film of hide glue will gradually harden from its jelled state as the balance of the water evaporates. As noted, however, it is hygroscopic and will continue to absorb and expel atmospheric moisture. In the past it was recommended that the film be further cured and made somewhat more moisture-resistant by lightly spraying the support with a weak solution of formaldehyde in water.
☞ *CAUTION: **Formaldehyde is a possible carcinogen. Do NOT use it.***

HIDE GLUE SIZE FOR PAPER

Some papers made specifically for aqueous painting techniques need no further surface preparation. Other papers, which are not presized, can have a weak solution of hide glue applied. (See Box 3.4.)

BOX 3.3. HOW TO APPLY HIDE GLUE TO A PANEL

MATERIALS

- Hot hide glue, as prepared in Box 3.1.
- Panel.
- Sandpaper.
- Rags.
- Denatured ethyl alcohol or mineral spirits.

METHOD

1. Sand and dust the panel; bevel its edges. If the surface is oily or waxy, wipe it off with a rag dampened in denatured ethyl alcohol or mineral spirits and allow it to dry. This preparatory stage

is important; otherwise the glue won't stick properly.
☞ *CAUTION: **Alcohol is a toxic health and fire hazard. The vapors can make you lightheaded, and ingestion of denatured alcohol can be fatal. Use either alcohol or mineral spirits with plenty of ventilation and keep them away from sparks or flame.***

2. Apply the size thinly, as to a stretched fabric. The edges and back should also be covered; this will retard moisture penetration and equalize shrinkage and stress on both faces of the panel.

MATERIALS

- Dry hide glue.
- Cold tap water.
- Warm water.
- Double boiler.
- Electric hot plate with a rheostat so that the temperature can be controlled, and a metal cover over the heating element to lessen the danger of fire.
- Tub or tray large enough to hold the paper.
- Large sheet of glass or smoothly sanded plywood.

METHOD

1. Put 1 part dry glue into 10 parts cold water, and soak and heat as in Box 3.1.

2. When the solution has formed, stir it into 30 additional parts of warm water. The final proportion is 1 part glue to 40 parts water, by volume.
3. Put the weak glue solution in a tub or tray large enough to hold the paper.
4. Immerse the paper in the glue—several sheets can be done at once—and soak for several hours.
5. Remove each sheet and drain off the excess glue. Lay the sheets flat on a large sheet of glass or smoothly sanded plywood, and leave them until they dry. It is important that the paper be allowed to dry naturally at room temperature. Do not force-dry it with heat lamps, heaters, or sunlight.

HIDE GLUE FOR MOUNTING FABRIC ON A PANEL

To prepare hide glue for the mounting technique described in Chapter 2, combine about 3 parts by volume of dry glue with 10 parts cold water; then soak and heat as usual.

OTHER MATERIALS FOR SIZES

Hide glue is the traditional size material, but it poses definite dangers under certain circumstances. Other adhesives can be substituted for hide glue for making a protective size. Most of them are easier to make and use. Some are safer from the standpoint of physical stability, and are not subject to organic decomposition. However, many are more expensive.

If you choose an alternative, be aware of the principle of reversibility. It is sometimes preferable for a film-forming material such as a size or varnish to be reversible—that is, for it to be easily removable by dissolving it with its original diluent. Some sizes are resistant to removal.

REVERSIBLE SIZES

These reversible sizes are easily removed when redissolved in their diluents. They all provide a measure of protection for the support and will reduce its absorbency. A few shrink (size) a stretched fabric as they dry. Some can be used on a fabric or paper to which oil paints will be applied. Some may pose stresses similar to those of hide glue.

Gelatin

Powdered gelatin is a refined relative of hide glue, prepared from the same source. It can be purchased through scientific supply houses. Edible gelatin, found in supermarkets, can also be used. Gelatin yellows upon aging; its stress characteristics are similar to those of hide glue (being of the same composition but weaker); and, when dry, it is attractive to molds and insects. The formulas for making, using, and storing a gelatin size are approximately the same as for hide glue.

Starch

Vegetable flours such as those derived from rice and wheat can be used to make weak glues. They are adequate but inconsistently effective sizes. They lose their adhesiveness after a long period, they decompose in storage, and they are susceptible to molds and insects.

To make a size with wheat flour, mix 1 part by volume of the flour into 2 to 3 parts

cold water and blend into a smooth paste. Stir this paste into 3 parts boiling water slowly enough to avoid forming lumps. Allow the mixture to cool.

For brushing onto a support, thin 1 part of the starch glue with 5 to 10 parts cold water—or enough water to make the solution very thin. This size does not have to be heated, but it should be made fresh each time.

Methyl Cellulose

This is a methyl ether of cellulose, the basic constituent of plants. It comes in the form of a flaky, somewhat spongy white powder, and you can dissolve it in cold water to make a glue. It need not be heated to dissolve, remains liquid when cool, does not decompose in storage, and is not as attractive as the other materials to insects and molds. (See List of Suppliers for sources of methyl cellulose.) Methyl cellulose powder has a shelf life of about one year, after which time its adhesive power diminishes. The prepared glue will have a longer life if it is made with distilled water.

To make a methyl cellulose size, add 24 parts cold water to 1 part of the powder. Mix and stir into a smooth syrup. Thin 1 part of the syrup with 10 to 20 parts cold water to make the size.

Acrylic Solutions

Gelatin, starch, and methyl cellulose are all hygroscopic to some degree; acrylic resins are not. Polymerized acrylic resins (see Chapter 4) are dissolved in a solvent to produce syrupy solutions. One variety that is reversible is Acryloid B-67MT, made by the Rohm and Haas Company, with the resin dissolved in mineral spirits.

Thin the solution for application by brush by adding about 5 to 10 parts by volume of solvent to 1 part acrylic resin solution. For spray applications, dilute further with about 5 to 10 more parts by volume of solvent. The fabric should be tightly stretched. Do not heat the solution.

☞ *CAUTION: The solvents used in acrylic solutions can be health and fire hazards. Do not use them near an open flame. If you are going to spray these solutions—which is far more dangerous than brushing them—wear a smock or long-sleeved shirt, solvent-proof rubber gloves, splash goggles, and a vapor mask rated for organic mists. Local exhaust ventilation is also recommended.*

IRREVERSIBLE SIZES

These materials are not easily removed by their original diluents after they've dried; stronger solvents must be used. They protect the support and reduce its absorbency, but do not shrink the fabric. They are very effective substitutes for hide glue.

Acrylic Emulsions

Polymerized acrylic resins can be emulsified in water. You can use them as a protective sealer and buy them wherever acrylic emulsion paints are sold under various proprietary names. Use the "matte medium" variety for this purpose.

Mix about 2 parts water and 1 part medium and apply the mixture with a brush; for spraying, thin with about 2 more parts of water. The fabric support should be tightly stretched, and the size should not be heated. The size remains liquid and does not decompose in storage. Store the size in a tightly covered plastic container to prevent evaporation, and avoid freezing it. Metal containers will rust.

☞ *CAUTION: Acrylic emulsions are considered relatively safe to use, but sometimes the vapors can produce an allergic reaction. Use all synthetic polymer emulsions with adequate ventilation—at least ten complete air changes in the room per hour. Check the container label for the product's health labeling certification by the Art and Craft Materials Institute (see Figure 7.3), and follow label instructions.*

Polyvinyl Acetate Emulsions

Polymerized vinyl acetate (PVA) resin, finely dispersed in water, is readily recognized as the common white glue used for paper and wood. Some of the PVA emulsions reportedly yellow on exposure to ultraviolet light, but archival PVA emulsions reportedly do not yellow. When exposed to water, PVA

emulsion films cloud—turn from translucent to nearly opaque white—but do not lose their film properties.

Mix 5 to 10 parts water with 1 part PVA emulsion, depending on whether it will be brushed or sprayed, and apply to the support. The size should not be heated. It will not decompose in storage, nor does it attract insects or molds. Store the size in plastic containers, and avoid freezing it.

Note: Neither the PVA nor the acrylic emulsions form perfectly continuous films when diluted for application as a size. They are apt to be full of pinholes, so two thin coats are recommended.

GROUNDS

The next intermediate layer between a support and subsequent films is a ground, sometimes also called a primer. A ground is unnecessary for some painting techniques. In transparent watercolor, for example, the white paper is both support and ground. Sometimes the artist's aims are better realized when the paint is applied directly to an unprimed support. An example of this is the effect obtained when diluted acrylic emulsion paint is used to stain raw cotton duck. Whether to use a ground is often an aesthetic question, but it is important to be aware of the technical considerations. The yellowing of the cotton duck, for instance, will quickly change the color balance of the original picture. (Morris Louis's paintings have shown this change over the last twenty years or so.)

Most supports are unevenly absorbent, even if they have been correctly sized. It is difficult to predict the results of a paint film laid on an unevenly absorbent surface. The loaded brush may not respond to your touch; it may skip and drag across the support in an uncontrolled way, or the paint film may show areas of glossiness or dullness that you did not intend. A ground will ensure that a particular kind of paint will perform with reasonable predictability.

A ground is also a structural element, a key for the paint films—a toothy coating for the paint to grip—and a definite layer between the support and the paint. If the support should deteriorate, a paint film somewhat isolated by a ground layer can more easily be stabilized. Without a ground, treatment is much more difficult.

Perhaps most important is the color of the ground and its effect on the color of the painting. Many paint films, particularly those in an oil vehicle, grow more transparent as they age. If the ground is white, the hues in the painting will retain their relative value relationships and may even grow more intense as the film becomes transparent. If the support is unprimed or the ground itself is pigmented and dark, the increasing transparency of the paint film will eventually lower and alter the picture's color system.

In summary, grounds should meet these requirements:

- The ground should be white. A middle-tone wash of color can be applied over the dried ground to reduce its brilliance, but the ground itself should not be tinted.
- The ground should have a tooth. A toothy surface can be obtained by slightly "underbinding" the ground—using less binder than would be used for making a normal paint film—so that pigment particles project above the binder film. You can also create a toothy surface by using pigment particles of varying sizes. A ground should also be somewhat absorbent.
- A ground should be an even and thinly applied coating, without pinholes or other application defects that leave areas of the support uncovered.
- When applied to a flexible support, the ground should not be too much affected by the continuous movement (expansion and contraction) of the support. Brittle grounds such as glue gesso need rigid supports.

GROUNDS FOR FLEXIBLE SUPPORTS

Several types of primers meet the requirements for a ground applied to flexible supports. They are divided into two principal categories: oil grounds and acrylic emulsion grounds.

OIL GROUNDS

The traditional ground for oil painting is called an oil ground. Although ingredients for oil grounds have been altered in present-day commercial formulas, the basic constituents of the original material are lead white pigment and linseed oil.

Applying an oil ground is simple, though you'll have to practice a bit to get a thin, uniform coating. The resulting surface is unique in its texture, look, and effect on a painting.

Lead White in Oil
Lead white (basic carbonate of lead) is one of the earliest pigments and was, until the middle of the nineteenth century, the only white pigment that would remain opaque when mixed with oil. Its virtues are that it is dense and opaque; it forms tough, relatively flexible and fast-drying films in linseed oil; and it uses very little oil when mixed into a coating material, thus satisfying the requirement that an oil ground be lean, or underbound.

However, lead white has several faults. It is toxic when ingested, absorbed through breaks in the skin, or inhaled. It can turn dark when exposed to sulfide pigments or hydrogen sulfide in the atmosphere. Its films in oil, which become transparent with age, also grow progressively rigid—a fault more of the oil than the pigment.

Do not dismiss lead white because of its inconvenience; it remains a valuable ground for oil paints. The harmful aspects of lead white can be avoided by good hygiene, sensible and cautious work habits, and protective equipment. The darkening effect is reduced to a negligible level when the pigment is properly encased in a binder like linseed oil—and lead white is not used with binders other than those that thoroughly encase it.

Artists who wish to use lead-in-oil grounds can purchase an artists' white lead oil paint that has been specially formulated for use in underpainting or as a ground (Winsor & Newton sells one), or they can purchase the paste from a supplier. A stiff paste of lead white in linseed oil may be available from industrial suppliers, though you will have to convince them that you are a serious professional who knows the rules for the proper use of the product.

Other Pigments and Oils for Grounds
Titanium white, zinc white, and titanium-and-zinc combinations are pigment mixtures used by commercial manufacturers in oil grounds that are sold ready to apply. (See Box 3.5.) These pigments have considerable advantage over lead white: They are whiter, do not change hue or value when kept in the dark, and are nontoxic. In linseed oil, however, these pigments form less durable paint films. Poppyseed oil, safflower oil, or other nonyellowing drying oils, combined with driers and solvents, are used as the vehicles in these commercial preparations. The products are useful as both paints and grounds.

A pigmented, oil-modified alkyd resin under the trade name Oil Painting Primer is sold by Winsor & Newton. Daniel Smith, Inc., also sells a version of this ground. These primers are thinned with mineral spirits and can be applied in the same way as the lead white ground. The alkyd grounds are potentially significant improvements over the traditional oil grounds: The binder is relatively nonyellowing, the vehicle is more flexible than straight linseed oil, and the drying time is shorter. However, an alkyd ground should be used only under alkyd or oil paints, not under acrylics.

ACRYLIC EMULSION GROUNDS

Acrylic emulsion grounds are called gesso by their manufacturers, although they neither contain the same ingredients nor show the surface qualities of a true gesso. (True gessoes contain chalk, pigment, and hide glue. They are much more absorbent and softer than acrylic emulsion grounds, and they are discussed further on pages 50–54.) The synthetic emulsion grounds are a mixture of white pigment (usually a titanium-zinc combination), barium sulfate pigment (or chalk, mica, silica, or marble dust—all used to give the mixture tooth), and the acrylic resin dispersed in water.

BOX 3.5. HOW TO APPLY AN OIL GROUND TO A FABRIC SUPPORT

MATERIALS

- Barrier cream. Barricaide, made by the Mentholatum Company, is one brand; Daniel Smith sells its Upfront cream through its mail-order catalogue.
- Stretched and sized but unprimed fabric.
- Stiff bristle brush.
- Palette knife or spatula.
- Pure gums spirits of turpentine or mineral spirits.
- Lead white in oil paste: a tubed or canned lead white in linseed oil. Use other white oil or alkyd paints only if they are designed specifically to be used as grounds. Using a manufactured paste or modified tube paint will prove to be expensive; your consolation is that there is no real substitute for an oil ground.
- Container for mixing the primer large enough to store leftover primer.
- Plastic film to cover the leftover primer.
- Fine sandpaper and dust mask if fabric has a heavy weave.

METHOD

1. Be sure the fabric is well stretched and sized; the sizing should be allowed to dry for 24 hours before you apply the ground. Remove any surface dust or dirt.
2. Use a barrier cream on your hands and arms if you're using large quantities of primer. The thinners, gum turpentine or mineral spirits, can be allergenic agents when put in contact with skin. Observe label precautions about handling lead white.
3. Put enough paste for two coats of ground into the container. The amount depends on how many supports are being primed.
4. Thin the paste to a smooth brushable consistency by adding some thinner a bit at a time. Some writers have compared the proper consistency to that of whipped cream—the paste should stand in peaks.
5. Use the bristle brush to apply the priming to the support. Do a small area at a time, and work the priming thoroughly into the weave of the fabric. Cover the entire front of the support, and coat the edges where the fabric turns over the chassis. This will prevent oil paint from seeping into the support; paint that bleeds over the edges of the painting can make the support brittle even when it is well sized. It is not necessary to cover the fabric on the back of the bars.
6. When the support is covered, use the knife or spatula to scrape off the excess primer. This should be done before the primer has a chance to set up, and should leave a very thin, even coating. Avoid leaving marks from the stretcher bars by using your fingers to push the fabric gently away from the bars. Discard the scraped-off primer.
7. Store the remaining primer in its container. Pack it down and press the plastic wrap over the surface to exclude air.
8. Wash your hands and forearms thoroughly, using a scrub brush.
9. Put the support in a dry, well-lit room for a few days. Drying will take anywhere from 4 days to 2 weeks; humid conditions and low temperatures will retard drying.
10. A single coat of priming is desirable if the support is thin or has a fine weave. Double priming is recommended for heavier weaves, or to obscure the weave. When the first coat is dry, apply a second coat in the same way as described above. To remove any raised nap or fuzz, lightly sand the support with fine sandpaper before giving it the second coat.

 ☞ *CAUTION: The dust raised by sanding contains lead white pigment, which is toxic. Wear a dust mask.*
11. The double-primed support should be left to dry for about 2 weeks. Some writers suggest a curing time of 6 to 12 months before an oil-primed support is used. During this time, lead white grounds may darken or yellow if stored in a dark or humid place. The effect is reversible: Expose the primed support to sunlight in a warm, dry room for a few days, and it will be bleached to its former whiteness.

The grounds are brilliant white, very adhesive, and retain flexibility and toughness as they age. They may be applied to most permanent supports—provided the support is not oily or greasy—both flexible and rigid, and are used as a foundation for a wide variety of mediums. They should not be applied over a hide glue size. Application and cleanup are easy and convenient, because water is the diluent. (See Box 3.6.)

Although the acrylic emulsion primers work well with most mediums, their physical properties may preclude their use under oil paints on flexible supports. Oil paint films grow increasingly rigid and brittle with age, whereas the acrylic emulsion films remain pliant and flexible. Over a period of time, the increasingly different degrees of flexibility may cause the oil paint to separate from the ground. Therefore it is advisable to avoid using the acrylic primer under large oil paintings on fabric supports. For paintings over 2.4 m² (3 square feet in area), use an oil ground. Of course, it is possible to avoid this problem by painting on a rigid support or fabric mounted on a rigid substrate.

As an acrylic emulsion ground dries, the fabric can shrink a little, so the support should be stretched firmly, but not too tightly. Sizing is not required, because the primer is impervious to oil paint.

Some brands of acrylic emulsion primer appear to sink into and conform with the weave of the textile—much more so than an oil primer. This effect can be countered by applying the ground, unthinned, with a large spatula or a rubber squeegee (like the kind used by window washers). The primer will be forced into the weave but removed from the top of each thread. Several coats will produce a smoother surface. Up to five or more coats of ground can be applied with a brush, with each coating applied at right angles to the layer beneath, to produce a smoother surface. Some commercial acrylic emulsion grounds are harder and less absorbent than an oil ground. A light sanding of the final coat will roughen the surface to give it some tooth.

Although acrylic emulsion primers can be used on most permanent supports, the support must be free of oily or greasy films. For this reason, acrylic grounds should not be applied over old oil paintings in an attempt to salvage and reuse the support. There is always the chance that the ground will not adhere and will later separate from the old painting.

BOX 3.6. HOW TO APPLY ACRYLIC EMULSION PRIMER

MATERIALS

- Tightly stretched, unsized, unprimed support.
- Any brand of acrylic emulsion primer, usually labeled "acrylic gesso."
- Housepainter's brush, 5 to 7.5 cm (2 to 3 inches) wide.
- Water.
- Sandpaper.

METHOD

1. Use the primer as it comes from the container, or thin it slightly with water; do not add more than about a tablespoon of water per quart of primer. Overthinned primer may powder off the support.
2. Brush on the primer, beginning at the center of the support and working toward the edges. Coat the edges where the fabric turns over the chassis. Brush in all directions and finish by smoothing the surface with parallel brushstrokes. Allow the priming to dry for at least an hour.
3. Lightly sand the surface if you wish, after waiting overnight. A second coat may be applied, but do not thin the primer. Allow the second coat to dry overnight before using the support.
4. Cleanup is easy. Wash the tools and equipment in warm, soapy water. Do not allow the primer to dry on the tools—the acrylic emulsion is insoluble in water once it dries. If this should happen, paint removers available from some artists' materials companies can dissolve the dried emulsion.

GROUNDS FOR RIGID SUPPORTS

The grounds described above can be applied to rigid supports as well as to flexible ones. The surfaces of these grounds, however, tend to be slicker and less absorbent on rigid substrates. A ground perfectly suited for rigid supports is made from a combination of chalk, pigment, and hide glue. This is the traditional glue gesso; the word "gesso" is Italian for gypsum, or plaster.

Gesso grounds are smooth, hard, and white. They do not yellow with age and are quite absorbent. They are suitable for a wide variety of oil- and water-based mediums, as long as the absorbency of the surface is adjusted for the type of paint. Because they are hard and brittle, gesso grounds should be applied only to rigid supports such as the hardboards. They can also be applied to fabrics or papers that have been mounted on a rigid support.

The recipes for gesso vary in measurements and proportions. Some call for equal parts of chalk and pigment, while others reduce the amount of pigment. Some require that the glue be fairly strong, while others recommend a weak glue. The chalk provides bulk, and the pigment provides opacity and whiteness.

Glue strength is important. A weak glue may not bind the chalk and can produce a ground that is soft and crumbly. A glue that is too strong will make a ground that is too hard or that cracks when it has dried. These defects become apparent as soon as the gesso dries. Observe the effects of the recipes and make adjustments accordingly, and remember

that the source and age of the hide glue can affect its performance.

The grade of the chalk is also important. All chalk is composed of calcium carbonate, derived from natural deposits of limestone or dolomite, with textures ranging from fine to coarse. Common whiting, found in hardware or paint supply stores, may be too coarse to make a smooth gesso. Grades labeled "gilder's whiting" or "Paris white" are smoother, finer-grained varieties. Artificial chalk, also called precipitated chalk, is the smoothest of the

MATERIALS

- Dry hide glue.
- Titanium white pigment or zinc oxide pigment.
- Natural or precipitated chalk.
- Water.
- Double boiler.
- Hot plate with rheostat and covered heating element.
- Graduated quart or liter measure.
- Separate container for mixing and heating the glue.
- Wooden spoon.
- Fine-mesh kitchen strainer.
- Fine cheesecloth.

METHOD A: ADDING THE FILLER TO THE GLUE

1. Mix the filler—that is, the mixture of chalk and pigment. Avoid raising dust and breathing it during this operation. The proportions of chalk to pigment can vary, though generally only a little pigment is needed. Try using 4 parts chalk and 1 part pigment, by volume. However it is mixed, the total volume of the filler should be equal to that of the glue solution. That is, for every 1 part of glue, make 1 part filler. If a coarse natural chalk is being used, increase the volume of the filler to about $1^1/2$ times that of the glue. In this case, the filler-to-glue ratio is 3 to 2 (Figure 3.1).

available chalks—it consists of very small, uniform particles of calcium carbonate made in a laboratory. Precipitated chalk is less dense than natural chalk, so less is needed in the following recipes.

GLUE CHALK GESSO

There are three ways to prepare this gesso; they differ only in the way the glue is combined with the filler. (See Box 3.7.) Because it is vital to avoid forming bubbles when mixing the chalk and glue, you may prefer the first method to the second or third. The slow and laborious nature of the first technique seems to reduce bubbling. In the second and third approaches, you will be tempted to hurry and pour the glue in too quickly. If there are bubbles in the gesso when it is applied, pinholes or tiny pits will appear in the drying surface as the bubbles burst. You cannot easily remove these pits, nor can they be easily covered up by subsequent coats of gesso. They will show through thin coats of paint as dark specks.

BOX 3.7. HOW TO MAKE GLUE CHALK GESSO

2. In a separate container, add 2 parts by volume of the dry glue to 10 parts cold water. Allow the mixture to soak 3 hours (or overnight), and heat it gently in the top of the double boiler until the glue dissolves. Remember not to let it boil, or it will lose its adhesiveness. Remove the glue from the heat but keep it warm.

3. Slowly sprinkle the filler through the strainer into the warm glue. To prevent the formation of air bubbles, add small amounts at a time. As the filler absorbs the glue it will sink to the bottom of the pot.

4. After all the filler has been added, gently stir the mixture with the wooden spoon.

FIGURE 3.1. Filler-to-glue combinations for glue gesso. *Top,* 1:1 proportion of filler to glue, with filler consisting of 4 parts chalk to 1 part pigment. *Bottom,* 3:2 proportion of filler to glue, if coarse natural chalk is being used. Proportion of chalk to pigment remains 4:1.

Avoid vigorous agitation or rapid stirring, both of which can cause air bubbles. The color and texture of the gesso should be like that of light coffee cream.

5. If the gesso has coarse particles or bits of undissolved glue floating on the surface, strain it through the cheesecloth before using it.

METHOD B: ADDING THE GLUE TO THE FILLER

1. Follow Steps 1 and 2 of Method A. Then place the container of filler in a hot water bath. Add a small amount of glue to the filler—enough to make a thick paste. Mix the paste with the wooden spoon until it is smooth and free of lumps. This may remind you of making a flour-based gravy.

2. Slowly add the rest of the glue in a thin, intermittent stream, while gently stirring with the spoon.

3. Strain if gritty.

METHOD C: ADDING WATER TO THE DRY GLUE AND FILLER

1. Mix dry glue and the filler materials, in the correct proportions, in a large container. Pour in very hot but not boiling water, and slowly stir and mix until all lumps have dispersed and the glue has dissolved. This is just what you would do with a commercially prepared glue gesso.

☞ *CAUTION: Avoid breathing the chalk or pigment dusts. Neither the pigment nor the chalk is a significant hazard, but inhaling any dust can be irritating to the lungs and a possible source of chronic health problems. You may wish to wear an inexpensive dust mask.*

The procedure for applying gesso either to a rigid support or to a mounted fabric is simple. (See Box 3.8). Because the product may be somewhat disappointing at first, the best way to learn about gesso and its application is through experience. Make and use it a few

BOX 3.8. HOW TO APPLY GESSO TO A SUPPORT

MATERIALS

- Warm gesso mixture.
- Panel, prepared as recommended in Chapter 2. The panel should be sized with a regular-strength hide glue and allowed to dry overnight.
- Housepainter's brush, 5 to 7.5 cm (2 to 3 inches) wide.
- Fine sandpaper or garnet paper wrapped around a wooden block.
- Soft cotton cloth.
- Stainless steel spoon.

METHOD A: APPLICATION TO A RIGID SUPPORT

1. Apply the first coat of gesso to the front of the support by scrubbing it on with the brush. Lay the brush aside and massage the entire surface of the gesso with your fingertips; this will work it into the panel and remove any air bubbles. If the panel has no bracing, coat the rear with a layer of gesso to equalize the tension between front and back. Allow the panel to dry.

2. Apply the second coat with a fully charged brush: lay down strokes parallel to each other and to one edge of the panel. Don't stroke back and forth as though you were painting a wall; overpainting will pick up or roughen previous strokes. Coat the rear of the panel if it is not braced. Let it dry—each layer will take a bit longer.

3. Apply the third coat in the same manner, but with the strokes at right angles to those in the coat below. Again coat the rear—this time the angle doesn't matter—and allow the panel to dry.

4. Continue in this way, applying fresh coats as soon as the previous one is dry, making the brushstrokes of each layer at right angles to the layer below. Between two and ten layers of gesso can be applied, depending on the thickness and opacity of the mixture or your requirements.

5. When the panel is dry, the surface may be sanded to remove superficial defects such as lumps or brushstroke ridges. Use fine sandpaper or garnet paper wrapped around a flat wooden block. Sand gently, with a circular motion.
 ☞ *CAUTION: Do not breathe the dust raised during sanding. Dust off the surface of the panel before using it.*

6. The gesso can also be polished. Dampen a soft cotton cloth with water, wring it out, and fold it into a small pad. Rapidly polish the panel using gentle, circular strokes. Be sure not to polish too long in one spot; the damp pad may dissolve the gesso right down to the bare support. Polishing will produce a smooth surface like eggshell.

7. For a harder, ivorylike finish, burnish the polished gesso with the back of a stainless steel spoon. Allow the panel to dry before burnishing.

METHOD B: APPLICATION TO A MOUNTED FABRIC

1. Mount thin muslin, cotton, or fine linen onto a panel, as instructed in Chapter 2.

2. Follow the same procedures outlined above, but apply only one or two coats of gesso. Do not obscure the weave of the fabric.

3. When the gesso has dried, scrape or sand it down so that the weave of the fabric is visible, while its interstices remain filled. This will give a somewhat textured surface.

times, then note the results. Keep the following tips in mind as you proceed.

- The pigment and chalk portion of the gesso has a tendency to settle to the bottom of the pot. It is necessary to stir the mixture from time to time as you are applying it to keep the pigment and chalk in suspension in the glue.
- If the gesso cools during application, you can return the pot to the hot plate to warm it. Continuous heating, however, will evaporate water from the mixture and make it too thick to apply easily. If the gesso thickens, add a little warm water. Do not add more glue.
- Leftover gesso can be stored in a cool place and will keep for about 2 weeks. Cool gesso will jell; to use it, gently reheat on a hot plate. If it is too thick, add a little warm water.
- Try this: Make the gesso in an old deep-fat fryer or electric slow-cooker pot; buy one at a yard sale for about $3 and make sure it has a rheostatically controlled heating element. Allow the gesso mixture to cool. Cover it with a cloth and a board, and store it overnight. This procedure may prevent jelling, and will allow any bubbles to rise out of the mixture. The next morning, your gesso should be perfectly smooth, and may be creamy and ready to apply as is. If there is any grit on the surface, remove it by gently drawing the cloth across its surface.
- The finished surface of dried gesso should be somewhat soft, but not so soft that it can be easily scratched by your fingernail. If it can be easily scratched, or too easily sanded, there is not enough glue in the mixture. If sanding it is difficult, then there is too much glue in the mixture. Dilute it with warm water mixed with a bit of chalk. It's a good idea to test the strength of the gesso on a piece of scrap wood before applying it to a panel.
- If the panel is correctly braced, the coating on the back can be eliminated. If the panel is not braced, you can be a bit frugal with the gesso by substituting an X-shaped coating for a full layer.

The finished gesso ground is very absorbent. Absorbency is required for some painting techniques (such as egg tempera) but should be adjusted for others (such as oil paint) by applying a size. The size can be made of a very thin glue solution, or a dilute varnish resin, acrylic emulsion, or acrylic solution. When the size is colored with pigment or paint to tint the ground to a middle tone, it is sometimes called an imprimatura or a veil. An imprimatura can be applied to any kind of ground, not just gesso.

To make a size for the gesso ground, dilute 1 part by volume of the chosen material with 2 to 3 parts of its diluent. Brush it onto the ground in liberal amounts and before it has a chance to dry, wipe it off with a soft cloth. This will produce a thin continuous film that will not interfere with the mechanical bond between the paint and the ground. If you wish, you can add color to the veil before applying it to the support.

GESSO AND OIL EMULSION GROUNDS

Emulsions of gesso and linseed oil are sometimes called half-chalk grounds, and are occasionally suggested for artists who want to combine the virtues of the oil ground (toughness and flexibility) with those of the gesso ground (whiteness and absorbency). If it is correctly made, a half-chalk ground may be flexible enough to survive the continual movement of a fabric support. (See Box 3.9.)

The problem with using a half-chalk ground is that it combines the defects of its components along with the virtues: The oil yellows and tends to separate from the emulsion, and the glue chalk's inherent brittleness may cause it to flake off the support. Apply this ground to a rigid panel that has been mounted with a finely woven fabric.

Half-chalk grounds tend to separate because the glue in the solution is not a good emulsifier. To aid in emulsification, 7 gm ($^1/_4$ ounce by weight) of ammonium carbonate—available in any pharmacy—crushed into a smooth paste with a little water, can be added to 960 ml (1 quart) of the solution. Warm the mixture until the smell of ammonia dissipates. However, even when the emulsion is helped along by the addition of ammonium carbonate, the oil may still rise to the top of the drying ground.

☞ *CAUTION: Ammonia is harmful. Do not inhale the vapors. Avoid handling ammonium carbonate paste with your bare hands.*

BOX 3.9. HOW TO MAKE AND APPLY A GESSO AND OIL EMULSION GROUND

MATERIALS

- Panel mounted with fabric.
- Standard glue gesso.
- Covered glass jar.
- Artists' grade alkali-refined linseed oil or stand oil.
- Wooden spoon.
- Housepainter's brush.
- Sandpaper.

METHOD

1. Add no more than 1 part by volume of the linseed oil to 3 parts of the warm gesso. Add the oil slowly, in a thin stream, stirring constantly with the wooden spoon. Stir rapidly enough to emulsify the mixture, but not so rapidly as to cause air bubbles. This is somewhat like making mayonnaise. The proportions of oil to gesso should not exceed 1 to 4. Stand oil is more viscous than alkali-refined linseed oil, so slightly more will be needed.
2. When the oil is fully incorporated into the gesso, allow the mixture to rest for a few minutes before applying it to the panel. If the oil rises to the surface, stir it again.
3. Use the brush to coat both sides of the panel smoothly. Allow it to dry for several days, and store the unused emulsion in a covered glass jar.
4. Before applying the second coat, warm the gesso and stir it gently. Coat both sides of the panel again, and allow it to dry for about a week before using it.
5. The surface of the dry half-chalk gesso can be smoothed by sanding. It is considerably harder than a regular gesso.

When it is applied to a mounted fabric, the half-chalk ground can be finished in the same way as a plain gesso ground. As it ages, the ground will turn yellow.

Half-chalk grounds on stretched, sized fabric supports will at first appear to be as white as the plain gesso and as supple as an oil ground. The ground will yellow and become brittle with age, and if the oil content is too low, the ground may separate from the support. The layers of ground should be applied very thinly.

These admonitions suggest that there is little advantage in using a half-chalk ground. Its manufacture cannot be precisely controlled, and the product is often erratic. Nevertheless, some people like its effects when it is properly made. It is worth trying.

PREPARED GESSO GROUNDS

There are proprietary mixtures of chalk, pigment, and dry glue to which only the correct amount of warm water need be added. If they are made of pure ingredients in the correct proportions, commercial preparations are convenient to use. The support must still be sized, and since glue gesso is inexpensive and easy to make, it hardly seems economical to pay a premium price for someone else's simple labor: See Method C in Box 3.7. Custom-made gesso panels are also available. Usually the binder in these is casein-based and is sometimes harder than when made with hide glue. Again, a gesso panel can be made from scratch less expensively.

Because hide glue decomposes, those gessoes on the market in liquid form must use some other adhesive binding, such as the acrylic emulsion. These binders have handling and surface characteristics much different from glue gesso.

Flat interior water-based wall paints with latex or casein binders are sometimes suggested as substitutes for gesso or even for the acrylic emulsion primers. Since these materials are not made for art applications and have little durability, they should not be used for anything that is to be permanent.

Tables 3.1 and 3.2, which follow, provide a quick reference to supports and grounds.

TABLE 3.1. RIGID SUPPORTS

Key: An "x" indicates that a size or ground can be used on that support.

SIZES	Hide Glue	Gelatin	Starch	Methyl Cellulose	Acrylic Solution	Acrylic Emulsion	PVA Emulsion
SOLID WOOD							
Hardwood	x	x	x	x	x	x	x
Softwood	x	x	x	x	x	x	x
LAMINATED WOOD							
Plywood	x	x	x	x	x	x	x
Paperboard							
Museum board	x	x	x	x	x	x	x
pH neutral cardboard	x	x	x	x	x	x	x
pH neutral binder's board	x	x	x	x	x	x	x
pH neutral corrugated board							
Die board	x	x	x	x	x	x	x
CHIPBOARD							
Small flake					x	x	x
Large flake					x	x	x
HARDBOARD							
Plain (untempered)	x	x	x	x	x	x	x
Impregnated (tempered)	x	x	x	x	x	x	x
CORED BOARDS							
Impregnated paper core							
Plywood surface	x	x	x	x	x	x	x
Hardboard surface	x	x	x	x	x	x	x
Paper surface					x	x	x
Aluminum core							
Hardboard surface	x	x	x	x	x	x	x
Polyester surface					x	x	x
Aluminum surface						x	
Foam-cored							
Uncoated							
Paper surface							
METALS							
Copper					x	x	x
Steel					x	x	x
Aluminum					x	x	x
GLASS							
WALLS							
Interior							
Wood			x	x		x	x
Plaster					x	x	
Wallboard	x	x	x	x	x	x	x
Exterior							
Wood						x	x
Brick						x	x
Concrete							x
Stucco							x

TABLE 3.1. RIGID SUPPORTS, CONT'D.

Key: An "x" indicates that a size or ground can be used on that support.

GROUNDS	Oil	Acrylic Emulsion	Glue Chalk Gesso	Gesso-Oil Emulsion
SOLID WOOD				
Hardwood	x	x	x	x
Softwood	x	x	x	x
LAMINATED WOOD				
Plywood	x	x	x	x
Paperboard				
Museum board		x		
pH neutral cardboard		x		
pH neutral binder's board		x		
pH neutral corrugated board		x		
Die board	x	x	x	x
CHIPBOARD				
Small flake		x		
Large flake		x		
HARDBOARD				
Plain (untempered)	x	x	x	x
Impregnated (tempered)	x	x	x	x
CORED BOARDS				
Impregnated paper core				
Plywood surface	x	x	x	x
Hardboard surface	x	x	x	x
Paper surface		x		
Aluminum core				
Hardboard surface	x	x	x	x
Polyester surface		x		
Aluminum surface		x		
Foam-cored				
Uncoated				
Paper surface				
METALS				
Copper	x	x		
Steel	x	x		
Aluminum	x	x		
GLASS		x		
WALLS				
Interior				
Wood		x		
Plaster		x		
Wallboard		x		
Exterior				
Wood		x		
Brick		x		
Concrete		x		
Stucco		x		

TABLE 3.1. RIGID SUPPORTS, CONT'D.

	Durability	Other Comments
SOLID WOOD		
Hardwood	Fair	Solid panels crack easily
Softwood	Fair	Crack easily; will show grain through paint
LAMINATED WOOD		
Plywood	Good	Hardwood veneers preferred
Paperboard	Poor	Not recommended
Museum board	Very good	Dilute glue and gelatin sizes; prepare and preserve properly
pH neutral cardboard	Very good	Same cautions as for museum board
pH neutral binder's board	Good	New material; durability presumed good
pH neutral corrugated board	Very good	For framing only
Die board	Very good	Very heavy; best is 100% hardwood
CHIPBOARD		
Small flake	Fair-Good	Industrial material, structurally weak; heavy
Large flake	Fair-Good	Same as for small flake, but lighter weight
HARDBOARD		
Plain (untempered)	Very good	Soft, porous; edges fragile; should be braced
Impregnated (tempered)	Excellent	Surface should be sanded; should be braced
CORED BOARDS		
Impregnated paper core		
Plywood surface	Very good	Wood veneer grain may show through; fill cut edges
Hardboard surface	Excellent	Sand surface; attach wooden surround
Paper surface	Very good	Fragile surface; paper should be thick; attach wooden surround
Aluminum core		
Hardboard surface	Excellent	Sand surface; attach wooden surround
Polyester surface	Excellent	Sand surface; attach wooden surround; deteriorates in ultraviolet light
Aluminum surface	Good	Sand surface; degrease; acrylic emulsion paints only; oxidizes
Foam-cored		
Uncoated		Not recommended; use for backing framed works if archival
Paper surface		Not recommended; use for backing framed works if archival
METALS		
Copper	Good	Sand surface; brace if large; oxidizes beneath paint
Steel	Good	Same as for copper; can rust; best for porcelain enamel
Aluminum	Good	Same as for copper; use only acrylic emulsion paints
GLASS	Excellent	Adhesion problems; etch or sandblast surface
WALLS		
Interior		
Wood	Good	Grain pattern and joints can show; may crack or warp
Plaster	Very good	Settling can cause cracks; moisture can cause deterioration
Wallboard	Very good	Paper covering must be coated; acrylic emulsion paints best
Exterior		
Wood	Fair-Good	Grain pattern will show; moisture can cause deterioration
Brick	Very good	Sensitive to moisture and efflorescence; must be isolated from ground
Concrete	Very good	Ground not imperative; should be sized; may effloresce if impure
Stucco	Very good	Size and ground not imperative; may effloresce; sensitive to moisture

TABLE 3.2. FLEXIBLE SUPPORTS

Key: An "x" indicates that a size or ground can be used on that support.

SIZES	Hide Glue	Gelatin	Starch	Methyl Cellulose	Acrylic Solution	Acrylic Emulsion	PVA Emulsion
PAPER							
Newsprint							
Bleached cellulose	x	x	x	x	x	x	x
"Rag content"	x	x	x	x	x	x	x
100% rag	x	x	x	x	x	x	x
"Rag content," neutral pH	x	x	x	x	x	x	x
Nonrag, neutral pH	x	x	x	x	x	x	x
Museum board	x	x	x	x	x	x	x
Drawing	x	x	x	x	x	x	x
Watercolor	x	x	x	x	x	x	x
Illustration board	x	x	x	x	x	x	x
TEXTILES							
Natural Fibers							
Cotton duck	x	x	x	x	x	x	x
Cotton muslin	x	x	x	x	x	x	x
Linen	x	x	x	x	x	x	x
Hemp, jute, burlap							
Silk	x	x	x	x		x	x
Synthetics							
Acrylic							
Fiberglass						x	x
Polyester							
Polypropylene							

GROUNDS	Oil	Acrylic Emulsion	Glue Chalk Gesso	Gesso-Oil Emulsion
PAPER				
Newsprint		x		
Bleached cellulose		x		
"Rag content"		x		
100% rag		x		
"Rag content," neutral pH		x		
Nonrag, neutral pH		x		
Museum board		x		
Drawing		x		
Watercolor		x		
Illustration board		x		
TEXTILES				
Natural Fibers				
Cotton duck	x	x	(x)	(x)
Cotton muslin	x	x	x	x
Linen	x	x	(x)	(x)
Hemp, jute, burlap				
Silk				
Synthetics				
Acrylic		x		
Fiberglass		x		
Polyester		x		
Polypropylene		x		

TABLE 3.2. FLEXIBLE SUPPORTS, CONT'D.

	Durability	Other Comments
PAPER		
Newsprint	Poor	Not recommended for permanent work
Bleached cellulose	Fair	Bleach and/or sulphite content contribute to deterioration
"Rag content"	Fair-Good	If rest of ingredients are stable and pH neutral, % rag unimportant
100% rag	Very good	Sizing and buffers should be alkaline and appropriate for rag fiber used
"Rag content," neutral pH	Very good	Same as "rag content" papers; alkaline is better than "neutral"
Nonrag, neutral pH	Poor-Excellent	Check package label for contents
Museum board	Very good	Check package label for contents
Drawing	Variable	Durability depends on content
Watercolor	Variable	Generally excellent; check for "right" and "wrong" sides
Illustration board	Variable	Durability depends on content; white fibers can be acidic or alkaline
TEXTILES		
Natural Fibers		
Cotton duck	Good	Short fibers yellow and grow brittle (x under grounds = if mounted only)
Cotton muslin	Good	Should be mounted; short fibers yellow and grow brittle
Linen	Good-Excellent	Fragile but long fibers; large variety of choices (x = if mounted only)
Hemp, jute, burlap	Poor	Not recommended for permanent work
Silk	Excellent	Variable textures and weaves; strong but light; ground obscures surface
Synthetics		
Acrylic	Fair	Deteriorates in light
Fiberglass	Good	Stretches poorly; poor adhesion
Polyester	Good-Excellent	Thermoset ground applied by manufacturer; sags in high heat
Polypropylene	Good-Excellent	Thermoset ground applied by manufacturer; can deteriorate in light

Note: What constitutes the "best" paper is often a matter of aesthetics. Papers can be well made with shoddy materials or poorly made with excellent materials. There are more than 2,000 varieties of art papers available (see List of Suppliers for a few places to order them). You can use any paper you like, provided it is well made of excellent materials of proven durability. Consider these factors: buffering against atmospheric acidity; the length of the paper's fibers and its wet strength; whether the paper has been sized during or after manufacture, and the type of sizing material; the quality or type of water used by the manufacturer; the thickness and weight of the paper for the proposed technique; whether the paper is lightfast if colored. Ask the retailer, wholesaler, and manufacturer.

4 **Binders**

A binder is an adhesive liquid that distinguishes one paint from another, and it is different from a vehicle. A vehicle is the entire liquid content of a paint system and may contain, in addition to the binder, such additives as solvents, driers, or preservatives that modify the binder and enhance the performance of the paint system.

A paint binder can be spread out by brushing, spraying, applying with a knife, or by any other means. It dries into a more or less continuous layer and—again, more or less—locks the coloring agent into it. The "more or less" qualifications are stated because how well a binder performs depends on what it is composed of, what it is being applied to, the conditions of application, and the conditions of exhibition or storage after the picture is finished.

The layer or film of binder also attaches the coloring agent to the support. If the binder is strong enough, it can be worked up into a relatively substantial thickness, though most work best when applied as thin films.

The binder also has a visual affect on the coloring agent: It brings out the chromatic character of the pigment, giving it a different optical quality than it had in its dry state. This is significant, for it makes an ultramarine blue in oil look distinctively different from the same ultramarine blue in, say, watercolor. Refraction—the bending of light rays as they pass from one medium to another—contributes to this difference in appearance.

Refractive index is a numerical representation of the relationship between the angle of a ray of light in air—relative to the surface it strikes—to the angle of the ray once it passes through or into another medium. When light strikes a translucent surface like a paint film, some of the light is reflected and some passes through the surface. The more light reflected, the higher the refractive index of the surface (or medium). The less light reflected—and therefore the more that penetrates or passes through—the lower the refractive index.

Air has a refractive index of 1. Every other medium is less transparent and has a higher refractive index; some are more transparent than others. The following binders and mediums are listed in order of increasing transparency according to their refractive indices:

Relatively Translucent	Molten beeswax
	Damar varnish solution
	Linseed oil
	Poppyseed oil
	Gum turpentine
	Hide glue in water
	Gum arabic in water
Relatively Transparent	Water

From this list you can see why ultramarine blue looks different in watercolor (gum arabic) than it does in oil.

Here are some qualifications for binders:
- Binders for artists' paints should not change color as they age, thereby affecting the color of the pigments mixed with them. Many binders yellow or darken as they age,

mainly as a result of exposure to ultraviolet light. Linseed oil is a good example of this tendency to yellow, and you can see its affects in a white paint most easily.

- Binders should also not cause the pigments in a paint to change color. This is usually not a problem, although some binders can affect certain pigments. The acrylic emulsion and fresco binders are very alkaline and can bleach susceptible colors.
- Binders should retain their adhesive qualities as they age. They should not only continue to bind the coloring particles to one another, but the whole of the paint film to the support. Storage conditions and ultraviolet light play a part in deteriorating a paint's binding strength.
- Binders should remain structurally stable as they age. They should resist cracking, peeling, flaking, and so on, and should have a good degree of chemical and atmospheric stability once they have dried. Atmospheric conditions—light, temperature, humidity, pollution—will all affect the structural integrity of a binder film.
- After a binder has dried, it should not be easily dissolved by mild solvents used in normal cleaning or conservation operations. Watercolors and pastels will be easily destroyed by the injudicious use of plain water.
- Binders should not be harmful (toxic or flammable) when handled with normal caution. Some paints can be unhealthy, but it is usually the solvent content of the vehicle—not the binder—that makes them hazardous.

☞ *CAUTION: Be particularly aware of the solvents used in binders. Read all container labels carefully for any safety warnings. This is simple common sense, because to use any material in ignorance is to invite trouble.*

Many artists make the mistake of picking one binder and never trying others. Collections of binder samples are available from raw materials manufacturers to help you experiment. (See List of Suppliers.) Remember, you will not be able to judge the quality of binders purchased in stores or through raw materials

suppliers unless you make paints, or otherwise use the binders, and record your observations.

There are no perfect binders, but many materials work very well when appropriately used. These can be divided into two classes: natural binders and synthetic binders.

NATURAL BINDERS

Liquids that can be used as paint binders are abundant in the natural world. Some of them, the plant gums in particular, have been used for thousands of years.

DRYING OILS

Drying oils are plant oils, squeezed mainly from seeds or nuts, that dry by oxidation. That is, the oil absorbs oxygen from the air and solidifies into a tough, leathery film. As it oxidizes, a drying oil also polymerizes: Its molecular structure changes so that once it has solidified, it is a substance quite different from its original form. (A polymer is composed of two different monomers chemically linked at the molecular level and repeated in chains.) A unique characteristic of the drying oils and similar polymers— most of the synthetic emulsions, for example— is that they cannot be changed back into their original state by dissolving them in their original diluents.

LINSEED OIL

Linseed oil is the most widely used of the drying oils. It is pressed from the seeds of the flax plant *(Linum usitatissimum),* the same plant that is the source of linen fibers. It can be processed into a variety of forms useful to artists. Its advantages are that it is a good film former, giving tough, resilient paint films, and it is compatible with a huge number of colorants. Its disadvantages include yellowing and embrittlement, which occur with age and exposure to light and are nearly unavoidable, and the apparent darkening of the paint film when it is stored in the dark, an effect reversed by reexposure to light.

Cold-Pressed Linseed Oil

Made by crushing the flax seed under great pressure, this is the variety of linseed oil considered to be the most pure and desirable for making oil paints. Its color ranges from a pale strawlike yellow to a deeper, golden yellow. It dries comparatively fast. Cold-pressed linseed oil was at one time the oil normally used by commercial paint makers for artists' paints. Because of the high cost and low yield of cold pressing, however, refined steam-pressed linseed oil has largely replaced it.

Steam-Pressed Linseed Oil

Nineteenth-century producers found that steam-heating the seeds before pressing gave a greater yield of oil. The quality of the oil was somewhat reduced by the addition of water vapor from the steam, so several refining techniques have been developed to make an oil that is comparable to the cold-pressed variety:

- Acid-refined linseed oil is a steam-pressed oil that has been treated with sulfuric acid to remove the mucilaginous matter (called "foots") and other impurities caused by the extraction process.
- Solvent extraction is a technique for removing the oil from the seeds that leaves most of the impurities behind, and is the most modern and widely employed method for producing oil.
- Alkali-refined oil is treated with an alkali to reduce the acidity, then water-washed to remove the precipitated salts. This is the preferred treatment for oils to be used in artists' paints, because a lower acid content reduces somewhat the oil's tendency to yellow.

Stand Oil

A partially polymerized but unoxidized linseed oil is made by heating the oil to about 300° C (570° F) in the absence of oxygen. Stand oil is also called heat-bodied oil. It is not a good binder because it is too viscous, but it is an excellent addition to painting and glazing mediums. It yellows less than other forms of linseed oil and has good leveling properties. Its film gives a smooth, enamel-like surface without brushmarks.

Sun-Thickened Linseed Oil

This process for refining linseed oil dates from the Renaissance. Equal parts of linseed oil and water are thoroughly mixed and exposed to strong sunlight for a few weeks. The oil that results is viscous, somewhat bleached, and a pretty good drier. The oil is partially polymerized and slightly oxidized; it is a good leveler.

To make a sun-thickened linseed oil, mix equal parts cold-pressed or alkali-refined linseed oil and water in a clear glass bottle by thoroughly shaking them together. Cover the mouth of the bottle with a cheesecloth cap and put it on a windowsill with a southern exposure so that it gets full direct sun. Agitate the mixture occasionally. After several weeks, depending on the amount of light, the oil will thicken and become paler. Drain off the water, using a separatory funnel or a gravy separation pitcher, and filter the oil through several layers of fine cheesecloth. Store it in a tightly closed glass jar. Keep air out of the jar as the oil is used by raising the oil level to the top of the bottle with glass marbles.

Washed Linseed Oil

Cold-pressed linseed oil can be water-washed to remove some impurities. The process does not increase the viscosity or the drying rate of the oil. Here is how it is done:

Put 1 part oil and 1 part water in a glass bottle, leaving an air space. Shake until thoroughly mixed. Let the mixture sit; after several hours it will separate into three layers. The top layer is oil, the middle is mucilage, and the bottom is water. Pour off the oil, being careful to leave the layers of mucilage and water behind. Repeat to clarify the oil further.

Other Forms of Linseed Oil

Raw (unprocessed) linseed oil, blown linseed oil, and boiled linseed oil are of interest to the housepainter, not the artist. These varieties have been treated with air or heat or both to make them dry more quickly. Though they physically resemble stand oil—being thick and viscous—they tend to darken and grow brittle quickly. Linoxyn, a semisolid type of oxidized linseed oil, is the basis for linoleum.

SAFFLOWER OIL

Safflower oil is pressed from the seeds of the safflower plant *(Carthamus tinctortus)* found in the Near East and cultivated for the dye extracted from its blossoms. It is grown commercially in North America as a source of a paint oil and an edible oil. Safflower oil is classified as a semidrying or a drying oil, but it can be used in artists' paints by the addition of small amounts of driers. Since it is a pale oil and yellows less than linseed oil, it is sometimes used in lighter-colored paints, specifically the whites. It has been suggested that safflower oil becomes more brittle more quickly than does linseed oil (see List of Suppliers).

POPPYSEED OIL

Poppyseed oil is extracted from the seed of *Papaver somniferum,* the poppy plant. It is a pale, nearly colorless oil that is also used in making artists' whites and light-colored paints (especially the pale blues). Poppyseed oil dries rather slowly, and some sources claim that it is susceptible to cracking. A well-known European manufacturer, Blockx, claims to use poppyseed oil in its line of artists' paints (see List of Suppliers).

WALNUT OIL

A drying oil pressed from walnuts *(Juglans regia)* has been used by artists who make their own paints. Walnut oil is nonyellowing and dries at a rate comparable to that of safflower and poppyseed oils. Like many nut oils, walnut oil does not store well—it will turn rancid unless it is refrigerated. Because demand for it is low, it is expensive (see List of Suppliers).

SOYBEAN OIL

Soybean oil, also known as soya bean oil, is a semidrier from the soybean plant *(Soya hispida),* grown throughout the world. It dries much more slowly than linseed oil, but has been successfully incorporated into synthetic binders to ensure flexibility. Winsor & Newton's alkyd paints have a synthetic soybean-type oil as a constituent of the alkyd resin binder. Soybean oil yellows less than linseed oil (see List of Suppliers).

TUNG OIL

Tung oil is extracted from the Chinawood tree *(Aleurites fordii, A. montana,* or *A. cordata)* and is also known as Chinawood oil. This is a rapid drier that has a tendency to bloom (frost) and yellow; it is used in the furniture industry but not in artists' paints.

SEMIDRYING OILS

Corn, olive, peanut, and other types of vegetable oils familiar to cooks are generally classified as semidrying oils. They do dry, but very slowly, and are sometimes used in cheap housepaints (where they are adulterants).

Semidriers are not recommended for permanent painting, although they can be made to work for throwaway sketches on paper if the artist has pigments to disperse in them.

Think before you sell one of your impermanent throwaway sketches! Is your reputation worth the money?

NONDRYING OILS

Nondriers, like motor oil or castor oil, never form a completely dry film—they will remain tacky and soft for years. Asphaltum, a colored petroleum derivative, was used in the nineteenth century as a painting medium or additive because of its pleasing color and handling characteristics. However, it was a total disaster for the paintings. Nondrying oils should not be used in permanent painting.

Castor oil comes from the castor bean *(Ricinus communis)* and is almost clear, soluble in alcohol, and highly viscous. It can be changed into a drying oil by chemically dehydrating it (removing the hydrogen) to form dehydrated or dehydrogenated castor oil. It has been proposed that this oil be used in artists' paints, but there is little information about its performance.

WAXES

Waxes can be derived from animal, vegetable, and mineral sources. They have been used as protective coatings, binders, ingredients in painting mediums, adhesives, and stabilizers for mixtures of pigments and binders. Waxes are versatile and stable, and they do not generally oxidize at normal temperatures. Waxes do not decay in the normal sense, although they react to extremes in temperature. Also, they do not attract insects, bacteria, or molds. Waxes are waterproof but soluble in organic solvents. They "dry" by solidifying from the liquid state.

A note of caution: When waxes, whether synthetic or natural, are added to paints in the form of a medium—either a manufactured medium like Dorland's or a homemade medium—they can produce soft paint films. As a rule of thumb, do not add more than 10 percent of a wax-containing medium, by volume, to any paint.

In addition, although waxes are very stable they are susceptible to rapid changes in temperature, and can crack when exposed to cold temperatures. Do not expose paintings made of wax (encaustic), or containing wax mediums, to extreme cold.

BEESWAX

Beeswax in the honeycomb form is familiar to everyone. When the honey is extracted, a crude yellow wax is left that can be melted and filtered. When yellow beeswax is melted, formed into thin sheets, and bleached by sunlight, it becomes white. The bleaching process also raises the melting point of the wax. Because it is colorless, bleached white beeswax is the recommended choice for most techniques calling for wax ingredients; it is the binder for encaustic paints. Its melting point (MP) is around 63° C (145° F). (See List of Suppliers.)

CARNAUBA WAX

This comparatively hard wax is scraped from the leaves of a Brazilian palm tree. The various commercial grades are bleached, yellow, or gray. It is an ingredient in some automobile waxes, but grades are variable in quality, so its use in art is confined mostly to conservation processes, where it is used as a hardener. MP: 84° C (183° F).

CANDELILLA

Candelilla wax is found on the leaves of a plant grown in the southwestern portion of North America. It is similar in many respects to carnauba wax, but is not quite as hard. Used in varnishes, waterproofing processes, and paint removers, it is primarily an industrial material. MP: 68° C (154° F).

JAPAN WAX

Japan wax is obtained from the berries of a species of sumac tree native to Japan and China, but it is not actually a wax. In its chemical composition, it is more like an oil. It is used in the cosmetics industry and as an adhesive in wax recipes for some art-related work. MP: 52° C (125° F).

OZOKERITE

Ozokerite is a natural mineral wax found in the Americas, Europe, and South Africa. Its properties are variable, but it is used in a proprietary wax emulsion manufactured for artists called Dorland's Wax Medium. (See List of Suppliers.) MP: 59–90° C (138–194° F).

OTHER WAXES

A number of manufactured waxes (such as the polyethylene waxes) are used in the preparation of wax crayons and watercolors, and as matting agents for varnishes.

WATER-SOLUBLE BINDERS

Plant gums, glues, and animal by-products that dissolve in water have been used for centuries as adhesives and paint binders. Most are hygroscopic and easily redissolved in water, and some are plastic and durable enough to work admirably in permanent painting.

Gums are exuded or tapped saps from trees or shrubs and either dissolve in warm water or swell into a jellylike mass called a colloid solution. They usually require the addition of a plasticizer to make them more flexible in a paint binder, though some can be used alone.

Vegetable glues like the starches and cellulose mentioned in Chapter 3 are adequate for many applications, but they are not strong enough for permanent painting. They will serve well, in a pinch, for studies or sketches.

Animal by-products can be made into very strong glues, some of which have been used as binders. On rigid supports with absorbent grounds, they make interesting but difficult-to-handle paints.

GUM ARABIC

This is more formally known as gum acacia. It exudes from incisions made in the bark of the acacia tree, found in Australia and Asia, but principally in Africa. Many writers claim that the best types come from Africa—these are known by the name of their place of origin. Gum senegal and gum kordofan are examples.

Gum arabic is dissolved in hot water and used as an adhesive (common librarian's mucilage is boiled gum arabic), as a "stop-out" in lithographic printing techniques, as a size, as an ingredient in candies, and as the binder in opaque and transparent watercolors and pastels. In most uses, a plasticizer is added to the formula, since the gum film is rather brittle.

GUM TRAGACANTH

This gum comes from the shrub *Astragalus,* found in the Middle East and western Asia. It swells into a translucent colloid in hot water. The gel is pressed through a filter, and the liquid is used as a stabilizer for coating emulsions and as a binder for pastel chalks. Gum tragacanth is also used in foods, as a thickener.

GUM KARAYA

Gum karaya comes from *Sterculia urens,* a plant that is found in India. Superficially it resembles gum tragacanth, and therefore is sometimes used as a substitute for it.

DEXTRIN

Dextrin is one of the starches used in some artists' materials as binders or additions to vehicles. It is a water-soluble adhesive prepared from wheat starch. Other starches, or flours such as from rice or potatoes, are similarly prepared and used. Dextrin is sometimes the binder in tempera poster colors, and is used in designer's gouaches as an addition to the gum arabic binder. It is also used as a glue in conservation and restoration.

HIDE GLUE

Aside from being used as a size, hide glue has been used as a binder for distemper paints. It is difficult to use because it so readily redissolves: Overpainting tends to pick up or muddy the dried paint layers below.

NATURAL EMULSIONS

An emulsion is a liquid composed of two parts: an aqueous (watery) part, and an oily, greasy, resinous, or fatty part. Emulsions of two normally immiscible ingredients can be made with any two dissimilar ingredients, but artists' emulsions usually have water as one of the components. In an emulsion, either oil in water or water in oil, small droplets of one liquid are dispersed uniformly throughout the other liquid. The dispersion is held constant by an ingredient called an emulsifier, a material that modifies the surface tension of the two liquids to stabilize the mixture.

Natural emulsions make versatile paint binders, within limitations. Though they are water-resistant and not hygroscopic, the films are not waterproof.

WHOLE EGG

Hens' eggs consist of yolk and white, both of which are emulsions. The yolk contains egg oil, a watery solution of albumen, and lecithin, an efficient emulsifier found in many natural or

manufactured food products. Albumen is the main constituent of the egg white and is an advantageous ingredient: It coagulates under the influence of heat and light. Whole eggs can be used in vehicles for a variety of egg tempera and egg-oil emulsion tempera paints.

EGG YOLK

The plain egg yolk, cleaned of the white and separated from its sac, is a well-known natural emulsion binder. It contains the same ingredients as the whole egg, but in different proportions. Thinned with water, it is used as the binder for the classic and unusually delicate egg tempera paint.

GLAIR

Glair is egg white beaten until frothy, mixed with a little water, and allowed to stand until the froth subsides. Glair makes a weak and little-used binder that spoils quickly. It has been used for centuries as the adhesive for gilding and as the binder for paints used in manuscript illumination.

CASEIN

When the butterfat is removed from milk, it becomes skim milk. When skim milk is soured—naturally, or by adding acid, or by coagulating it with the enzyme rennet—and the curd is extracted and dried, the lumpy yellowish powder that results is called casein. The powder can be dissolved in hot water with the help of an alkali additive (either ammonium carbonate or ammonium hydroxide) to form a clear, syrupy solution that can be used as a binder, the ingredient in glue gessoes, a size, and an excellent strong furniture glue (see List of Suppliers).

CATALYTIC BINDERS

When calcium carbonate (chalk) is roasted to drive off its water content, calcium oxide (lime) is produced. The lime is mixed into water, with which it reacts to form calcium hydroxide—slaked lime. Aged slaked lime,

mixed again with water to form a soft white paste and enough sand to stabilize the mixture, is troweled onto prepared walls and used, while damp, as the substrate and binder for the classical mural technique called fresco.

Pigments ground with water are brushed onto the wet slaked lime plaster, where they are absorbed into the wall and become a part of it; only pigments resistant to the alkaline lime can be used. (For more about fresco techniques, see Chapter 15.) Further reaction occurs first as the wall dries out, and second as the calcium hydroxide combines with carbon dioxide to return eventually to its native form, calcium carbonate.

The process of fresco (Italian for "fresh") painting is fairly well understood, but the medium is not used often today for two reasons. Preparation, materials, and labor can be very expensive. Also, our modern atmosphere, polluted as it is with acidic compounds, will destroy an unprotected fresco painting in a short time. Any surface protection applied over the painting will defeat the main objective, which is to have a huge decorated surface that can be seen, without the interference of reflections, from all angles. Indoor murals, in environments that have a regulated atmosphere, are still a possibility. But it takes resources (financial, technical, and aesthetic) to consider attempting this kind of painting.

SYNTHETIC BINDERS

Synthetic materials used as paint binders are a product of late nineteenth- and early twentieth-century technology. Derived from petroleum by-products, natural gas, or other organic sources, and from mineral sources, the synthetic binders have opened up a versatile range of possibilities for the painter. Many of these are industrial materials, and the requirements for a binder of artists' paints are more particular than those for some industrial applications. Only since the 1940s has much research been done on the use of the synthetics as artists' materials—several companies have produced reliable paints from them—and only in recent years has there been a concerted effort to do more research. It is imperative that the painter

who wishes to experiment with the new developments be aware of their pitfalls as well as their advantages.

"Resins" is a term associated with the word "synthetic," and bears definition here. There are two kinds: natural and synthetic. They are both more or less transparent, fusible materials. The term can be used to describe any polymer that is a basic material for paints. Resins are sometimes flammable, and they are soluble in organic solvents, but not usually in water.

VINYL RESINS

Vinyl resins are derived from ethylene, distilled from crude petroleum. The term "vinyl" also refers to the many compounds that contain the vinyl group of molecules, such as vinyl acetate, vinyl chloride, and the polymerized variations of them: polyvinyl acetate (PVA), polyvinyl chloride (PVC), and polyvinyl chloride acetate (PVCA). Other resins useful to artists are also relatives of vinyl: co-polymers (a combination of two polymers) of the PVAs and the PVCAs, the acrylic resins, the methacrylate resins, the polystyrene resins, and so on. The chemistry is complex.

Most vinyls are characterized by their durable, nonyellowing properties (if they are not already yellowish), and by the fact that they are soluble only in volatile and toxic solvents. This last factor should prohibit the prudent artist from using them in the raw form. They are used in industry as coatings, plastics, and sheetings.

The vinyl resins are of interest to artists, however, when they are polymerized or co-polymerized and emulsified with water. In this form they are safer—and readily recognized in their most common form as white glue. This all-purpose adhesive for wood and paper is marketed under many different trade names and can be used as a size, and in a pinch as a binder for sketch paints. The archival variety can be used as a collage glue, or in conservation framing. The polyvinyl acetate emulsions (PVAEs) form rather porous though water-resistant films. Manufacturers of artists' acrylic emulsion paints may use the PVCs or PVAEs, or derivatives of them,

in their co-polymer or ter-polymer (three polymers) emulsion vehicles.

☞ *CAUTION:* **The PVC paints may contain plasticizers that may be hazardous upon chronic overexposure.**

ACRYLIC RESINS

The acrylic resins are a subgroup of the vinyls. The basic constituent is acrylic acid. Polymerization of the acrylic acid molecule leads to various forms of plastics; the polymers can also be linked to other polymers to make co- or ter-polymers. These variations can be dispersed in water to form a type of emulsion.

The straight acrylic resins, methyl methacrylate in particular, have been used in paint binders for quite some time, since the Rohm and Haas Company introduced them to industry in the early 1930s. In their solid form, these resins are familiar under the trade names Lucite and Plexiglas.

The first accepted artists' paint application of the straight acrylic resin solution binder was in Leonard Bocour's Magna paints, which appeared on the market in the late 1940s. Rohm and Haas's American trade name for a group of the syrupy acrylic solutions dissolved in a solvent is Acryloid, and the European version is called Paraloid. Most of these syrups are 45 to 50 percent resin solutions in dangerous solvents like toluene or other aromatic hydrocarbons (Acryloid B-72). Some are soluble in less dangerous solvents such as mineral spirits (Acryloid B 67MT) or VM&P Naphtha (Acryloid B-67 and Acryloid F-10).

If the acrylic resin is polymerized and dispersed in water, the common name for the product is acrylic polymer emulsion. These are sold on an industrial scale under such trade names as Rhoplex (Rohm and Haas). There are many different forms of Rhoplex: Rhoplex AC-33, AC-34, and possibly a few of the other 30 or so varieties are the most used in making artists' paints. Artists' paints made with these binders are exceptionally adhesive and durable. Henry Levison's Liquitex paints, originally manufactured by Permanent Pigments (now Binney and Smith—owned by Hallmark), were the first accepted acrylic emulsion paints.

The dried acrylic emulsion paint films exhibit a tendency to absorb atmospheric moisture like the porous polyvinyl acetate emulsions; they should be varnished with an acrylic solution varnish to protect them. The acrylic emulsion binders are also not as clear as the straight acrylic solution binders, nor even as clear as the linseed oils, even though they are advertised as being clear. Observe the difference between the oils and acrylic emulsions by spreading out samples of the same colors in the two different vehicles. The acrylic emulsion paint may look a bit lighter, or perhaps a bit chalky, compared to the oil paint.

The acrylic polymer emulsion paints have come to be known simply as "the acrylics." This term is unfortunate, since it can mean *either* acrylic solution or acrylic emulsion. Nonetheless, the paints have become one of the most useful and popular products available to artists. Do not assume that their versatility will solve all your painting problems. Their popularity is based on their convenience, ease of use and clean-up, and the little-known but obvious fact that 90 percent of those who buy art materials are hobbyists and "Sunday painters." Manufacturers consider only 10 percent of us to be serious artists, and they produce what the market wants with one corporate eye on the bottom line.

ALKYD RESINS

A plastic resin called an alkyd is made by reacting a polyhydric alcohol (usually glycerol) with a polybasic acid (usually phthalic anhydride, which is derived from petroleum). The resin can be modified by adding synthetic or natural vegetable oils to increase its flexibility, and the resin can then be used as a paint binder.

The alkyd resins have been in commercial industrial applications for about 30 years—in automobile finishes and interior house paints. In the late 1970s Winsor & Newton introduced an alkyd-based artists' paint, modified with what it calls a "synthetic soya bean-type"

drying oil, and thinned with mineral spirits or gum turpentine.

The alkyd paints are a significant addition to the variety of materials offered to the artist mainly because of two factors. The drying time is faster than oil, though slower than the acrylic emulsions; and the binders and mediums are clear and theoretically nonyellowing. Although they have been tested extensively for more than 20 years by Winsor & Newton, the paints have yet to prove themselves in wide use by artists over a similar period (and conservators still view them with skepticism, since yellowing of the films has been reported). Even so, these new paints seem very promising for painters who like the convenience of relatively quick-drying paints, but prefer the optical qualities of an oil-like vehicle.

SILICATES

Silicate binders are generally used in industrial situations, but some writers on artists' materials have suggested that they may have possibilities as binders for outdoor mural paints.

These paints are based on sodium, potassium, lithium, or ethyl silicate, are thinned with water or water plus a little alcohol, and resemble a volatile thinner when unpigmented. Only Kurt Wehlte, in Germany (in the 1950s and 1960s), conducted much research into using the silicates for artistic painting. While he extolled the paints for their durability and reliability, conservators today have expressed doubts about their long-term survival.

Practically speaking, the silicate paints are difficult to handle, but no more so than the fresco paints. They are alkaline, and only alkali-proof pigments can be used. The binder—depending on the variety—must be made fresh each day, since the catalytic reaction that results cannot be stopped (see List of Suppliers).

Table 4.1, which follows, provides a quick reference to binders.

TABLE 4.1. BINDERS

Key: n/a = not applicable; NR = not recommended; MSDS = Material Safety Data Sheet; P/CD = *Paint/Coatings Dictionary*.
Remember, the *higher* a material's flash point, the *less* flammable it is.

COMMON NAME	Cold-pressed linseed oil	Steam-pressed linseed oil	Linseed stand oil
TYPE	Natural drying oil	Natural drying oil, alkali-refined	Natural drying oil
SOURCE	*Linum usitatissimum* flax seed, pressed cold	*Linum usitatissimum* flax seed, steam-pressed	*Linum usitatissimum* flax seed, heated without oxygen; not oxidized
COLOR/APPEARANCE	Pale Y to darker YO	Pale Y to darker YO	Pale Y
USE	Binder, ingredient in mediums	Binder, ingredient in mediums	Ingredient in mediums
REFRACTIVE INDEX	Relatively low	Relatively low	Relatively low
VISCOSITY	Low to medium	Low to medium	Medium to high
THINNER/SOLVENT	Mineral spirits, gum turpentine, stronger	Mineral spirits, gum turpentine, stronger	Mineral spirits, gum turpentine, stronger
REVERSIBILITY	Not with original thinner	Not with original thinner	Not with original thinner
pH	Slightly acidic	Slightly acidic; refining reduces acidity	Relatively neutral, depending on refining
DURABILITY			
Interior	Good-excellent	Good-excellent	Good-excellent
Exterior	Fair	Fair	Fair
Rigid Support	Good-excellent	Good-excellent	Good-excellent
Flexible Support	Fair	Fair	Fair
RESISTANCE TO:			
Water	Good	Good	Good
Acid	Poor	Poor	Poor
Alkali	Fair	Fair	Fair
Pollutants	Fair	Fair	Fair
Ultraviolet light	Fair	Fair	Fair
Decay	Good	Good	Good
HAZARDS			
Health	n/a	n/a	n/a
Fire (flash point)	Over 260°C (500°F)	Over 260°C (500°F)	Over 260°C (500°F)
OTHER COMMENTS	Excellent for making paints; good wetting ability; good drying; expensive; color varies	Most used for commercial and studio-based paint making; average drier; less costly; only a fair binder, but in use for more than 500 years—reliable	Good for mediums, poor for vehicles; less color change over time than other linseed oils; good drier; levels—will not show brushstrokes

TABLE 4.1. BINDERS, CONT'D.

Key: n/a = not applicable; NR = not recommended; MSDS = Material Safety Data Sheet; P/CD = *Paint/Coatings Dictionary*. Remember, the *higher* a material's flash point, the *less* flammable it is.

COMMON NAME	Sun-thickened linseed oil	Washed linseed oil	Safflower oil
TYPE	Natural drying oil	Natural drying oil	Natural semidrying oil
SOURCE	*Linum usitatissimum* flax seed, processed as in text	*Linum usitatissimum* flax seed, processed as in text	*Carthamus tinctorus*, native of India
COLOR/APPEARANCE	Pale Y	Pale Y	Pale Y
USE	Ingredient in mediums	Ingredient in mediums	Binder in light colors and whites, with driers added
REFRACTIVE INDEX	Relatively low	Relatively low	Low
VISCOSITY	Medium to high	Medium to high	Low to medium
THINNER/SOLVENT	Mineral spirits, gum turpentine, stronger	Mineral spirits, gum turpentine, stronger	Mineral spirits and stronger
REVERSIBILITY	Not with original thinner	Not with original thinner	Not with original thinner
pH	Slightly acidic unless water-washed	Relatively neutral if thoroughly washed	Relatively neutral
DURABILITY			
Interior	Good-excellent	Good-excellent	Good-excellent
Exterior	Fair	Fair	Fair-good
Rigid Support	Good-excellent	Good-excellent	Good
Flexible Support	Fair	Fair	Fair-good
RESISTANCE TO:			
Water	Good	Good	Good
Acid	Poor	Poor	Poor
Alkali	Fair	Fair	Fair
Pollutants	Fair	Fair	Fair
Ultraviolet light	Fair	Fair	Fair
Decay	Good	Good	Good
HAZARDS			
Health	n/a	n/a	n/a
Fire (flash point)	Over 260°C (500°F)	Over 260°C (500°F)	Very high
OTHER COMMENTS	Similar to linseed stand oil and easily homemade	Easily refined in the studio; some commercial alkali-refined oils improve in color when water-washed	Edible oil; used with driers; yellows less than linseed oils but gets brittle faster

TABLE 4.1. BINDERS, CONT'D.

Key: n/a = not applicable; NR = not recommended; MSDS = Material Safety Data Sheet; P/CD = *Paint/Coatings Dictionary*. Remember, the *higher* a material's flash point, the *less* flammable it is.

COMMON NAME	Poppyseed oil	Walnut oil	Soybean oil
TYPE	Natural semidrying oil	Natural drying or semidrying oil	Natural semidrying oil
SOURCE	*Papaver somniferum,* opium plant	*Juglans regia,* walnuts	*Soya hispida,* soybean plant
COLOR/APPEARANCE	Very pale Y	Pale (varies)	Pale Y
USE	Binder in light colors and whites, with driers added	Binder for oils, if sufficient quantities available	Plasticizing oil for alkyd resin-based paints, with driers
REFRACTIVE INDEX	Low	Low	Low
VISCOSITY	Low to medium	Low	Low to medium
THINNER/SOLVENT	Mineral spirits and stronger	Mineral spirits and stronger	Mineral spirits and stronger
REVERSIBILITY	Not with original thinner	Not with original thinner	Not with original thinner
pH	Relatively neutral	Relatively neutral	Relatively neutral
DURABILITY			
Interior	Good-excellent	Good	Good
Exterior	Fair	Fair	Good
Rigid Support	Good	Good	Good-excellent
Flexible Support	Fair-good	Fair-good	Good
RESISTANCE TO:			
Water	Good	Good	Good
Acid	Poor	Poor	Poor
Alkali	Fair	Fair	Fair
Pollutants	Fair	Fair	Fair
Ultraviolet light	Fair	Fair	Fair
Decay	Good	Good	Good
HAZARDS			
Health	n/a	n/a	n/a
Fire (flash point)	Very high	Very high	Very high
OTHER COMMENTS	Edible oil; poor drier— may crack	Edible oil; used in Renaissance to make nonyellowing oil for paint; expensive; comparable to safflower and poppyseed oils	Edible oil used in long-oil alkyds for paints containing up to 70% soy oil—more like resin-modified oil paints than industry designation as "oil-modified alkyd"

TABLE 4.1. BINDERS, CONT'D.

Key: n/a = not applicable; NR = not recommended; MSDS = Material Safety Data Sheet; P/CD = *Paint/Coatings Dictionary*. Remember, the *higher* a material's flash point, the *less* flammable it is.

COMMON NAME	Perilla oil	Tung oil	Corn, olive, & peanut oils
TYPE	Natural drying oil	Natural drying oil	Natural nondrying oils
SOURCE	*Perilla ocymoides* and *Perilla nankinensis* (Asia)	*Aleurites fordii, montana, or cordata,* Chinawood tree	Corn, olives, & peanuts
COLOR/APPEARANCE	Pale Y	Medium Y or YO	All very pale Y
USE	Varies	Furniture finishes	Cooking; cheapening extender for housepaints
REFRACTIVE INDEX	Low	Medium	All low
VISCOSITY	Low to medium	Low to medium	All low
THINNER/SOLVENT	Aliphatic hydrocarbons	Mineral spirits and stronger	n/a
REVERSIBILITY	Aromatic hydrocarbons	n/a	n/a
pH	Varies—neutral to slightly acidic	Relatively neutral	n/a
DURABILITY		NR	NR
Interior	Excellent		
Exterior	Fair		
Rigid Support	Excellent		
Flexible Support	Fair-good		
RESISTANCE TO:		NR	NR
Water	Excellent		
Acid	Poor		
Alkali	Fair		
Pollutants	Fair		
Ultraviolet light	Fair		
Decay	Good		
HAZARDS			
Health	n/a	Do not ingest	n/a
Fire (flash point)	Very high	High	Very high
OTHER COMMENTS	Industrial use; experimental use only in artists' paints	Use *only* to finish frames, not in paint	Found in the cheapest products; not for artists' use

TABLE 4.1. BINDERS, CONT'D.

Key: n/a = not applicable; NR = not recommended; MSDS = Material Safety Data Sheet; P/CD = *Paint/Coatings Dictionary*. Remember, the *higher* a material's flash point, the *less* flammable it is.

COMMON NAME	Castor and dehydrogenated castor oils	Mineral oil	Beeswax
TYPE	Natural oils; nondrying and semidrying	Petroleum derivative	Natural wax
SOURCE	*Ricinus communis,* castor bean seed	Refined "high molecular weight hydrocarbon" (P/CD)	Bees' honeycombs
COLOR/APPEARANCE	Both nearly colorless	Colorless	Dark Y to W, depending on degree of refinement
USE	Plain: extender; dehydrogenated: plasticizer and experimental use	Medicinal	Binder for encaustics and certain crayons; ingredient in emulsions, surface waxes
REFRACTIVE INDEX	Both low	Low	High when solid; low as a liquid
VISCOSITY	Both high	Low	High when solid; low as a liquid
THINNER/SOLVENT	Strong solvents	n/a	Mineral spirits
REVERSIBILITY	n/a	n/a	Excellent; if hardeners are added, more resistant
pH	n/a	n/a	Quite neutral
DURABILITY	NR	NR	
Interior			Excellent
Exterior			Fair-poor
Rigid Support			Excellent
Flexible Support			Fair-poor
RESISTANCE TO:	NR	NR	
Water			Excellent
Acid			Good
Alkali			Good
Pollutants			Good
Ultraviolet light			Good
Decay			Excellent
HAZARDS			
Health	n/a	n/a	Do not overheat; do not breathe vapors
Fire (flash point)	Very high	Very high	Vapors flammable
OTHER COMMENTS	Dehydrogenated form may prove useful; considered experimental	Does not dry; not for artists' use	Excellent artists' material. Paint films can be too soft if overused or hardeners not used

TABLE 4.1. BINDERS, CONT'D.

Key: n/a = not applicable; NR = not recommended; MSDS = Material Safety Data Sheet; P/CD = *Paint/Coatings Dictionary*.
Remember, the *higher* a material's flash point, the *less* flammable it is.

COMMON NAME	Carnauba wax	Spermaceti	Candelilla
TYPE	Natural wax	Natural wax	Natural wax
SOURCE	Brazilian palm; many varieties	Sperm whale head cavity (and other species)	Plant wax
COLOR/APPEARANCE	Y to Gray to bleached W	Clean W	Pale Y or Y to GBr
USE	Auto wax and conservation	NR; save the whales	Electric insulation; paint removers, etc. (P/CD)
REFRACTIVE INDEX	High when solid; low as a liquid	High when solid; low when liquid	High when solid; low when liquid
VISCOSITY	High when solid; low as a liquid	High when solid; low when liquid	High when solid; low when liquid
THINNER/SOLVENT	Variable	Variable	Variable
REVERSIBILITY	Variable	Good	Good
pH	Relatively neutral	Neutral	Relatively neutral
DURABILITY Interior Exterior Rigid Support Flexible Support	NR	NR	NR
RESISTANCE TO: Water Acid Alkali Pollutants Ultraviolet light Decay	NR	NR	NR
HAZARDS Health Fire (flash point)	n/a, but do not overheat Vapors flammable	n/a Vapors flammable	n/a; do not overheat Vapors flammable
OTHER COMMENTS	Hardener for conservation adhesives; could be used to harden beeswax mixtures; poor color stability	Formerly widely used; now wisely preserved in live whales	In paint removers, allows active materials to coat vertical surfaces without flowing; not an artists' material

TABLE 4.1. BINDERS, CONT'D.

Key: n/a = not applicable; NR = not recommended; MSDS = Material Safety Data Sheet; P/CD = *Paint/Coatings Dictionary*.
Remember, the *higher* a material's flash point, the *less* flammable it is.

COMMON NAME	Japan wax	Ozokerite	Microcrystalline wax
TYPE	Natural wax	Natural wax	Petroleum wax
SOURCE	Far Eastern species of sumac; berries	Natural mineral wax from Europe, Australia, and the Americas	Petroleum
COLOR/APPEARANCE	Oily W wax	Variable but refined varieties are W	W
USE	Cosmetics and conservation	In proprietary mixtures like Dorland's Wax Medium	Ingredient in adhesive mixtures for conservation
REFRACTIVE INDEX	High when solid; low when liquid	High when solid; low when liquid	High when solid; low when liquid
VISCOSITY	High when solid; low when liquid	High when solid; low when liquid	High when solid; low when liquid
THINNER/SOLVENT	Variable	Mineral spirits	Aliphatic hydrocarbons and stronger
REVERSIBILITY	Good	Good	Good
pH	Neutral	Relatively neutral	Neutral
DURABILITY	NR		
Interior		Good	Excellent
Exterior		Fair-poor	Fair
Rigid Support		Excellent	Excellent
Flexible Support		Fair	Fair-good
RESISTANCE TO:	NR		
Water		Excellent	Excellent
Acid		Fair	Fair
Alkali		Fair	Fair
Pollutants		Good	Good
Ultraviolet light		Good	Fair-good
Decay		Excellent	Excellent
HAZARDS			
Health	n/a; do not overheat	n/a; do not overheat	n/a; do not overheat
Fire (flash point)	Vapors flammable	Vapors flammable	Vapors flammable
OTHER COMMENTS	More like oil than wax; not an artists' material; used in some wax-based adhesives for art-related work	Relatively soft wax combined with oils and resins in wax soaps for artists' use. Use in minimum quantities with care; wax soaps can make films that are easily damaged	Conservation adhesive; soft and sticky at room temperature—must have hardeners added

TABLE 4.1. BINDERS, CONT'D.

Key: n/a = not applicable; NR = not recommended; MSDS = Material Safety Data Sheet; P/CD = *Paint/Coatings Dictionary*. Remember, the *higher* a material's flash point, the *less* flammable it is.

COMMON NAME	Gum acacia (gum arabic)	Gum tragacanth	Gum karaya
TYPE	Natural gum	Natural gum	Natural gum
SOURCE	Sap from several species of acacia trees	Shrub *Astragalus;* Middle East and Western Asia	*Sterculia urens;* Asian plant
COLOR/APPEARANCE	Pale Y dusty lumps or crushed powder	Pale Y tears; W crushed powder; translucent pale Y colloidal solution	Pale Y tears; W crushed powder; pale Y colloid
USE	Binder; adhesive; thickener; lithographic stop-out	Binder (pastel); thickener	Substitute for gum tragacanth
REFRACTIVE INDEX	Low	Low as binder	Low as binder
VISCOSITY	Medium to high	Medium to high as colloid solution; low in binder solution	Medium to high as colloid solution; low in binder solution
THINNER/SOLVENT	Water	Water	Water
REVERSIBILITY	Good	Good	Good
pH	Slightly acidic	Slightly acidic	Relatively neutral
DURABILITY			
Interior	Excellent	Excellent	Excellent
Exterior	Poor	Poor	Poor
Rigid Support	Excellent	Excellent	Excellent
Flexible Support	Excellent in *thin* films	Excellent in *thin* films	Excellent in *thin* films
RESISTANCE TO:			
Water	Poor	Poor	Poor
Acid	Poor	Poor	Poor
Alkali	Poor	Poor	Poor
Pollutants	Poor	Poor	Poor
Ultraviolet light	Fair	Fair	Fair
Decay	Fair-good	Fair-good	Fair-good
HAZARDS			
Health	n/a; beware of mixtures	n/a; beware of mixtures	n/a; beware of mixtures
Fire (flash point)	n/a	n/a	n/a
OTHER COMMENTS	Excellent binder; thick films will not work; hygroscopicity encourages cracking and mold	Excellent, versatile, but weak binder; thick films will not work; hygroscopicity encourages cracking and mold	Similar to gum tragacanth

TABLE 4.1. BINDERS, CONT'D.

Key: n/a = not applicable; NR = not recommended; MSDS = Material Safety Data Sheet; P/CD = *Paint/Coatings Dictionary*. Remember, the *higher* a material's flash point, the *less* flammable it is.

COMMON NAME	Dextrin	Methyl cellulose	Hide glue	Whole egg
TYPE	Natural starch	Processed natural	Natural	Natural emulsion
SOURCE	Partially hydrolized starch	Methyl ether of cellulose, natural plant material	Animal bones, hides, hooves, cartilage, etc.	Fowl
COLOR/APPEARANCE	W powder	W flaky powder	Hard Br sheets or granules	Like a raw egg
USE	Additive for water-thinned vehicles	Thickener, stabilizer, cheap binder, and adhesive	Strong adhesive; binder for size paints	Binder for egg-oil emulsions
REFRACTIVE INDEX	Low to medium as a binder	High when dry; medium when prepared	Low to medium when prepared	Low in vehicle
VISCOSITY	Low when thinned	Low to high, depending on use	Low when heated; high when cooled	Low
THINNER/SOLVENT	Water	Water	Water	Water
REVERSIBILITY	Good	Good	Good	Poor; destroyed by water, not reversed
pH	Relatively neutral	Neutral	Relatively neutral	Neutral
DURABILITY				
Interior	Fair-good	Good-excellent	Good	Excellent
Exterior	Poor	Poor	Poor	Poor
Rigid Support	Good	Good-excellent	Excellent	Excellent
Flexible Support	Fair	Fair	Poor	Poor
RESISTANCE TO:				
Water	Poor	Poor	Poor	Poor-fair
Acid	Fair	Fair	Fair	Poor
Alkali	Fair	Fair	Fair	Poor
Pollutants	Poor	Fair	Fair	Fair
Ultraviolet light	Poor	Fair-good	Poor	Good
Decay	Poor	Good-excellent	Poor	Fair-good
HAZARDS				
Health	n/a	n/a	n/a	n/a
Fire (flash point)	n/a	n/a	n/a	n/a
OTHER COMMENTS	Found in best commercial watercolors as thickener or binder extender; used alone, not a good binder; good, cheap, temporary vehicle	Many varieties; similar to starches but more stable and resistant; good but weak adhesive	Traditional size for textile supports, now thought hazardous because too strong; use synthetics instead	Excellent binder and ingredient in egg-oil emulsion vehicles

TABLE 4.1. BINDERS, CONT'D.

Key: n/a = not applicable; NR = not recommended; MSDS = Material Safety Data Sheet; P/CD = *Paint/Coatings Dictionary*. Remember, the *higher* a material's flash point, the *less* flammable it is.

COMMON NAME	Egg yolk	Glair	Casein
TYPE	Natural emulsion	Natural emulsion	Natural emulsion
SOURCE	Fowl	Fowl	Dried skim milk curd
COLOR/APPEARANCE	Y	W, slightly translucent	W to Y powder; clear syrup when prepared
USE	Binder for pure egg tempera	Binder for manuscript illumination paints	Binder for casein paints and gesso; adhesive
REFRACTIVE INDEX	Low in vehicle	Low	Low
VISCOSITY	Medium to high	Low when prepared	Low to high, depending on dilution
THINNER/SOLVENT	Water	Water	Water; stronger for dried films
REVERSIBILITY	Poor; destroyed by water	Good	Poor; destroyed by scrubbing with water
pH	Neutral	Neutral	Alkaline
DURABILITY			
Interior	Excellent	Good	Excellent
Exterior	Poor	Poor	Poor
Rigid Support	Excellent	Good	Excellent
Flexible Support	Poor	Poor	Poor
RESISTANCE TO:			
Water	Fair	Poor	Fair
Acid	Poor	Poor	Poor
Alkali	Poor	Poor	Poor
Pollutants	Fair	Fair	Fair
Ultraviolet light	Good	Fair	Good
Decay	Fair-good	Fair-good	Fair-good
HAZARDS			
Health	n/a	n/a	n/a; solutions alkaline
Fire (flash point)	n/a	n/a	n/a
OTHER COMMENTS	Excellent classic binder for egg tempera; cannot be duplicated by acrylic emulsions	Classic binder for manuscript paintings; can also be used as a paper size and as an adhesive for gilding	Excellent adhesive and binder, but inconvenient to prepare; cannot be duplicated by acrylic emulsions

TABLE 4.1. BINDERS, CONT'D.

Key: n/a = not applicable; NR = not recommended; MSDS = Material Safety Data Sheet; P/CD = *Paint/Coatings Dictionary*. Remember, the *higher* a material's flash point, the *less* flammable it is.

COMMON NAME	Slaked lime (calcium hydroxide)	Vinyl resins		Acrylic resins	
TYPE	Natural catalytic	Synthetic resin; lacquer		Synthetic resin	
SOURCE	Roasted calcium carbonate + water (see text)	Ethylene; crude petroleum; large variety		Vinyl resins; large variety	
COLOR/APPEARANCE	Dull W putty	Large clear lumps that fracture like glass; in emulsion, milky W		Large clear lumps or W powder; in emulsion, milky W	
USE	Support, ground, and binder for *fresco buono*	Varies		Varies	
REFRACTIVE INDEX	n/a	Low, depending on form		Low, depending on form	
VISCOSITY	High in putty form; lime water has low viscosity	Low to medium in solution of emulsion		Low to medium in solution of emulsion	
THINNER/SOLVENT	Water will destroy lime walls	Aromatic hydrocarbons, ketones for solutions; water for emulsions unless dry		Aliphatics for most solutions; water for emulsions unless dry	
REVERSIBILITY	Poor; destroyed by water if improperly applied	Good in solution; poor in emulsion		Good in solution; poor in emulsion	
pH	Alkaline	Neutral in solution; alkaline in emulsion		Neutral in solution; alkaline in emulsion	
DURABILITY		**Solution:**	**Emulsion:**	**Solution:**	**Emulsion:**
Interior	Excellent	Good	Good	Excellent	Good-Excellent
Exterior	Poor	Fair	Fair-good	Good	Fair
Rigid Support	Excellent	Excellent	Excellent	Excellent	Excellent
Flexible Support	Poor	Fair	Fair-good	Fair	Good-Excellent
RESISTANCE TO:					
Water	Poor	Excellent	Fair	Excellent	Fair
Acid	Poor	Excellent	Poor	Fair	Poor
Alkali	Poor	Fair	Poor	Fair	Poor
Pollutants	Poor	Good	Fair	Fair-good	Fair
Ultraviolet light	Good	Fair	Fair	Fair	Fair
Decay	Good	Excellent	Excellent	Excellent	Excellent
HAZARDS					
Health	Very alkaline; can burn	Solvents are a major hazard		Solvents are a major hazard	
Fire (flash point)	n/a	Varies; solvent hazard		Varies; solvent hazard	
OTHER COMMENTS	Excellent mural material under the right environmental conditions; inconvenient and expensive to prepare	Solutions hazardous because of solvents; emulsions safer but good only for adhesives; see MSDSs for hazards		Solutions hazardous because of solvents, but can make good paints; use only solutions that can be thinned with mineral spirits; see MSDSs for hazards	

TABLE 4.1. BINDERS, CONT'D.

Key: n/a = not applicable; NR = not recommended; MSDS = Material Safety Data Sheet; P/CD = *Paint/Coatings Dictionary.*
Remember, the *higher* a material's flash point, the *less* flammable it is.

COMMON NAME	Alkyd resins	Latex	Silicates
TYPE	Synthetic resin	Natural or synthetic emulsion	Silicate
SOURCE	Condensed ester of a polyhydric alcohol and a polybasic acid	Natural fine dispersion of rubber or resin in water (e.g. fig milk)	Pure silica; dissolved in a solvent or dispersed as a colloid in water
COLOR/APPEARANCE	Y to YR, depending on modifier	Milky W	Clear or bluish liquid
USE	Major industrial use as a paint binder	Binder	Industrial binder; experimental for artists
REFRACTIVE INDEX	Low to medium	Medium to high liquid; Low to medium dry film	Low
VISCOSITY	High, but in artists' paint vehicle low to medium	Low to high, depending on vehicle contents	Low until hydrolysis; medium to high until dry
THINNER/SOLVENT	Varies, but in artists' binders, mineral spirits; higher aromatics for dried films	Water; higher solvents when dry	Varies from water to mineral spirits to alcohol
REVERSIBILITY	Poor; aromatic solvents will destroy, not reverse	Poor	Not possible
pH	Oil-modified: slightly acidic	Alkaline	Alkaline to *very* alkaline
DURABILITY		Depends on type	Depends on type
Interior	Excellent	Good-excellent	Excellent
Exterior	Good	Fair-good	Excellent
Rigid Support	Excellent	Good-excellent	Excellent
Flexible Support	Good-excellent	Good-excellent	Poor
RESISTANCE TO:			
Water	Excellent	Good	Good
Acid	Fair	Fair	Fair
Alkali	Fair	Fair	Fair
Pollutants	Good	Good	Excellent
Ultraviolet light	Good	Fair	Good
Decay	Excellent	Good	Excellent
HAZARDS			
Health	n/a, except if misused or abused	n/a but be aware of other vehicle contents	Silica can cause silicosis; prepared binder can burn the skin
Fire (flash point)	Very high flash point	n/a	Varies from n/a to flammable
OTHER COMMENTS	With more than 50% oil in vehicle, paints are really oil paints; versatile, nonyellowing (depending on oil), quick-drying, less apt to crack than linseed oil binders; better color development than acrylic emulsion binders	Generic term for a wide variety of water-based dispersions of particles of rubber or resin in water; common latex housepaint is not an artists' material	Potential exterior mural paint binder; "one package" systems require only pigment dispersion, application similar to fresco; serious health hazard: see MSDSs for hazards and follow all instructions

5 Solvents and Thinners

Thinners and solvents are used for diluting binders, for thinning paints to working consistency, for cleaning up around the studio, for dissolving varnish resins or waxes, and as cleaning agents in the conservation or restoration of paintings. The material is called a thinner when it is used to dilute another liquid, such as a painting medium, and a solvent when it is used to dissolve something, such as a varnish resin. For the purposes of this chapter's discussion, I am using the term "solvent" to refer to both categories.

Solvents are usually volatile—that is, they evaporate rapidly—and leave little or no residue behind. The most common solvents the average artist will encounter are water, mineral spirits or gum turpentine, and, once in a while, alcohol.

Solvents used by artists should meet these specifications:

* The vapors given off by a solvent should be nontoxic. Few solvents meet this requirement; many present both acute and chronic hazards to those who are careless with them or ignorant about their proper use.
* The solvent should be completely volatile and leave no residues. Aged gum turpentine can leave a gummy deposit in the bottom of your palette cup.
* The solvent should not dissolve already-dried paint layers when used in a painting medium. In some cases, as when painting with watercolors, this problem is difficult to avoid if you do much overpainting.
* The solvent should not induce a chemical reaction with the other materials or

ingredients used with it, and if it does—by design or by accident—then the reaction products should not be toxic to you or harmful to the painting. In the same vein, the solvent should mix completely with all the other materials with which it is used, and produce no precipitates or residues.
* When it is used as a solvent, the liquid should dissolve the other substance completely and not leave behind any reaction products.

FIRE HAZARDS

Most solvents are flammable, and some are extremely dangerous for this reason. An indication of a liquid's flammability is expressed by its flash point: the lowest temperature at which a solvent gives off vapors that can be ignited by an open flame or spark. Note the inverse relationship between flash point and flammability: The *lower* the flash point, the *more* flammable the liquid is. Here are classifications of flammability, based on the flash point of a solvent:

Combustible	Flash point 38 to 65° C (100 to 150° F)
Flammable	Flash point -7 to 38° C (20 to 100° F) (consider this room temperature)
Extremely flammable	Flash point around -7° C (20° F)
Explosive	Flash point at or below -12° C (10° F)

☞ *CAUTION: To avoid the danger of fire when using solvents, take the following important precautions:*

1. Know the flash point of the solvent, or determine its flammability by reading the container label carefully.
2. Make sure that all container labels have complete information, including any cautions about hazards other than fire, with instructions for the treatment of injuries or overexposure and warnings about proper storage. Following this advice will also prevent you from using the wrong solvent by accident, which can have serious consequences for you and your painting. *Never transfer solvents to unlabeled containers.*
3. Purchase solvents in the smallest quantities practical. There is little need to buy them in quantities larger than a gallon (3.8 L), but if you must, then store solvents in fireproof steel cabinets that have a provision for automatically extinguishing fires. Lab Safety Supply and other dealers have a good selection of these expensive cabinets (see List of Suppliers).
4. Store solvents in their original containers, tightly closed, away from sources of heat (including direct sunlight), and out of the pathway to an exit from your studio.
5. Keep even small containers of solvents closed when working—open them only to remove the solvent.
6. *Never smoke in the presence of solvents.*
7. Make sure that heating and ventilating equipment (exhaust fans) has explosion-proof motors, and that all other electrical equipment in your studio is in excellent condition, with properly grounded wiring.
8. Dispose of soaked rags and materials properly. The ideal container is one with a self-closing top, made of steel, that is fireproof or self-extinguishing. Empty the container every day to avoid a buildup of flammable vapors.
9. Have a good-quality carbon dioxide or dry chemical fire extinguisher located in a prominent place, preferably near the exit and away from the storage area.

HEALTH HAZARDS

The health hazards of solvents are perhaps more significant than the fire hazards. Much has been made of these potential hazards in recent years; in industry they have been more extensively studied than in the arts. In the fine arts, familiar materials are often repackaged into containers much smaller than the package in which the original material was shipped, with less specific and less detailed cautionary labeling. Furthermore, the uses to which artists put solvents—not to mention other potentially harmful materials—are frequently variable, uncontrolled, unknown to the manufacturer or distributor of the product, or conducted somewhat carelessly. If you use a product carefully, with full understanding of its dangers, there will be less cause for alarm.

Exposure to the hazards of solvents can occur in three ways: by absorption through the skin, especially through scratches or cuts; by inhalation of the vapors into the lungs or aspiration (breathing in) of the liquid; and by ingestion. Inhalation is the most dangerous hazard because it is most frequently encountered unintentionally. The various solvents have varying degrees of hazards, and can have either *acute toxic effects* (producing symptoms of injury immediately after exposure) or *chronic toxic effects* (producing symptoms of injury only after prolonged exposure, even to low levels).

The toxicity of solvents can be classified into four general categories:

Extremely toxic solvents can produce major injury, or death, from a single incident of acute exposure. Skin damage or a severe allergic reaction can be produced by absorption through the skin. Brain damage or severe irritation of the nose, throat, and lungs can result from inhalation. Fatal injury can result from the aspiration or ingestion of small amounts. These materials can also produce chronic severe damage from regular exposures to smaller amounts over a sustained period of time.

Highly toxic solvents may have a less severe acute effect during a single exposure to smaller amounts than extremely toxic materials, but

they should still be considered quite hazardous. The injuries may be minor but permanent; chronic dermatitis from skin absorption is a good example. The inhalation of highly toxic vapors can cause headaches, nausea, and lung irritation. Aspiration or ingestion can be fatal unless immediate and massive first aid is applied. Repeated exposure to small amounts of a highly toxic material can have the same results as a single acute exposure to an extremely toxic material.

Moderately toxic solvents may produce minor injury that can be treated by removal from contact with the material. An allergic skin reaction to a solvent can be avoided by not using it, or by protecting your skin with the appropriate gloves or creams. Intoxication from inhaling moderately toxic solvent vapors can be reversed by removing the victim to fresh air. Serious injury can still result from overexposure to large amounts of moderately toxic solvents.

Slightly toxic solvents have a small chance of producing an acute or chronic injury, especially if exposure conditions are abused.

The chronic effects of exposures to solvents are more difficult to assess than the acute effects, which usually show up immediately. Some of the illnesses that have been shown to result from exposure to materials with a chronic toxic effect include sterility; birth defects and/or harm to a developing fetus; harm to a nursing infant; various forms of cancer; personality changes or mental injury; damage to organ systems such as the blood, liver, heart, lungs, reproductive organs, or brain; and allergic skin or lung reactions.

☞ CAUTION: *To avoid injury when using solvents, take the following important precautions:*

1. *Always know the contents of the solvents you're using. If the container is improperly labeled, do not use the solvent.* Look for certification seals from the Art and Craft Materials Institute regarding health labeling on the products you are using. (See Figure 7.3, page 136.) Write to the manufacturer and ask for the Material Safety Data Sheets (MSDSs) on the material. These sheets provide some information about the harmful or hazardous content of the material, although they cannot be considered 100 percent reliable. If the manufacturer cannot or will not supply information about the material, do not use the product—there is no reason to risk serious injury. If at all possible, avoid the use of highly toxic solvents.

 Note: Material Safety Data Sheet information applies not only to solvents but also to other types of materials. If you have a question about the labeling of any product used in your studio, request a MSDS from the manufacturer.

2. If you have further questions, consult a physician who has some knowledge of toxicology. Do *not* telephone the manufacturer of an artists' material with a health question. Because of legal liability, the manufacturer will not be able to give you medical advice and will refer you to a poison control center.

3. Wear splash goggles, or a full face mask, and gloves when using more than small amounts of a solvent. You must choose the proper glove for the particular solvent, since some gloves will permit particular solvents to penetrate (see Table 5.1 on pages 89–96 for this information). Barrier creams can be used under gloves for additional protection, or for short-term protection for bare skin when using small amounts of the solvent.

4. Never use solvents to clean your hands. Use soap and a scrub brush or a solventless hand-cleaning cream.

5. Use the proper ventilation to remove solvent vapors from the studio. The phrase "adequate ventilation" is on almost every solvent label, but its meaning is not always explained. *An open window is generally not enough:* There must be cross-ventilation to remove solvent vapors, and "adequate ventilation" means at least 10 air changes in the room per hour. Cross-ventilation directs the flow of air away from your face and out of your studio.

 A general exhaust fan placed in a window can provide air changes in a room if there is another window or door opposite that can let in fresh, uncontaminated air.

You should feel a slight breeze, which will tell you that the air is moving out of the room. *A general exhaust fan should be used ONLY with harmful solvents, NOT with toxic or highly toxic solvents.* To remove highly toxic or toxic vapors, direct local exhaust is recommended: Either a laboratory hood or a flexible duct system can be used to remove vapors directly from your work area to the outside. If neither general nor direct local exhaust systems are feasible, you can use an organic vapor mask, provided with the correct cartridge filter.

FIGURE 5.1. Ventilation, where fan is pulling air out the window. *Top to bottom,* unsafe ventilation, better ventilation, best ventilation.

Figure 5.1 shows examples of correct and incorrect exhaust setups. Figure 5.2 shows organic vapor and air-supply protective masks. Lab Safety Supply, in the List of Suppliers, is a source for this equipment.

The importance of knowing the hazards of using solvents cannot be overemphasized. It is, however, equally necessary to keep a perspective about them: You will have no need, in the normal course of events, to use the more dangerous solvents. Most painters live quite happily using only water, gum turpentine, mineral spirits, and occasionally alcohol or the more hazardous "lacquer thinners"—a generic term for various manufacturers' combinations of solvents like xylene and toluene, which are used to thin automotive lacquers or dissolve the lacquer stencil films used in serigraphy.

Most precautionary advice about solvents is based on common sense. Follow the advice given here and in the more specific and detailed accounts found in books such as *Artist Beware* by Michael McCann (New York: Lyons and Burford, 1992) or *The Artist's Complete Health and Safety Guide* by Monona Rossol (New York: Allworth Press, 1991). Practice good studio hygiene, and use protective equipment. Have the telephone number of a poison control center posted by your phone. If you work regularly with toxic solvents or other harmful materials, discuss possible long-term effects with your doctor, and make sure that he or she is well versed in toxicology. Remember that ignorance is more dangerous than any particular solvent; even a relatively harmless solvent can be abused.

COMMON SOLVENTS

The more common solvents encountered in a painting studio are discussed below. For quick reference to technical information, see Table 5.1 on pages 89–96. For more detailed information on the less common solvents, consult one of the texts specializing in this kind of information, such as *The Artist's Complete Health and Safety Guide.* For medical advice, see your doctor or call a local poison control center.

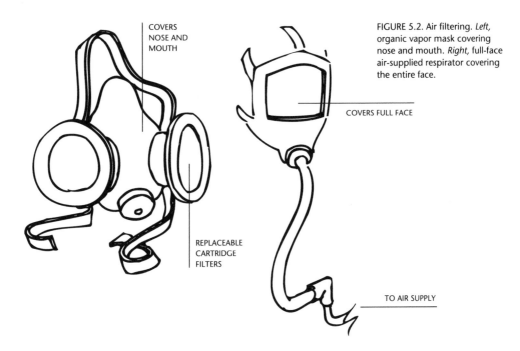

COVERS
NOSE AND
MOUTH

FIGURE 5.2. Air filtering. *Left,* organic vapor mask covering nose and mouth. *Right,* full-face air-supplied respirator covering the entire face.

COVERS FULL FACE

REPLACEABLE
CARTRIDGE
FILTERS

TO AIR SUPPLY

The relative toxicity ratings of the solvents below are adapted from *Artist Beware* by Michael McCann.

WATER

Water is called the universal solvent, and it is the thinner most often used by artists for many studio procedures. It thins and dilutes watercolors, casein, tempera, acrylic polymer and polyvinyl acetate emulsions, and fresco.

Distilled water is often specified for the preparation of binders for water-thinned paints, since dissolved mineral salts in ordinary tap water can affect the performance or durability of the paint. Where local water is soft, there should be no problem, and distilled water (not spring water or mineral water) is usually available at supermarkets or pharmacies.

GUM TURPENTINE

Turpentine is the general name for several products distilled from the sap of pine trees: the longleaf yellow pine *(Pinus palustris)* or the loblolly pine *(Pinus taeda)*. The whole crude sap, or oleoresin, was originally called turpentine, but now the word usually refers only to the more volatile spirit, or liquid.

Gum turpentine (or "turps") is properly called "pure gum spirits of turpentine." It is distilled from the sap of live pine trees and for artistic use must be anhydrous, or water-free. Fresh turpentine is colorless or slightly yellow and has a distinctive odor; as it ages, it turns yellow and its odor grows sharper and more pronounced. Gum turps bought in a hardware store, where the stock turnover is rapid, is usually fresher than the smaller amounts found in art supply stores.

A slightly gummy residue is left behind as gum turpentine evaporates. This is partly the result of polymerization and oxidation, and does little harm to mixtures in which it is used. Fresh turps is better in this respect.

Gum turpentine is classified as a moderately toxic solvent. Some varieties are more harmful than others (depending on the species of tree) and require a health-hazard warning label to be certified by the Art and Craft Materials Institute. This requirement applies only to turpentines marketed as art supplies, not to turpentines sold in hardware stores. Gum turps is reasonably safe with regard to fire hazards, with a flash point of around 35° C (95° F): flammable. It should be stored in closed, opaque containers, away from heat and light. The vapors can be irritating to the nose, throat, and

eyes, and skin contact should be minimized because some people develop severe skin allergies to gum turpentine. Do not use gum turpentine to clean brushes or hands.

The other varieties of turpentine are steam-distilled wood turpentine, from pine scraps or stumps; sulfate wood turpentine; and destructively distilled wood turpentine. None of these is as pure or as useful as pure gum turpentine. They may often contain water and can be much more irritating than gum turpentine.

PETROLEUM PRODUCTS

A variety of solvents that painters use are derived from crude oil. All are varieties of hydrocarbons, and painters are generally concerned with two classes: aliphatic hydrocarbons and aromatic hydrocarbons.

The aliphatic solvents are considered less volatile and less active than the aromatics, although they may contain a percentage of aromatics in the less pure grades. Gasoline and kerosene are included in this group.

The aromatic solvents include benzene and naphthalene. They are quite volatile and consequently more active solvents. Most are highly flammable and some are highly toxic.

ALIPHATIC HYDROCARBONS

These petroleum distillates are generally slower-acting and less volatile than the aromatic hydrocarbons.

Mineral Spirits

This is a refined distillate of petroleum with a low aromatic content, known by the general designation of "paint thinner." It is usually sold under proprietary names like P & W Paint Thinner or Turpenoid. Its properties are similar to those of gum turpentine, but with several advantages: It does not leave a gummy residue when it evaporates, it does not deteriorate with age, it is less likely to affect those with an allergic reaction to gum turpentine, and it is much less expensive than gum turpentine. It can replace gum

turps for studio operations that do not involve damar or other hard resins or varnishes.

Mineral spirits is classified as moderately toxic, though when ingested it can be highly toxic. Its flash point is 30 to 40° C (85 to 105° F): flammable.

Varnish Maker's and Painter's Naphtha

Also known as VM&P naphtha, this solvent is more volatile than mineral spirits and is used occasionally as a substitute for it. The name "benzine" is still sometimes used as a name for VM&P naphtha but should not be, since it can be easily confused with the highly toxic "benzene," an aromatic hydrocarbon solvent. The naphthas should be used with care—some of them may contain aromatic additives, which can make them more flammable and more toxic.

VM&P naphtha is classified as moderately toxic, though when ingested it can be highly toxic. Its flash point is -7 to 13° C (20 to 55° F): flammable.

Kerosene

This is a fuel oil that is sometimes used as a cleanup solvent. It can leave behind a greasy residue as it evaporates, and is not suitable for studio use. The proprietary solvent Varsol is only slightly better; it can be used for cleanup but should not be used to thin or dilute paints or varnishes.

Kerosene is moderately toxic; when ingested it can be highly toxic. Its flash point is 38 to 74° C (100 to 165° F): combustible.

Gasoline

This fuel is a good paint thinner, but many varieties contain additional ingredients such as lead or benzene that make it very dangerous to use. In addition, it is a serious fire hazard.

Gasoline is extremely toxic. Its flash point is -46° C (-50° F): explosive.

AROMATIC HYDROCARBONS

These petroleum distillates are significantly more active solvents than the aliphatic hydrocarbons, and some of them are more flammable and toxic.

Benzene

This dangerous and explosively flammable solvent was formerly found in many commercial solvent-thinned products; the odor was familiar to users of rubber cement. Now the solvent used in that product is usually n-hexane (which itself is harmful).

Benzene should never be used in your studio. It is extremely toxic—a carcinogen. Its flash point is -11° C (12° F): explosive.

Xylene

Used as a solvent in picture conservation and restoration and sometimes found in fast-drying marker inks, xylene is less toxic and flammable than benzene, but its use should be avoided where possible.

Xylene is moderately toxic. Its flash point is 24° C (75° F): flammable.

Toluene

Toluene is found as the solvent in some commercially prepared spray varnishes and fixatives. Use these very carefully and avoid using the solvent by itself.

Toluene is moderately toxic. Its flash point is 7° C (45° F): flammable.

Note: Commercial brands of benzene, xylene, and toluene may be labeled benzol, xylol, and toluol. Unless they are chemically pure (designated "C.P."), they may contain small amounts of one another as additives. Commercial "lacquer thinners" can also contain one or more of them, with the label giving a nonspecific phrase such as "contains aromatic hydrocarbons." Generally, none of these solvents need be used by the average painter.

n-Hexane

This solvent is now used in most brands of rubber cement. It is slightly toxic, though ingestion can cause a moderately toxic reaction. Its flash point is -57° C (-70° F): explosive. Use with caution.

ALCOHOLS

The alcohols find minor use among artists as resin solvents, wetting agents, and cleaners.

Ethyl Alcohol

This is also called ethanol or grain alcohol, and usually contains a small proportion of water. Absolute alcohol, or 100 percent anhydrous (water-free) alcohol, can be had through chemical supply firms. Denatured ethyl alcohol, available in paint supply and hardware stores, contains ingredients to make it poisonous—small amounts of gasoline, methyl alcohol, or other solvents. Denatured ethyl alcohol is most often used for studio operations.

Ethyl alcohol is moderately toxic; denatured ethyl alcohol is highly toxic. The flash point of both kinds is 12 to 16° C (54 to 60° F): flammable.

Methyl Alcohol

Also called methanol or wood alcohol, with the same general solvent properties as ethyl alcohol, it has significantly higher toxicity. It should not be used in the studio. Methyl alcohol is extremely toxic by ingestion. Its flash point is 12 to 16° C (54 to 60° F): flammable.

Glycerine

This is a trihydroxy alcohol also known as glycerin or glycerol—a nonvolatile, syrupy alcohol that bears little resemblance to its cousins. Glycerine is used in medicines and foods, and in commercial coatings as a plasticizer. It finds the same use in manufactured and homemade paints containing brittle binders, principally watercolors.

Glycerine is neither toxic nor flammable.

KETONES

The ketones are a group of organic solvents used in paint and varnish removers and as lacquer and plastic solvents. They are considerably stronger in their solvent action than some of the aromatic hydrocarbons. Some of them are more hazardous than the aromatics, some are less. What is called "lacquer thinner" may contain one or more of the ketones.

Acetone

This is the most familiar of the ketones, and it is used as a solvent for a variety of natural

and synthetic resins and recommended by some writers as a "quick-dry" solvent for cleaning brushes.

Acetone should be classified as moderately toxic. Its flash point is -19 to -10° C (-4 to 15° F): explosive. Avoid its use when possible because of the fire hazard.

Methyl Ethyl Ketone

This is also known as MEK and has many of the same solvent properties as acetone, although it is not as volatile. It is used as a vinyl resin solvent. MEK-peroxide is a derivative of MEK, used as a catalytic additive for polyester resins; it is highly toxic.

Methyl ethyl ketone should be classified as moderately toxic. Its flash point is -4 to -1° C (24 to 30° F): flammable.

Cyclohexanone

Also called hexanone, cyclohexanone is known as the chemical basis for a ketone resin varnish supplied with Winsor & Newton's alkyd resin paints. The solvent form (*not* the varnish form) should be classified as moderately toxic, and highly toxic by inhalation. Its flash point is around 44° C (111° F): combustible.

MISCELLANEOUS

The following solvents are other materials that you might encounter but that are not generally found in the average studio. It is helpful to be aware of them. This is not a comprehensive list.

Cellosolve

This solvent is sometimes used in acrylic polymer emulsion binders in very small amounts. Cellosolve is a proprietary name for this water-miscible solvent.

Cellosolve should be classified as slightly toxic, though by ingestion it is moderately toxic. The amounts in commercial emulsions are

not significant with regard to this classification. Its flash point is 42° C (107° F): combustible.

Carbitol

This is also a proprietary solvent with properties and uses similar to those of Cellosolve. Carbitol should be classified as slightly toxic, though by ingestion it is moderately toxic. The amounts in commercial emulsions are not significant with regard to this classification. Its flash point is 96° C (205° F): combustible.

Ethylene Glycol

This is a type of alcohol used in emulsion dispersions as a plasticizer; it provides stability to the emulsion if it is frozen. (It is also used as an antifreeze for automobile radiators.)

Ethylene glycol should be classified as slightly toxic, though by ingestion it is moderately toxic. The amounts found in commercial emulsions may be significant depending on the proprietary formula of the manufacturer, but generally speaking the material does not pose a serious threat. The flash point is 111° C (232° F): combustible.

For quick reference to the technical aspects of solvents and thinners, their uses, hazards, and some cautions about them, consult Table 5.1, which follows. *For medical advice, see your doctor.*

In Table 5.1, Type of Ventilation is defined as follows: *General* = open door and window sufficient to provide draft for cross-ventilation. *General exhaust* = open door and window, assisted by ventilation fan to provide draft for cross-ventilation. *Local direct exhaust* = system providing for removal of vapors directly from work area to the outside; for example, a window-mounted exhaust fan connected to ductwork that goes to work area. *Fume hood* = self-contained ventilation system that completely separates work area from rest of studio (see your local chemistry laboratory for example).

TABLE 5.1. SOLVENTS AND THINNERS

Key: n/a = not applicable; ST = slightly toxic; MT = moderately toxic; HT = highly toxic; ET = extremely toxic; NR = not recommended; C.P. = chemically pure. Remember, the *higher* a material's flash point, the *less* flammable it is.

COMMON NAME	Water		Distilled water		Pure gum spirits of turpentine	
TYPE	Aqueous		Aqueous		Nonaqueous; should be anhydrous	
SOURCE	Ground water		Distilled; also deionized		*Pinus palustris* or *Pinus taeda;* many species of pine	
COLOR/APPEARANCE	Clear liquid		Clear liquid		Very pale Y when fresh	
USE	"Universal solvent"; polluted water may contain dissolved heavy metals		Mainly for "clean" techniques		Diluent for oils and alkyds; solvent for damar resin	
HAZARDS						
Flash point	n/a		n/a		35°C (95°F)	
Fire hazard rating	n/a		n/a		Flammable	
Health hazard rating by route of entry	Acute:	Chronic:	Acute:	Chronic:	Acute:	Chronic:
Absorption	n/a	n/a	n/a	n/a	MT	MT
Aspiration					HT	HT
Ingestion					MT	MT
Inhalation					MT	MT
ACUTE EFFECTS	n/a		n/a		Skin irritation; severe lung damage; aspiration can be fatal	
CHRONIC EFFECTS	n/a		n/a		Skin allergy or rash; vapors may sensitize skin	
TYPE OF VENTILATION (Explosion-proof motors)	n/a		n/a			
General (10 air changes per hour)					x	
General exhaust					x, preferred	
Local direct exhaust						
Fume hood						
BARRIERS	n/a		n/a			
Type of respirator Dust Organic vapor Air-supplied					x, if spraying	
Goggles or other eye protection					x, if spraying	
Type of rubber glove Latex/neoprene Nitrile					x	
Solvent-proof cream					x, if sensitive	
OTHER COMMENTS	Soft tap water can be used; avoid hard water, mineral waters, sea water		For procedures where dissolved metallic salts could affect paint; diluent for sensitive water-thinned paints		Relatively safe, but avoid if possible; certain species more likely to cause adverse reaction; use mineral spirits	

TABLE 5.1. SOLVENTS AND THINNERS, CONT'D.

Key: n/a = not applicable; ST = slightly toxic; MT = moderately toxic; HT = highly toxic; ET = extremely toxic; NR = not recommended; C.P. = chemically pure. Remember, the *higher* a material's flash point, the *less* flammable it is.

COMMON NAME	Steam-distilled turpentine	VM&P naphtha	Mineral spirits
TYPE	Nonaqueous but may contain water	Nonaqueous	Nonaqueous
SOURCE	Ground pine wood pulp; lumber industry by-product	Petroleum distillate	Petroleum distillate
COLOR/APPEARANCE	Darker than pure gum turps	Clear liquid	Clear liquid
USE	Commercial use	Paint thinner; cleanup	Thinner; cleanup; resin solvent
HAZARDS	NR	NR	
Flash point	35°C (95°F)	-7 to -13°C (20 to 55°F)	30 to 40°C (80 to 105°F)
Fire hazard rating	Flammable	Flammable	Flammable
Health hazard rating by route of entry	Acute: Chronic:	Acute: Chronic:	Acute: Chronic:
Absorption	MT MT	MT MT	MT MT
Aspiration	HT HT	ET ET	ET ET
Ingestion	MT MT	MT MT	MT MT
Inhalation	MT MT	MT MT	MT MT
ACUTE EFFECTS	Same as pure gum turps, but can be more acute	Skin irritation; slight narcotic; aspiration can be fatal	Skin irritation; slight narcotic; aspiration can be fatal
CHRONIC EFFECTS	Same as pure gum turps, but can be more acute	Skin irritation; vapors harmful	Skin irritation; concentration of vapors can be harmful
TYPE OF VENTILATION (Explosion-proof motors)			
General (10 air changes per hour)		x, at least	x, at least
General exhaust	x	x, preferred	x, preferred
Local direct exhaust			
Fume hood			
BARRIERS			
Type of respirator			
Dust			
Organic vapor	x, at least	x	x, if spraying
Air-supplied			
Goggles or other eye protection	x	x	x, if spraying
Type of rubber glove			
Latex/neoprene			
Nitrile	x	x	x
Solvent-proof cream	x	x	x
OTHER COMMENTS	Not an art material; likely to contain other materials that could cause more severe reactions	Not an art material; mineral spirits cleaner and safer, though has same hazards	Good general-purpose solvent with excellent characteristics

TABLE 5.1. SOLVENTS AND THINNERS, CONT'D.

Key: n/a = not applicable; ST = slightly toxic; MT = moderately toxic; HT = highly toxic; ET = extremely toxic; NR = not recommended; C.P. = chemically pure. Remember, the *higher* a material's flash point, the *less* flammable it is.

COMMON NAME	Kerosene (kerosine)	Gasoline (leaded or unleaded)	Benzene (benzol)
TYPE	Nonaqueous (may contain water)	Nonaqueous	Nonaqueous; may not be C.P.
SOURCE	Petroleum fuel oil	Petroleum fuel oil	Distilled petroleum aromatic hydrocarbon
COLOR/APPEARANCE	Greasy W to pale Y liquid	Clear to pinkish liquid	W (clear) liquid
USE	Fuel; cleanup	Fuel	Solvent
HAZARDS	NR	NR	NR
Flash point	38 to 74°C (100 to 165°F)	-46°C (-50°F)	-11°C (12°F)
Fire hazard rating	Combustible	Explosive	Explosive
Health hazard rating by route of entry	Acute: Chronic:	Acute: Chronic:	Acute: Chronic:
Absorption	MT MT	ET ET	HT ET
Aspiration	ET ET	ET ET	ET ET
Ingestion	MT HT	ET ET	ET ET
Inhalation	MT MT	ET ET	ET ET
ACUTE EFFECTS	Skin irritant; narcotic; aspiration can be fatal	Ingestion or aspiration can be fatal; skin defatting; narcotic	Carcinogenic: *do not use*
CHRONIC EFFECTS	Skin irritation; concentration of vapors can be harmful	Brain damage; skin defatting; other organ damage	
TYPE OF VENTILATION (Explosion-proof motors)			
General (10 air changes per hour)	x, at least		
General exhaust	x, preferred		
Local direct exhaust		x	
Fume hood		x, preferred	x, mandatory
BARRIERS			
Type of respirator			
Dust			
Organic vapor	x	x	
Air-supplied			x, mandatory
Goggles or other eye protection	x	x	x
Type of rubber glove			
Latex/neoprene			
Nitrile	x	x	x
Solvent-proof cream	x	x	x, under gloves
OTHER COMMENTS	Not an art material; greasy and dirty	Very dangerous material; good solvent properties, *but do not use*	A human carcinogen; *do not use;* do not confuse with the old name for VM&P naphtha, benzine

TABLE 5.1. SOLVENTS AND THINNERS, CONT'D.

Key: n/a = not applicable; ST = slightly toxic; MT = moderately toxic; HT = highly toxic; ET = extremely toxic; NR = not recommended; C.P. = chemically pure. Remember, the *higher* a material's flash point, the *less* flammable it is.

COMMON NAME	Xylene (xylol)		Toluene (toluol)		n-Hexane	
TYPE	Nonaqueous; may not be C.P.		Nonaqueous; may not be C.P.		Nonaqueous; may not be C.P.	
SOURCE	Distilled petroleum aromatic hydrocarbon		Distilled petroleum aromatic hydrocarbon		Distilled petroleum aromatic hydrocarbon	
COLOR/APPEARANCE	W or slightly Y liquid		W (clear) liquid		W (clear) liquid	
USE	Solvent; found in some rapid-dry felt-tip markers		Solvent; found in some spray varnishes		Solvent; may replace highly toxic benzene in some rubber cements	
HAZARDS						
Flash point	24°C (75°F)		7°C (45°F)		-57°C (-70°F)	
Fire hazard rating	Flammable		Flammable		Explosive	
Health hazard rating by route of entry	Acute:	Chronic:	Acute:	Chronic:	Acute:	Chronic:
Absorption	MT	MT	MT	MT	ST	ST
Aspiration	ET	ET	HT	HT	HT	HT
Ingestion	HT	HT	HT	HT	MT	MT
Inhalation	HT	HT	ST	ST	HT	HT
ACUTE EFFECTS	Skin, eye, nose, throat irritant; concentrated vapors—heart failure		Skin, eye, nose, throat irritant; concentrated vapors—heart failure		Skin, eye, nose, throat irritant; concentrated vapors—heart failure	
CHRONIC EFFECTS	Skin defatting; possible organ damage		Skin defatting; possible organ damage		Skin defatting; possible organ damage	
TYPE OF VENTILATION (Explosion-proof motors)						
General (10 air changes per hour)						
General exhaust					x, at least	
Local direct exhaust	x		x		x, preferred	
Fume hood	x, preferred		x, preferred		x, preferred	
BARRIERS						
Type of respirator Dust						
Organic vapor	x		x		x, at least	
Air-supplied	x, preferred		x, preferred		x, preferred	
Goggles or other eye protection	x		x		x	
Type of rubber glove Latex/neoprene						
Nitrile	x		x		x	
Solvent-proof cream	x, under gloves		x, under gloves		x	
OTHER COMMENTS	Odor familiar to users of solvent-based markers; use general exhaust at least		Use caution if spraying; use general exhaust at least		Not as hazardous as the former solvent for rubber cement (benzene), but use with caution	

TABLE 5.1. SOLVENTS AND THINNERS, CONT'D.

Key: n/a = not applicable; ST = slightly toxic; MT = moderately toxic; HT = highly toxic; ET = extremely toxic; NR = not recommended; C.P. = chemically pure. Remember, the *higher* a material's flash point, the *less* flammable it is.

COMMON NAME	Ethyl alcohol (ethanol)		Denatured ethyl alcohol		Methyl alcohol (methanol)	
TYPE	Nonaqueous; may contain water; hygroscopic		Nonaqueous; hygroscopic; contains toxic materials		Nonaqueous; hygroscopic; may be contaminated	
SOURCE	Distilled from grain		Distilled from grain		Distilled from grain	
COLOR/APPEARANCE	W liquid		W liquid		W liquid	
USE	Solvent		Solvent		Solvent and fuel	
HAZARDS					NR	
Flash point	12 to 16°C (54 to 60°F)		12 to 16°C (54 to 60°F)		12 to 16°C (54 to 60°F)	
Fire hazard rating	Flammable		Flammable		Flammable	
Health hazard rating by route of entry	**Acute:**	**Chronic:**	**Acute:**	**Chronic:**	**Acute:**	**Chronic:**
Absorption	ST	ST	ST	ST	MT	MT
Aspiration	HT	HT	HT	HT	HT	HT
Ingestion	MT	MT	HT	HT	ET	ET
Inhalation	ST	ST	ST	ST	MT	MT
ACUTE EFFECTS	Intoxication; aspiration into lungs can be very harmful		Intoxication; euphoria; coma; organ damage depends on denaturant		All effects of ethyl plus fatal coma, severe organ damage; blindness	
CHRONIC EFFECTS	Liver and other organ damage		Liver and other organ damage		All effects of ethyl; chronic effects can be fatal	
TYPE OF VENTILATION (Explosion-proof motors)						
General (10 air changes per hour)	x		x			
General exhaust	x, preferred		x, preferred			
Local direct exhaust					x	
Fume hood					x, preferred	
BARRIERS						
Type of respirator						
Dust						
Organic vapor	x, if spraying		x, if spraying		x	
Air-supplied					x, preferred	
Goggles or other eye protection	x, if spraying		x, if spraying		x	
Type of rubber glove						
Latex/neoprene	x		x		x	
Nitrile	x, preferred		x, preferred		x, preferred	
Solvent-proof cream	x		x		x, under gloves	
OTHER COMMENTS	Grain alcohol, about 90% alcohol and 10% water (180 proof), safer and easier to get than 100% ethyl; 100% ethyl better for anhydrous needs; not a safe material		More commonly used than ethyl, and easier to get, but *poisonous;* use with caution		A toxic solvent; avoid its use	

TABLE 5.1. SOLVENTS AND THINNERS, CONT'D.

Key: n/a = not applicable; ST = slightly toxic; MT = moderately toxic; HT = highly toxic; ET = extremely toxic; NR = not recommended; C.P. = chemically pure. Remember, the *higher* a material's flash point, the *less* flammable it is.

COMMON NAME	Glycerine (glycerol)		Ethylene glycol (ethylene alcohol)		Propylene glycol (1,2 propanediol)	
TYPE	Nonaqueous; hygroscopic		Nonaqueous; hygroscopic		Nonaqueous; hygroscopic	
SOURCE	Distilled from grain; trihydroxy alcohol		Distilled from grain; dihydric alcohol		Distilled from grain; dihydric alcohol	
COLOR/APPEARANCE	Viscous W syrup with sweet odor		Viscous W liquid or opaque waxy solid		Viscous W liquid or opaque waxy solid	
USE	Plasticizer		Plasticizer		Plasticizer	
HAZARDS						
Flash point	Not flammable		Not flammable unless heated: *do not heat*		Not flammable unless heated: *do not heat*	
Fire hazard rating	Not flammable					
Health hazard rating by route of entry	Acute:	Chronic:	Acute:	Chronic:	Acute	Chronic:
Absorption	n/a	n/a	ST	ST	ST	ST
Aspiration	n/a	n/a	HT	HT	ST	ST
Ingestion	n/a	n/a	MT	MT	ST	ST
Inhalation	n/a	n/a	ST	ST	ST	ST
ACUTE EFFECTS	n/a		Ingestion can be fatal		Current research indicates not harmful except when heated	
CHRONIC EFFECTS	n/a		Chronic ingestion of small amounts can lead to organ damage			
TYPE OF VENTILATION (Explosion-proof motors)	n/a					
General (10 air changes per hour)			x		x	
General exhaust						
Local direct exhaust						
Fume hood						
BARRIERS	n/a					
Type of respirator Dust Organic vapor Air-supplied			x		x	
Goggles or other eye protection			x		x	
Type of rubber glove Latex/neoprene Nitrile			x		x	
Solvent-proof cream			x		x, instead of gloves OK	
OTHER COMMENTS	A safe alcohol; used as a plasticizer in watercolors		Additive for some artists' acrylic emulsion paints; little need in the average studio		Additive for some artists' acrylic emulsion paints; little need in the average studio; less than 1% by weight concentration in tubes of paint; paint should not be heated or eaten	

TABLE 5.1. SOLVENTS AND THINNERS, CONT'D.

Key: n/a = not applicable; ST = slightly toxic; MT = moderately toxic; HT = highly toxic; ET = extremely toxic; NR = not recommended; C.P. = chemically pure. Remember, the *higher* a material's flash point, the *less* flammable it is.

COMMON NAME	Acetone (propanone; dimethyl ketone)		Methyl ethyl ketone (MEK; 2-butanone)		Methyl butyl ketone (MBK; 2-hexanone)	
TYPE	Nonaqueous; miscible with water		Nonaqueous		Nonaqueous	
SOURCE	Distilled from natural gas and other sources		Distilled from natural gas and other sources		Distilled from natural gas and other sources	
COLOR/APPEARANCE	W liquid		W liquid		W liquid	
USE	Solvent		Solvent		Solvent	
HAZARDS					NR	
Flash point	-19 to -10°C (-4 to 15°F)		-4 to -1°C (24 to 30°F)		23 to 35°C (73 to 95°F)	
Fire hazard rating	Explosive		Flammable		Flammable	
Health hazard rating by route of entry	**Acute:**	**Chronic:**	**Acute:**	**Chronic:**	**Acute:**	**Chronic:**
Absorption	ST	ST	MT	MT	HT	HT
Aspiration	HT	HT	HT	HT	ET	ET
Ingestion	MT	MT	MT	MT	MT	MT
Inhalation	ST	ST	MT	MT	ET	ET
ACUTE EFFECTS	Intoxication; skin irritation or drying		Intoxication; skin irritation or drying		Intoxication; weakness and nerve damage	
CHRONIC EFFECTS	Intoxication; skin irritation or drying. *Do not drink alcohol while using acetone*		Intoxication; skin irritation or drying. *Do not drink alcohol while using MEK*		General deterioration of the nervous system	
TYPE OF VENTILATION (Explosion-proof motors)						
General (10 air changes per hour)						
General exhaust						
Local direct exhaust	x, fire hazard		x, fire hazard		x	
Fume hood					x, preferred	
BARRIERS						
Type of respirator Dust						
Organic vapor	x, if spraying		x, if spraying		x	
Air-supplied					x, preferred	
Goggles or other eye protection	x, if spraying		x, if spraying		x	
Type of rubber glove Latex/neoprene	x		x		x	
Nitrile					(dissolves in MBK)	
Solvent-proof cream	x, instead of gloves OK		x, instead of gloves OK		x, under gloves	
OTHER COMMENTS	Dangerously explosive but not a health hazard		Very flammable but not a health hazard; use with caution; MEK-peroxide (a derivative of MEK) is highly toxic		Very hazardous to health; *do not use* if possible	

TABLE 5.1. SOLVENTS AND THINNERS, CONT'D.

Key: n/a = not applicable; ST = slightly toxic; MT = moderately toxic; HT = highly toxic; ET = extremely toxic; NR = not recommended; C.P. = chemically pure. Remember, the *higher* a material's flash point, the *less* flammable it is.

COMMON NAME	Methyl isobutyl ketone (MIBK; hexone)		Cyclohexanone (hexanone)	
TYPE	Nonaqueous		Nonaqueous	
SOURCE	Distilled from natural gas and other sources		Distilled from natural gas and other sources	
COLOR/APPEARANCE	W liquid		W liquid	
USE	Solvent		Solvent; polymerized form: resin varnish	
HAZARDS	NR		NR	
Flash point	24°C (74°F)		44°C (111°F)	
Fire hazard rating	Flammable		Combustible	
Health hazard rating by route of entry	Acute:	Chronic:	Acute:	Chronic:
Absorption	MT	MT	MT	MT
Aspiration	HT	HT	ET	ET
Ingestion	MT	MT	ST	ST
Inhalation	MT	MT	HT	HT
ACUTE EFFECTS	Intoxication; narcosis; skin, eye, nose, and throat irritation		Intoxication; skin, eye, nose, and throat irritation	
CHRONIC EFFECTS	Same as acute, but more severe irritation of mucous membranes		Organ damage	
TYPE OF VENTILATION (Explosion-proof motors)				
General (10 air changes per hour)				
General exhaust				
Local direct exhaust	x		x, preferred	
Fume hood	x, preferred			
BARRIERS				
Type of respirator Dust				
Organic vapor	x		x, preferred	
Air-supplied	x, preferred			
Goggles or other eye protection	x		x, if spraying	
Type of rubber glove Latex/neoprene Nitrile	x		x	
Solvent-proof cream	x		x	
OTHER COMMENTS	Safer than MBK but still hazardous; *do not use* if possible		Not useful as a solvent; more useful in the form known as a "ketone resin varnish"	

6 Varnishes, Balsams, Driers, Preservatives, and Retarders

Varnishes are solutions of natural or synthetic resins that dry, usually by evaporation, when spread thinly on a surface. The dried films are solid and relatively transparent. According to the composition of the solution, the films exhibit varying qualities of gloss, protective ability, flexibility, and durability.

Artists use two major categories of varnishes: solution varnishes and cooked-oil varnishes. Lacquers and enamels, varnishlike coatings that are often colored, are classified by some writers as a third category of varnish.

SOLUTION VARNISHES

The solution varnishes are made by dissolving the resin in its solvent. They are sometimes called "cold cut varnishes" because they are not heated to dissolve the resin. If alcohol ("spirits of wine") is the solvent, the varnish may sometimes be called a "spirit varnish."

Solution varnishes dry by simple evaporation. Theoretically, the dried films are reversible and can be reliquefied by using the original solvent; practically, this is not always the case.

These varnishes are easily homemade (examples are damar in gum turpentine and shellac in alcohol). The concentration of a natural resin varnish made by solution is called a "cut."

The cut is determined by the proportion of the weight of the resin to a gallon volume of the solvent. Therefore, the phrase "5-pound cut" means that 5 pounds (2.3 kg) of the resin

were dissolved in 1 gallon (3.8 L) of the solvent. A 5-pound cut is the usual concentration for solution varnishes.

COOKED-OIL VARNISHES

Cooked-oil varnishes are more complex solutions of resins melted in heated oils, with the addition of driers and thinners. The drying process is also more complex: The solvent evaporates and the oil polymerizes and oxidizes. The dried films are consequently much harder than the solution varnish films, and are not easily reliquefied with the original solvent because of the change in the nature of the oil content. An example of a cooked-oil varnish is linseed oil-copal.

Debate about the use of cooked-oil varnishes has centered on the fact that they contain those heated oils, which have a tendency to darken and grow brittle more rapidly than unheated oils. Furthermore, the hard resins used in making them are more variable in quality than the softer resins, and do not easily reliquefy. This would be significant if the cooked-oil varnish were to be used as a final coating on a finished work, where its removal would be desirable when the work needs to be cleaned. If the cooked-oil varnish is to be incorporated into a painting medium, its potential irreversibility is actually an advantage.

☞ *CAUTION: Cooked-oil varnishes should not be homemade, because the heating of solvents and oils also presents significant health and safety*

hazards. The production of cooked-oil varnishes is restricted to large-scale manufacturing processes, where the precise mixture of potentially harmful ingredients can be easily monitored.

LACQUERS AND ENAMELS

These varnishlike coatings are widely used in industry and have found sporadic application in artistic painting.

LACQUERS

Lacquers can be based on nitrocellulose or other cellulose derivatives dissolved in strong solvents such as acetone. They have more recently been based on the vinyl resins and their derivatives—the acrylics—again using strong, volatile solvents.

The rapid drying time of lacquers, particularly when they are sprayed in very thin coats on rigid substrates, makes them useful in high-speed production processes. But unless they are applied under carefully controlled conditions, their usefulness is relatively limited insofar as durable artistic painting is concerned. The older nitrocellulose lacquers showed a marked tendency to crack, darken, yellow, and lose adhesion. The newer lacquers must still be applied with a great deal of care, lest they too crack or lose adhesion.

ENAMELS

Enamels are industrially prepared combinations of varnish and oil that are usually colored with a pigment. When they are applied in thin, uniform layers on a rigid support, commercial enamels perform reasonably well. They are noted for their leveling properties, which produce smooth surfaces with good gloss. However, the requirement that enamels be applied in thin films does not necessarily lend itself to the free-flowing brushstrokes used in some painting styles, and violating this rule about their use can produce a paint that wrinkles, creeps, or cracks.

Commercial enamel manufacturers frequently change production formulas and pigments, and they sometimes use materials that are not durable.

USES OF VARNISHES

Varnishes are used for different purposes, in combination with other materials, and in different strengths. Below are some uses of a varnish.

FOR PICTURE PROTECTION

A varnish is used as a final coating on a finished painting to give the surface a consistent appearance and to protect the painting from dirt, dust, and other atmospheric impurities.

To function well in this capacity, a varnish chosen for use as picture protection should meet the requirements listed below, which are adapted from an article by Rutherford J. Gettens in the November 1934 issue of the *Journal of Chemical Education*, and quoted in Ralph Mayer's *The Artist's Handbook* (revised edition, 1981). Even after more than five decades, these requirements still stand as desirable.

- A varnish should provide protection from atmospheric impurities. Dust and chemical pollutants, even in air-conditioned environments, can wreak havoc on a painting by discoloring and disfiguring or pitting and physically deteriorating the picture's surface. A varnish should take the brunt of this damage. Its removal during cleaning saves the picture.
- A varnish should expand and contract in response to atmospheric changes. This is particularly important if the varnish is used on a picture painted on a flexible support. Brittle lacquers do not make good picture varnishes.
- A varnish should preserve the elasticity of the painting. A brittle varnish can easily transfer its mechanical action to inflexible areas of the painting.
- The varnish should be transparent and colorless. This almost goes without saying, except that many varnishes have a slight tinge of color. Damar is distinctly yellow—and gets yellower as it ages. Acrylic emulsions marketed as varnishes are translucent when wet, but dry to a state somewhere between transparent and translucent.

- The varnish film should be able to be applied in a thin layer. A thin coating of varnish will not disturb any textural effects on the surface of the painting. A thick coating is apt to change color more rapidly or present such a reflective surface that the work cannot easily be seen. A thin coating is less likely to crack as it expands and contracts. Too thin a coating, however, can be too easily removed or may deteriorate too rapidly.

- A varnish should be reversible. The conservation or restoration of a painting often includes the removal of embedded surface dirt by carefully removing the varnish coating. Many varnishes do not remain soluble in their original solvents, even though they were once thought to. The removal of irreversible varnishes requires stronger agents that may be dangerous for the paint underneath. Some varnishes grow less soluble by such slow degrees that the fact that they are not entirely reversible is unimportant: If the surface of the varnish is removable, then the purpose is served. Some conservators insist that a varnish be completely removable.

- The varnish should not cloud. This defect is also known as "bloom," and results from the penetration of water vapor into the film or condensation of water vapor within the film. The painting may look like it's covered with frosted glass—a whitish or bluish veil seems to grow over its surface. A varnish can bloom because it attracts water vapor: Mastic varnish's solvent is alcohol, which is hygroscopic. Bloom can also be the result of faulty application: A cloudy, humid day is not a good day to varnish a painting, because water vapor can be trapped beneath the drying film.

- A varnish should have the "proper" degree of gloss. Glossiness is an attractive quality, and a hard gloss gives a surface that dust and dirt will not stick to (soft, glossy varnishes are sticky enough to attract dirt). But glossy paintings are hard to see unless they are lighted carefully. Matte surfaces are easier to view, but they have a microscopic texture that allows the deposit of surface durt. Semigloss surfaces are a reasonable alternative.

No varnish is yet capable of meeting all of the above requirements. There is no "best" varnish for any purpose, since the use of a particular varnish will be dictated by environmental circumstances such as heat, humidity, exposure to light, and so on. Furthermore, all varnishes eventually deteriorate on the surface of a painting—yellowing, cracking, crazing, or blooming are the common signs of this—and must be replaced. Research into the problem of varnishes continues.

Some varieties of acrylic solution varnishes hold promise, although it has been shown that some of them also become insoluble on exposure to ultraviolet light by a process called cross-linking. Both Daniel Smith, Inc., and Golden Artist Colors, Inc., have begun selling acrylic solution varnishes that have ultraviolet light absorbers or inhibitors in them and will cross-link much more slowly.

The ketone resin varnishes, derived from cyclohexanone and sold by Winsor & Newton, are also a promising alternative. Though they eventually become insoluble, they do so more slowly than the acrylics. Winsor & Newton is also the American distributor of Charbonnel's Conserv-Art varnish for conservators, based on a methacrylate resin dissolved in toluene. This varnish is not recommended for use in the average artist's studio because of the hazards of toluene.

Damar resin dissolved in gum turpentine, while subject to yellowing and embrittlement with aging, is still recommended to the artist who wishes to manufacture and use varnish-containing painting mediums. However, it is not recommended as a final varnish coating.

The usual concentration for a heavy picture varnish is a 3-pound cut, which can be reduced to a 2-pound cut for a lighter varnish.

AS A RETOUCH VARNISH

A retouch varnish is a solution varnish greatly thinned with its solvent and applied in extremely thin films. Its purpose is to make that portion of a painting you're working on that looks dried out or sunken-in look wet again. Sinking-in is the result of a ground that's too absorbent or unevenly absorbent,

which starves the paint layer of its binder. Sinking-in occurs more often, and is a more serious problem, in oil painting than in any other technique.

The retouch varnish is applied only to those areas of the picture that require it—not as a continuous film over the entire surface of the painting. The retouch makes color-matching of fresh paint to dry paint much easier. You apply the varnish with a soft brush or by spraying. ☞ *CAUTION: Spraying is a health and fire hazard because of the solvent in the retouch. At least wear a vapor mask if you spray a retouch varnish.*

More than one coat of a retouch varnish may often be necessary to get the "wet look" but avoid the heavy buildup that could produce a glossy layer. The point is to change the refractive index of the dried paint, not interfere with the structure of the painting.

The usual concentration for a retouch varnish is a 1-pound cut.

AS AN INGREDIENT IN OTHER MIXTURES

Varnish can be used in painting or glazing mediums, emulsion binders, and in some wax vehicles to impart hardness and a degree of gloss to the painted films.

If solution varnishes are used in these mixtures, there is a chance of producing a paint film that is easily redissolved by overpainting, or a whole painting that is subject to embrittlement, or a picture that could be damaged during cleaning. Using a cooked-oil varnish as an ingredient in a medium may prevent the paint layer from being dissolved, but it could also lead to darkening and embrittlement if the hard varnish resin is unreliable. So use a solution varnish, but keep the varnish content of the medium as small as possible: In a 10-parts-by-volume medium, use no more than 1 part solution varnish, including the thinner (if the varnish contains a thinner). As parts of emulsion or wax vehicles, the varnish content can be slightly higher.

The usual concentration of the varnish used in a medium or binder is a 5-pound cut.

AS A SIZE

A greatly diluted varnish solution can be used to size an absorbent surface, as noted in Chapter 3. Some resins, such as the acrylics or shellac, can also be diluted and used as fixatives for chalk or pastel drawings. A pigmented size is called an imprimatura.

The usual concentration for a varnish used as a size is a 1-pound cut.

NATURAL RESINS

Natural varnish resins are hard or semihard tree saps, insect secretions, or fossil deposits formed by decaying vegetation. They are shipped as hard lumps that may vary in color, shape, toughness, solubility, and quality. Few of these resins are soluble in water—although gum arabic, a water-soluble gum, can be made into a kind of varnish. The names of the resins may be derived from their places of origin or the ports that ship them.

When you are buying natural resins, look for batches of large, clean pieces. Crushed or powdered resin may mean that the batch has been accidentally adulterated with dirt, twigs, or other debris. The small sacks of dry resin found in art supply stores are usually fairly clean.

DAMAR

Damar resin, also spelled dammar, is tapped from the damar fir tree (Dipterocarpaceae family) found chiefly in Indonesia and Malaya. It appears in stores as clear or slightly yellowish, dusty lumps about 2.5 to 5 cm (1 to 2 inches) in diameter. Gum turpentine is the solvent of choice for the artist; other solvents either dissolve the resin incompletely or are not safely kept in the average studio.

Making damar varnish is simple. (See Box 6.1.) The standard 5-pound cut can be made in gallon lots, but this is usually too large a volume for the small user. Instead, use an equivalent proportion of 280 gm (10 ounces) of damar resin to 480 ml (1 pint) of gum turpentine.

BOX 6.1. HOW TO MAKE DAMAR VARNISH

MATERIALS

- Large, wide-mouthed glass jar with a lid. The jar should be big enough that the resin will be completely submerged in the gum turpentine.
- Square of fine-mesh cheesecloth.
- String.
- 280 gm (10 ounces) damar resin (see List of Suppliers).
- 480 ml (1 pint) pure gum spirits of turpentine.
- Pencil or nail.

METHOD

1. Wrap the resin in the cheesecloth and tie it into a bag with the string. Leave a length of string to hang the bag.
2. Punch a hole in the center of the lid.
3. Pour the gum turpentine into the jar.
4. Put the bag of resin in the gum turpentine and thread the string through the hole in the lid.
5. Screw the lid on and pull the string to raise the bag. The bag should hang freely, not touching the sides or bottom of the jar. Tie the string to a pencil or nail to hold the bag in place.
6. Let the resin dissolve for a day or two. If the bag sticks to the sides of the jar, dislodge it by raising and lowering it a few times. Agitation will also speed up the solvent action of the gum turpentine.
7. When all the resin has dissolved, remove the bag and discard it. To tell whether the resin has dissolved, remove the cover and lift the bag slightly; it should drain completely. There may be a fair amount of debris no matter how clean the dry resin appeared. If debris has filtered out of the bag into the varnish, allow the solution to settle for a few days and then decant it through cheesecloth into another container. Store the varnish at room temperature in an airtight container.

In all phases of varnish-making, water must be kept from the varnish. Water in the gum turpentine, in the jar used for making the solution, or even water vapor in the atmosphere on very humid days can cause a dried varnish film to bloom.

A homemade damar varnish may not be as clear and pale as what you will find in stores (at 5 to 10 times the cost of the homemade kind). Natural waxes in the resin can cause the solution to appear cloudy, but when the film dries the wax will be transparent. Techniques for precipitating or dissolving the wax recommended by some writers usually say to add acetone. Since the undissolved wax is transparent when dried and has no structural effect on the dried film, there is little point in going to the effort.

Damar varnish yellows with age, and its films become brittle. This is caused by exposure to ultraviolet light, present in most lighting systems, and is nearly unavoidable unless you use special filters over the light source. Yellowing and embrittlement are also caused by oxidation, which in turn is encouraged by exposure to ultraviolet light. Damar is a reversible varnish, but its repeated removal and replacement to counteract yellowing are significant problems for conservators charged with the care of a work, since the process can be harmful to the painting.

Raymon H. LaFontaine, in *Studies in Conservation*, 24 (1979), suggests that the addition of an antioxidant will slow the yellowing rate of the resin. After experimentation, he concluded that Irganox 565, a product of Ciba-Geigy Canada, Ltd., dissolved into a solution of damar and toluene or xylene will slow the yellowing. These two solvents are better, in his opinion, than gum turpentine, which may also contribute to the yellowing of damar. Spraying is the recommended application procedure, since the volatile solvents have a high rate of evaporation. The prepared solution reportedly has a shelf life of only a few days.

The use of an antioxidant may be the answer for those who wish to continue to use damar varnish, but:

☞ *CAUTION: Using toluene or xylene in your home studio is not recommended because both are health and fire hazards; spraying solvent-containing solutions increases the risk.*

For now, we will be content with the ultraviolet light absorbers and inhibitors being used in acrylic varnishes by Daniel Smith and Golden Artist Colors. These varnishes use mineral spirits as the thinner, a slower-drying but safer solvent.

MASTIC

Mastic resin is collected from pistachio trees *(Pistachia lentitiscus),* which grow in the Mediterranean region of southern Europe. The resin comes in the form of small, roundish "tears," or drops, which are clear when fresh and yellowish if aged. (See List of Suppliers.)

Mastic can be dissolved in alcohol or gum turpentine, but not in mineral spirits. It forms an easily manipulated, glossy varnish. But it is also known for an inclination to bloom, darken, and yellow with age; it is therefore in less favor than damar. You can easily make it in your studio using the same procedures as for damar.

A painting medium popular in the nineteenth century was made by combining a thick solution of mastic varnish with linseed oil that had been cooked with lead white pigment. The mixture, called Meglip, gave a pleasing feel and look to oil paints that were mixed with it, although it eventually caused a great many film defects in the paintings on which it was used.

Mastic resin should be used only as a solution varnish, not as an addition to painting mediums.

SANDARAC

Sandarac is a hard resin collected from the alerce tree *(Calitris quadrivalis),* found in North Africa. It comes as yellowish "tears" that are dissolved in alcohol and stronger solvents to form a hard, brittle varnish. It was formerly used as a protective coating or ingredient in mediums. Because it is best replaced with the less brittle damar resin, it is little used today.

COPAL

Copal resins are fossilized resins that were exuded from living plants. Some are hard, some are soft, and the group as a whole is so large and ill-defined that the label "copal" can be used only in the most general way. The copals have varying degrees of cold solubility in solvents such as alcohol, but are most familiar to artists as manufactured cooked-oil varnishes, mixed with linseed oil and driers.

The varnish films produced by some of the cooked-oil mixtures made with the hard copals are glossy and somewhat brittle, with a tendency to darken and crack with age. Furthermore, they are made with a drying oil and are therefore not reversible in simple solvents. Other forms of copals may not suffer these deficiencies.

The arguments and discussions about copal, which went on for years, are now moot. Copal resins, mined mainly in Africa, are no longer being shipped with any regularity, and the varnishes and mediums made with them may no longer be produced. However, since it is still possible to find examples of "copal painting mediums" in art supply stores, you should consider how they can be used: in small proportions by volume in simple painting mediums. Do not use copals for final varnishes.

Incidentally, products called "Kopal" painting mediums (note the spelling) do not contain copal resins.

SHELLAC

Shellac is a secretion from the insect *Laccifer lacca,* scraped from twigs and branches of several species of trees found in India and Indochina. The resin may be reddish-orange in hue, although the color can range from a deeper brown to a milky white. The more refined it is, the lighter its color.

The solvent for shellac is denatured ethyl alcohol, which gives a cloudy solution. When the solution is allowed to settle and the clear upper portion is decanted, the result can be used in diluted form as a fixative for drawings and pastel paintings (see Box 6.2) or as a

size for absorbent surfaces. It should not be used as a final or retouch varnish coating, or as an ingredient in mediums, because it rapidly yellows and grows brittle.

Fixative can be made from shellac purchased in a hardware store, already in solution with alcohol. White shellac resin in powder form can also be used, although it is unlikely that you will easily find the material. (Try chemical supply houses and expect to pay a lot.)

SYNTHETIC RESINS

Some of the synthetic resins discussed in Chapter 4 hold the promise of becoming accepted as useful varnishes for paintings. The acrylic solutions, dissolved in such solvents as toluene, xylene, or mineral spirits, have been shown to be clear, durable, and tough. In fact, proprietary spray fixatives have used some of the acrylic resins in solution with toluene and other solvents for years (one well-known brand name is Krylon). There is wide market acceptance of these products, even though they have not been shown to be entirely acceptable to the community of conservators.

ACRYLIC RESINS

The solutions of acrylic resins sold by Rohm and Haas (see List of Suppliers) can be diluted and used as varnishes:

- Acryloid B-72 or B-67 are probably the versions used in proprietary spray varnishes because they are soluble in fast-drying toluene, but toluene is a health and fire hazard and normally should not be kept in the studio.
- Acryloid F-10 and Acryloid B-67MT are soluble in VM&P naphtha and mineral spirits, respectively, which could make them safer for home use. But it has been reported that they cross-link and become insoluble, thus violating the principle of reversibility—a requirement for a picture varnish.

BOX 6.2. HOW TO MAKE FIXATIVE FROM SHELLAC

MATERIALS

- Good grade of bleached white shellac. The usual concentration is a 4-pound cut.
- Denatured ethyl alcohol, anhydrous if possible.
- 2 glass jars with plastic-lined caps. Metal caps will react with the shellac, darkening it.

METHOD

1. Dissolve 1 part by volume of the shellac in 5 parts by volume of the alcohol. Put the shellac in the jar first, then add the alcohol.
2. Shake the mixture from time to time, and then let it settle overnight.
3. Decant the clear, very slightly yellow liquid from the settled precipitate. The clear liquid is the stock solution and must be stored in a glass container away from contact with metal. The stock solution will keep about 6 months before it begins to yellow; make a new stock and discard the yellowed solution.
4. Do not discard the settled, cloudy white precipitate, which merely contains a higher proportion of natural waxes. Store the precipitate in the second glass jar, and use it to shellac the insides of homemade frames.
5. To use the fixative, dilute 1 part of the stock solution with between 5 and 10 parts of denatured alcohol by volume. The concentration will vary with the material being fixed. Try 1 part solution to 5 parts alcohol for powdery charcoal and pastels, or 1 part solution to 10 parts alcohol for pencil or graphite.
6. Apply the fixative by spraying.
 ☞ *CAUTION: The solvent, alcohol, is a health and fire hazard. The same precautions hold true for commercial fixatives. For spraying techniques and equipment, see the section on varnishing in Chapter 16.*

- Acryloid B-67MT is soluble in mineral spirits and so far does not exhibit a tendency to cross-link quickly. Since it remains reversible, it is probably the best choice for use as a final varnish.

Acryloid B-67MT can be bought either as a dry resin, a white powdery material, or as a 45 to 50 percent solids solution in mineral spirits. The latter is probably the best form to have it in, since the price difference between the two forms is negligible and the solution is easier to obtain. B-67MT in solution is a viscous, syrupy solution that must be diluted for use. Try a proportion of about 10 parts by volume of mineral spirits to 1 part by volume of the resin solution, adding the mineral spirits to the solution in small amounts while stirring. Do not stir too vigorously, or bubbles will form, and the bubbles will take a long time to rise out of a thick solution. The solution can be brushed on paintings as a final coating, or sprayed on paintings or dusty drawings as a fixative.

☞ *CAUTION: Again, the health and fire hazard precautions apply when spraying this mixture. At least wear an organic vapor mask.*

Daniel Smith, Inc., sells an acrylic solution varnish that contains an ultraviolet light absorber, and Golden Artists Colors sells an acrylic solution varnish that contains an ultraviolet light inhibitor. (See List of Suppliers for their addresses.) Both of these added ingredients will extend the life of colorants that are considered fugitive, but will not prevent them from eventually fading. Both can be used over oil, alkyd, resin-oil, acrylic solution, or acrylic emulsion paints.

None of the acrylic resins should be presumed to be miscible with linseed or other natural oils and resins. Therefore, do not use them as ingredients in oil or other natural binder painting techniques; damar resin is still the best for that. The acrylic solution varnishes can be mixed with the acrylic solution paints and with alkyd paints.

Various acrylic emulsion varnishes are also on the market, and the Rhoplex variations may be available from Rohm and Haas. (See List of Suppliers. However, because of questions of liability or misuse, such products may be available only to industrial users, manufacturers, or other accredited users.) The proprietary versions come in gloss and matte finishes; they make excellent ingredients to mix with the acrylic polymer emulsion paints, to use as sizes when greatly thinned with water, and to use as collage adhesives. However, they should *not* be used as final varnishes on acrylic emulsion paintings, because they are porous and admit atmospheric moisture, dust, and smoke; they are not soluble in mild solvents; and they are translucent, not transparent. Instead, use an acrylic *solution* varnish for a protective coating on acrylic *emulsion* paintings.

VINYL RESINS

The vinyl resins are soluble only in solvents too hazardous to be used by the average artist. The polyvinyl acetate emulsions, dispersed in water, have the same drawbacks as the acrylic emulsions.

KETONE RESINS

Winsor & Newton sells a ketone resin varnish under the name Winton Picture Varnish. There is a gloss version, and a matte version that contains a wax additive to reduce gloss. The ketone resin varnishes are for use only as final protective coatings, not as painting mediums.

Winsor & Newton's other versions of the ketone resin varnishes are called Artists' Picture Varnish, Barbola Varnish, Griffin Picture Varnish, Winton Matt Varnish, and Winton Retouching Varnish. All contain the ketone resin, white spirit (mineral spirits), and in the matte version, wax or mica flakes.

ALKYD RESINS

The alkyd resins are used only in painting and glazing mediums, not in final varnish coatings. Prepared alkyd painting and glaze mediums are available from Winsor & Newton (see Appendix).

Table 6.1, on pages 107–109, provides a quick reference to varnishes.

BALSAMS

Balsams are the thick, viscous, saplike secretions from plants. The secretions are also known as oleoresins. They do not form hard lumps like the varnish resins, but have a soft, sometimes semiliquid consistency. Like the varnishes, they can be mixed with the oils and solvents used in oil painting. They do not mix with water.

When balsams dry, by evaporation, they remain relatively reversible. They are customarily used as additives to painting mediums in oil and encaustic techniques, and can be used as the oily ingredient in egg tempera emulsions. There are a few varieties to consider but only one, Venice turpentine, is widely used today.

GUM THUS

Gum thus is the oleoresin from one of the American longleaf yellow pines from which gum turpentine is distilled. It has been used as a plasticizer in commercial varnishes, but should not be used in artistic painting because the rosin content causes darkening.

VENICE TURPENTINE

Venice turpentine is tapped from the European larch tree *(Larix europea* or *Larix decidua)* and is sometimes called larch turpentine. Supplies of Venice turpentine are readily found in America. Venice turpentine is a good additive for oil painting mixtures because it contributes to the stability of the films. It is relatively nonyellowing and, because of its slight rosin content, more flexible than many resins. It is also an excellent addition to egg tempera emulsions and encaustic mediums in place of the usual varnish resins.

STRASBOURG TURPENTINE

Strasbourg turpentine is tapped from the silver fir tree *(Abies pectinata)* or white fir tree and is used in Europe as the equivalent of Venice turpentine.

BURGUNDY AND JURA TURPENTINES

Both varieties are European and are not usually found in this country. Their characteristics and uses are similar to those of Venice turpentine.

COPAIBA BALSAM

Copaiba balsam comes from several typesof South American trees of the genus *Copaifera.* It is a slow-drying oleoresin—a poor additive for oil painting mediums, which dry slowly enough.

Proprietary oil painting restorers often contain copaiba balsam. Application of these concoctions to old, dried-out-looking oil paint films increases their refractive index and so temporarily improves the appearance of the paint. Meanwhile, however, as the sticky balsam dries, it collects dust. Eventually the balsam dries out and the process must be repeated. This is bad news for the painting!

DRIERS

Driers—also called siccatives—are added to oil paints to make them dry faster. They are composed of metallic salts dissolved in a solvent, and they promote oxidation by forcing, accelerating, or starting the absorption of oxygen.

Most writers agree that driers are harmful to oil paint films (especially when used to excess by an individual artist), since they can darken or weaken the dried paint. But then they go on to recommend ways they can be used safely. The slow drying of oil paint is one of its natural attributes—one many artists find desirable. Since there are now other paints that can come close to the optical effects of oil paints but dry faster (the alkyds and the acrylic solution paints), it seems foolhardy to risk the early deterioration of an oil paint by using driers.

Of the driers available, manganese linoleate is the one characterized as least harmful. Driers are used in the commercial production of some oil paints, where they are necessary to produce a full line of colors that will dry at about the same rate, and where the careful addition of small amounts can be monitored accurately.

PRESERVATIVES

Materials that prevent or inhibit the growth of microorganisms in water-containing products are called preservatives. Preservatives are used in many packaged food products, and in some manufactured paints. They are also recommended additions to some homemade paints.

The preservatives used in manufactured paints are necessary in order to ensure a reasonable shelf life. (Once the paint has been applied and has dried, preventing mold growth is no longer an issue if the painting is cared for properly.) If you are making your own paints you do not necessarily need to add preservatives unless you are making a considerable volume of the paint; preservatives must be used in such small percentages that controlling their addition to half a liter (a pint) of binder requires precise measuring tools not often found in the studio.

Preservatives themselves no longer have a very good reputation. Some, like formaldehyde, mercury, and the phenols, are health hazards and must be avoided. A few have been approved for use in food products by the Food and Drug Administration of the U.S. Government; they can be used if absolutely necessary.

Small amounts of Cunilate 2174-NO, an FDA-approved preservative, can be bought from Conservation Materials, Ltd. (see List of Suppliers.) This preservative is used in a concentration of about 0.15 percent or less, based on the weight of the binder or adhesive.

Using preservatives is a questionable practice except on an industrial scale. It is better to avoid the problem by making small volumes of the mixtures that might require them, storing them properly, and using them without delay.

RETARDERS

Retarders are liquids that slow the drying of oil paint so that wet-into-wet painting effects can be accomplished over a longer period of time. Plant oils (sweet-smelling liquids that are actually like very slow-drying thinners) have been used as retarders. The most commonly mentioned is oil of cloves. If you want to retard the drying of your oil paints, it is probably better to add a slower-drying oil to the painting medium. Poppyseed oil can work. Keep the proportion of slow-drying oil to the rest of the painting medium low—around 10 percent by volume.

Retarding the drying of other paints is sometimes desirable. Both types of acrylics and the alkyds are occasionally found to dry too rapidly for certain techniques. In this case, use one of the proprietary additives made by the company that manufactures the paints. In the acrylic emulsion paints, most retarders contain proportions of jelled glycols; retarders for the acrylic solution and alkyd paints may also have beeswax added. In all cases, avoid the addition of too much of the retarder, because you could make the resulting paint films too soft.

Any discussion of balsams, driers, and retarders is academic. There are now a number of products made for the alkyd paints that can be mixed with oils to provide the same results as the natural additives. If not overused, these products may be superior—more durable and reliable.

Tables 6.1 and 6.2, which follow, provide quick reference to varnishes, and to balsams, driers, retarders, and preservatives, respectively.

TABLE 6.1. VARNISHES

Key: NR = not recommended; NT = not tested. Remember, the *higher* a material's flash point, the *less* flammable it is.

COMMON NAME	Damar (dammar, damer)	Mastic	Sandarac
SYNONYM OR OTHER NAME	Gum damar	Gum mastic	
TYPE	Natural solution	Natural solution	Natural solution
SOURCE	*Dipterocarpaceae,* damar fir tree	*Pistachia lentitiscus,* pistachio tree	*Calitris quadrivalis,* alerce tree
COLOR/APPEARANCE	Yellowish lumps; Y solution	Small W tears; pale Y solution	Y tears; pale Y solution
REFRACTIVE INDEX	Low to medium	Low to medium	Low to medium
USES			
Ingredient	x	x, but NR	x, but NR
Picture	x, but NR	x	
Retouch	x		x, but NR
Size	x		
REVERSIBILITY	Fair to good	Fair to good	Fair to good
SOLVENT	Gum turps and aromatic hydrocarbons	Alcohol and aromatic hydrocarbons	Alcohol and aromatic hydrocarbons
DURABILITY			
Interior	Good	Fair to good	Fair to good
Exterior	Poor	Poor	Poor
Rigid support	Good	Good	Good
Flexible support	Fair	Fair to good	Fair to good
RESISTANCE TO:			
Water	Fair to good	Poor to fair	Poor to good
Acid	Poor	Poor	Poor
Alkali	Poor	Poor	Poor
Pollutants	Good	Fair	Fair
Ultraviolet light	Fair	Poor to fair	Poor to fair
Decay	Good	Good	Good
HAZARDS			
Fire (flash point)	Resin not flammable	Resin not flammable	Resin not flammable
Health	Harmful when sprayed	Harmful when sprayed	Harmful when sprayed
OTHER COMMENTS	Good as ingredient; no longer thought to be a very good final varnish	Should not be used—blooms; newer synthetics far better	Not recommended as an art material; newer synthetics far better

TABLE 6.1. VARNISHES, CONT'D.

Key: NR = not recommended; NT = not tested. Remember, the *higher* a material's flash point, the *less* flammable it is.

COMMON NAME	Copal	Shellac	Acrylic solution
SYNONYM OR OTHER NAME			Synvar (Weber); Soluvar (Liquitex); Acryloid B-67MT, etc.
TYPE	Natural cooked oil, with solvents and driers	Natural solution	Synthetic acrylic
SOURCE	Fossil resin; various	*Laccifer lacca,* insect secretion	Esters of acrylic acid, methacrylic acid, or acrylonitrile
COLOR/APPEARANCE	Pale Y to dark RY; clear lumps	Dark R flakes or powder; bleached: Y or W solution	W powder; clear syrupy solution
REFRACTIVE INDEX	Low to medium	Low to medium	Low
USES Ingredient Picture Retouch Size	 x, but NR x, but NR x, but NR 	 x, or fixative	 x x x x
REVERSIBILITY	Fair	Fair to good	Good to excellent
SOLVENT	Alcohol and aromatic hydrocarbons	Alcohol	Mineral spirits; alcohol; aromatic hydrocarbons
DURABILITY Interior Exterior Rigid support Flexible support	 Good to excellent Poor Good Fair to good	 Fair Poor Good Poor	 Excellent Good Excellent Excellent
RESISTANCE TO: Water Acid Alkali Pollutants Ultraviolet light Decay	 Good Poor Poor Fair Poor to fair Good	 Fair Poor Poor Poor to fair Poor Fair	 Good Good Good Very good Very good Excellent
HAZARDS Fire (flash point) Health	 Resin not flammable Harmful when sprayed	 Resin not flammable Harmful when sprayed	 Very high Free monomers may be released from drying films
OTHER COMMENTS	Original not likely to be available; beware of alternate spellings: "Kopal" is not copal; replaced by new synthetics	Cheap alternative to commercial fixatives, but yellows with age; as a varnish, not recommended	Usual commercial product is a complex combination of several acrylic resins, plus other ingredients, in various concentrations by weight of the solids; many varieties; *do not confuse with acrylic emulsions*

TABLE 6.1. VARNISHES, CONT'D.

Key: NR = not recommended; NT = not tested. Remember, the *higher* a material's flash point, the *less* flammable it is.

COMMON NAME	Vinyl solution	Ketone resin
SYNONYM OR OTHER NAME	Many proprietary names	Winsor & Newton trade names: Winton, etc.
TYPE	Vinyl resin	Ketone resin
SOURCE		Cyclohexanone derivative
COLOR/APPEARANCE	Clear W or Y lumps; W powder; clear solution	Pale W or milky solution
REFRACTIVE INDEX	Low	Low to medium
USES		
Ingredient		x, perhaps
Picture		x
Retouch	x	x
Size	x	
REVERSIBILITY	Good	Good
SOLVENT	Aromatic hydrocarbons	Mineral spirits and aromatic hydrocarbons
DURABILITY		
Interior	Good	Excellent
Exterior	Fair	NT
Rigid support	Excellent	Excellent
Flexible support	Fair	Good to Excellent
RESISTANCE TO:		
Water	Good	Good
Acid	Fair	Good
Alkali	Fair	Good
Pollutants	Good	Good
Ultraviolet light	Fair	Good
Decay	Excellent	Good
HAZARDS		
Fire (flash point)	Solvent highly flammable	Solvent highly flammable
Health	Major health hazards with solvents	Spray mist may be toxic; skin irritant
OTHER COMMENTS	Not recommended because of solvent hazard; *do not confuse with less hazardous vinyl emulsions*	Relatively new and promising material; manufacturer-tested only

TABLE 6.2. BALSAMS, DRIERS, RETARDERS, PRESERVATIVES*

*Preservatives are generally not necessary in small-scale studio operations. It is far better to make and use fresh materials. Key: NR = not recommended; NT = not tested; n/a = not applicable. Remember, the *higher* a material's flash point, the *less* flammable it is.

COMMON NAME	Gum thus	Strasbourg turpentine	Venice turpentine	Copaiba balsam
SYNONYM OR OTHER NAME				
TYPE	Balsam	Balsam	Balsam	Balsam
SOURCE	Sap of American longleaf yellow pine	*Abies pectinata,* white fir tree	*Larix europa,* or *Larix decidua,* the European larch	*Copaifera*
USE	Commercial varnish plasticizer	Plasticizer for oils, egg temperas, encaustics	Plasticizer for oils, egg temperas, encaustics	Oil paint film "rejuvenator"
COLOR/APPEARANCE	Y syrup	Pale to deep Y syrup	Pale to deep Y syrup	Dark Y
REFRACTIVE INDEX	Low to medium	Low to medium	Low to medium	Low to medium
EFFECTS	Darkens paint	Increases resolubility of paint films; can cause yellowing	Increases resolubility of paint films; can cause yellowing	Very slow drier; increases refractive index of oil
DURABILITY				NR
Interior	Good	Good	Good	
Exterior	Fair	Poor	Poor	
Rigid support	Excellent	Excellent	Excellent	
Flexible support	Fair	Fair to good	Fair to good	
RESISTANCE TO:				NR
Water	Good	Good	Good	
Acid	Fair	Fair	Fair	
Alkali	Fair	Fair	Fair	
Pollutants	Fair	Fair	Good	
Ultraviolet light	Poor	Fair to good	Fair to good	
Decay	Good	Good	Good	
HAZARDS				
Fire (flash point)	Very high	Very high	Very high	Very high
Health	Varieties from certain pines can be allergenic	Varieties from certain pines can be allergenic	Varieties from certain pines can be allergenic	Varieties from certain pines can be allergenic
OTHER COMMENTS	Not an art material; raw gum source of gum turpentine; rosin content causes darkening	Use with caution; overuse can contribute to later technical problems	Use with caution; overuse can contribute to later technical problems	Not recommended as an art material

TABLE 6.2. BALSAMS, DRIERS, RETARDERS, PRESERVATIVES*, CONT'D.

*Preservatives are generally not necessary in small-scale studio operations. It is far better to make and use fresh materials.
Key: NR = not recommended; NT = not tested; n/a = not applicable. Remember, the *higher* a material's flash point,
the *less* flammable it is.

COMMON NAME	Manganese linoleate	Essential plant oils: oil of cloves, oil of lavender, etc.	Various proprietary names
SYNONYM OR OTHER NAME			
TYPE	Drier	Retarders	Retarders
SOURCE	Metallic salt of manganese in solution with solvents	Oils pressed from plants	Mixtures of gelled propylene or ethylene glycol; beeswax may be added
USE	Drier for oil paints and linseed oil mediums	Retards drying of oil paints	Retards drying of alkyd or acrylic emulsion paints
COLOR/APPEARANCE	Thin dark V or P liquid	Varies from pale Y to RY	Pale W, translucent gel or liquid
REFRACTIVE INDEX	Low in thin films or weak concentrations	Low	Low to medium, depending on concentration
EFFECTS	Darkens, embrittles, or weakens oil films if used in excess	Softens oil films if used in excess	Softens paint films if used in excess; paints never dry
DURABILITY Interior Exterior Rigid support Flexible support	NT	NR	Inert
RESISTANCE TO: Water Acid Alkali Pollutants Ultraviolet light Decay	NT	NR	Inert
HAZARDS Fire (flash point)	Solvents flammable	n/a unless in solvent	n/a
Health	Metallic salts can be allergenic; nausea from ingestion; possible chronic health hazard	n/a unless in solvent	Do not ingest; protection needed if paint is to be sprayed
OTHER COMMENTS	Not recommended for use with oil paints; use a faster-drying paint, or drier-type pigments with oil (see Table 7.1)	Not recommended because of unreliable properties; use a slower-drying oil instead	Use with caution; only occasionally necessary

TABLE 6.2. BALSAMS, DRIERS, RETARDERS, PRESERVATIVES*, CONT'D.

*Preservatives are generally not necessary in small-scale studio operations. It is far better to make and use fresh materials.
Key: NR = not recommended; NT = not tested; n/a = not applicable. Remember, the *higher* a material's flash point,
the *less* flammable it is.

COMMON NAME	Vinegar	Formaldehyde	Mercuric chloride
SYNONYM OR OTHER NAME			
TYPE	Preservative	Preservative	Preservative
SOURCE	Impure, dilute acetic acid (5%)	Formalin: 40% formaldehyde, 55% water, 5% methanol	Mercuric chloride
USE	Preservative for homemade vehicles	Preservative	Preservative
COLOR/APPEARANCE	Clear liquid	Clear liquid with strong odor	n/a
REFRACTIVE INDEX	Low	Low	n/a
EFFECTS	Soft films if used in excess	Weak films if used in excess	n/a
DURABILITY Interior Exterior Rigid support Flexible support	NR	NR	NR
RESISTANCE TO: Water Acid Alkali Pollutants Ultraviolet light Decay	NR	NR	NR
HAZARDS Fire (flash point)	n/a	n/a	n/a
Health	n/a at 5%	*May be carcinogenic: Do not use*	*Highly toxic: Do not use*
OTHER COMMENTS	Not an art material; make fresh materials and do not use preservatives	*Do not use this material*	*Do not use this material*

TABLE 6.2. BALSAMS, DRIERS, RETARDERS, PRESERVATIVES*, CONT'D.

*Preservatives are generally not necessary in small-scale studio operations. It is far better to make and use fresh materials. Key: NR = not recommended; NT = not tested; n/a = not applicable. Remember, the *higher* a material's flash point, the *less* flammable it is.

COMMON NAME	2,2' methylene bis (4-chlorophenol)	Copper 8-quinolin-oleate	Sodium benzoate
SYNONYM OR OTHER NAME	Cuniphen 2778-I (trade name)	Cunilate 2174-NO (trade name)	
TYPE	Preservative	Preservative	Preservative
SOURCE	Same as common name	Same as common name	Same as common name
USE	Preservative	Preservative	Preservative
COLOR/APPEARANCE	Dark YR liquid	Pale G	W powder
REFRACTIVE INDEX	Low	Low	n/a
EFFECTS	n/a	n/a	n/a
DURABILITY Interior Exterior Rigid support Flexible support	n/a	n/a	n/a
RESISTANCE TO: Water Acid Alkali Pollutants Ultraviolet light Decay	n/a	n/a	n/a
HAZARDS Fire (flash point)	n/a	n/a	n/a
Health	Low degree of human toxicity; FDA-approved	FDA-accepted for food use	FDA-approved for food use; overdose may cause nausea
OTHER COMMENTS	Use at less than 0.50% concentration by weight of the solution; better to make fresh materials	Use at less than 0.15% concentration by weight of the solution; better to make fresh materials	Use at less than 5% concentration by weight of the solution; better to make fresh materials

7 Pigments

Pigments are small particles of colored material that are insoluble in water, oils, and resins. When suspended in liquid binders or vehicles, these colorants form paint. With a few exceptions, the same pigments are used in all paints. The binder or total vehicle accounts for the differing kinds of paint.

"Colorants" is the term that color scientists use for the entire range of coloring materials, including pigments and dyes.

HISTORY

In prehistoric times, early humans found many colorants in the minerals occurring in soils and clays. Cave paintings using red and yellow colored clays, black from charred wood or bones, and white from chalk deposits date from at least 15,000 B.C. As long ago as 8000 B.C., artists in Egypt had discovered how to process natural minerals, animal products, and vegetable matter into useful and fairly stable colorants.

Examples of the early Egyptian color range include reds from iron and cinnabar (a mercury ore), yellows from iron and arsenic ores, greens and blues from copper ores, purples and red-purples from *Rubia tinctorum* (the madder plant), black from charcoal and burned animal fats, and white from chalk.

The 1,500 years after the birth of Christ saw the development of more sophisticated means for processing raw materials into pigments or pigmentlike colorants. White lead, a precipitated lead carbonate, is probably the best-known early artificial pigment that is still

in demand and in wide use today. Iron oxides were mined extensively in Italy and processed by heating, levigating (water washing), and other mechanical means into a range of red, yellow, green, and red-purple hues that are still some of the most useful colorants artists have. A green copper carbonate produced verdigris. Resinous materials made reddish dyes (Dragon's blood). Vegetable and animal materials made ever more interesting reds (sepia, bistre, cochineal), yellows (turmeric, saffron, Indian yellow, quercitron), blues (indigo), and greens (sap green). More involved mineral processing produced smalt: (potassium glass and cobalt oxide), King's yellow (arsenic sulfide), and the well-known ultramarine blue (lapis lazuli).

In 1704 the first man-made pigment, Prussian blue, was discovered. In rapid succession over the next 150 years, there appeared dozens of colors that replaced the less stable, more costly or rare, and more dangerous of the earlier pigments. These newer pigments are now almost indispensable to the modern artist. They include cobalt blue (1802), synthetic ultramarine blue (accidentally discovered in 1828), viridian green (1838), cadmium yellow (1846), and zinc white (first produced in 1751 but not commercially available until about 1850).

The modern era started with the development of the synthetic organic "coal-tar" dyes by William Perkins in 1856, although these colors, because of their fugitive nature, quickly got a bad reputation. In 1868 the first synthetic duplication of a natural organic colorant, alizarin crimson, was marketed and

accepted by artists. It replaced the reputedly less stable rose madder (also called madder lake) and greatly improved the violet side of our palette.

The last quarter of the nineteenth century, and the first quarter of this century, saw tremendous improvement in the color range and durability of processed mineral and synthetic organic pigments—synthesized copies of the hues found in animal- and vegetable-derived organic colorants, made in laboratories under controlled conditions. The production of the phthalocyanine colors (blue and green, in 1928 and 1935, respectively), very stable and powerful colorants, led to a renewed interest in synthetic organic pigments. Today, the synthetic organics make up the largest share of colorants used in industry and are extensively tested for use in artists' paint lines. Some of the new organics are excellent and valuable additions to our list of choices.

STANDARDS FOR PIGMENTS

The pigments and dyes used by industry are not expected to last forever—or even as long as ten years in some applications. These colorants need not be durable in light to any great extent, and they may not be required to stand up to other kinds of exposure.

The pigments used in artists' paints, however, must have special qualities that guarantee their durability over long periods of time. The word "permanent" is often used to describe one of the requirements of an artists' paint. "Permanent" means "continuing or enduring without fundamental or marked change"—an apt description of what we usually expect of a painting. But unless the conditions of exposure and use of the paint, or painting, are given and understood, "permanent" has little meaning.

For it to be suitable for use in an artists' paint, a pigment must meet these qualifications:

- A pigment must be a fine, smooth powder. Many older pigments, such as smalt, were rather rough, granulated materials. Smalt too finely ground is colorless; in order to retain its hue and other color characteristics,

it had to be kept in a relatively crude state. Modern dry pigments often resemble a pile of colored dust.

- A pigment should not alter in hue (color), chroma (the relative intensity of the color), or value (the relative lightness or darkness of the color) when exposed to normal conditions of light over a long period of time. "Normal" conditions are not easy to define; we think of museum conditions as being the standard—dim natural north daylight or low-power incandescent light.

 Artists' pigments should be able to withstand continuous exposure to controlled low-level light for at least a century without showing a visually detectable change. If a pigment does not alter after test exposures equivalent to the 100-year real-time exposure, it can be considered lightfast. Some of the changes in a pigment are not detectable unless the colorant is measured by an instrument.

- A pigment should not react chemically or physically with the other paints or supplementary materials to which it is exposed. These materials include the binder, varnishes, thinners or solvents, glaze or painting mediums, grounds, and other pigments. When viridian green is used in acrylic emulsion vehicles, for example, it can "break" the emulsion— cause it to separate. Lead white is unstable in the acrylic emulsion vehicles; only titanium white or zinc white is used. However, viridian green and lead white are still perfectly viable pigments; it is the *combination* of vehicle and pigment that's important, and the artist must know what works well with what else.

- A pigment should not react to the changes in normal atmospheric conditions. Lead white has a tendency to turn brown or darken to a gray when exposed to hydrogen sulfide (a component of polluted air found in our modern cities) and moisture. For this reason, it is only used in oily or resinous binders that encase it thoroughly in a waterproof vehicle to prevent its exposure to moisture and pollutants.

- A pigment should form a good film with the binder, one that is durable and appropriately strong for the type of paint. No pigment is perfect in all binders. Pigments that do not meet this requirement in one binder sometimes meet it in another; pigments that cannot meet this requirement at all usually reveal their defects shortly after the paint is manufactured. For example, some pigments flocculate: They rise to and project above the surface of a dried paint film, and powder off. Others agglomerate: They coagulate into lumps and resist dispersion in the binder. Both of these defects can be the result of faulty manufacturing processes, occurring most often with the complex acrylic emulsion binders, but they can also be controlled through careful monitoring.

- A pigment should not migrate or bleed through dried paint layers. Migration is the action of a pigment or dye moving through a dried paint film and thereby discoloring it. Bleeding is the result of the action of the binder, vehicle, or solvent used in the vehicle leading to the diffusion of a colorant. Neither of these traits is desirable. Some dye-based organic colorants easily bleed or migrate—those used in artists' paints should not.

- A pigment should not have added to it ingredients that adversely affect its color or handling. Many pigments, especially the synthetic organics, must be reduced with inert additives because they are such powerful colorants that they can easily overwhelm the other hues in the palette. The phthalocyanines, for example, are such strong tinters that they can be reduced by 60 to 75 percent without harming their color properties, and this kind of extension is not considered an adulteration of the colorant. However, some pigments (particularly in the student grades of paints) have been reduced with inert additives to reduce the cost of the paint. This type of extension results in a paint that can have a lower tinting strength than the professional grade of the color, and is rightly thought of as adulteration.

- A pigment should be nontoxic when properly handled. Pigments are dusty powders that can hang in the air and be inhaled if mishandled.

 ☞ *CAUTION: **Always avoid inhaling the pigment dust, even if the pigment itself is not harmful. Wear a dust mask.***

 Check Table 7.2 for the potential hazards of particular pigments, and note that for every pigment there is the instruction to avoid dust.

- A pigment should be supplied by a manufacturer or repackager that is willing to provide information about the colorant's origins, quality, test results, and other characteristics. The manufacturer of the raw pigment is usually willing to supply this information (see List of Suppliers). Retailers or repackagers are less often capable of providing the information, merely because they know only what they are told by their suppliers. The artists' paint manufacturers are in a similar situation, although they make a genuine effort to provide as much information as possible.

A nonpartisan reference to pigments such as *The Pigment Handbook* or the *The Colour Index* can provide a great deal of useful information about colorants. (See Bibliography.) But no reference source is complete, especially regarding the newer pigments, because the field is subject to continuous research and rapid development.

POTENTIAL HAZARDS

Exercise good hygiene in handling dry pigments by storing them in covered containers that are clearly labeled and promptly replacing the covers after use. Do not splash dry pigments around so that the dust hangs in the air, and avoid overexposure to the dust. Once the pigments are dispersed in the medium, either a thinner or a binder, their hazards are considerably reduced.

The specific hazards of each pigment are generally more related to use and type of exposure than to content. There are,

naturally, some exceptions. The lead-containing pigments should be handled with caution, even in paste form. Recently published accounts of the hazards of pigments have overstated the dangers associated with using some pigments, the cadmiums in particular, by not distinguishing various uses of the dry or paste materials. Be aware of how the pigment, or paint made with the pigment, is going to be used. Use, or abuse, of the pigment will be a factor in determining hazard if it contains a potentially toxic—acute or chronic—ingredient.

Finally, remember that there has never been a scientifically conducted study of how artists use their materials, and under what circumstances specific uses present hazards. Use Table 7.2 as a guide, but do not rely on it for medical advice. If in doubt, use caution and common sense. Ask your physician if you have questions, but be sure he or she is well-versed in toxicological issues.

COLOR AND COLOR THEORY

The most obvious attribute of a pigment is its color. While its physical attributes determine its suitability for a particular kind of painting, a pigment's color will determine its use in a particular painting.

Color theory is not a simple subject, despite myriad attempts on the part of artists and writers to make it so; a complete discussion of it would require another book. There are some good elementary texts on the subject of color theory, and several are listed in the Bibliography. But it is necessary to delve into color theory a little here to understand the importance of pigment choice.

Color is technically divisible into three parts: hue, value, and chroma. *Hue* is the name by which we distinguish one color from another: red, orange, yellow, green, blue, purple, black, white, and the intermediate mixtures of those hues. *Value,* also called lightness, refers to the apparent lightness or darkness of one color in relation to another. That is, black is darker than white and so is regarded as having a lower value.

Chroma is the apparent intensity (saturation) of a color in relation to another color of the same value. A red of the same lightness as a yellow may be less intense (lower in chroma, or grayer) than the yellow, since it must have more white added to it to make it the same value as the yellow. Adding white does not always lower chroma, however; adding a little white to a full-strength dioxazine purple will raise its chroma. Chroma is often the most difficult attribute of color to understand—but practice applying the theory, using actual visual examples, can easily clear up misunderstandings.

The existence of light makes it possible to perceive color. Light is a form of electromagnetic energy, energy in wave form, and is the only part of the electromagnetic spectrum visible to the naked eye. Visible light falls between ultraviolet light and infrared light on the electro-magnetic spectrum. Other types of electromagnetic energy include radio waves and microwaves.

Visible light is a tiny part of the spectrum, about 300 nanometers in length. A nanometer is a unit of length equivalent to 10^{-9} meters, used to measure a wavelength of light. (A radio wave is measured in meters, a substantially larger unit.) Each pure hue has a separate narrow band of wavelengths within the spectrum. A modern measuring device such as a spectrophotometer, which can separate the wavelengths in the visible spectrum, can be used to measure the light precisely and determine a hue with accuracy.

Edwin Land, inventor of the Polaroid camera, has theorized that all color perception is generated within our brains. Another theory—more popular, and supported with much scientific evidence (but not necessarily more correct since it too is a just a theory)—holds that light and the hues within it are not visible until the light strikes a surface:

- If all the light is absorbed into the surface, as it might be if it struck a piece of black velvet, your perception is of black. But practically speaking, there is always some reflectance, however little. It is only theoretically possible to have a "pure"

black, the black holes in outer space, which have such strong gravitational pull that not even light can escape.

- If all the light is reflected from the surface, say from a pressed cake of dry magnesium oxide pigment, the perception is of white. Again, in fact, there is always some absorption, so that it is hard to get a 100 percent pure white. Under certain specified light conditions, smoked magnesium oxide (sometimes pressed dry barium sulfate) is the closest practical thing to "pure" white.

- If equal parts of every wavelength are absorbed by the object, your perception is of a neutral, hueless gray.

- If most of the light rays pass through the object, your perception is that the object is transparent or translucent (partly transparent). This particular attribute is related to the refractive index of a material and is quite variable from one material to another, and within same material under different conditions. If there were really total transparency, you would not perceive the object at all.

- Finally, if only some of the wavelengths are reflected and most are absorbed, you perceive a particular hue. The blue wall absorbs all the other wavelengths and reflects only blue (Figure 7.1).

According to this theory, therefore, reflected light is how we can see. When we consider a painting, we realize how very complex reflection can become. There is not only reflectance but also refraction (in which rays of light are bent), *diffraction* or *scattering* (two very similar light actions in which light rays are diffused or scattered), *transmittance* (in which light reflects off lower layers of the painting through glazed layers), and *specular reflection* (mirrorlike reflections that can interfere with perception of a hue). Whitish reflections from the surface of a curved glass bottle are specular reflections. A slide of a painting will always look somehow "purer"

FIGURE 7.1. Different actions of light. Theory: *top left,* "pure" black and complete absorption; *top right,* "pure" white and complete reflection; *bottom left,* "pure" transparency and light passing completely through the object. Reality: *bottom right,* light being absorbed, diffracted and scattered, and reflected all at once.

than the actual work—assuming it's a good slide—because it is missing the interference that specular reflection can cause.

ADDITIVE COLOR

Color mixture systems differ according to their application. In lighting for the theater, we deal with transmitted colored lights reflecting from colored surfaces (the costumes, the scenery). Different colored lights in a theater seem to project a single colored light onto the stage. This system whereby, say, two colored lights mix to produce a third color is called *additive color*. Additive color happens in nature as well. Up close, the leaves on a tree will be seen to have a rather large variation in hues, but from a distance the hues blend into one generalized green.

In color television projection systems, tiny dots of colored light blend into various hues. And in Seurat's painting, tiny dots of pure colorants seem to mix and blend into different hues when seen from the proper distance. Actually, though, this is not purely additive color, since light energy has not been added, as in color television. Seurat's paintings used what is now recognized as a *partitive* color system; a yellow dot next to a blue dot in this system will yield a gray with a greenish cast when viewed from a distance, not as pure a green as you might expect.

Additive mixtures, when they are from transmitted light, are always brighter than the separate hues used to make the mixtures. In Seurat's work, where the mixtures are partly additive and partly from reflected instead of transmitted light, the mixtures appear duller.

Primary colors are those that cannot be mixed from any other colors. The *additive primary colors,* taken from the spectrum of visible light, are *red, green,* and *blue*. Magenta is red light plus blue light, cyan is blue light plus green light, and yellow is red light plus green light.

This last mixture is difficult to comprehend unless you see it. Set up three slide projectors side by side and use colored theatrical gels as color filters over the projector lenses. If the colored gels are of the correct spectral wavelengths,

you can easily demonstrate that this mixture works. (Gels of nearly the correct wavelengths are available from Edmund Scientific. See List of Suppliers.)

It is essential to understand additive color if you wish to understand fully how painters can use color.

SUBTRACTIVE COLOR

Subtractive color is the kind of color most people are familiar with: We know that red paint plus blue paint gives purple paint, blue paint plus yellow paint gives green paint, yellow paint plus red paint gives orange paint, and so on. This is because the color of most things is determined by what light is absorbed into the object's surface and what is reflected. Since some of the light rays are absorbed, they can be considered to be *subtracted* from white light—hence the term subtractive color.

A mixture of artists' paints is a subtractive mixture. If the paints are mixed as thick, opaque films, the mixture is called *complex subtractive* color because of the complexity of light's actions on the paint. These mixtures will always be darker and duller (lower in value and chroma) than the pure hues used to make the mixture.

If the color mixtures are made with thin, transparent glazes, as in the works of Maxfield Parrish and many of the Pre-Raphaelite painters, the mixture is called *simple subtractive* color. Simple subtractive color mixtures are used in modern four-color printing processes (using cyan, magenta, yellow, and black inks of varying degrees of transparency, plus the white of the paper). Subtle, simple, and beautiful color harmonies are quite possible from this limited range of hues.

In fact, the *subtractive primary colors* are *magenta, cyan,* and *yellow*. Red is magenta plus yellow, green is yellow plus cyan, and blue is cyan plus magenta.

Using the three-projector demonstration in proving the issue of additive color will reveal that these mixtures work. However, beginners are less apt to use the simplest mixtures possible—and, of course, will not be familiar with which pigments are opaque or

transparent, nor with which pigments are appropriate for mixing which hues. The result is most often complex subtractive mixtures involving reflectance, refraction, and scattering. These complications, as described above, lead to the loss of chroma (duller mixtures) and the loss of value (darker mixtures). Overly complicated color mixtures, where many different colors are mushed together in a desperate attempt to match the hue of the thing observed, give rise to what painting teachers call muddy color.

The additive and subtractive primary colors explained above are quite interrelated; they are complementary. The complement of red is cyan, the complement of green is magenta, and the complement of blue is yellow. In the additive system, two complementary colors mixed together will yield white.

In the subtractive system, however, the complement of red is green, the complement of blue is orange, and the complement of yellow is purple. Mixtures of the complements give subtle grays that are sometimes neutral in hue and sometimes tinged with one or the other of the parent hues.

The foregoing can easily lead to an understanding of why artists have always used the simpler red, yellow, and blue color mixing system. Most artists don't know why they use the simpler system except that it can work. It can produce all the intermediate hues—orange, green, and purple—and the complementary and tertiary mixtures give the desirable and necessary neutral hues. These are good enough reasons to use the red-yellow-blue system.

The red-yellow-blue color mixture system will work, though, *only* if you know which pigments of the chosen hues to mix to get your desired color. You will not get as clear a purple by mixing a cadmium red medium with an ultramarine blue as you will by mixing an alizarin crimson and the ultramarine. For a further discussion of the myriad of color-mixing possibilities, see Michael Wilcox's excellent little book, *Blue and Yellow Don't Make Green, or How to Mix the Colour You Really Want—Every Time* (Perth, Western Australia: Artways, 1987; distributed in the United States by North Light, Cincinnati).

SELECTING A PALETTE FOR COLOR HARMONIES

The selection of pigments is important. There are vast lists of colors to choose from in every manufacturer's catalogue (and a quick glance at the pigment list in Table 7.1 should be enough to startle a beginner), so here is a limited list with which to start. A *limited palette* contains colors of relatively low chroma so that you can easily make color harmonies. Students will find it instructive to use the following colors for a beginning painting:

- ivory black: a cool black that when mixed with white yields a cool, bluish gray.
- flake (lead) white: a warm, quick-drying white.
- yellow ochre: a dull yellow earth that when mixed with ivory black and flake white gives an olive green.
- light red oxide: a dull red earth color that when mixed with ivory black and flake white gives a dull purple.

These four colors have been used to produce subtle and interesting works by students in a beginning class. They allow you some degree of freedom from the difficulties of mixing high-chroma hues, but force you to make deliberate mixtures lest the result be muddied.

A slightly more advanced palette contains, in addition to those pigments above, the following:

- cadmium red light: a bright, slightly yellow red, dense and opaque. Use the real cadmium pigment.
- alizarin crimson or natural madder lake: both alike in hue, a deep cool red. In acrylic emulsion paints, use the more permanent quinacridone crimson, whose hue and undertone are similar.
- ultramarine blue: a relatively strong, pure blue hue.
- cobalt blue: a cool blue indispensable for making clear purple mixtures with various reds. Do not use a substituted "cobalt blue hue."
- cerulean blue: a clear, slightly greenish blue.

- viridian: a weak, transparent, but useful green.
- chromium oxide opaque: the stronger, opaque version of viridian.
- cadmium yellow light (or lemon): a bright, strong, and opaque yellow. Use the real cadmium pigment.

These additions to the limited palette provide an extended range of chroma.

Before jumping to the next step, it is helpful to spend an afternoon mixing colors from the two palettes just given. Color charts reproduced in books are absolutely no substitute for finding out about color firsthand, and specific instructions about what to mix with what also do no good. Because one cadmium red may be quite different from another, to say "Mix cadmium red with cobalt blue to get a deep purple" without specifying exact brands can be misleading. The best thing to do is to spend a few hours making all the mixtures possible from a range of colors, along with at least ten value steps for each of the mixtures. Try to avoid using black to make the dark values. Use the complementary hue instead, and remember that darkness is a relative term—one color is dark next to another, not by itself.

To extend the range of chroma even further, add these pigments:
- A phthalocyanine blue. There are two: One is reddish, and the other is greenish.
- A phthalocyanine green. There are two: One is bluish, and the other is yellowish.
- An arylide (Hansa) yellow.

These very bright hues can disrupt the quiet, low-chroma palette first given. Use bright color judiciously, and do not confuse brightness with lightness.

Experiment with color mixtures, and keep records of the results. You might use a grid format to record what a color looks like:
- At full strength.
- Mixed with white in varying ratios.
- Mixed with its complement in varying ratios.
- Mixed with black in varying ratios.
- Mixed 1:1:1 with black and white.
- Mixed with other colors.

Note: Be sure to make clean and complete color mixtures. Do not allow streaks of one color to show in the other.

HOW BINDERS AFFECT PIGMENTS

When pigments are mixed into binders of various refractive indices, various color effects are seen. If the binder is yellowish, as linseed oil is, the result of adding a very light blue or white pigment is not necessarily desirable. That, of course, is why some manufacturers disperse their white and light colors in safflower or poppyseed oil, both of which are less yellow than linseed oil. And that is one of the reasons why the alkyd, acrylic solution, and acrylic emulsion paints were developed.

The differences between the same pigment in different binders is apparent when we compare a blue in oil paint with the same blue in pastel—the pastel, consisting of almost pure pigment with only a little binder, appears lighter and brighter.

A more subtle but still perceptible difference can be seen by comparing the same blue in oil with the same blue in an acrylic emulsion binder: The acrylic emulsion hue is slightly lighter (and less yellow), since the binder is less transparent than the oil binder. It is true, of course, that the acrylic emulsion binders are also "underloaded" with pigment because the emulsions are more sensitive than oil. An obvious lesson in this is to compare a dry blue pigment with the same blue dispersed in any transparent binder. The binder affects the hue, value, and chroma of the pigment.

QUALITY OF LIGHT AND PIGMENT

The color of the light striking the pigment also affects its hue, value, and chroma. All light is colored to some extent. Think of sunlight transmitted through a light cloud cover at noon as the purest white light there is, because the cloud cover scatters all wavelengths to mix white light. That is the specification of white

light used in most modern technical color measurement (specified by color temperature: 6500° Kelvin). Light coming through a north-facing window is 7500–12,000° K, slightly bluish, and is the light of choice in most artists' studios.

Consider this, however: You paint in this cool north light, which is bluish, and then exhibit the painting in a gallery where it is lit by bright yellow spotlights. No wonder so many artists get a shock when they put their pictures on a gallery wall!

By knowing the attributes of light, color, and pigments, you can make appropriate adjustments in your studio lighting. Interested painters are encouraged to consult the available texts for a further understanding of technical color.

COLOR SYSTEMS

Color systems, such as those proposed through the years by Chevreul, Ostwald, and Munsell, are of great but peripheral interest to the practicing artist. Students will have much to gain by studying them, however, since many of them have excellent reproductions of color relationships that lay out clearly how hue, value, and chroma relate to one another, and since the theories and examples they promulgate are relatively easy to deal with.

Other modern systems, such as those published by the Color Society of Japan, the Scandanavian Institute, and the Optical Society of America, are more complicated but also worth studying. Whereas the Munsell *Book of Color* presents color in three dimensions, the OSA's Uniform Color Scales, for instance, give us 12 directions to go in—as though color is a variably colored mist occupying a space of indeterminate boundaries, which it is!

Suffice it to say that while these systems are important, they are not immediately relevant to this book. I strongly recommend that you have a look at them, though.

CATEGORIES OF PIGMENTS

Pigments are traditionally named in a number of ways: for their inventors (Scheele's green), chemical derivation or composition (cadmium

red), place of origin (Turkey brown), port from which they have been shipped (Solferino), use (underpainting white), or resemblance to something else (cerulean blue—that is, sky blue). Many of these names survive today.

This is a confusing system, since the names of many colors refer only to the hue, not the pigment. In the case of sap green, for instance, the original colorant was a very fugitive dye made from buckthorn berries. Today's sap green resembles the hue of the original but is chemically and physically different and, perhaps, more permanent.

A more sensible way of naming pigments has been suggested by other writers, and that is to use the chemical names of the constituent materials. That suggestion is good, but has its drawbacks. Many pigments are composed of a number of different materials, and some of the names of the substances used to make pigments are cumbersome and relatively meaningless. Some of the organic pigments have a group name, with many variations under the same designation. Most compelling, several pigments have a traditional common name so familiar that to change it (even for the sake of accuracy) might be confusing to users. A good example of the latter case is the name Prussian blue. There are two forms of Prussian blue, one called Prussian and one called Milori; the Milori variety is the better pigment, but to change the name after nearly 300 years of continuous use would confuse the somewhat stodgy traditionalists among us.

A further alternative, now used by manufacturers subscribing to the new Paint Standard (see pages 132–135), is to use the common name of the pigment and the *Colour Index* name of the pigment. The *CI* name is a number code by which you can refer to a specific pigment and its composition, source, and manufacturer.

A way to begin recognizing the basic differences between types of pigments is to categorize them by origin. Here are the generally accepted categories of pigments, with subcategories, adapted from the *Colour Index* definitions. (This information is adapted from the *Colour Index,* published by The Society

of Dyers and Colourists, Bradford, England, and the American Association of Textile Chemists and Colorists, Research Triangle Park, NC 27709-2215.)

INORGANIC

These are "colored, insoluble compounds of mainly inorganic composition" and include the elements, oxides, salts, and complex salts. All are usually simply called minerals, although this is a less specific designation. As a group, the inorganic pigments are considered highly durable in most painting processes, though some of the processed natural mineral pigments and manufactured mineral pigments are not.

EARTH COLORS, OR NATURAL MINERAL COLORS

Earth colors are crude ores colored mainly by iron but also by other metals, which are mined, washed, pulverized, and sometimes heated to produce different hues. They are characterized by low chroma, low to moderate tinctorial (tinting) strength, varying value ranges, and hues ranging from yellow to red, with some very dull red purples and greens. Natural deposits of white chalk can also be called earths.

PROCESSED NATURAL MINERAL COLORS

These are metallic ores treated alone or in conjunction with other metals, with heat or by chemical reaction, to produce more sophisticated and purer hues. Their appearance runs the gamut of hues, values, and chromas from very bright, light hues to very dark, dull hues. This is a large category.

MANUFACTURED MINERAL COLORS

This group of pigments contains duplications of the natural mineral colors or the processed natural mineral colors, made by synthesizing the components in a laboratory. They are similar in appearance to the processed mineral colors.

ORGANIC

These are "concentrated organic colorings with no salt-forming groups" composed mainly of arrangements of carbon atoms and carbon-based molecules. As a group, these colorants are thought of as highly durable, although some of the subgroups are notably fugitive. The inorganic pigments we have just discussed can be transparent, translucent, or opaque, but are discrete, characteristically shaped particles with an inherent color. Most organic pigments, by contrast, are transparent soluble dyes. This is the significant difference between the two groups. For an organic colorant to function as a pigment, it must be a particle. Dyes can bleed and migrate unless they are fixed in a particle form.

ANIMAL-DERIVED ORGANICS

Some organic pigments are made by extracting from or processing animal remains. For example, bone black is made from charred bone; sepia is from the ink of a squid; cochineal (carmine) is extracted from the dried body of an insect; Indian yellow is from the urine of cows force-fed mango leaves. Such pigments are usually (but not always) bright, vivid hues of an unstable nature with poor durability.

VEGETABLE-DERIVED ORGANICS

Organic pigments can also be made from vegetable matter, produced by making processed extracts of the plants. They have the same general hue characteristics and the same shortcomings, with some exceptions.

SYNTHETIC ORGANICS

These pigments, as mentioned earlier, are synthesized copies of the hues found in animal- and vegetable-derived organic colorants, made in laboratories under controlled conditions. These pigments run the gamut of hues, values, and chromas—although they are usually thought of as bright, transparent colors—and they also run the gamut of durability from poor to excellent.

FORMS OF ORGANIC PIGMENTS

There are two physical forms of organic pigments: toners and lakes.

A toner is a concentrated organic colorant, usually a water-soluble dye, chemically or electrically "fixed" on a precipitate. A precipitate is an inert, colorless (or nearly colorless) particle. Aluminum stearate and aluminum hydrate are examples of precipitates. Since toners are water-soluble, and since they are very concentrated, they may bleed and migrate despite being attached to a precipitate. They are not ordinarily found in the better lines of artists' paints because of this defect, although there is evidence that they have been used by some manufacturers to brighten otherwise duller hues. The use of toners is considered adulteration of the paint: A manufacturer can use a cheaper colorant to get the effect of an expensive pigment, at the cost to you, the artist, of lightfastness and/or resistance to bleeding or migration. Beware of cheap paints!

Lakes are similar to toners, being precipitated on an inert carrier like aluminum stearate, except that there is no "extra" dye, and the precipitate is considered a necessary part of the pigment. Lakes are less likely to bleed or migrate. Laked colorants are rarely adulterated, but they can be.

EXTENSION OF PIGMENTS

Both organic and inorganic pigments may be "extended," which means that the colorant is diluted with more precipitate or inert carrier than is necessary, in order to increase the volume yield of the colorant. While increasing the volume, extending a pigment can also decrease its color strength. Sometimes, as with the phthalocyanines, extending the colorant is necessary because the colorant is strong enough to overwhelm the others on the palette. Sometimes it is not necessary, and in this case an extended pigment should be considered adulterated or cheapened. In the student grades of artists' paints, extended pigments are common, which is why the paints are cheap. In professional lines adulteration is rare—only those pigments that require it are extended.

LEVEL OF OPACITY

A batch of pigment by itself is looks like a pile of opaque colored powder. Microscopically, however, the individual pigment particles have a much different character. The synthetic organic lakes precipitated on an inert carrier are usually of regular and repetitious form and, if dry, opaque in reflected light and translucent in transmitted light. When they are put into a wet medium such as a paint binder, however, they are quite transparent and glow like colored glass if viewed as a thinly spread-out film on a white substrate.

The inorganic pigments, by contrast, exhibit all sorts of particle shapes, from crystalline forms to irregular rocklike chunks. They also have varying degrees of opacity, from fully opaque, to translucent, to completely transparent. The size of the particle is also important in some cases. When smalt is ground too finely it is a weaker hue, lighter in value, lower in chroma, and with little tinctorial strength—almost totally useless in a liquid vehicle.

Whether the pigment itself is transparent, translucent, or opaque can be important when an artist chooses a colorant for a particular use. In practice it is possible to make a normally opaque pigment look transparent by grinding it into a dust and very thoroughly dispersing it in its binder. That is the case with transparent watercolor, where many opaque pigments display marvelous transparency. An ordinarily transparent pigment can give opaque effects if the paint layer is built up to a thickness—a technique possible only in some painting processes.

When you are choosing a pigment for a glazing techniques, it is always preferable to select a transparent pigment, since it allows more light to pass through it and thus produces a richer, more "resonant" appearance.

MASSTONE AND UNDERTONE

The masstone and undertone of a pigment are related to its transparency, translucency, or opacity.

The hue of a pigment, as a pile of dry powder or dispersed in a vehicle and spread

out in a thick, opaque film, is called *masstone*. It is also sometimes called body color, although this term can refer to a painting technique (gouache) and therefore is confusing.

When the pigment is dispersed in a vehicle and spread out into a thin, translucent layer, you see the *undertone*. The undertone of the hue can also be seen when the pigment is mixed into a tint with white, and when the colorant is thinned with a medium and spread out into a transparent film, as is done with transparent watercolors.

The masstone and undertone of many pigments are the same, but there are sometimes differences between these attributes in particular single pigments. Rose madder, for instance, has a deep red hue in masstone but a rosy, slightly bluish hue in undertone, depending on the variety (there are about 12 varieties of rose madder).

When choosing a pigment for a glazing or other transparent painting techniques, you should therefore be familiar with any differences between the masstone and undertone of the pigment. Most painting processes make use of both color effects. Since there are often several different varieties of a particular pigment, it is helpful to make your own assessment of the material's undertone and masstone. Attempts to add these attributes to a list of pigments often leads to confusion when the variety within a particular pigment is great.

TESTS FOR PIGMENTS

If you wish to try new pigments, or are unfamiliar with the special characteristics of the colors you use, you can conduct some simple tests. These tests are by no means quantitative, but they can be a relative measure of quality.

SOLUBILITY

The solubility of a pigment in various liquids can be important when you are determining vehicles the pigment will function in properly. A pigment that is soluble in water, for instance, will not work in any vehicle that contains water or for which water has been used as the thinner or solvent.

To test a pigment for solubility, place a small amount of the powder in a tall, clear glass jar. Fill the glass halfway with the solvent in question: water, or mineral spirits, or denatured ethyl alcohol, or vinegar (for acidic vehicles), or ammonia water (for alkaline vehicles). To make ammonia water, mix 1 part household ammonia with 10 to 20 parts tap water.

☞ *CAUTION: Denatured ethyl alcohol is a health and fire hazard; ammonia is a health hazard. Do not breathe the vapors of either alcohol or ammonia; be sure your studio is well ventilated.*

Cap the jar tightly, and shake the mixture thoroughly until the pigment is dispersed in the solvent. Allow the pigment to settle overnight, or until it is completely settled to the bottom of the glass. If the solvent has been slightly colored by the pigment so that it is not the same color as it was before adding the pigment, the pigment is soluble in that liquid. The pigment might not be good to use in a vehicle that has the liquid as a part, or for which the liquid is a thinner or solvent.

TINTING STRENGTH

In simple terms, tinting strength is the ability of a colorant to affect the hue of another colorant to which it has been added. It is also a measure of how strongly a color will affect a standard white. The method given in Box 7.1 is a subjective, qualitative test, but it provides a good means by which you can compare two manufacturers' paints for tinting strength.

LIGHTFASTNESS

The Random House College Dictionary, revised edition (New York: Random House, Inc., 1980), defines "permanent" as follows: "*adj.* 1. existing perpetually; everlasting. 2. intended to exist or function for a long, indefinite period without regard to unforeseeable conditions. 3. long-lasting. . . ." With this in mind, we can conclude that no work of art is truly permanent because it is subject to a host of "unforeseeable conditions."

If you are concerned with the durability and permanence of your work, testing for lightfastness (relative light permanence) of a

colored material is important. You can use paints like oils, acrylic emulsions, acrylic solutions, resin-oils (paints whose binder are a combination of linseed oil and a varnish resin), and alkyds with some degree of confidence regarding lightfastness. This is especially true if the container labels give the generic names of the pigment(s) used in the paint, and if the manufacturer certifies on the label that the paint conforms to a standard and lists the lightfastness rating of the paint (see the following section, "Standards for Paints").

BOX 7.1. HOW TO MEASURE TINTING STRENGTH

MATERIALS

- Large tube of artists' titanium white in oil. (The kind of oil does not matter: This is a test of color strength, not a test of vehicle contents.)
- Several different brands of oil paint labeled cobalt blue, for instance. Do not use paints labeled "Cobalt Blue Hue," since these will not contain cobalt pigment.
- Clean glass or porcelain-on-steel palette, and spatulas for mixing.
- Wall scraper with a flexible steel blade.
- Black plastic electrician's tape.
- Kitchen measuring spoons: 1 tablespoon and a $1/8$ teaspoon.
- White posterboard sealed with two coats of acrylic emulsion gesso. (If the posterboard had a glazed finish, it need not be sealed.) Cut the posterboard into strips about 10×20 cm (4 by 8 inches).
- Clipboard for holding the strips of posterboard while making the drawdown.
- Palette knife.

METHOD

1. Attach several (an equal number of) layers of the black tape to each end of the wall scraper's straight edge, so that they fold from one side of the blade to the other. This will create a small aperture from the edge of the blade itself to the edge of the tape on either side.
2. Measure out 2 tablespoons of the white paint and $1/8$ teaspoon of one of the paints. Mix them together thoroughly and completely to make a tint.
3. Place one of the strips of posterboard on the clipboard, positioning it in the center and making sure that it is held firmly by the clip.
4. Put a volume of the blue tinted oil paint near the top of the strip of posterboard and spread it lightly across the width of the strip with a palette knife.
5. Hold the clipboard down with one hand and use the other to hold the wall scraper. Put the wall scraper blade in front of the pile of paint and hold it at about a 45° angle. Draw the blade down over the tint, pressing firmly and evenly.
6. Remove the blade and the excess paint. Clean the blade and the palette knife. A uniform, opaque film of the paint mixture should have been deposited down the center of the strip of posterboard.
7. Make a second mixture of the white with another brand of paint, using steps 1 through 5 above. Make as many drawdowns, using these procedures, as there are paints to compare.
8. Compare the paints while they are wet and again after they dry (about 3 to 7 days at room temperature). Once the strips are dry, you can trim them with scissors so that all the edges are straight. Make the comparisons in natural north daylight, with the light striking the surfaces of the samples at an angle to lessen reflection. The differences between the brands of paint will be evident because of the heavy reduction of the color with white: The weaker tinters will be noticeably lighter in value. For example, cobalt blue paints of similar tinctorial strength but from different manufacturers may be strikingly different in cost. If two paints are equivalent, there is be no reason to buy the more expensive one.

Paints that have generic names for the pigments on their labels but do not certify compliance with a standard can also be used, but with less confidence in their durability.

Some traditional coloring materials (like watercolors and pastels) and many nontraditional materials (like colored pencils, colored markers, and inks) should be tested. Formulations for nontraditional mediums are not standardized. They may contain experimental ingredients, change composition formulas from batch to batch, or be labeled "permanent" without sufficiently explaining what "permanent" means. In many cases it means "waterproof." If you are interested in using these nontraditional materials, you should have a means of testing their reliability without having to rely solely on a manufacturer's promotional literature.

I have included two lightfastness tests that can be used with virtually any painting medium.

The first is easy to do and is the one most often recommended in a manual like this. The second is a little more complicated but produces more precise results.

LIGHTFASTNESS TEST 1

The test given in Box 7.2 is adequate in the grossest sense, but it does not take into account the many variables that can be encountered in testing different types of colorants. Here are some of the test's limitations:

- Different kinds of colorants are applied differently, and to different kinds of supports.
- Some paints are not used straight out of the tube, but are more often used in mixtures with white or in transparent layers. This method does not adequately test these paints under these normal use conditions.

BOX 7.2. HOW TO PERFORM LIGHTFASTNESS TEST 1

MATERIALS

- The colored medium or mediums to be tested: paints, colored pencils, colored inks, markers, and so on.
- Strips of fairly heavy, smooth-surfaced white paper. If possible, use a nonyellowing rag paper, because paper that yellows will affect your judgment about possible changes in the colored material. The strips should be large enough to handle easily, but not so large as to require lots of the material to cover them completely. Strips about 2.5 × 10 cm (1 by 4 inches) should do it.
- Stiff backboard to which the samples will be attached.

METHOD

1. Completely cover a strip of the heavy paper with the material being tested. Use a separate strip for each color. Cover the strip with as much color as possible to make an opaque, or nearly opaque, coating. With colored pencils this will not be possible, but get a thorough coating anyway. With transparent

watercolors, a thick, opaque coating is not desirable (and not a good test of what is supposed to be a thin, transparent paint), but try to get a deep, richly colored hue while maintaining some degree of transparency.

2. Cut the strip in half, leaving two 2.5 × 5 cm (1- by 2-inch) chips. Write the identification of each chip (color name, code number, manufacturer) on the back, and place one in a drawer or in a book to remove it from the light. Put the other chip on a backboard of some kind and expose it to full sunlight in a south-facing window. Any kind of daylight exposure will do, but south sunlight is the most intense and will shorten the test time.

3. Check the exposed sample against the sample kept in the dark at periodic intervals. Note any changes in the one exposed to sunlight.

4. After a few months, compare the samples more closely, under north daylight. Any clearly perceptible change will indicate that the colored material is not entirely lightfast.

- Neither is there away to rate the results of the test as other than "good" or "bad." Some colorants might fall into a category between the two, which would make them acceptable under certain conditions. The test cannot distinguish these colorants from those that will fail.
- Other considerations, such as the effect of heat, humidity, and darkness on the control sample, or the effects of the particular binder on the colorant, are also not adequately addressed by this test.

LIGHTFASTNESS TEST 2

The second method, given in Box 7.3, tries to take into account some of the deficiencies of the first. It uses a measuring device to separate the results into categories of lightfastness. It also specifies that paints normally applied as opaque or translucent films be mixed with white, to make a more severe test of the colorant as a tint, and it specifies appropriate supports for different mediums. The method is based on:
- "Methods for the Determination of the Colour Fastness of Textiles to Light and Weathering," The International Standards Organization Recommendation 105, published as British Standard BS1006:1971 (British Standards Institution, 2 Park Street, London WIA 2BS, England).
- "Felt-Tipped Markers and the Need for Standards of Lightfastness for Artists' Colorants," Bulletin of the American Group-IIC, 8, No. 1 (1967, pp. 24–26), by Dr. Robert L. Feller, of the Center on the Materials of the Artist and Conservator, Carnegie-Mellon Institute of Research, Pittsburgh, PA 15213.
- "Further Studies on the International Blue-Wool Standards for Exposure to Light," by Dr. Robert L. Feller, submitted to the ICOM Committee for Conservation, Zagreb, Yugoslavia, October 1978.

The technique described has been under development since 1981, and two even more precise versions are currently (1992–1993) being balloted as Standard Test Methods of the American Society for Testing and Materials (ASTM). Artists Hilton Brown, Joy Turner Luke, and Zora Sweet Pinney have contributed significantly to the development of the method; Mrs. Luke is the principal investigator.

This test is subject to many variables, not the least of which is the observer's experience in viewing color differences. It is a subjective, qualitative test. Unless both the samples and standards in the method below (see steps 6 and 7) are masked with a neutral gray card, changes in adjacent strips of color may affect the interpretation of the results. To avoid this possibility, paint a piece of paper with the Liquitex Neutral Gray paint described in the method and cut a slot in it that is the same size as the sample and standard strips. Compare the samples and standards by viewing them through this isolating mask.

Here are some additional points: The test does not expose all colorants in tints with white, a kind of exposure that is universally agreed to be a more severe test of a colorant's lightfastness. The test does not provide a method of making colorant films of a uniform thickness. The test does not evaluate the physical durability of the binders, vehicles, or other mediums in which the colorants are carried, nor is it possible to separate any hue/value/chroma changes that occur in the vehicle from those that occur in the colorant.

In addition to the cited references, artists may wish to consult the following test methods, which have application to this type of evaluation:
- AATCC Test Method 16C-1974: "Colorfastness to Light: Daylight." Published by the American Association of Textile Chemists and Colorists, PO Box 12215, Research Triangle Park, NC 27709.
- ASTM G24-73: "Standard Recommended Practice for Conducting Natural Light Exposures Under Glass." Published by the American Society for Testing and Materials, 1916 Race Street, Philadelphia, PA 19103.

BOX 7.3. HOW TO PERFORM LIGHTFASTNESS TEST 2

MATERIALS

- British Blue-Wool Standard Textile Fading Cards, which can be obtained from TALAS (see List of Suppliers). The cards are about 44×108 mm ($1^3/4$ inches by $4^1/4$ inches), with eight strips of wool cloth glued in horizontal bands down the length of the card. Each strip is colored with a blue dye of a known lightfastness. The top strip, Standard #1, is the least lightfast; the bottom strip, Standard #8, is the most lightfast. Each standard, beginning with Standard #1 and moving down to #8, takes approximately twice as long to change as the standard immediately preceding. The cards are very sensitive to light. They should be kept in complete darkness until they are ready to be used in the test. Wrap them in black paper, put them in an envelope, and store the package in a drawer or dark closet. High temperature and humidity may affect the blue dyes.
- Support appropriate for the material being tested. The support material should be stable, white and nonyellowing, and of known composition, so that any changes in the colorant will not be affected by unpredictable changes in the support. For testing oil paints, use 100 percent rag or other neutral pH paper, primed with a light ground of acrylic emulsion gesso. For other paste paints, such as the alkyds, acrylic emulsion, acrylic solution, casein, tempera, or opaque watercolors, use a plain, unprimed white 100 percent rag paper. For transparent watercolor, use a watercolor paper, 100 percent rag, white, with a cold-pressed or hot-pressed surface. A very rough surface will interfere with a clear interpretation of the color changes. For most other colored materials, use a smooth, plain white, 100 percent rag or neutral pH paper.

- Colored materials to be tested.
- Stiff backboard to which the samples will be attached.
- Stiff cover strips to protect the unexposed portion of the colored samples: Wooden lattice strips, inexpensive wooden rulers, or thin aluminum panels can be used.
- Any brand of artists' alizarin crimson oil paint. This is a control. Since it is known that alizarin crimson is just below the cutoff point for acceptable lightfastness, any color with less lightfastness than alizarin crimson certainly should not be used to make permanent works of art. Be sure of getting the true alizarin pigment by choosing a brand that gives the *Colour Index* identification on the label. The *Colour Index* identification of this pigment is Pigment Red 83/Colour Index Number 58000 (PR83/58000); see Table 7.1. Also buy any brand of artists' titanium white oil paint (PW6/77891).

METHOD

1. On the white support, paint out strips of each color of the material being tested. Use the normal application techniques for the particular medium; that is, transparent watercolors should be washed on in a film of average transparency, pastels stroked on in a consistent manner, and so on. Very transparent coatings will change quickly. Identify each strip of color: brand name, code number, color name, and so on. Paints normally applied as opaque or translucent films—oils, resin-oils, acrylic emulsions, acrylic solutions, alkyds, temperas, caseins, opaque watercolors—should be applied as tints with white, since this is the customary way of applying the paints while making a picture.

BOX 7.3. HOW TO PERFORM LIGHTFASTNESS TEST 2, CONT'D.

To make a consistent tint of each color, use the white of the particular paint being tested and mix it with the colored paint to match a Munsell Value 7. Liquitex makes a Neutral Gray (Value 7) acrylic emulsion paint that can be used as a reference. Fill in a strip of the sample sheet with the alizarin crimson oil mixed to a Munsell Value 7 with the titanium white oil.

2. Attach the support with the colored samples to the backboard. Use tape, glue, tacks, or clips. Attach the Textile Fading Card to the backboard near the color samples.

3. Cover half of the samples and half of the Textile Fading Card with the cover strip(s). Be sure to cover the written

identification as well. The cover must be stiff enough and securely attached so that it lies flat and does not allow light to leak underneath. Figure 7.2 gives a suggested arrangement of samples, cards, and covers.

4. Stand the backboard with the samples and the card attached in a south- or southwest-facing window, with the top of the board tilted back so that sunlight will reach the entire surface. North daylight, or other diffuse daylight, will be sufficient for testing the most fugitive colorants—but the testing time will be considerably extended in diffuse light.

5. To identify the extremely fugitive colors in a set of samples, it will be

FIGURE 7.2. Sample layout for Lightfastness Test 2.

COLOR IDENTIFICATION, HIDDEN UNDER COVER STRIP

COLOR SAMPLES

1
2
3
4
5
6
7
8

BLUE WOOL TEXTILE FADING CARD

SAMPLE CARD

STIFF COVER STRIP

necessary to check them, by gently lifting the cover strip, at daily intervals during the first month of exposure. With an unobstructed south-facing exposure and clear, sunny days, noticeable change may occur in one day.

Any color samples that begin to show change when Standards 1, 2, or 3 on the Textile Fading Card show change are not lightfast and should not be used for permanent works of art.

After approximately two months of exposure, check the color/contrast of Standard 6. When a change in the color of Standard 6 can just be perceived, the test is complete. At this point, also check for a change in the alizarin control. It may take anywhere from six weeks to as long as a year for Standard 6 to change, depending on the time of the year (whether the sun is high or low in the sky), weather conditions, geographic location, and the temperature and relative humidity of the room.

6. When Standard 6 has just begun to change, check all the color samples for changes. The changes may not be limited to fading; a loss or gain of chroma or a complete change in hue may also be observed. The samples that do not show a change by the time Standard 6 shows a perceptible change can be considered to have very good lightfastness. This is good enough for materials that will be exhibited indoors in average lighting.

7. To assign a rating to the colorants, compare the changes in them with the range of changes shown on the Textile Fading Card. Find the standard that shows the same degree of change as the colored sample. If, for example, a sample fades the same amount as Standard 3 faded, it is given a rating of 3.

Use the following list to assign a lightfastness rating to the samples once they have been given a number rating according to the blue-wool standards shown in the following table.

BLUE-WOOL STANDARDS AND LIGHTFASTNESS		
Blue-Wool Standards	Lightfastness	Approximate Lifetime in Years
1	Fugitive	Less than 20
2	Fugitive	Less than 20
3	Fugitive	Less than 20
4	Fair	20 to 100
5	Fair	20 to 100
6	Very good	About 100
7*	Excellent	More than 100
8*	Excellent	More than 100

* In order to rate colorants as excellent, it will be necessary to extend the test exposure until Standards 7 or 8 change. Any colors that do not change by the time Standard 7 or 8 changes can be rated excellent.

STANDARDS FOR PAINTS

A commercial standard for artists' paints that could serve as a purchasing guide for artists, and provide a means by which manufacturers could certify the quality of their products, was first published by the National Bureau of Standards (NBS) in 1942. The standard, known formally as "Commercial Standard 98-42" (CS98-42), was initially proposed by the Massachusetts Art Project of the WPA in 1938. After five years of study by artists, American manufacturers of artists' materials, conservators, and other interested parties, the standard was adopted as a voluntary guideline by the industry.

The Paint Standard, as it was called, was important for both artists and manufacturers because it established performance and composition standards for professional-grade oil paints. It published a table of nomenclature and a system of labeling in an attempt to eliminate the confusion found in traditional methods of labeling. It also proposed requirements for the best professional grades of oil paints so that artists could be assured of some objective measure of quality.

In 1962 the standard was revised and reissued as "Commercial Standard 98-62," with the addition of a few new pigments and the listing of some new materials under study that were being considered for addition to later revisions. CS98-42, however, remained essentially unchanged for over 40 years.

But, since the time of its publication and minor revision in 1962, five new binders have been developed and/or extensively marketed in this country: acrylic solutions, acrylic emulsions, the oil-modified alkyds, polyvinyl acetate emulsions, and resin-oils. The acrylic emulsion binders have become immensely popular. In addition, scores of pigments, mostly synthetic organic types, have been introduced by pigment manufacturers and adopted by paintmakers. CS98-62 has become virtually obsolete; few companies adhere to its guidelines because they are now irrelevant.

In 1976, members of Artists Equity Association, of Washington, D.C., a nonprofit lobbying organization of professional visual artists, contacted the NBS about a possible revision of CS98-62. The NBS gave its blessing to the project, but could not offer the services of a support staff to conduct testing. Committees within the American Society for Testing and Materials (ASTM) and the Inter-Society Color Council (ISCC) were then formed to study CS98-62 and coordinate its revision.

The ISCC is an organization of groups and individuals who have an interest in color and color science, and ASTM, well known to many industries, is the largest independent standards-writing body in the world. ASTM undertook to sponsor the new Paint Standard, and the ISCC actively supported the revision work.

Beginning in 1976, members of both groups—which include most of the major American and European artists' materials manufacturers, a number of artists' organizations, and individual artists, chemists, paint technologists, conservators, and teachers—met several times a year to discuss changes proposed for the new standard, to report on the progress of individual studies in areas of CS98-62 that needed revision, and to examine new materials and information that could be included in the new standard. The results of these efforts were published by ASTM in 1984, and include the following. (From ASTM Standards D4302-84, D4303-84, D4236-89, D4838-88, D4941-89, D5067-90, and D5098-90, © American Society for Testing and Materials, by permission of the publisher.)

- ASTM D4302, "Standard Specification for Artists' Oil and Acrylic Emulsion Paints"
- ASTM D4303, "Standard Test Methods for Lightfastness of Pigments Used in Artists' Paints"
- ASTM D4236, "Standard Practice for Labeling Art Materials for Chronic Health Hazards"

New standards developed since then include:

- ASTM D4236-89, "Standard Practice for Labeling Art Materials for Chronic Health Hazards," a revision of the original D4236, to include new information and to reflect the amendment to the Federal Hazardous Substances Act 15 USC 1277, which cites D4236-88
- ASTM D4302-90, "Standard Specification for Artists' Oil, Resin-Oil and Alkyd Paints," a revision and extension of the original D4302 to cover resin-oil and alkyd paints
- ASTM D4303-90, "Standard Test Methods for Lightfastness of Pigments Used in Artists' Paints," a revision of the original D4303
- ASTM D4838-88, "Standard Test Method for Determining the Relative Tinting Strength of Chromatic Paints"
- ASTM D4941-89, "Standard Practice for Preparing Drawdowns of Artists' Paste Paints"
- ASTM D5067-90, "Standard Specification for Artists' Watercolor Paints," a revision and extension of the original D4302 to cover watercolors
- ASTM D5098-90, "Standard Specification for Artists' Acrylic Emulsion Paints," also a revision and extension of the original D4302 to cover acrylic emulsion paints

Note: These standards, especially those designated as "specifications" and referring to different types of paints, are sometimes misconstrued by artists and/or manufacturers as having the effect of making all paints of that type "the same." This is not true: They are minimum standards that allow for wide variation in the quality of different brands, and those who take the time to read the standards will easily understand this distinction.

ASTM D4302-88 "STANDARD SPECIFICATION FOR ARTISTS' OIL, RESIN-OIL AND ALKYD PAINTS"

This standard specification describes labeling, composition, physical properties, and performance requirements for artists' oil, resin-oil, and alkyd paints, and covers pigments, vehicles, and additives for all three types of paint. The labeling requirements are of greatest interest to us. The following information will appear on every container label:

1. The complete identification of the pigment(s) contained in the paint, specified by common name, *Colour Index* name, and additional terms needed to identify the colorant(s). Placement of this information—whether on the front or back of the container—is also specified. Manufacturers are encouraged to include a simple chemical description of the colorant(s) where label size permits, but are required by the specification to give this information in company publications (like catalogues). In the case of pigments that have been duplicated by other colorants, the manufacturers are required to indicate the substitution by using the term "hue" after the name of the color, and by giving the name of the actual pigment used directly under the name of the color. For example:

 Cadmium red hue
 (Quinacridone)

 Where a manufacturer has used a mixture of pigments to make a proprietary hue, all the pigments in the mixture must conform to the specification, and the mixture itself must pass the requirements of the specification. Furthermore, the paint must be labeled in accordance with the previous requirement. For example:

 Permanent green
 (Ultramarine blue, Cadmium-barium yellow)

2. An identification of the vehicle—the vegetable origin of the oil and its method of refinement for oil paints; the type of fatty acid and its compatibility with oils for alkyd paints; and the vegetable origin of the oil, its method of refinement, and the type of resin or gum for resin-oil paints.

3. The lightfastness rating of the pigment(s) in the paint, either Lightfastness I (excellent) or Lightfastness II (very good).

Only those pigments that appear in a table of suitable pigments can be used in paints conforming to the specifications. The suitable pigments table is derived from tests done by a method given in ASTM D4303, and lists the *Colour Index* name of the pigment, its lightfastness rating in the different vehicles (the rating may differ, depending on the vehicle), the common name of the pigment, its chemical class or a simple chemical description, and its *Colour Index* number. Newly introduced pigments must pass the test in ASTM D4303 to be placed on the suitable pigments table.

An appendix to the table lists Lightfastness III (fair) pigments. These pigments are not suitably permanent for use in artists' paints, but are listed in the interest of establishing common terminology. Pigments such as alizarin crimson, Hooker's green, and certain varieties of naphthol red, thioindigoid magenta, and dioxazine purple are listed here. Lightfastness IV and V may at some point be added to the lists; IV and V colorants will not be found in professional-grade paints but will appear in paints not intended to be permanent, like "designers' gouache."

4. The volume contents of the container (required by law).

5. A statement certifying that the contents conform to the labeling requirements of the Federal Hazardous Substances Act (for acute hazards), its amendment (for chronic hazards), and ASTM D4236 (essentially, LHAMA, the amendment to the FHSA for chronic hazards).

6. A statement certifying that the contents conform to ASTM D4302.

7. The manufacturer's name and address, or the importer's name and address and the country of origin.

In addition to this labeling information, there are methods given for testing the paints for various physical and performance characteristics. The types of allowable additives to the vehicles are described, as are the reasons for adding inert pigments. Acceptable consistencies, fineness of grinds, freeze-thaw stability, and drying times are also discussed.

ASTM D4303-90, "STANDARD TEST METHODS FOR LIGHTFASTNESS OF PIGMENTS USED IN ARTISTS' PAINTS"

This standard test method describes the various tests on artists' pigments used to derive the table of suitable pigments given in ASTM D4302, D5067 (acrylic emulsion paints), and D5098 (watercolor paints). If a manufacturer wishes to conform to those other standards, these tests must be performed on the pigments, either by the manufacturer or by an outside contractor.

Aside from giving complete instructions on the preparation of samples for testing, the method describes the types of exposures allowable for the test. Each pigment must be exposed to at least two tests: an outdoor exposure in sunlight in Florida, as well as an indoor exposure to a fluorescent lamp apparatus or a xenon-arc fadeometer. All the methods of measurement (by instrument, not by visual comparison), calculation, and interpretation of results are given in the test, as well as instructions for determining the lightfastness categories of the test pigments.

Each time a manufacturer wishes to introduce a new pigment and list conformance to the standard, it must perform on the new pigment the tests described in ASTM D4303-90.

ASTM D4236-89, "STANDARD PRACTICE FOR LABELING ART MATERIALS FOR CHRONIC HEALTH HAZARDS"

This is a practice for labeling art materials for chronic health hazards (there is already a law covering acute hazards). It applies only to art materials packaged in small quantities for

individual or small group use (it does not apply, for instance, to materials packaged in bulk bags), and it applies only to materials for the adult artist, not for children.

In order for a manufacturer to comply with this standard, product formulations must be submitted to a toxicologist for review; to protect trade secrets the formulations and their review are confidential. In determining the need for precautionary labeling, the toxicologist takes into account the chemical composition of the material, the current knowledge of the chronic toxic potential of the components and the full formulation of the product, the amount of hazardous substance in the material, the chemical and physical form of the material, "reasonably foreseeable" uses of the material, the potential for the components of the material to react with each other, the potential for a chronic adverse health effect from the decomposition or combustion products resulting from the use of the material, and the opinions of various regulatory bodies on the potential for chronic adverse health effects from the use of the material.

The conclusions of the toxicologist determine what labeling requirements will be applied. The requirements include the use of a signal word ("WARNING"), a list of the potential hazards from using the material, the name of the hazardous component(s), instructions for the safe handling and use of the product, and a list of any components in the material that could cause skin or respiratory sensitization.

The label must also give the name of a source for more information about the health hazards of the material, such as instructions to contact a physician, a local poison control center, or a 24-hour toll-free poison control hotline. As of 1990, the label must also give the telephone number of the manufacturer— or, if the product is imported, the telephone number of the company's U.S. representative. This last addition is mandated by a new law, an amendment to the Federal Hazardous Substances Act 15 UCS 1277, which cites D4236-88. The law requires that the manufacturer's telephone number be given on the product label, *but you should not call the manufacturer for health information.* As I have said elsewhere, manufacturers will only tell you to call your doctor or a poison control center if you call them with health questions. Do not waste your money or your time calling a company about its health labeling. If you want information about health issues, contact a toxicologist specializing in art materials health hazards.

Following the text of the standard is a list of the various chronic hazard statements, and a list of the precautionary statements that can be used on labels. If all the requirements of the standard are met, the manufacturer can claim compliance with a statement like "conforms to ASTM Practice D4236."

The Art and Craft Materials Institute (715 Boylston Street, Boston, MA 02116) is one approved certifying body for ASTM D4236. Manufacturers wishing to comply with the standard submit their formulations to the institute's toxicologist, and upon approval may use one of the institute's certification seal on their product labels. (See Figure 7.3.)

SEALS OF THE ART AND CRAFT MATERIALS INSTITUTE

Manufacturers who are members of the Art and Craft Materials Institute and who submit their art materials to the Institute's toxicologist for review may use one of the following three seals on the product label or in catalogues or advertisements for the product.

1. THE AP NONTOXIC SEAL (APPROVED PRODUCT)

Products bearing this round seal are certified through toxicological evaluation to contain no materials in sufficient quantities to be hazardous to humans or to cause acute or chronic health problems. The products are certified by the Institute to be labeled in accordance with ASTM D4236.

A manufacturer may choose to use the square Health Label (see item 3 below), with the words "Nontoxic" or "No health labeling required" below it, instead of the AP Seal.

2. THE CP NONTOXIC SEAL (CERTIFIED PRODUCT)

Products bearing this round seal are certified through toxicological evaluation to contain no materials in sufficient quantities to be hazardous to humans or to cause acute or chronic health problems. The products are certified by the Institute to be labeled in accordance with ASTM D4236.

In addition, these products are certified by the Institute to meet the specific requirements of a quality standard issued by the Institute

or other recognized standards organization. In this case the name and number of the quality standard must appear beneath the seals in the following phrase: "Meets Performance Standard #____." In the case of professional materials, the standards to look for are ASTM D4302, D5067, or D5098.

A manufacturer may choose to use the square Health Label (see item 3 below) with the words "Nontoxic" or "No health labeling required" below it, instead of the AP Seal. In addition, the manufacturer must give the name and number of the quality standard.

3. THE HL SEAL (HEALTH LABEL)

Products bearing this square seal *without* the words "Nontoxic" or "No health labeling

FIGURE 7.3. The seals of the Art and Craft Materials Institute (ACMI). *Top, left to right,* AP Nontoxic Seal (Approved Product) and CP Nontoxic Seal (Certified Product). *Bottom,* HL Seal (Health Label).

required" contain hazardous materials, and are certified by the Institute to be properly labeled with cautionary information for the consumer in accordance with ASTM D4236. Specific labeling for the toxic ingredient(s) is required to appear directly below the seal.

A product certified by the Institute to meet the specific requirements of a quality standard issued by the Insitute or other recognized standards organization may bear the name and number of the quality standard below the cautionary statement. In the case of professional materials, the standards to look for are ASTM D4302, D5067, or D5098.

ASTM D5067-90 "STANDARD SPECIFICATION FOR ARTISTS' WATERCOLOR PAINTS"

This specification is essentially the same as D4302, except that it applies to transparent watercolor paints. A specification for opaque watercolors (gouache paints) is nearing completion, and a specification for colored pencils has been proposed based on D5067-90.

ASTM D5098-90 "STANDARD SPECIFICATION FOR ARTISTS' ACRYLIC EMULSION PAINTS"

This specification is essentially the same as D4302, except that it applies to acrylic emulsion paints.

ASTM D4838-88, "STANDARD TEST METHOD FOR DETERMINING THE RELATIVE TINTING STRENGTH OF CHROMATIC PAINTS"

This is a technical method that produces instrumentally readable results. The tinting strength test method described earlier in this chapter is too qualitative and subject to too many variables to be of value to a color scientist.

ASTM D4941-89, "STANDARD PRACTICE FOR PREPARING DRAWDOWNS OF ARTISTS' PASTE PAINTS"

This is a technical method that also produces instrumentally readable results. The drawdown method described earlier in this chapter is too qualitative and subject to too many variables to be of value to a scientist.

SOME CONCLUDING OBSERVATIONS

All these standards are voluntary, and thus manufacturers do not have to comply with them. ASTM D4236, however, is mandatory by default since it is now incorporated into a federal law.

A manufacturer may choose to have certain items in its line covered by the standards and let other items be marketed without submitting them to the standards' tests. For instance, a line of oil paints can contain alizarin crimson, a pigment that is not listed in the table of suitable pigments in D4302, as long as the label for that paint does not advertise compliance with D4302. Also, a material that conforms with D4302 automatically conforms with D4236 (and the appropriate specification), but a material that conforms to D4236 does not automatically conform to D4302.

It is necessary to *read the compliance statements carefully* to be sure of what *the label* is saying. It is also very important to remember that ASTM Standards are not static. That is, once they are written, they are under constant scrutiny by all the parties using them: in this case, manufacturers and artists. ASTM, in fact, has a system that requires a cycle of reapproval and revision of each of its standards over a five-year period; if a standard is not reapproved or revised within this period, it is phased out over a further three-year period (this is essentially what happened to the old NBS CS98-62). In this way, these ASTM Standards are kept contemporary with technical developments in the field of artists' materials.

Figures 7.4–7.6 show typical paint labels under the new paint standards.

Copies of the individual ASTM Standards can be obtained by writing to the American Society for Testing and Materials, 1916 Race Street, Philadelphia, PA 19103-1187.

SPECIALTY PIGMENTS

Unusual pigments in some commercial lines of acrylic emulsion paints are used mostly for special effects. These include metallic, fluorescent, and interference pigments.

METALLIC PIGMENTS

The principal hues are gold and silver, with occasional variants of the gold in bronze, reddish, or greenish shades. The particles are metal flakes of aluminum or bronze, or mixtures of bronze and copper. If the particles are well dispersed in and completely surrounded by the paint vehicle, they should be adequately protected from oxidation, the main cause of

discoloration. One artists' paint manufacturer, Golden Artist Colors, uses real stainless steel—a material that will not easily oxidize—for an unusual effect.

FLUORESCENT PIGMENTS

In red, green, blue, and yellow hues, these are composed of dyes that absorb invisible ultraviolet light, and then emit visible light of a longer wavelength than that absorbed (some also absorb visible light). The colorant thus appears to glow. It has been shown that the fluorescents eventually lose their power to be excited by irradiation. The fluorescent effect will eventually fade—and the hue may also fade if the dye is not lightfast.

Because of their inherent instability, fluorescent colorants should *not* be used in permanent painting, even if they can be temporarily protected against fading by varnishes containing ultraviolet light absorbers or inhibitors. The inhibitors and absorbers themselves eventually stop functioning.

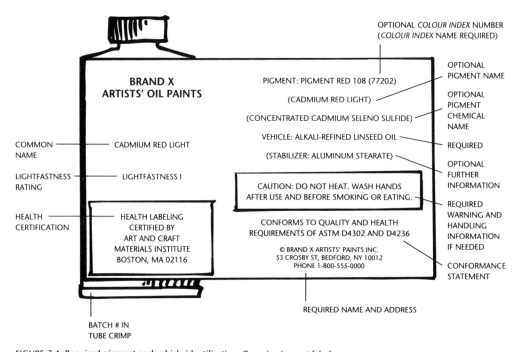

FIGURE 7.4. Required pigment and vehicle identification: Generic pigment label.

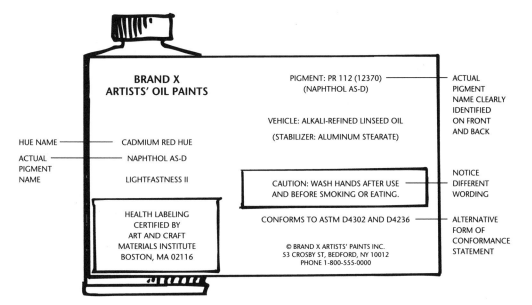

FIGURE 7.5. Alternative form of *Colour Index* name: Substituted pigment label (hue).

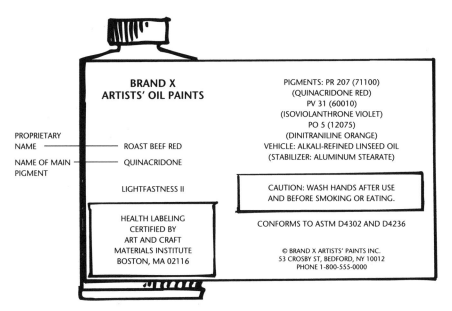

NAMES OF ALL THREE PIGMENTS USED IN THE MIXTURE ARE GIVEN AND FURTHER IDENTIFIED BY *COLOUR INDEX* NAMES. (*COLOUR INDEX* NUMBERS AND CHEMICAL NAMES ARE OPTIONAL FOR LABELS BUT RECOMMENDED FOR COMPANY LITERATURE.)

NOTE LIGHTFASTNESS RATING: LABEL MUST CARRY RATING FOR LEAST LIGHTFAST PIGMENT IN MIXTURE. PO 5 (12075) IS RATED II (PR 207 AND PV 31 ARE I), SO WHOLE PAINT IS II.

HEALTH CERTIFICATION STATEMENT CAN BE REPLACED BY ACMI SEAL.

LIGHTFASTNESS I = EXCELLENT
LIGHTFASTNESS II = VERY GOOD
LIGHTFASTNESS III = FAIR, AND *DOES NOT* CONFORM TO D 4302.

FIGURE 7.6. Proprietary label (single or mixed pigments).

INTERFERENCE PIGMENTS

These pigments are also known as "pearlescent" or "iridescent" pigments. "Interference" is the most appropriate name for them, since it describes how they work: Their color is dependent on the interference of light.

Interference pigments are not particles in the usual sense, but thin transparent flakes coated with a film of a higher refractive index than that of the flake. For example, flakes of mica can be coated with a microscopically thin film of titanium dioxide pigment. These platelets, as they are called, will simultaneously reflect and transmit light, depending on their orientation toward the light source, the thickness of the paint film, the angle of the light to the paint film, and the refractive index of the platelets. The various colors—bluish, greenish, yellowish, and reddish—with a pearly luminescence and sense of depth, result from the strengthening or weakening of various light wavelengths. The pigments work best against dark backgrounds.

Some manufacturers produce pigments that have a metallic appearance but are produced in the same way as the interference pigments.

The same flakes of mica are used, but are coated with thin films of various mineral pigments. Paints made with these pigments look similar to those made with actual metals, but the colorants are not susceptible to oxidation, corrosion, or the other defects of the metal pigments.

THE PIGMENT TABLES

Table 7.1, which appears on the following pages, summarizes important information about many pigments, presents a survey of pigments that have been and are being used in artists' paints, and provides quick reference to that information. Some of the pigments have been tested for the ASTM project. The information in this table is adapted from the *Colour Index* with permission of the publishers: The Society of Dyers and Colourists, Bradford, England, and the American Association of Textile Chemists and Colorists, Research Triangle Park, NC 27709.

Table 7.2, which begins on page 177, is about hazardous pigments; and Table 7.3, which begins on page 183, gives drying rates and film characteristics of pigments in oil.

TABLE 7.1. PIGMENTS

Key: The sequence of pigments for this table is determined first by the hue (Y, O, R, V, B, G, Br, Bk, W, in that order) and second by ascending *Colour Index* Names (i.e., PY 1 comes before PY 3, and PY 37 comes before PY 37:1).

PIGMENTS:
N = Natural
M = Metal
P = Pigment

COLORS:
Y = Yellow
O = Orange
R = Red
V = Violet
P = Purple
B = Blue
G = Green
Br = Brown
Bk = Black
W = White

PIGMENT TYPE:
E = Extended
L = Lake
P = Particle
T = Toner

ASTM LIGHTFASTNESS RATINGS:
I = Excellent
II = Very good
III = Fair

TYPES OF PAINT:
O = Oil
AE = Acrylic emulsion
R = Resin-oil*
A = Alkyd
WC = Watercolor
*Resin-oil paints are made only by Schmincke, a German company.

FOR OIL PAINTS:

Oil Absorption:
L = Low
M = Medium
H = High

Drying Rates in Oil:
E = Excellent
G = Good
A = Average
S = Slow
VS = Very Slow

Film Properties in Oil:
E = Excellent
G = Good
F = Fair
P = Poor

DRY REFRACTIVE INDEX:
L = Low
M = Medium
H = High

MISCELLANEOUS:
CC = Concentrated cadmium (Paints containing concentrated cadmium pigments can have up to 15% barium sulfate pigment added for color control. The cadmium-barium pigments are further extended with extra barium sulfate.)
CI = *Colour Index*
C.P. = Chemically pure
n/a = Not applicable
LF = Lightfast type (manufacturer's designation)
NR = Not recommended
NT = Not tested
NW = Not usable in water-based vehicles
RS = Red shade (manufacturer's code)
SL = May darken in strong sunlight
SM = Sensitive to moisture
SS = Sensitive to hydrogen sulfide in the atmosphere

NOTES:
HUE The common color name of the pigment.

COMMON NAME The most common pigment name.

COLOUR INDEX NAME (AND NUMBER) Reference to the volume of the *Colour Index* that gives each pigment's physical characteristics. The *Colour Index* is an internationally recognized reference to colorants of all types. The *Colour Index* name is written as a number, as in PY 42 (Pigment Yellow 42—yellow ochre). The *Colour Index* number is the reference to the volume of the *Colour Index* that gives the pigment's composition, formulation, and other sources of reference to the pigment. The number consists of five digits, as in 77493. The *Colour Index* name and number for yellow ochre is thus: PY 42 (77493).

GENERIC NAME Given if different from the common name.

PROPRIETARY NAME(S) Any of the various names by which the pigment has been known; usually company or trade names.

SYNONYM(S) Other common names for the pigment.

DATES AND PLACE OF DISCOVERY Available information about the origin of the pigment. The development of most pigments did not occur at a specific moment, but evolved over a period of time.

CHEMICAL CLASS Whether the pigment is organic or inorganic.

CONSTITUENTS The chemical contents of the pigment. This is not very specific when applied to some organic pigments because the usual representation of many of the organics is diagrammatic, or a series of long chemical designations that are relatively meaningless except to chemists.

SOURCE The simplified category of the pigment, with a comment in some cases about a pigment being "processed." The source can be one of the following: natural organic, natural inorganic, synthetic organic, or synthetic inorganic.

TYPE Whether the pigment is a particle, toner, lake, or extended.

MELTING POINT (°C) The melting point temperature of the pigment.

STABILITY TO (°C) The temperature at which the pigment may change color or deteriorate. If a time is stated, the pigment will deteriorate after that length of time at that temperature. For some pigments, information is included about the color it will become at a certain temperature.

LIGHTFASTNESS The rating given the *pigment in a paint* by ASTM.

USE IN VEHICLES The usefulness of the pigment in various binders and/or vehicles, with specific comments on the pigment's effects in oil. An "x" across from a binder or vehicle indicates that the pigment is useful in that particular medium. Occasionally a rating is given: EX = Excellent, VG = Very good, G = Good, F = Fair, P = Poor.

DRY REFRACTIVE INDEX The refractive index of the dry pigment, which is of course affected by the binder/vehicle/solvent combination in which it is dispersed.

DRY CHARACTERISTICS Indicates the hue range and so forth: R > Y means *reddish to yellowish.*

HAZARDS Cautionary notes about hazards. *Caution:* Avoid breathing all pigment dusts.

OTHER COMMENTS A brief commentary, including a discussion of the pigment's major use (which may not be in artists' paints).

TABLE 7.1. PIGMENTS, CONT'D.

HUE	Yellow	Yellow	Yellow
COMMON NAME	**Arylide Yellow G Medium**	**Arylide Yellow 10G Light**	**Cadmium yellow light**
COLOUR INDEX NAME (AND NUMBER)	PY 1 (11680)	PY 3 (11770)	PY 35 (77205)
GENERIC NAME	Acetoacetanilide AAA	Acetoacet-o-chloranilide	Cadmium yellow
PROPRIETARY NAME(S)	Azo, Monoazo, Hansa G	Azo, Monoazo, Hansa 10G	
SYNONYM(S)	Hansa, Azo, Hansa G	Hansa, Azo, Hansa 10G	C.P. cadmium yellow
DATES AND PLACE OF DISCOVERY	1909, Germany (?)	1909, Germany (?)	1840s
CHEMICAL CLASS	Organic	Organic	Inorganic
CONSTITUENTS	Substituted anilines plus arylimides of acetoacetic acid	Substituted anilines plus arylimides of acetoacetic acid	Concentrated cadmium zinc sulfide
SOURCE	Synthetic organic	Synthetic organic	Processed mineral
TYPE	T, L, E	T, L, E	P, E (up to 15%)
MELTING POINT (°C)	256	258	NT
STABILITY TO (°C)	150, 20 minutes	150, 20 minutes	Excellent
LIGHTFASTNESS ASTM	O II, AE II, R II, A II, WC III	O II, AE II, R II, A II, WC II	O I, AE I, R I, A I, WC I
USE IN VEHICLES			
Oil	x	x	x
Oil absorption	M	M	L
Drying rate	S	S	S
Film properties	G	G	G
Acrylic Solution	x	x	x
Acrylic Emulsion	x	x	x
Alkyds	x	x	x
Transparent watercolor	x	x	x
Opaque watercolor	x	x	x
Tempera	x	x	x
Casein	x	x	x
Encaustic	x	x	x
Frescoes	x	x	NT
Pastels	x	x	x
Experimental paints	x, test first	x, test first	x
DRY REFRACTIVE INDEX	M	M	H
DRY CHARACTERISTICS	Bright Y; does not lose chroma when extended	Bright GY, does not lose chroma when extended	Bright Y > YR
HAZARDS	Avoid breathing dust	Avoid breathing dust	Avoid dust; do not heat—metal fumes toxic
OTHER COMMENTS	Used in all paints; may fade in weak tints; Hansa is trade name (BASF Corporation) in Europe	Slightly greenish Y, useful in making bright green mixtures; may fade in weak tints; Hansa is trade name (BASF Corporation) in Europe	Used in all paints; sensitive to acidic environments; can be replaced by the less expensive cadmium-barium form

TABLE 7.1. PIGMENTS, CONT'D.

HUE	Yellow	Yellow	Yellow
COMMON NAME	**Cadmium-barium yellow light**	**Cadmium yellow (light, medium & deep)**	**Cadmium-barium yellow (medium & deep)**
COLOUR INDEX **NAME (AND NUMBER)**	PY 35:1 (77205:1)	PY 37 (77199)	PY 37:1 (77199)
GENERIC NAME	Cadmium-barium yellow light	Cadmium yellow	Cadmium-barium yellow
PROPRIETARY NAME(S)			
SYNONYM(S)		C.P. cadmium yellow	
DATES AND PLACE OF DISCOVERY	1927	1840s	1927
CHEMICAL CLASS	Inorganic	Inorganic	Inorganic
CONSTITUENTS	Cadmium zinc sulfide co-precipitated with barium sulfate	Concentrated cadmium sulfide (CC)	Cadmium zinc sulfide co-precipitated with barium sulfate
SOURCE	Processed mineral	Processed mineral	Processed mineral
TYPE	P, E	P, E (up to 15%)	P, E
MELTING POINT (°C)	NT	NT	NT
STABILITY TO (°C)	Excellent	Excellent	Excellent
LIGHTFASTNESS ASTM	O AE R A WC I I I I I	O AE R A WC I I I I I	O AE R A WC I I I I I
USE IN VEHICLES			
Oil	x	x	x
Oil absorption	L	L	L
Drying rate	S	S	S
Film properties	G	G	G
Acrylic Solution	x	x	x
Acrylic Emulsion	x	x	x
Alkyds	x	x	x
Transparent watercolor	x	x, sensitive to acid and water	x
Opaque watercolor	x	x	x
Tempera	x	x	x
Casein	x	x	x
Encaustic	x	x	x
Frescoes	NT	NT	NT
Pastels	x	x	x
Experimental paints	x	x	x
DRY REFRACTIVE INDEX	H	H	H
DRY CHARACTERISTICS	Bright Y > R	Bright Y > R	Bright Y > R
HAZARDS	Avoid dust; do not heat—metal fumes toxic	Avoid dust; do not heat—metal fumes toxic	Avoid dust; do not heat—metal fumes toxic
OTHER COMMENTS	Used in all paints; sensitive to acidic environments; not as expensive as C.P. cadmiums	Used in all paints; sensitive to acidic environments; can be replaced by the less expensive cadmium-barium form	Used in all paints; sensitive to acidic environments; not as expensive as C.P. cadmiums

TABLE 7.1. PIGMENTS, CONT'D.

HUE	Yellow	Yellow	Yellow
COMMON NAME	**Aureolin**	**Naples yellow**	**Mars orange**
COLOUR INDEX NAME (AND NUMBER)	PY 40 (77357)	PY 41 (77589) (77588)	PY 42 (77492)
GENERIC NAME	Aureolin	Naples yellow	Orange iron oxide
PROPRIETARY NAME(S)	Fischer's salt	(Naples yellow hue)	Mars orange
SYNONYM(S)	Indian yellow; Cobalt yellow	Giallolino; Antimony; Merimee's; Jaune Brilliant	
DATES AND PLACE OF DISCOVERY	1848	c. 600 B.C.; 1700s	1800s
CHEMICAL CLASS	Inorganic	Inorganic	Inorganic
CONSTITUENTS	Cobalt potassium nitrate	Lead antimonate	Hydrated iron oxide precipitated
SOURCE	Processed mineral	Processed natural mineral	Processed synthetic mineral
TYPE	P	P	P
MELTING POINT (°C)	NT	NT	NT
STABILITY TO (°C)	Poor	Excellent	Fair > R at 100+

LIGHTFASTNESS ASTM	O	AE	R	A	WC	O	AE	R	A	WC	O	AE	R	A	WC
	II	NR	II	NR	II	I	NR	NR	NR	NR	I	I	I	NR	I

USE IN VEHICLES			
Oil	x	x	x
Oil absorption	M	M	M
Drying rate	A	G	A
Film properties	G	G	E
Acrylic Solution	x, test first	NT	x
Acrylic Emulsion	P	NW	x
Alkyds	x	x	x
Transparent watercolor	x	NW	x
Opaque watercolor	x	NW	x
Tempera	x	test first	x
Casein	x	NW	x
Encaustic	x	x	x
Frescoes	P	NW	x
Pastels	x, test first	NR, toxic	x
Experimental paints	x	x	x

DRY REFRACTIVE INDEX	L	H	H
DRY CHARACTERISTICS	Bright, weak Y	Dull Y > YR > RY	Dull RY > YR
HAZARDS	Avoid dust	Toxic; avoid dust	Avoid dust (iron)
OTHER COMMENTS	Poor tinting strength; poor opacity; used in glass and porcelain painting; useful in glazes	Excellent pigment; contains lead and is not used dry; expensive—many imitations—check label for contents	Dense; opaque; useful pigment; origin of term "Mars" is uncertain

TABLE 7.1. PIGMENTS, CONT'D.

HUE	Yellow	Yellow	Yellow
COMMON NAME	**Mars yellow**	**Yellow ochre**	**Titanium yellow**
COLOUR INDEX NAME (AND NUMBER)	PY 42 (77492)	PY 43 (42) (77492)	PY 53 (77788)
GENERIC NAME	Yellow iron oxide	Yellow ochre	Nickel-titanate yellow
PROPRIETARY NAME(S)	Mars yellow; Yellow oxide		Titanium yellow; Titanium golden
SYNONYM(S)			
DATES AND PLACE OF DISCOVERY	1800s	Prehistoric	Modern
CHEMICAL CLASS	Inorganic	Inorganic	Inorganic
CONSTITUENTS	Hydrated iron oxide precipitated	Iron oxide	Combined oxides of nickel, antimony, and titanium
SOURCE	Processed synthetic mineral	Processed natural mineral	Processed synthetic mineral
TYPE	P	P	P
MELTING POINT (°C)	NT	NT	NT
STABILITY TO (°C)	Fair > YR at 100+	Fair > R at 100+	950

LIGHTFASTNESS ASTM	O	AE	R	A	WC	O	AE	R	A	WC	O	AE	R	A	WC
	I	I	I	NR	I	I	I	I	I	I	I	I	I	NR	NR

USE IN VEHICLES			
Oil	x	x	x
Oil absorption	M	M	M
Drying rate	A	S	A
Film properties	E	E	G
Acrylic Solution	x	x	x
Acrylic Emulsion	x	x	x
Alkyds	x	x	x
Transparent watercolor	x	x	x
Opaque watercolor	x	x	x
Tempera	x	x	x
Casein	x	x	x
Encaustic	x	x	x
Frescoes	x	x	x
Pastels	x	x	x
Experimental paints	x	x	x

DRY REFRACTIVE INDEX	H	M to H	M
DRY CHARACTERISTICS	Dull Y	Dull YR > YBr > Y	Bright, slightly G, Y
HAZARDS	Avoid dust (iron)	Avoid dust (iron)	Avoid dust; nickel may be a sensitizer; do not heat
OTHER COMMENTS	Dense; opaque; useful pigment; origin of term "Mars" is uncertain	Excellent natural equivalent of Mars pigments; semiopaque to opaque, depending on source	Useful all-round pigment

TABLE 7.1. PIGMENTS, CONT'D.

HUE	Yellow	Yellow	Yellow
COMMON NAME	**Nickel azo yellow**	**Benzimidazolone yellow**	**Nickel dioxine yellow**
COLOUR INDEX NAME (AND NUMBER)	PY 150 (12764)	PY 151 (13980)	PY 153 (48545)
GENERIC NAME	Nickel complex azo	Benzimidazolone	Nickel complex azo
PROPRIETARY NAME(S)	Various	Various	Various
SYNONYM(S)			
DATES AND PLACE OF DISCOVERY	Modern	Modern	Modern
CHEMICAL CLASS	Organic	Organic	Organic
CONSTITUENTS	Complex nickel salts (?)	Benzimidazolone	Benzimidazolone
SOURCE	Synthetic organic	Synthetic organic	Synthetic organic
TYPE	P, L	L	L
MELTING POINT (°C)	NT	NT	NT
STABILITY TO (°C)	NT	NT	NT
LIGHTFASTNESS ASTM	O AE R A WC I I NT NT NT	O AE R A WC I I NT NT NT	O AE R A WC I I I NT NT
USE IN VEHICLES			
Oil	x	x	x
Oil absorption	H	H	H
Drying rate	A	A	A
Film properties	G	G	G
Acrylic Solution	NT	NT	NT
Acrylic Emulsion	NT	NT	NT
Alkyds	NT	NT	NT
Transparent watercolor	NT	NT	NT
Opaque watercolor	NT	NT	NT
Tempera	NT	NT	NT
Casein	NT	NT	NT
Encaustic	NT	NT	NT
Frescoes	NT	NT	NT
Pastels	NT	NT	NT
Experimental paints	NT	NT	NT
DRY REFRACTIVE INDEX	L	L	L
DRY CHARACTERISTICS	Y	Y	Y
HAZARDS	Avoid dust; nickel may sensitize skin	Avoid dust	Avoid dust; nickel may sensitize skin
OTHER COMMENTS	ASTM tested for lightfastness only; test before use	ASTM tested for lightfastness only; test before use	ASTM tested for lightfastness only; test before use

TABLE 7.1. PIGMENTS, CONT'D.

HUE	Yellow	Yellow	Orange
COMMON NAME	Benzimidazolone yellow H3G	Benzimidazolone yellow H6G	Dinitraniline orange (SM)
COLOUR INDEX NAME (AND NUMBER)	PY 154 (11781)	PY 175 (11784)	PO 5 (12075)
GENERIC NAME	Benzimidazolone H3G	Benzimidazolone H6G	Dinitraniline
PROPRIETARY NAME(S)	Various	Various	Various
SYNONYM(S)			Azo orange
DATES AND PLACE OF DISCOVERY	Modern	Modern	Modern
CHEMICAL CLASS	Organic	Organic	Organic
CONSTITUENTS	Benzimidazolone	Benzimidazolone	"Monoazo"
SOURCE	Synthetic organic	Synthetic organic	Synthetic organic
TYPE	L	L	L
MELTING POINT (°C)	NT	NT	302
STABILITY TO (°C)	NT	NT	150
LIGHTFASTNESS ASTM	O AE R A WC I I I NT NT	O AE R A WC I I NT NT NT	O AE R A WC II II NT NT NT

USE IN VEHICLES

Oil	x	x	x
Oil absorption	H	H	H
Drying rate	A	A	A
Film properties	G	G	G
Acrylic Solution	NT	NT	NT
Acrylic Emulsion	x	x	x
Alkyds	NT	NT	x
Transparent watercolor	NT	NT	x (but NT)
Opaque watercolor	NT	NT	x (but NT)
Tempera	NT	NT	x
Casein	NT	NT	x
Encaustic	NT	NT	x
Frescoes	NT	NT	NT
Pastels	NT	NT	x
Experimental paints	NT	NT	NT

DRY REFRACTIVE INDEX	L	L	L
DRY CHARACTERISTICS	Y	Y	O
HAZARDS	Avoid dust; nickel may sensitize skin	NT	Avoid dust
OTHER COMMENTS	ASTM tested for lightfastness only; test before use		ASTM tested for lightfastness only; test before use; used in paints, printing inks, emulsions, alkyd enamels, lacquers, paper, cloth, linoleum, rubber, styrenes, waxes

TABLE 7.1. PIGMENTS, CONT'D.

HUE	Orange	Orange	Orange
COMMON NAME	Cadmium orange (CC)	Cadmium-barium orange	Cadmium vermilion orange
COLOUR INDEX NAME (AND NUMBER)	PO 20 (77196) (77199) (77202)	PO 20:1 (77196) (77199) (77202:1)	PO 23 (77201)
GENERIC NAME	Cadmium orange	Cadmium-barium orange	Cadmium mercury orange
PROPRIETARY NAME(S)	Cadmium orange	Cadmium-barium orange	
SYNONYM(S)	Cadmium orange	Cadmium-barium orange	
DATES AND PLACE OF DISCOVERY	1840s	1920s	Modern
CHEMICAL CLASS	Inorganic	Inorganic	Inorganic
CONSTITUENTS	Concentrated cadmium sulfoselenide	Cadmium sulfoselenide co-precipitated with barium sulfate	Concentrated cadmium sulfide plus mercuric sulfide
SOURCE	Processed natural mineral	Natural inorganic	Processed natural mineral
TYPE	P, E (up to 15%)	P, E	P
MELTING POINT (°C)	NT	Excellent	NT
STABILITY TO (°C)	260	Excellent	260
LIGHTFASTNESS ASTM	O AE R A WC I I I I I	O AE R A WC I I NT NT I	O AE R A WC I I NT NT NT
USE IN VEHICLES			
Oil	x	x	x
Oil absorption	M	M	M
Drying rate	S	S	S
Film properties	G	G	G
Acrylic Solution	x	x	x
Acrylic Emulsion	x	x	x
Alkyds	x	x	x
Transparent watercolor	x (sensitive to acid)	x (sensitive to acid)	Sensitive to acid
Opaque watercolor	x (sensitive to acid)	x (sensitive to acid)	Sensitive to acid
Tempera	x	x	x
Casein	x	x	x
Encaustic	x	x	x
Frescoes	x	x	x
Pastels	x	x	x
Experimental paints	NT	NT	NT
DRY REFRACTIVE INDEX	H	H	
DRY CHARACTERISTICS	YO > RO	YO > RO	YO > RO
HAZARDS	Do not heat: Cd fumes toxic	Do not heat: Cd fumes toxic	Do not heat: Cd fumes toxic; potential hazard from mercury
OTHER COMMENTS	Excellent but expensive pigment	Excellent pigment; less expensive than C.P. cadmium orange	Excellent pigment, but may darken if not properly dispersed in protective binder or poorly processed (exposure to polluted atmospheres may darken mercury content)

TABLE 7.1. PIGMENTS, CONT'D.

HUE	Orange	Orange	Orange
COMMON NAME	**Cadmium-barium vermilion orange**	**Benzimidazolone orange HL**	**Perinone orange**
COLOUR INDEX **NAME (AND NUMBER)**	PO 23:1 (77201:1)	PO 36 (11780)	PO 43 (71105)
GENERIC NAME	Cadmium mercury orange	Benzimidazolone HL	Perinone
PROPRIETARY NAME(S)	Various	Various (Azo orange)	Various
SYNONYM(S)	Various		
DATES AND PLACE OF DISCOVERY	Modern	Modern	Modern
CHEMICAL CLASS	Inorganic	Organic	Organic
CONSTITUENTS	Cadmium mercury sulfide co-precipitated with barium sulfate	"Monoazo" compound	Anthraquinone derivative
SOURCE	Processed natural mineral	Synthetic organic	Synthetic organic
TYPE	P, E	L	L
MELTING POINT (°C)	NT	NT	NT
STABILITY TO (°C)	**260**	Good	200

LIGHTFASTNESS	O	AE	R	A	WC	O	AE	R	A	WC	O	AE	R	A	WC
ASTM	I	I	NT	NT	NT	I	I	NT	NT	NT	I	NT	NT	I	NT

USE IN VEHICLES			
Oil	x	x	x
Oil absorption	M	H	H
Drying rate	S	A	A
Film properties	G	G	G
Acrylic Solution	x	G	NT
Acrylic Emulsion	x	x	x
Alkyds	x	x	x
Transparent watercolor	x (sensitive to acid)	x	x
Opaque watercolor	x (sensitive to acid)	x	x
Tempera	x	x	x
Casein	x	x	x
Encaustic	x	x	x
Frescoes	x	x	x
Pastels	x	x	x
Experimental paints	NT	x	x
DRY REFRACTIVE INDEX	H	L	L
DRY CHARACTERISTICS	YO > RO	O	O
HAZARDS	Do not heat: Cd fumes toxic; potential hazard from mercury	Avoid dust	Avoid dust
OTHER COMMENTS	Excellent pigment, but may darken if not properly dispersed in protective binder or poorly processed (exposure to polluted atmospheres may darken mercury content)	ASTM tested for lightfastness only; test before use; used in industrial paints, printing inks, plastics	Used in industrial paints, printing inks, vinyl and polyolefin plastics

TABLE 7.1. PIGMENTS, CONT'D.

HUE	Orange	Orange	Orange
COMMON NAME	**Quinacridone gold**	**Quinacridone deep gold**	**Benzimidazolone orange HGL**
COLOUR INDEX NAME (AND NUMBER)	PO 48 (n/a)	PO 49 (n/a)	PO 60 (11782)
GENERIC NAME	Quinacridone	Quinacridone	Benzimidazolone
PROPRIETARY NAME(S)	Various	Various	Various (Azo orange)
SYNONYM(S)			
DATES AND PLACE OF DISCOVERY	Modern	Modern	Modern
CHEMICAL CLASS	Organic	Organic	Organic
CONSTITUENTS	"Linear quinacridone" (unspecified derivative)	"Linear quinacridone" (unspecified derivative)	"Monoazo" compound
SOURCE	Synthetic organic	Synthetic organic	Synthetic organic
TYPE	L	L	L
MELTING POINT (°C)	NT	NT	NT
STABILITY TO (°C)	NT	NT	G
LIGHTFASTNESS ASTM	O AE R A WC I I NT NT NT	O AE R A WC I I NT NT NT	O AE R A WC I I NT NT NT
USE IN VEHICLES			
Oil	x	x	x
Oil absorption	H	H	H
Drying rate	A	A	A
Film properties	G	G	G
Acrylic Solution	NT	NT	G
Acrylic Emulsion	x	x	x
Alkyds	x	x	x
Transparent watercolor	NT	NT	x
Opaque watercolor	NT	NT	x
Tempera	NT	NT	x
Casein	NT	NT	x
Encaustic	NT	NT	x
Frescoes	NT	NT	x
Pastels	NT	NT	x
Experimental paints	NT	NT	x
DRY REFRACTIVE INDEX	L	L	L
DRY CHARACTERISTICS	YO > O > RO	O	O
HAZARDS	Avoid dust	Avoid dust	Avoid dust
OTHER COMMENTS	ASTM tested for lightfastness only; test before use	ASTM tested for lightfastness only; test before use	ASTM tested for lightfastness only; test before use; used in industrial paints, printing inks, plastics

TABLE 7.1. PIGMENTS, CONT'D.

HUE	Orange	Red	Red
COMMON NAME	Benzimidazolone orange H5G	Naphthol, ITR	Naphthol, AS-TR
COLOUR INDEX NAME (AND NUMBER)	PO 62 (11775)	PR 5 (12490)	PR 7 (12420)
GENERIC NAME	Benzimidazolone	Naphthol, ITR coupling	Naphthol, AS-TR coupling
PROPRIETARY NAME(S)	Various (Orange H5G)	Naphthol carmine FB	Naphthol crimson
SYNONYM(S)			Various
DATES AND PLACE OF DISCOVERY	Modern	Modern	Modern
CHEMICAL CLASS	Organic	Organic	Organic
CONSTITUENTS	Acetoactyl "aniline derivative"	"Monoazo"; 3-Hydroxy-2-naphthanilide	"Monoazo"
SOURCE	Synthetic organic	Synthetic organic	Synthetic organic
TYPE	L	L	L
MELTING POINT (°C)	330	306 (decomposes)	NT
STABILITY TO (°C)	About 55	160	NT
LIGHTFASTNESS ASTM	O AE R A WC I I NT NT I	O AE R A WC II II NT NT NT	O AE R A WC I I I NT NT
USE IN VEHICLES			
Oil	x	F	x
Oil absorption	M	M	M
Drying rate	A	A	A
Film properties	G	G	G
Acrylic Solution	NT	F	F
Acrylic Emulsion	x	F	x
Alkyds	x	NT	NT
Transparent watercolor	x	NT	NT
Opaque watercolor	x	NT	NT
Tempera	x	NT	NT
Casein	x	NT	NT
Encaustic	x	NT	NT
Frescoes	x	NT	NT
Pastels	x	NT	NT
Experimental paints	NT	NT	NT
DRY REFRACTIVE INDEX	L	M	M
DRY CHARACTERISTICS	O	Bright BR	Bright R
HAZARDS	Avoid dust	Avoid dust	Avoid dust
OTHER COMMENTS	ASTM tested for lightfastness only; test before use	Only fair lightfastness; used in industrial printing inks, emulsions, rubber, linoleum	Better lightfastness than PR 5

TABLE 7.1. PIGMENTS, CONT'D.

HUE	Red	Red	Red
COMMON NAME	**Natural madder lake**	**Naphthol AS-OL**	**Naphthol AS-D**
COLOUR INDEX NAME (AND NUMBER)	NR 9 (Natural red 9) (75330) (75420)	PR 9 (12460)	PR 14 (12380)
GENERIC NAME	Madder lake	Naphthol red FRLL	Naphthol red FGR
PROPRIETARY NAME(S)	Rose madder	Permanent red FRLL	Permanent bordeaux FGR
SYNONYM(S)	Various	Various	Various
DATES AND PLACE OF DISCOVERY	1826	Modern	Modern
CHEMICAL CLASS	Organic	Organic	Organic
CONSTITUENTS	Ground root of *Rubia tinctorum* on alumina base	"Monoazo"	"Monoazo"
SOURCE	Natural organic	Synthetic organic	Synthetic organic
TYPE	L, E	L	L
MELTING POINT (°C)	NT	280	NT
STABILITY TO (°C)	300 (darkens)	150	140
LIGHTFASTNESS **ASTM**	O AE R A WC II NT NT NT NT	O AE R A WC II I NT I NT	O AE R A WC II II NT NT NT
USE IN VEHICLES			
Oil	VG	VG	VG
Oil absorption	M	H	M-H
Drying rate	A	A	A
Film properties	G	G	G
Acrylic Solution	NT	P	P
Acrylic Emulsion	NT	EX	VG
Alkyds	VG	P	VG
Transparent watercolor	VG	G	VG
Opaque watercolor	VG	G	VG
Tempera	VG	NT	VG
Casein	NT	G	VG
Encaustic	VG	NT	VG
Frescoes	P	P	VG
Pastels	F	F	F
Experimental paints	NT	NT	NT
DRY REFRACTIVE INDEX	L	M	M
DRY CHARACTERISTICS	YR > BR	Bright YR	BR
HAZARDS	Avoid dust	Avoid dust	Avoid dust
OTHER COMMENTS	Minimum lightfastness for artists' paints; formerly thought to be less lightfast than alizarin crimson; useful hue	Poor lightfastness in tints with white; poor resistance to organic solvents; not used in exterior paints; used in industrial printing inks, paper, linoleum	Minimum lightfastess; poor solvent resistance; not used in exterior paints; used in industrial printing inks, latex interior paints, paper, paper coatings

TABLE 7.1. PIGMENTS, CONT'D.

HUE	Red	Red	Red
COMMON NAME	**Alizarin crimson**	**Thioindigoid red**	**Indian red**
COLOUR INDEX NAME (AND NUMBER)	PR 83 (58000:1)	PR 88 MRS (73312)	PR 101 (77491) (77015) (77492) (77538)
GENERIC NAME	Alizarin crimson	Indigoid	Indian red, bluish
PROPRIETARY NAME(S)	Various	Various; Permanent red violet MRS	Various; Venetian red, Indian red
SYNONYM(S)		Various	Light red (yellowish/bluish), Red iron oxide
DATES AND PLACE OF DISCOVERY	1869: First synthesis of a natural organic pigment	Modern	Ancient (natural variety); modern (synthetic variety)
CHEMICAL CLASS	Organic	Organic	Inorganic
CONSTITUENTS	1:2 dihydroxyanthraquinone on alumina base	Acetic acid heated with concentrated sulfuric or chlorosulfonic acid	Iron oxide prepared from pulverized iron ore
SOURCE	Synthetic organic	Synthetic organic	Processed natural mineral
TYPE	L	L	P
MELTING POINT (°C)	NT	NT	Very high
STABILITY TO (°C)	300 (darkens)	175	Excellent

LIGHTFASTNESS ASTM	O	AE	R	A	WC		O	AE	R	A	WC		O	AE	R	A	WC
	III	NT	NT	III	NT		I	NT	I	NT	NT		I	I	I	NT	I

USE IN VEHICLES			
Oil	VG	x	x
Oil absorption	H	M	L
Drying rate	S	A	G
Film properties	F	G	G
Acrylic Solution	P	x	x
Acrylic Emulsion	P	x	x
Alkyds	F	NT	x
Transparent watercolor	F	x	x
Opaque watercolor	F	x	x
Tempera	F	x	x
Casein	P	NT	x
Encaustic	F	x	x
Frescoes	P	NT	x
Pastels	F	G	x
Experimental paints	NT	NT	x

DRY REFRACTIVE INDEX	L	M	H
DRY CHARACTERISTICS	YR > BR	RP	Depending on source, dull YO > YR > R > RBr
HAZARDS	Avoid dust	Avoid dust	Avoid dust
OTHER COMMENTS	Less than the minimum recommended lightfastness for artists' paints; useful hue	Lightfastness ratings apply only to PR 88 MRS supplied by American Hoechst Corporation; colorants named "thioindigoid" are notoriously unstable in light	Useful hue; weak tinting strength

TABLE 7.1. PIGMENTS, CONT'D.

HUE	Red	Red	Red
COMMON NAME	Light (or English) red oxide	Mars red (red iron oxide)	Mars violet (violet iron oxide)
COLOUR INDEX NAME (AND NUMBER)	PR 101 (77491) (77015) (77492) (77538)	PR 101 (77491)	PR 101 (77015)
GENERIC NAME	Light red oxide, yellowish	Red iron oxide	Violet iron oxide
PROPRIETARY NAME(S)	English red, Spanish red	Mars red	Mars violet
SYNONYM(S)	Earth red		
DATES AND PLACE OF DISCOVERY	Ancient > 1800s	1800s	1800s
CHEMICAL CLASS	Inorganic	Inorganic	Inorganic
CONSTITUENTS	Iron oxide prepared from pulverized iron ore	Synthesized iron oxide plus aluminum oxide	Synthesized iron oxide
SOURCE	Processed natural mineral	Synthetic inorganic	Synthetic inorganic
TYPE	P	P	P
MELTING POINT (°C)	Very high	Very high	Very high
STABILITY TO (°C)	Excellent	Excellent	Excellent
LIGHTFASTNESS ASTM	O AE R A WC I I NT NT I	O AE R A WC I I I NT I	O AE R A WC I I I NT I
USE IN VEHICLES			
Oil	x	x	x
Oil absorption	M	M	M
Drying rate	G	G	G
Film properties	G	G	G
Acrylic Solution	x	x	x
Acrylic Emulsion	x	x	x
Alkyds	x	x	x
Transparent watercolor	x	x	x
Opaque watercolor	x	x	x
Tempera	x	x	x
Casein	x	x	x
Encaustic	x	x	x
Frescoes	x	x	x
Pastels	x	x	x
Experimental paints	x	x	x
DRY REFRACTIVE INDEX	H	H	H
DRY CHARACTERISTICS	Depending on source, YR > R	Dull R	Dull RB
HAZARDS	Avoid dust	Avoid dust	Avoid dust
OTHER COMMENTS	Useful basic hue	Useful pigment; dense and heavy; more stable than natural counterpart; origin of "Mars" name uncertain	Very useful pigment; dense and heavy; origin of "Mars" name uncertain

TABLE 7.1. PIGMENTS, CONT'D.

HUE	Red	Red	Red
COMMON NAME	**Venetian red**	**Light red**	**Vermilion**
COLOUR INDEX NAME (AND NUMBER)	PR 101 (77491)	PR 102 (77491) (77492)	PR 106 (77766)
GENERIC NAME	Red iron oxide, yellowish	Light red	Mercuric sulfide
PROPRIETARY NAME(S)	Venetian red		Cinnabar, Chinese red
SYNONYM(S)	Venetian red		Cinnabar, Chinese red
DATES AND PLACE OF DISCOVERY	Ancient (natural variety); modern (synthetic variety)	Ancient	Ancient
CHEMICAL CLASS	Inorganic	Inorganic	Inorganic
CONSTITUENTS	Synthesized iron oxide plus calcium sulfate	Calcined yellow iron oxide	Mercuric sulfide
SOURCE	Natural processed mineral	Natural inorganic	Natural inorganic
TYPE	P	P	P
MELTING POINT (°C)	Very high	Very high	446
STABILITY TO (°C)	Excellent	Excellent	Excellent
LIGHTFASTNESS ASTM	O AE R A WC I I NT NT I	O AE R A WC I I NT NT NT	O AE R A WC I I NT NT NT
USE IN VEHICLES			
Oil	G	x	x
Oil absorption	L	M	L
Drying rate	G	G	G
Film properties	F	G	G
Acrylic Solution	x	x	x
Acrylic Emulsion	x	x	x
Alkyds	x	x	x
Transparent watercolor	x	x	P
Opaque watercolor	x	x	P
Tempera	x	x	P
Casein	x	x	P
Encaustic	x	x	P
Frescoes	x	x	P
Pastels	x	x	NT
Experimental paints	x	x	P
DRY REFRACTIVE INDEX	H	H	H
DRY CHARACTERISTICS	Dull YR > R (> BR)	Dull YR > R	Deep R
HAZARDS	Avoid dust	Avoid dust	Avoid dust; do not heat: metal fumes toxic
OTHER COMMENTS	Useful pigment; brittle films in oil have been reported	One of the best of the earth reds	Will darken in oil if impure or if exposed to polluted atmospheres; excellent hue but erratic; cadmiums do not replace its special hue and physical character

TABLE 7.1. PIGMENTS, CONT'D.

HUE	Red	Red	Red
COMMON NAME	Cadmium-barium red (light, medium, or deep)	Cadmium red (light, medium, or deep)	Naphthol AS-D
COLOUR INDEX NAME (AND NUMBER)	PR 108 (77202)	PR 108:1 (77202:1)	PR 112 (12370)
GENERIC NAME	Cadmium-barium red (light, medium, or deep)	Cadmium red (light, medium, or deep)	Naphthol red, AS-D coupling
PROPRIETARY NAME(S)			Naphthol red FGR, Permanent red FGR
SYNONYM(S)	Cadmium sulfoselenide, Lithopone red	C.P. Cadmium red	
DATES AND PLACE OF DISCOVERY	1926	1893(?)–1907	Modern
CHEMICAL CLASS	Inorganic	Inorganic	Organic
CONSTITUENTS	Cadmium sulfide + cadmium selenide + approximately 60% barium sulfate, calcined and co-precipitated	Cadmium sulfide + cadmium selenide, calcined and co-precipitated, concentrated but with up to 15% barium sulfate	"Monoazo"
SOURCE	Processed natural inorganic	Natural inorganic	Synthetic organic
TYPE	P, E	P	L
MELTING POINT (°C)	Very high	Very high	NT
STABILITY TO (°C)	500	500	180
LIGHTFASTNESS ASTM	O AE R A WC I I I I I	O AE R A WC I I NT NT I	O AE R A WC II II NT NT NT
USE IN VEHICLES Oil	x	x	VG
Oil absorption	L	L	M
Drying rate	G	G	A
Film properties	E	E	G
Acrylic Solution	x	x	NT
Acrylic Emulsion	x	x	VG
Alkyds	x	x	x
Transparent watercolor	x	x	x
Opaque watercolor	x	x	x
Tempera	x	x	x
Casein	x	x	x
Encaustic	x	x	x
Frescoes	x	x	NT
Pastels	x	x	NT
Experimental paints	x	x	NT
DRY REFRACTIVE INDEX	H	H	M
DRY CHARACTERISTICS	Bright YR > R > RB	Bright YR > RO > RB	Bright R > BR
HAZARDS	Avoid dust	Avoid dust; do not heat: metal fumes toxic	Avoid dust
OTHER COMMENTS	Excellent hue, with variety among different manufacturers	Same as cadmium-barium but more concentrated; expensive	Moderate resistance to solvents; very good lightfastness; good hue

TABLE 7.1. PIGMENTS, CONT'D.

HUE	Red	Red	Red
COMMON NAME	**Cadmium vermilion red (light, medium, or deep)**	**Cadmium-barium vermilion red (light, medium, or deep)**	**Naphthol red**
COLOUR INDEX **NAME (AND NUMBER)**	PR 113 (77201)	PR 113:1 (77201:1)	PR 119 (12469)
GENERIC NAME			Naphthol red
PROPRIETARY NAME(S)	Cadmium mercury red	Cadmium mercury, Lithopone red	(Mobay R6226)
SYNONYM(S)	Chinese red, French red	Chinese red, French red	
DATES AND PLACE OF DISCOVERY	Modern	Modern	Modern
CHEMICAL CLASS	Inorganic	Inorganic	Organic
CONSTITUENTS	Cadmium sulfide + mercury sulfide, concentrated but with up to 15% barium sulfate	Cadmium sulfide + mercury sulfide + approximately 60% barium sulfate	"Monoazo"
SOURCE	Synthetic inorganic	Synthetic inorganic	Synthetic organic
TYPE	P	P, E	L
MELTING POINT (°C)	Very high	Very high	Unknown
STABILITY TO (°C)	260	260	Unknown
LIGHTFASTNESS ASTM	O AE R A WC I I NT NT NT	O AE R A WC I I NT NT NT	O AE R A WC I I NT NT NT

USE IN VEHICLES

Oil	x	x	x
Oil absorption	L	L	NT
Drying rate	G	G	NT
Film properties	G	G	NT
Acrylic Solution	x	x	NT
Acrylic Emulsion	x	x	x
Alkyds	x	x	x
Transparent watercolor	NT	NT	NT
Opaque watercolor	NT	NT	NT
Tempera	x	x	NT
Casein	x	NT	NT
Encaustic	x	x	NT
Frescoes	NT	NT	NT
Pastels	NT	NT	NT
Experimental paints	NT	NT	NT

DRY REFRACTIVE INDEX	H	H	M
DRY CHARACTERISTICS	YR > Deep BR	YR > Deep BR	Bright R
HAZARDS	Avoid dust; do not heat: metal fumes toxic (cadmium *and* mercury)	Avoid dust; do not heat: metal fumes toxic (cadmium *and* mercury)	Avoid dust
OTHER COMMENTS	Rich, deep hue; poor exterior resistance; 15% barium sulfate used for hue development and manufacturing control; less expensive than C.P. cadmium	Same as PR 113 but weaker tinting strength because of barium extender	New pigment; little information available; ASTM test for lightfastness only

TABLE 7.1. PIGMENTS, CONT'D.

HUE	Red	Red	Red
COMMON NAME	Quinacridone magenta	Perylene vermilion	Perylene
COLOUR INDEX NAME (AND NUMBER)	PR 122 (73915)	PR 123 (71145)	PR 149 (71137)
GENERIC NAME	Quinacridone magenta	Perylene	Perylene
PROPRIETARY NAME(S)	Acra violet or red, Quinacridone magenta	Perylene vermilion	Perylene red
SYNONYM(S)	Quinacridone magenta		
DATES AND PLACE OF DISCOVERY	Modern	Modern	Modern
CHEMICAL CLASS	Organic	Organic	Organic
CONSTITUENTS	"Linear quinacridone"; 2,9-Dimethyl derivative of cyclized 2,5 diarylaminoterephalic acid	"Anthraqinone derivative," a perelene-tetracarboxylic anhydride condensed with p-ethoxyaniline	"Anthraqinone derivative"
SOURCE	Synthetic organic	Synthetic organic	Synthetic organic
TYPE	L	T, L	L
MELTING POINT (°C)	NT	NT	NT
STABILITY TO (°C)	150	150	200
LIGHTFASTNESS ASTM	O AE R A WC I I I I NT	O AE R A WC I II NT NT NT	O AE R A WC I I NT NT NT

USE IN VEHICLES			
Oil	x	x	x
Oil absorption	M	M	M
Drying rate	A	A	A
Film properties	G	G	G
Acrylic Solution	NT	NT	NT
Acrylic Emulsion	x	VG	x
Alkyds	x	NT	NT
Transparent watercolor	x	NT	x
Opaque watercolor	x	NT	x
Tempera	x	NT	x
Casein	x	NT	x
Encaustic	x	NT	x
Frescoes	x	NT	NT
Pastels	x	NT	x
Experimental paints	NT	NT	NT
DRY REFRACTIVE INDEX	M	L	M
DRY CHARACTERISTICS	Bright BR	R	R
HAZARDS	Avoid dust	Avoid dust	Avoid dust
OTHER COMMENTS	Durable pigment; weak tinting strength but useful	Good hue though weak chroma in tints; used in auto paints, alkyd resin enamels, vinyl and acrylic lacquers, printing inks, plastics	Probably similar to PR 123 but is untested except for ASTM lightfastness

TABLE 7.1. PIGMENTS, CONT'D.

HUE	Red	Red	Red
COMMON NAME	Brominated anthanthrone	Naphthol F3RK-70	Naphthol F5RK
COLOUR INDEX NAME (AND NUMBER)	PR 168 (59300)	PR 170 (12475)	PR 170 (12475)
GENERIC NAME	Brominated anthanthrone	Naphthol carbamide	Naphthol carbamide
PROPRIETARY NAME(S)	Brominated anthanthrone red	Hoechst F3RK-70, Naphthol red F3RK	Hoechst F5RK, Naphthol red F5RK
SYNONYM(S)			
DATES AND PLACE OF DISCOVERY	Modern	Modern	Modern
CHEMICAL CLASS	Organic	Organic	Organic
CONSTITUENTS	"Anthraqinone derivative," bromated anthanthrone	"Monoazo"; same as PR 7 but with different coupling specified structure in CI	"Monoazo" same as PR 7 but with different coupling specified structure in CI
SOURCE	Synthetic organic	Synthetic organic	Synthetic organic
TYPE	L	L	L
MELTING POINT (°C)	NT	NT	NT
STABILITY TO (°C)	NT	160	160
LIGHTFASTNESS ASTM	O AE R A WC II I NT NT NT	O AE R A WC II I NT NT NT	O AE R A WC II II NT NT NT
USE IN VEHICLES			
Oil	x	G	G
Oil absorption	M	M	M
Drying rate	A	A	A
Film properties	G	G	G
Acrylic Solution	NT	NT	NT
Acrylic Emulsion	x	x	x
Alkyds	NT	NT	NT
Transparent watercolor	NT	NT	NT
Opaque watercolor	NT	NT	NT
Tempera	NT	NT	NT
Casein	NT	NT	NT
Encaustic	NT	NT	NT
Frescoes	NT	NT	NT
Pastels	NT	NT	NT
Experimental paints	NT	NT	NT
DRY REFRACTIVE INDEX	L	H, M	H, M
DRY CHARACTERISTICS	Bright YR	BR	BR
HAZARDS	Avoid dust	Avoid dust	Avoid dust
OTHER COMMENTS	New untested pigment except for ASTM lightfastness; rated as excellent in some industrial applications	Used in industrial printing inks, lacquers, emulsion paints; solubility in organic solvents makes artists' use doubtful; ASTM test for lightfastness only	Used in industrial printing inks, lacquers, emulsion paints; solubility in organic solvents makes artists' use doubtful; ASTM test for lightfastness only

TABLE 7.1. PIGMENTS, CONT'D.

HUE	Red	Red	Red
COMMON NAME	Benzimidazolone bordeaux	Benzimidazolone maroon	Perylene maroon
COLOUR INDEX NAME (AND NUMBER)	PR 171	PR 175 (12513)	PR 177 (65300)
GENERIC NAME	Benzimidazolone red	Benzimidazolone red	Perylene maroon
PROPRIETARY NAME(S)	Benzimidazolone bordeaux (Golden)	Benzimidazolone maroon HFM	
SYNONYM(S)			
DATES AND PLACE OF DISCOVERY	Modern	Modern	Modern
CHEMICAL CLASS	Organic	Organic	Organic
CONSTITUENTS	"Monoazo": "cyclic carbonamide"; similar to other monoazo pigments	"Monoazo": "cyclic carbonamide"; similar to other monoazo pigments	
SOURCE	Synthetic organic	Synthetic organic	Synthetic organic
TYPE	L	L	L
MELTING POINT (°C)	220	NT	NT
STABILITY TO (°C)	NT	220	NT
LIGHTFASTNESS ASTM	O AE R A WC NT I NT NT NT	O AE R A WC NT I NT NT NT	O AE R A WC NT NT I NT NT
USE IN VEHICLES			
Oil	NT	x	Resin-oil paints only
Oil absorption	M	M	NT
Drying rate	A	A	NT
Film properties	G	G	NT
Acrylic Solution	NT	NT	NT
Acrylic Emulsion	x	x	NT
Alkyds	NT	x	NT
Transparent watercolor	NT	x	NT
Opaque watercolor	NT	x	NT
Tempera	NT	x	NT
Casein	NT	x	NT
Encaustic	NT	x	NT
Frescoes	NT	x	NT
Pastels	NT	x	NT
Experimental paints	NT	NT	NT
DRY REFRACTIVE INDEX	M	M	M
DRY CHARACTERISTICS	R > BR	R > BR	R > BR
HAZARDS	Avoid dust	Avoid dust	Avoid dust
OTHER COMMENTS	Used by Golden Artists Colors in its acrylic emulsion paints	Fair solubility in organic solvents; ASTM test for lightfastness only; used in industrial inks, PVC plastics, lacquers, latex emulsion paints	Used by Schmincke in its resin-oil paints

TABLE 7.1. PIGMENTS, CONT'D.

HUE	Red	Red	Red
COMMON NAME	**Perylene maroon**	**Perylene maroon**	**Thioindigoid red**
COLOUR INDEX **NAME (AND NUMBER)**	PR 178 (71155)	PR 179 (71130)	PR 181 (73360)
GENERIC NAME	Perylene maroon	Perylene	Thioindigoid
PROPRIETARY NAME(S)		Perylene maroon	
SYNONYM(S)			
DATES AND PLACE OF DISCOVERY	Modern	Modern	1907
CHEMICAL CLASS	Organic	Organic	Organic
CONSTITUENTS		"Anthraquinone derivative"; similar to PR 123, although molecular structure is different	Oxidized 6-chloro-4-methyl-3 (2H)-thianaphthenone
SOURCE	Synthetic organic	Synthetic organic	Synthetic organic
TYPE	L	L	L
MELTING POINT (°C)	NT	NT	NT
STABILITY TO (°C)	NT	NT	NT
LIGHTFASTNESS	O AE R A WC	O AE R A WC	O AE R A WC
ASTM	NT NT I NT NT	I I NT NT NT	NR I NT NT NT
USE IN VEHICLES			
Oil	Resin-oil paints only	x	P
Oil absorption	NT	L	NT
Drying rate	NT	A	NT
Film properties	NT	G	NT
Acrylic Solution	NT	NT	NT
Acrylic Emulsion	NT	x	x
Alkyds	NT	x	NT
Transparent watercolor	NT	NT	NT
Opaque watercolor	NT	NT	NT
Tempera	NT	NT	NT
Casein	NT	NT	NT
Encaustic	NT	x	NT
Frescoes	NT	NT	NT
Pastels	NT	NT	NT
Experimental paints	NT	NT	NT
DRY REFRACTIVE INDEX	M	L	NT
DRY CHARACTERISTICS	R > BR	Dull R	Bright pink > BR
HAZARDS	Avoid dust	Avoid dust	Not documented but avoid dust
OTHER COMMENTS	Used by Schmincke in its resin-oil paints	ASTM test for lightfastness only; test before use	ASTM test for lightfastness only; test before use; textile vat dye but poorly documented in artists' materials

TABLE 7.1. PIGMENTS, CONT'D.

HUE	Red	Red	Red
COMMON NAME	**Naphthol AS**	**Perylene red, red deep**	**Quinacridone red**
COLOUR INDEX **NAME (AND NUMBER)**	PR 188 (12467)	PR 190 (71140), PR 194 (71100)	PR 192 (n/a)
GENERIC NAME	Naphthol red HF3S	Perylene	Quinacridone red ¥
PROPRIETARY NAME(S)	Naphthol red HF3S		Acra red
SYNONYM(S)			
DATES AND PLACE OF DISCOVERY	Modern	Modern	Modern; 1930s–1950s
CHEMICAL CLASS	Organic	Organic	Organic
CONSTITUENTS	"Monoazo" same as PR 7 but with different coupling specified structure in *CI*	"Perylene"; structure specified in *CI*; similar to other perylenes	"Linear quinacridone red ¥"; structure specified in *CI*; see PR 207
SOURCE	Synthetic organic	Synthetic organic	Synthetic organic
TYPE	L	L	L
MELTING POINT (°C)	NT	NT	NT
STABILITY TO (°C)	200	NT	NT
LIGHTFASTNESS ASTM	O AE R A WC I I NT NT NT	O AE R A WC I I NT NT NT	O AE R A WC I I NT NT NT
USE IN VEHICLES			
Oil	x	x	x
Oil absorption	H	NT	NT
Drying rate	NT	NT	NT
Film properties	NT	NT	NT
Acrylic Solution	NT	G	NT
Acrylic Emulsion	x	x	x
Alkyds	NT	G	NT·
Transparent watercolor	x	x	NT
Opaque watercolor	x	x	NT
Tempera	x	x	NT
Casein	x	x (NT)	NT
Encaustic	x	NT	NT
Frescoes	NT	NT	NT
Pastels	x	x	NT
Experimental paints	NT	NT	NT
DRY REFRACTIVE INDEX	M	M	M
DRY CHARACTERISTICS	YR (orange)	R	Bright YR
HAZARDS	Avoid dust	Avoid dust	Avoid dust
OTHER COMMENTS	ASTM test for lightfastness only; test before use; fair solvent resistance; used in PVC plastics, industrial printing inks and lacquers	ASTM test for lightfastness only; test before use; used in industrial printing inks, vinyls, auto paints	ASTM test for lightfastness only; test before use

TABLE 7.1. PIGMENTS, CONT'D.

HUE	Red	Red	Purple
COMMON NAME	**Quinacridone scarlet**	**Pyrrole red**	**Cobalt violet**
COLOUR INDEX NAME (AND NUMBER)	PR 207 (n/a)	PR 254 (n/a)	PV 14 (77360)
GENERIC NAME	Quinacridone scarlet	Pyrrolo-pyrrole red	Cobalt violet
PROPRIETARY NAME(S)	Acra scarlet	Pyrrole red (Golden)	
SYNONYM(S)			
DATES AND PLACE OF DISCOVERY	Modern; 1930s–1950s	Modern	1859
CHEMICAL CLASS	Organic	Organic	Inorganic
CONSTITUENTS	"Linear quinacridone"; derivative of cyclized 2,5 diarylaminoterephtalic acid	Pyrrolopyrrol	Calcined cobalt oxide and phosphorous oxide
SOURCE	Synthetic organic	Synthetic organic	Processed natural inorganic
TYPE	L	L	P
MELTING POINT (°C)	NT	NT	NT
STABILITY TO (°C)	300 (darkens)	NT	700

LIGHTFASTNESS ASTM	O	AE	R	A	WC	O	AE	R	A	WC	O	AE	R	A	WC
	I	I	NT	NT	NT	NT	I	NT	NT	NT	I	NT	I	NT	I

USE IN VEHICLES			
Oil	x	x	x
Oil absorption	M	NT	L
Drying rate	A	NT	G
Film properties	G	NT	G
Acrylic Solution	x	NT	x
Acrylic Emulsion	x	x	NT (P)
Alkyds	x	NT	x
Transparent watercolor	x	NT	x
Opaque watercolor	x	NT	x
Tempera	x	NT	x
Casein	x	NT	x
Encaustic	x	NT	x
Frescoes	NT	NT	x
Pastels	x	NT	x
Experimental paints	NT	NT	x

DRY REFRACTIVE INDEX	L	M-H	H
DRY CHARACTERISTICS	YR	R	P
HAZARDS	Avoid dust	Avoid dust	Avoid dust; metallic cobalt is a slight hazard
OTHER COMMENTS	High-quality pigment widely used in industry; performs well in artists' paints	Used by Golden Artists Colors and Daniel Smith in their paints; lightfastness tests incomplete but so far rated I. *A notable pigment: a duplication of the cadmiums, and a nearly opaque organic*	Widely used in many applications; weak tinter with dull chroma; *cobalt arsenate* is *toxic* [$CO_3(AsO_4)_2$], rarely found today but formerly the pigment used for this hue

TABLE 7.1. PIGMENTS, CONT'D.

HUE	Purple	Purple	Purple
COMMON NAME	**Ultramarine red**	**Ultramarine violet**	**Manganese violet**
COLOUR INDEX NAME (AND NUMBER)	PV 15 (77007)	PV 15 (77007)	PV 16 (77742)
GENERIC NAME	Ultramarine red	Ultramarine red	Manganese violet
PROPRIETARY NAME(S)			
SYNONYM(S)			Mineral violet
DATES AND PLACE OF DISCOVERY	1828 (?)	1828 (?)	1868
CHEMICAL CLASS	Inorganic	Inorganic	Inorganic
CONSTITUENTS	Complex silicate of sodium and aluminum with sulfur	Complex silicate of sodium and aluminum with sulfur	Manganese ammonium pyrophosphate
SOURCE	Synthetic inorganic	Synthetic inorganic	Synthetic inorganic
TYPE	P	P	P
MELTING POINT (°C)	NT	NT	NT
STABILITY TO (°C)	NT	NT	NT
LIGHTFASTNESS ASTM	O AE R A WC I I I NT I	O AE R A WC I I I NT I	O AE R A WC I NT NT NT I
USE IN VEHICLES			
Oil	x	x	x
Oil absorption	M	M	L
Drying rate	A	A	G
Film properties	G	G	G
Acrylic Solution	x	x	NT
Acrylic Emulsion	x	x	P
Alkyds	x	x	x
Transparent watercolor	x	x	x
Opaque watercolor	x	x	x
Tempera	x	x	x
Casein	NT	NT	NT (P?)
Encaustic	x	x	x
Frescoes	P	P	P
Pastels	x	x	x
Experimental paints	NT	NT	NT
DRY REFRACTIVE INDEX	H in water, L in oil	H in water, L in oil	M
DRY CHARACTERISTICS	P	P	BP
HAZARDS	Avoid dust	Avoid dust	Avoid dust
OTHER COMMENTS	A weak pigment but with good chroma and lightfastness; sensitive to alkalines, acids, and some metals	A weak pigment but with good chroma and lightfastness; sensitive to alkalines, acids, and some metals	Good but expensive hue; sensitive to alkali

TABLE 7.1. PIGMENTS, CONT'D.

HUE	Purple	Purple	Purple
COMMON NAME	**Quinacridone violet**	**Quinacridone red**	**Dioxazine purple**
COLOUR INDEX NAME (AND NUMBER)	PV 19 (45600) (73900)	PV 19 (73900)	PV 23 RS (red shade) (51319)
GENERIC NAME	Quinacridone violet b	Quinacridone red ¥, Quinacridone violet	Dioxazine violet
PROPRIETARY NAME(S)	Acra violet	Acra violet	Carbazole violet
SYNONYM(S)			
DATES AND PLACE OF DISCOVERY	1930s–1950s	Modern; 1930s–1950s	Modern
CHEMICAL CLASS	Organic	Organic	Organic
CONSTITUENTS	"Linear quinacridone, red b"; same as PR 207 with different particle size and configuration	"Linear quinacridone, red ¥"; same as PR 207 with different particle size	Carbazole dioxazine, a complex condensation of 3-Amino-9-ethyl-cabazole with chloranil in trichlorobenzene
SOURCE	Synthetic organic	Synthetic organic	Synthetic organic
TYPE	L	L	L
MELTING POINT (°C)	NT	NT	NT
STABILITY TO (°C)	165	300 (darkens)	150

LIGHTFASTNESS ASTM	O	AE	R	A	WC	O	AE	R	A	WC	O	AE	R	A	WC
	I	I	I	I	II	I	I	NT	NT	II	I	II	NT	I	NT

USE IN VEHICLES			
Oil	x	x	x
Oil absorption	M	M	M
Drying rate	A	A	A
Film properties	G	G	G
Acrylic Solution	x	x	x (G)
Acrylic Emulsion	x	x	VG
Alkyds	x	x	x
Transparent watercolor	x	x	x
Opaque watercolor	x	x	x
Tempera	x	x	x
Casein	x	x	x
Encaustic	x	x	NT
Frescoes	NT	NT	NT
Pastels	x	x	x
Experimental paints	NT	NT	NT

DRY REFRACTIVE INDEX	L	L	L
DRY CHARACTERISTICS	Bright P	Bright P > RP	BP
HAZARDS	Avoid dust	Avoid dust	Avoid dust
OTHER COMMENTS	High-quality pigment widely used in industry; performs well in artists' paints	High-quality pigment widely used in industry; performs well in artists' paints; could be the source of a new substitute for alizarin crimson	Excellent hue with good tinting strength and lightfastness; resistance to solvents requires testing before use; PV 23 BS (blue shade) has less lightfastness (II in oil, NR in acrylic emulsions)

TABLE 7.1. PIGMENTS, CONT'D.

HUE	Purple	Purple	Blue
COMMON NAME	**Dioxazine purple**	**Isoviolanthrone violet**	**Phthalocyanine blue**
COLOUR INDEX **NAME (AND NUMBER)**	PV 23 BS (blue shade) (51319)	PV 31 (60010)	PB 15 (74160)
GENERIC NAME	Dioxazine violet	Isoviolanthrone	Phthalocyanine blue (red shade)
PROPRIETARY NAME(S)	Carbazole violet	Indanthrebrilliant-violet RR, 4R	Thalo, Phthalo, Winsor, Monastral, etc.
SYNONYM(S)			
DATES AND PLACE OF DISCOVERY	Modern	1909	1928–1935
CHEMICAL CLASS	Organic	Organic	Organic
CONSTITUENTS	Carbazole dioxazine; see PV 23 RS (red shade)	Anthraquinone derivative: dichlorobenzanthrone treated with an alkali	Copper phthalocyanine, alpha form
SOURCE	Synthetic organic	Synthetic organic	Synthetic organic
TYPE	L	L	L, E
MELTING POINT (°C)	NT	NT	NT
STABILITY TO (°C)	150	NT	150
LIGHTFASTNESS ASTM	O AE R A WC II NR NT NT NT	O AE R A WC I I NT NT NT	O AE R A WC I I NT I II
USE IN VEHICLES			
Oil	x	x	x
Oil absorption	M	M	M
Drying rate	A	A	G
Film properties	G	G	E
Acrylic Solution	G	NT	x
Acrylic Emulsion	VG	x	x
Alkyds	x	NT	x
Transparent watercolor	x	NT	x
Opaque watercolor	x	NT	x
Tempera	x	NT	x
Casein	x	NT	x
Encaustic	NT	NT	x
Frescoes	NT	NT	x (?)
Pastels	x	NT	x
Experimental paints	NT	NT	x
DRY REFRACTIVE INDEX	L	L	L
DRY CHARACTERISTICS	BP	BP	Bright RB
HAZARDS	Avoid dust	Avoid dust	Avoid dust; copper may be of some concern
OTHER COMMENTS	This pigment is less lightfast than PV 23 RS	ASTM test for lightfastness only; test before use	Most widely used pigment in artistic and industrial applications; must be greatly extended because of very high tinting strength; red shade blue more susceptible to solvents than (74100)

TABLE 7.1. PIGMENTS, CONT'D.

HUE	Blue	Blue	Blue
COMMON NAME	**Phthalocyanine blue**	**Indanthrone blue**	**Prussian blue**
COLOUR INDEX NAME (AND NUMBER)	PB 16 (74100)	PB 22 (69810)	PB 27 (77510)
GENERIC NAME	Phthalocyanine blue (metal-free)	Indanthrone, green shade	Prussian blue
PROPRIETARY NAME(S)	Thalo, Phthalo, Winsor, Monastral, etc.	Indanthrone	
SYNONYM(S)			Pris, Milori, Chinese
DATES AND PLACE OF DISCOVERY	1928–1935	1903	1704, the earliest synthetic mineral pigment
CHEMICAL CLASS	Organic	Organic	Inorganic
CONSTITUENTS	Metal-free copper phthalocyanine	Indanthrone chlorinated with sulfuryl chloride	Ferri-ammonium ferrocyanide (ferric ammonium ferrocyanide)
SOURCE	Synthetic organic	Synthetic organic	Synthetic inorganic
TYPE	L, E	L	P
MELTING POINT (°C)	NT	NT	NT
STABILITY TO (°C)	150	400	120 (darkens)
LIGHTFASTNESS ASTM	O AE R A WC I I I NT NT	O AE R A WC I I NT NT NT	O AE R A WC I NT I I I

USE IN VEHICLES

Oil	x	x	x
Oil absorption	M	NT	M
Drying rate	G	NT	G
Film properties	E	G	G
Acrylic Solution	x	NT	x
Acrylic Emulsion	x	x	P
Alkyds	x	x	x
Transparent watercolor	x	x	x
Opaque watercolor	x	x	x
Tempera	x	x	NT
Casein	x	x	NT (P)
Encaustic	x	x	NT
Frescoes	x (?)	P	NT
Pastels	x	x	x
Experimental paints	x	NT	NT

DRY REFRACTIVE INDEX	L	M	H
DRY CHARACTERISTICS	Bright GB	RB > Bright B	B
HAZARDS	Avoid dust	Avoid dust	Avoid dust
OTHER COMMENTS	Same as PB 15 (74160) but with better resistance to solvents; will flocculate if improperly formulated in a paint system; will bronze if used full strength	ASTM test for lightfastness only	Some dispute over the name: the Milori variety is claimed to be more stable but Prussian name is better known; a widely used and reliable pigment, unstable in alkaline vehicles and high heat

TABLE 7.1. PIGMENTS, CONT'D.

HUE	Blue	Blue	Blue
COMMON NAME	**Cobalt blue**	**Ultramarine blue**	**Manganese blue**
COLOUR INDEX **NAME (AND NUMBER)**	PB 28 (77346)	PB 29 (77007)	PB 33 (77112)
GENERIC NAME	Cobalt blue	Ultramarine blue	Manganese blue
PROPRIETARY NAME(S)	Cobalt blue	French ultramarine, etc.	Manganese blue, Cement blue, etc.
SYNONYM(S)			
DATES AND PLACE OF DISCOVERY	1802	Natural: 1200–1300; artificial: 1828 (accidentally)	1935
CHEMICAL CLASS	Inorganic	Inorganic	Inorganic
CONSTITUENTS	Oxides of cobalt and aluminum	Natural: Semiprecious gem, lapis lazuli, washed and ground; Artificial: Complex silicate of sodium and aluminum with sulfur	Barium manganate + barium sulfate
SOURCE	Synthetic inorganic	Processed natural inorganic, or synthetic inorganic	Synthetic inorganic
TYPE	P	P	P
MELTING POINT (°C)	NT	NT	NT
STABILITY TO (°C)	900–1000	300	NT
LIGHTFASTNESS ASTM	O AE R A WC I I I I I	O AE R A WC I I I I I	O AE R A WC I I I NT I
USE IN VEHICLES			
Oil	x	x	x
Oil absorption	L	M	M
Drying rate	A	A-S	G
Film properties	G	G	G
Acrylic Solution	x	x	x
Acrylic Emulsion	x	x	x
Alkyds	x	x	x
Transparent watercolor	x	x	G
Opaque watercolor	x	x	G
Tempera	x	x	x
Casein	x	x	x
Encaustic	x	x	x
Frescoes	x	NT (turns W in calcium ions)	x
Pastels	x	x	x
Experimental paints	x	x	NT
DRY REFRACTIVE INDEX	H	H	M
DRY CHARACTERISTICS	Dark B	Bright B	GB
HAZARDS	Avoid dust; cobalt content may be a hazard	Avoid dust	Avoid dust; manganese content may be a hazard
OTHER COMMENTS	Unique hue, valuable in violet mixtures; sometimes imitated by mixtures of ultramarine	Reliable and brilliant; lapis often specified in medieval paintings; weak tinting strength, and makes dull violets with reds	Reliable; weak tinting strength; affected by sodium and aluminum sulfates

TABLE 7.1. PIGMENTS, CONT'D.

HUE	Blue	Blue	Blue
COMMON NAME	**Cerulean blue**	**Cerulean blue, chromium**	**Indanthrone blue**
COLOUR INDEX **NAME (AND NUMBER)**	PB 35 (77368)	PB 36 (77343)	PB 60 (69800)
GENERIC NAME	Cerulean blue	Cerulean blue, chromium	Indanthrone blue, red shade
PROPRIETARY NAME(S)		Cobalt aluminate	
SYNONYM(S)	Coeruleum Blue, etc.		
DATES AND PLACE OF DISCOVERY	1860	Modern	Modern
CHEMICAL CLASS	Inorganic	Inorganic	Organic
CONSTITUENTS	Oxides of cobalt and tin; cobalt sulfate calcined with stannous chloride and chalk	Oxides of cobalt and chromium	Anthraquinone derivative: aminoanthraquinone with potassium hydroxide and a potassium salt
SOURCE	Processed synthetic inorganic	Processed synthetic inorganic	Synthetic inorganic
TYPE	P	P	L
MELTING POINT (°C)	NT	NT	NT
STABILITY TO (°C)	NT	NT	200
LIGHTFASTNESS ASTM	O AE R A WC NT NT NT NT NT	O AE R A WC I I I NT I	O AE R A WC I I I NT NT
USE IN VEHICLES			
Oil	x	x	x
Oil absorption	M	L	M
Drying rate	A	A	A
Film properties	G	G	G
Acrylic Solution	x	x	NT
Acrylic Emulsion	x	x	x
Alkyds	x	x	X
Transparent watercolor	x	x	NT (x)
Opaque watercolor	x	x	NT (x)
Tempera	x	x	NT (x)
Casein	x	x	NT (x)
Encaustic	x	x	x
Frescoes	x	x	NT
Pastels	x	x	x
Experimental paints	x	x	NT
DRY REFRACTIVE INDEX	M	H	M
DRY CHARACTERISTICS	Clear bright GB	B > GB	RB
HAZARDS	Avoid dust; cobalt may be a hazard	Avoid dust; cobalt may be a hazard	Avoid dust
OTHER COMMENTS	"Sky blue"; reliable and inimitable, though expensive hue	A variety of cobalt blue (PB 28) made with chromium to give it the cerulean hue	Excellent lightfastness in tints but loses chroma when reduced too greatly; expensive, and ASTM test for lightfastness only, so test before use

TABLE 7.1. PIGMENTS, CONT'D.

HUE	Green	Green	Green
COMMON NAME	Phthalocyanine green	Green gold	Chromium oxide green
COLOUR INDEX NAME (AND NUMBER)	PG 7 (74260)	PG 10 (12775)	PG 17 (77288)
GENERIC NAME	Phthalocyanine green	Nickel azo yellow	Chromium oxide green
PROPRIETARY NAME(S)	Thalo, Phthalo, Monastral, etc.		
SYNONYM(S)			
DATES AND PLACE OF DISCOVERY	1935–1938	1946	1862
CHEMICAL CLASS	Organic	Organic	Inorganic
CONSTITUENTS	Chlorinated copper phthalocyanine (polychloro copper phthalocyanine)	"Monoazo"; nickel chelated azo, with structure specified in CI	Anhydrous chromium sesquioxide
SOURCE	Synthetic organic	Synthetic organic	Processed synthetic inorganic
TYPE	L, E	L	P
MELTING POINT (°C)	NT	NT	NT
STABILITY TO (°C)	150	190	900–1000

LIGHTFASTNESS ASTM	O	AE	R	A	WC	O	AE	R	A	WC	O	AE	R	A	WC
	I	I	I	I	I	I	I	NT	NT	NT	I	I	I	NT	I

USE IN VEHICLES			
Oil	x	x	x
Oil absorption	M	M	L-M
Drying rate	A	A	A
Film properties	G	G	G
Acrylic Solution	x	x	x
Acrylic Emulsion	x	x	x
Alkyds	x	x	x
Transparent watercolor	x	x	x
Opaque watercolor	x	x	x
Tempera	x	x	x
Casein	x	x	x
Encaustic	x	x	x
Frescoes	x	NT	x
Pastels	x	x	x
Experimental paints	x	x	x
DRY REFRACTIVE INDEX	L	L	M
DRY CHARACTERISTICS	Bright G	YG	Dull YG > G
HAZARDS	Avoid dust; copper may be a slight hazard	Avoid dust; nickel may be a slight hazard	Avoid dust; chromium may be a slight hazard
OTHER COMMENTS	Widely used in artistic and industrial applications; flocculates in some paint systems; very strong tinter that must be extended	Unusual hue with excellent lightfastness; used in auto paints and other exterior applications; weak tinter	Excellent all-round colorant, but with low chroma and weak tinting strength; used in industrial plastics, enamels, ceramics, printing inks for currency

TABLE 7.1. PIGMENTS, CONT'D.

HUE	Green	Green	Green
COMMON NAME	**Viridian**	**Cobalt green**	**Green earth**
COLOUR INDEX NAME (AND NUMBER)	PG 18 (77289)	PG 19 (77335)	PG 23 (77009)
GENERIC NAME	Hydrated chromium oxide green	Cobalt green	Green earth
PROPRIETARY NAME(S)	Verte emeraud, Emerald green, Guiget's green	Rinmann's green, Gellert green	Green earth, Terre verte
SYNONYM(S)			Terre verte, Green sand, Green stone
DATES AND PLACE OF DISCOVERY	1838	1780s	Roman
CHEMICAL CLASS	Inorganic	Inorganic	Inorganic
CONSTITUENTS	Hydrous chromium sesquioxide	Calcine oxides of cobalt and zinc	Natural greenish clay, colored by iron oxides, aluminum, potassium, and magnesium
SOURCE	Processed synthetic inorganic	Processed synthetic inorganic	Processed natural inorganic
TYPE	P	P	P
MELTING POINT (°C)	NT	NT	NT
STABILITY TO (°C)	250 (blackens)	NT	Fair (turns BrR)

LIGHTFASTNESS ASTM	O	AE	R	A	WC	O	AE	R	A	WC	O	AE	R	A	WC
	I	NT	NT	I	I	I	I	I	NT	I	I	I	I	I	NT

USE IN VEHICLES			
Oil	x	x	x
Oil absorption	M	M	H
Drying rate	A	A	S
Film properties	G	G	F
Acrylic Solution	x	x	x
Acrylic Emulsion	P	x	x
Alkyds	x	x	x
Transparent watercolor	NT	x	x
Opaque watercolor	NT	x	x
Tempera	x	x	x
Casein	NT	x	x
Encaustic	x	x	x
Frescoes	NT	NT	x
Pastels	x	x	x
Experimental paints	NT	x	x

DRY REFRACTIVE INDEX	L	H	L
DRY CHARACTERISTICS	BG > G	Dull YG > BG	Dull Gray G > YG Gray
HAZARDS	Avoid dust; chromium may be a hazard	Avoid dust; cobalt may be a hazard	Avoid dust
OTHER COMMENTS	Brighter than PG 17 but still with low chroma and weak tinting strength; widely used in industry		Weak, transparent colorant but of unusual hue; difficult to obtain; often imitated; the classical underpainting color for medieval egg temperas

TABLE 7.1. PIGMENTS, CONT'D.

HUE	Green	Brown	Brown
COMMON NAME	Phthalocyanine green	Mars brown (brown iron oxide)	Burnt sienna
COLOUR INDEX NAME (AND NUMBER)	PG 36 (74265)	PBr 6 (77499)	PBr 7 (77492)
GENERIC NAME	Phthalocyanine green	Brown iron oxide	Brown iron oxide
PROPRIETARY NAME(S)	Thalo, Phthalo, Monastral, etc.	Mars brown	
SYNONYM(S)			Burnt siena, Spanish red, Caput mortuum, Van Dyke brown
DATES AND PLACE OF DISCOVERY	1935–1938	1800s	Prehistoric
CHEMICAL CLASS	Organic	Inorganic	Inorganic
CONSTITUENTS	Brominated and chlorinated copper phthalocyanine, a derivative of Phthalocyanine blue, PB 15	Synthetic brown iron oxide or blends of synthetic iron oxides PY 42, PR 101, and PBk 11	Calcined natural iron oxide
SOURCE	Synthetic organic	Synthetic inorganic	Processed natural inorganic
TYPE	L, E	P	P
MELTING POINT (°C)	NT	NT	NT
STABILITY TO (°C)	300	150	150
LIGHTFASTNESS ASTM	O AE R A WC I I I NT NT	O AE R A WC I I I NT NT	O AE R A WC I I I I I
USE IN VEHICLES			
Oil	x	x	x
Oil absorption	M	L-M	L
Drying rate	A	A	A
Film properties	G	E	G
Acrylic Solution	x	x	x
Acrylic Emulsion	x	x	x
Alkyds	x	x	x
Transparent watercolor	x	x	x
Opaque watercolor	x	x	x
Tempera	x	x	x
Casein	x	x	x
Encaustic	x	x	x
Frescoes	x	x	x
Pastels	x	x	x
Experimental paints	x	x	x
DRY REFRACTIVE INDEX	L	H	L-H
DRY CHARACTERISTICS	Bright G > YG	Light Br > dark RBr	Light RBr > RBr > dark RBr > PBr
HAZARDS	Avoid dust; copper may be a slight hazard	Avoid dust	Avoid dust
OTHER COMMENTS	Excellent colorant in wide industrial and artistic use; extended due to extremely high tinting strength; high chroma	Excellent stable pigment; low chroma; better than the natural equivalents; origin of "Mars" name uncertain	Excellent pigment; hue depends on source and method of processing; low tinting strength and inexpensive

TABLE 7.1. PIGMENTS, CONT'D.

HUE	Brown	Brown	Brown
COMMON NAME	**Burnt umber**	**Raw sienna**	**Raw umber**
COLOUR INDEX NAME (AND NUMBER)	PBr 7 (77492) (77491) (77499)	PBr 7 (77492) (77491) (77499)	PBr 7 (77492) (77491) (77499)
GENERIC NAME	Brown iron oxide	Brown iron oxide	Brown iron oxide
PROPRIETARY NAME(S)			
SYNONYM(S)	Turkey brown	Raw siena	Turkey brown
DATES AND PLACE OF DISCOVERY	Prehistoric	Prehistoric	Prehistoric
CHEMICAL CLASS	Inorganic	Inorganic	Inorganic
CONSTITUENTS	Calcined natural iron oxide containing manganese dioxide, alumina, and silica (trace)	Calcined natural iron oxide	Calcined natural iron oxide containing manganese dioxide, alumina, and silica (trace)
SOURCE	Processed natural inorganic	Processed natural inorganic	Processed natural inorganic
TYPE	P	P	P
MELTING POINT (°C)	NT	NT	NT
STABILITY TO (°C)	150	150	150
LIGHTFASTNESS ASTM	O AE R A WC I I I I I	O AE R A WC I I I I I	O AE R A WC I I I I I
USE IN VEHICLES Oil	x	x	x
Oil absorption	M	L	M
Drying rate	E	A	E
Film properties	G	G	G
Acrylic Solution	x	x	x
Acrylic Emulsion	x	x	x
Alkyds	x	x	x
Transparent watercolor	x	x	x
Opaque watercolor	x	x	x
Tempera	x	x	x
Casein	x	x	x
Encaustic	x	x	x
Frescoes	x	x	x
Pastels	x	x	x
Experimental paints	x	x	x
DRY REFRACTIVE INDEX	M	M	M
DRY CHARACTERISTICS	Dark GBr > Dark PBr	Light RBr > RBr > dark RBr > PBr	Dark GBr > Dark PBr
HAZARDS	Avoid dust; manganese may be a slight hazard	Avoid dust	Avoid dust; manganese may be a slight hazard
OTHER COMMENTS	Good pigment; good drier in oil; variable hue; low chroma; inexpensive; wide industrial and artistic use	Excellent pigment; hue depends on source and method of processing; low tinting strength and inexpensive	Good pigment; good drier in oil; variable hue; low chroma; inexpensive; wide industrial and artistic use

TABLE 7.1. PIGMENTS, CONT'D.

HUE	Black	Black	Black
COMMON NAME	Lamp black	Carbon black	Ivory black
COLOUR INDEX NAME (AND NUMBER)	PBk 6 (77266)	PBk 7 (77266)	PBk 9 (77267)
GENERIC NAME	Lamp or Carbon black		Bone black
PROPRIETARY NAME(S)	Carbon black	Carbon black	
SYNONYM(S)	Carbon black	Furnace black	Bone Black
DATES AND PLACE OF DISCOVERY	Prehistoric	Prehistoric	Prehistoric
CHEMICAL CLASS	Inorganic	Inorganic	Organic/Inorganic
CONSTITUENTS	Nearly pure amorphous carbon made by burning petroleum residues such as tar or creosote	Nearly pure amorphous carbon made by burning petroleum residues such as tar or creosote or by collecting soot from burning natural gas	Amorphous carbon produced from charred or burned animal bones (formerly ivory tusks, hence the name)
SOURCE	Processed natural inorganic	Processed natural inorganic	Processed natural inorganic
TYPE	P	P	P
MELTING POINT (°C)	NT	NT	NT
STABILITY TO (°C)	NT	NT	Turns to ash at high temperatures
LIGHTFASTNESS ASTM	O AE R A WC I I I I I	O AE R A WC I I I NT I	O AE R A WC I I I I I
USE IN VEHICLES Oil Oil absorption Drying rate Film properties Acrylic Solution Acrylic Emulsion Alkyds Transparent watercolor Opaque watercolor Tempera Casein Encaustic Frescoes Pastels Experimental paints	 x Very high VS F-P NT x x x x x x x x x x	 Very high VS F-P NT x x x x x x x x x x	 x H S F-P NT x x x x x x x x x x
DRY REFRACTIVE INDEX	M	M	H
DRY CHARACTERISTICS	Bk (warm)	Bk (warm)	Bk (cool)
HAZARDS	Avoid dust; carbon may be a hazard	Avoid dust; carbon may be a hazard	Avoid dust; carbon may be a hazard
OTHER COMMENTS	Do not use in excess in oil vehicles—films slow drying and unreliable; good hue	Do not use in excess in oil vehicles—films slow drying and unreliable; good hue	This is the only blue-black, called "cool"; same limitations as other carbon blacks

TABLE 7.1. PIGMENTS, CONT'D.

HUE	Black (Gray)	Black	White
COMMON NAME	Graphite	Mars black	Flake white
***COLOUR INDEX* NAME (AND NUMBER)**	PBk 10 (77265)	PBk 11 (77499)	PW 1 (77597)
GENERIC NAME	Graphite	Black iron oxide	White lead (Basic lead carbonate)
PROPRIETARY NAME(S)	Various	Mars black	
SYNONYM(S)	Black lead, Plumbago		Cremnintz, Silver, etc.
DATES AND PLACE OF DISCOVERY	Ancient, but name "graphite" coined in 1789 (from the Greek: "to write")	1800s	Ancient Greece/Rome
CHEMICAL CLASS	Organic	Inorganic	Inorganic
CONSTITUENTS	Hexagonally crystallized allotrope of carbon	Synthetic black iron oxide; ferroso ferric oxide from magnetic iron ore or from $FeSO_4$	Basic lead carbonate; combination of lead carbonate and lead hydroxide by carbonation of lead
SOURCE	Natural organic or synthetic inorganic	Processed synthetic inorganic	Processed natural inorganic
TYPE	P, hexagonal crystal; E, sometimes, with clay	P	P
MELTING POINT (°C)	NT	NT	NT
STABILITY TO (°C)	NT	150 > R	230 > R or YR
LIGHTFASTNESS ASTM	O AE R A WC NT NT NT NT NT	O AE R A WC I I I NT NT	O AE R A WC I NT I I NT
USE IN VEHICLES	A drawing material		
Oil		x	x
Oil absorption	NT	L	L
Drying rate	H	A	E
Film properties	VS	G	G
Acrylic Solution	NT	x	NT
Acrylic Emulsion	NT	x	P
Alkyds	NT	x	x
Transparent watercolor	NT	x	P
Opaque watercolor	NT	x	P
Tempera	NT	x	P
Casein	NT	x	P
Encaustic	NT	x	NT
Frescoes	NT	x	NT
Pastels	NT	x	NT
Experimental paints	NT	x	NT
DRY REFRACTIVE INDEX	M	H	H
DRY CHARACTERISTICS	BrBk > Bk > Gray Bk	Bk (warm)	W (warm)
HAZARDS	Avoid dust; the dust is *highly toxic* by inhalation	Avoid dust	Avoid dust; lead is *toxic*
OTHER COMMENTS	Greasy dense black; may be combined with kaolin to regulate hardness and softness	Excellent pigment, generally better performer than other blacks; weak tinting strength	Well-known ancient pigment; excellent in oils; a toxic pigment, not to be used dry

TABLE 7.1. PIGMENTS, CONT'D.

HUE	White	White
COMMON NAME	Zinc white	Titanium white
COLOUR INDEX NAME (AND NUMBER)	PW 4 (77947)	PW 6 (77891)
GENERIC NAME	Zinc oxide	Titanium dioxide
PROPRIETARY NAME(S)	Chinese white	Titanium white, anatase or rutile
SYNONYM(S)		Titanium white
DATES AND PLACE OF DISCOVERY	1751; first commercial production in 1850	1870; first popular use in the early 1900s
CHEMICAL CLASS	Inorganic	Inorganic
CONSTITUENTS	Zinc oxide; calcined zinc ore that has been oxidized	Titanium dioxide (either rutile or anatase) with barium sulfate or zinc oxide
SOURCE	Processed natural inorganic	Processed natural inorganic
TYPE	P, E usually with titanium dioxide	P, E usually
MELTING POINT (°C)	NT	NT
STABILITY TO (°C)	At high temperatures, > Y; if cooled, returns to W	NT

LIGHTFASTNESS ASTM	O	AE	R	A	WC		O	AE	R	A	WC
	I	I	I	NT	I		I	I	NT	I	I

USE IN VEHICLES		
Oil	x	x
Oil absorption	H	M
Drying rate	VS	S
Film properties	F	F
Acrylic Solution	x	x
Acrylic Emulsion	P	x
Alkyds	x	x
Transparent watercolor	x	x
Opaque watercolor	x	x
Tempera	x	x
Casein	x	x
Encaustic	x	x
Frescoes	x	x
Pastels	x	x
Experimental paints	x	x

DRY REFRACTIVE INDEX	M	H
DRY CHARACTERISTICS	W (cool)	W (cool)
HAZARDS	Avoid dust; zinc may be a very slight hazard in dry form	Avoid dust; titanium dioxide may be a very slight hazard in dry form
OTHER COMMENTS	Excellent all-round colorant in wide use; commonly mixed with titanium white for stability in artists' paints—makes soft films in oil paints	Excellent all-round colorant in wide use; extension improves films in oil; rutile variety is more opaque; anatase variety chalks in exterior use and is bluer

TABLE 7.2. HAZARDOUS PIGMENTS

Key:
P = Pigment
n/a = *CI* name and number not assigned
NA = Not applicable

Y = Yellow
O = Orange
R = Red
V = Violet
B = Blue
G = Green
Br = Brown
Bk = Black
W = White

HUE	Yellow	Yellow	Yellow
COMMON NAME	**Chrome yellows**	**Cadmium-barium yellow light**	**Cadmium yellow light, medium, and deep**
***CI* NAME (NUMBER)**	PY 34 (77600)	PY 35:1 (72205:1)	PY 37 (77199)
TOXIC INGREDIENT	Lead chromates	Cadmium sulfide	Cadmium sulfide
RATING BY ROUTE OF ENTRY			
Absorption	Toxic	NA	NA
Aspiration	Toxic	Harmful	Harmful
Ingestion	Toxic	NA	NA
Inhalation	Toxic	Harmful	Harmful
POSSIBLE EFFECTS	Lead poisoning	Cadmium metal poisoning	Cadmium metal poisoning
CLASS OF HAZARD			
Severe	x		
Moderate		x	x
Mild			
Unknown		x: tests not conclusive as to the toxicity of cadmium *in this form*	x: tests not conclusive as to the toxicity of cadmium *in this form*
CAUTIONS	*Do not use the lead chromates*	Do not ingest or overheat	Do not ingest or overheat
OTHER COMMENTS	Yellow pigments of better stability and less hazard are now available	The hazards of cadmium pigments have been overstated in some published accounts, but do not ignore them	The hazards of cadmium pigments have been overstated in some published accounts, but do not ignore them

TABLE 7.2. HAZARDOUS PIGMENTS, CONT'D.

HUE	Yellow	Yellow	Yellow
COMMON NAME	**Cadmium-barium yellow**	**Naples yellow**	**Titanium yellow**
CI **NAME (NUMBER)**	PY 37:1 (77199)	PY 41 (77589) (77588)	PY 53 (77788)
TOXIC INGREDIENT	Cadmium sulfide	Lead	Nickel
RATING BY ROUTE OF ENTRY			
Absorption	NA	Harmful	Skin sensitizer
Aspiration	Harmful	Harmful	Harmful
Ingestion	NA	Toxic	Harmful
Inhalation	Harmful	Toxic	Harmful
POSSIBLE EFFECTS	Cadmium metal poisoning	Lead poisoning	Skin allergy
CLASS OF HAZARD			
Severe		x	
Moderate	x		x
Mild			
Unknown	x: tests not conclusive as to the toxicity of cadmium *in this form*		
CAUTIONS	Do not ingest or overheat	Do not ingest or overheat	Avoid skin exposure; do not overheat
OTHER COMMENTS	The hazards of cadmium pigments have been overstated in some published accounts, but do not ignore them	Use caution if handling this pigment in the dry state	

HUE	Yellow	Yellow	Orange
COMMON NAME	**Nickel azo yellow**	**Nickel dioxine**	**Cadmium orange**
CI **NAME (NUMBER)**	PY 150 (12764)	PY 153 (48545)	PO 20 (77196) (77199) (77202)
TOXIC INGREDIENT	Nickel	Nickel	Cadmium sulfoselenide
RATING BY ROUTE OF ENTRY			
Absorption	Skin sensitizer	Skin sensitizer	NA
Aspiration	Harmful	Harmful	Harmful
Ingestion	Harmful	Harmful	NA
Inhalation	Harmful	Harmful	Harmful
POSSIBLE EFFECTS	Skin allergy	Skin allergy	Cadmium metal poisoning
CLASS OF HAZARD			
Severe			
Moderate	x	x	x
Mild			
Unknown			x: tests not conclusive as to the toxicity of cadmium *in this form*
CAUTIONS	Avoid skin exposure; do not overheat	Avoid skin exposure; do not overheat	Do not ingest or overheat
OTHER COMMENTS			The hazards of cadmium pigments have been overstated in some published accounts, but do not ignore them

TABLE 7.2. HAZARDOUS PIGMENTS, CONT'D.

HUE	Orange	Orange	Orange
COMMON NAME	**Cadmium-barium orange**	**Cadmium vermilion**	**Cadmium-barium vermilion**
CI **NAME (NUMBER)**	PO 20:1 (77196) (77199) (77202:1)	PO 23 (77201)	PO 23:1 (77201:1)
TOXIC INGREDIENT	Cadmium sulfoselenide	Cadmium and mercury	Cadmium and mercury
RATING BY ROUTE OF ENTRY			
Absorption	NA	Harmful	Harmful
Aspiration	Harmful	Harmful	Harmful
Ingestion	NA	Harmful	Harmful
Inhalation	Harmful	Harmful	Harmful
POSSIBLE EFFECTS	Cadmium metal poisoning	Cadmium and mercury poisoning	Cadmium and mercury poisoning
CLASS OF HAZARD			
Severe			
Moderate	x	x	x
Mild			
Unknown	x: tests not conclusive as to the toxicity of cadmium *in this form*		
CAUTIONS	Do not ingest or overheat	Do not ingest or overheat	Do not ingest or overheat
OTHER COMMENTS	The hazards of cadmium pigments have been overstated in some published accounts, but do not ignore them		

HUE	Red	Red	Red
COMMON NAME	Vermilion	Cadmium-barium red	Cadmium red
CI **NAME (NUMBER)**	PR 106 (77766)	PR 108 (77202)	PR 108:1 (77202:1)
TOXIC INGREDIENT	Mercuric sulfide	Cadmium sulfoselenide	Cadmium sulfoselenide
RATING BY ROUTE OF ENTRY			
Absorption	Harmful to toxic	NA	NA
Aspiration	Harmful	Harmful	Harmful
Ingestion	Harmful to toxic	NA	NA
Inhalation	Harmful	Harmful	Harmful
POSSIBLE EFFECTS	Mercury poisoning	Cadmium poisoning	Cadmium poisoning
CLASS OF HAZARD			
Severe	x		
Moderate	x	x	x
Mild			
Unknown		x: tests not conclusive as to the toxicity of cadmium *in this form*	x: tests not conclusive as to the toxicity of cadmium *in this form*
CAUTIONS	Do not ingest or overheat	Do not ingest or overheat	Do not ingest or overheat
OTHER COMMENTS		The hazards of cadmium pigments have been overstated in some published accounts, but do not ignore them	The hazards of cadmium pigments have been overstated in some published accounts, but do not ignore them

TABLE 7.2. HAZARDOUS PIGMENTS, CONT'D.

HUE	Red	Red	Purple
COMMON NAME	Cadmium vermilion red	Cadmium-barium vermilion red	Cobalt violet
CI NAME (NUMBER)	PR 113 (77201)	PR 113:1 (77201:1)	PV 14 (77360)
TOXIC INGREDIENT	Cadmium and mercury sulfides	Cadmium and mercury sulfides	Cobalt oxide
RATING BY ROUTE OF ENTRY			
Absorption	Harmful	Harmful	NA
Aspiration	Toxic	Toxic	Harmful
Ingestion	Toxic	Toxic	Harmful
Inhalation	Harmful	Harmful	Harmful
POSSIBLE EFFECTS	Cadmium and mercury poisoning	Cadmium and mercury poisoning	Cobalt sensitization
CLASS OF HAZARD			
Severe			
Moderate	x	x	
Mild			x
Unknown			
CAUTIONS	Do not ingest or overheat	Do not ingest or overheat	Avoid skin exposure; do not ingest or overheat
OTHER COMMENTS			Do *not* confuse this with *cobalt arsenate:* $Co_3(AsO_4)_2$, which is *toxic*

HUE	Purple	Blue	Blue
COMMON NAME	Manganese violet	Phthalocyanine blue	Cobalt blue
CI NAME (NUMBER)	PV 16 (77742)	PB 15 (74160)	PB 28 (77346)
TOXIC INGREDIENT	Manganese	Copper (alpha form)	Cobalt oxide
RATING BY ROUTE OF ENTRY			
Absorption	Skin sensitizer	Harmful	Harmful
Aspiration	Harmful	Harmful	Harmful
Ingestion	Harmful	Harmful	Harmful
Inhalation	Harmful	Harmful	Harmful
POSSIBLE EFFECTS	Manganese sensitization	Copper sensitization	Copper sensitization
CLASS OF HAZARD			
Severe			
Moderate			
Mild	x	x	x
Unknown			
CAUTIONS	Avoid skin exposure; do not ingest or overheat	Avoid skin exposure; do not ingest or overheat	Avoid skin exposure; do not ingest or overheat
OTHER COMMENTS		Copper may be a slight hazard	

TABLE 7.2. HAZARDOUS PIGMENTS, CONT'D.

HUE	Blue	Blue	Blue
COMMON NAME	Manganese blue	Cerulean blue	Cerulean blue (chromium)
CI NAME (NUMBER)	PB 33 (77112)	PB 35 (77368)	PB 36 (77343)
TOXIC INGREDIENT	Barium manganate	Cobalt oxide	Cobalt oxide
RATING BY ROUTE OF ENTRY			
Absorption	Harmful	Harmful	Harmful
Aspiration	Harmful	Harmful	Harmful
Ingestion	Harmful	Harmful	Harmful
Inhalation	Harmful	Harmful	Harmful
POSSIBLE EFFECTS	Manganese sensitization	Cobalt sensitization	Cobalt sensitization
CLASS OF HAZARD			
Severe			
Moderate			
Mild	x	x	x
Unknown			
CAUTIONS	Avoid skin exposure; do not ingest or overheat	Avoid skin exposure; do not ingest or overheat	Avoid skin exposure; do not ingest or overheat
OTHER COMMENTS			

HUE	Green	Green	Green
COMMON NAME	Phthalocyanine green	Green gold	Chromium oxide
CI NAME (NUMBER)	PG 7 (74260)	PG 10 (12775)	PG 17 (77288)
TOXIC INGREDIENT	Polychloro copper phthalocyanine	Nickel	Chromium
RATING BY ROUTE OF ENTRY			
Absorption	Skin sensitizer	Skin sensitizer	Skin sensitizer
Aspiration	Harmful	Harmful	Harmful
Ingestion	Harmful	Harmful	Harmful
Inhalation	Harmful	Harmful	Harmful
POSSIBLE EFFECTS	Copper sensitization	Nickel sensitization	Chromium sensitization
CLASS OF HAZARD			
Severe			
Moderate			
Mild	x	x	x
Unknown			
CAUTIONS	Avoid skin exposure; do not ingest or overheat	Avoid skin exposure; do not ingest or overheat	Avoid skin exposure; do not ingest or overheat
OTHER COMMENTS			

TABLE 7.2. HAZARDOUS PIGMENTS, CONT'D.

HUE	Green	Green	Brown
COMMON NAME	Cobalt green	Phthalocyanine green	Burnt and raw umbers
CI NAME (NUMBER)	PG 19 (77335)	PG 36 (74265)	PBr 7 (77492) (77491) (77499)
TOXIC INGREDIENT	Cobalt	Copper	Manganese
RATING BY ROUTE OF ENTRY			
Absorption	Skin sensitizer	Skin sensitizer	Skin sensitizer
Aspiration	Harmful	Harmful	Harmful
Ingestion	Harmful	Harmful	Harmful
Inhalation	Harmful	Harmful	Harmful
POSSIBLE EFFECTS	Cobalt sensitization	Copper sensitization	Manganese sensitization
CLASS OF HAZARD			
Severe			
Moderate			
Mild	x	x	x
Unknown			
CAUTIONS	Avoid skin exposure; do not ingest or overheat	Avoid skin exposure; do not ingest or overheat	Avoid skin exposure; do not ingest or overheat
OTHER COMMENTS			

HUE	Black	White	White	White
COMMON NAME	All carbon blacks	Flake white	Zinc white	Titanium white
CI NAME (NUMBER)	PBk 6 and PBk 7	PW 1 (77597)	PW 4 (77947)	PW 6 (77891)
TOXIC INGREDIENT	Carbon	Lead carbonate	Zinc	Titanium
RATING BY ROUTE OF ENTRY				
Absorption	Harmful	Harmful	NA	NA
Aspiration	Toxic	Toxic	Harmful	Harmful
Ingestion	Harmful	Toxic	NA	NA
Inhalation	Toxic	Toxic	Harmful	Harmful
POSSIBLE EFFECTS	Carbon particles can cause lung problems	Lead poisoning	Zinc is generally considered inert, but can cause allergies	Titanium sensitization
CLASS OF HAZARD				
Severe		x		
Moderate	x			
Mild			x	x
Unknown				
CAUTIONS	Avoid skin exposure; do not ingest or overheat	Avoid skin exposure; do not ingest or overheat	Avoid skin exposure; do not ingest or overheat	Avoid skin exposure; do not ingest or overheat
OTHER COMMENTS				

TABLE 7.3. DRYING RATES AND FILM CHARACTERISTICS OF PIGMENTS IN OIL

PIGMENT	DRYING RATE				FILM QUALITY				
	Fast	Average	Slow	Very slow	Hard	Brittle	Strong	Flexible	Soft
Umbers	x				x		x		
Prussian blue	x				x				
Phthalocyanine blues	x				x				
Flake white	x				x		x	x	
Burnt sienna	x				x		x		
Earth yellows		x					x		
Cobalt blue		x				x			
Cobalt violet		x				x			
Synthetic iron oxides (Mars)		x					x		
Cobalt green		x			x				
Chromium oxide (opaque)		x			x			x	
Viridian (transparent chromium)		x			x			x	
Naples yellow		x					x	x	
Zinc yellow		x			x	x			
Natural red iron oxides		x				x			
Green earth			x					x	x
Cerulean blue			x						x
Ultramarines			x		x	x			
Yellow ochre			x				x		
Quinacridones			x						x
Dioxazine purple			x						x
Arylide yellows and oranges			x		x				
Ivory, carbon, and lamp blacks				x					x
Cadmiums				x			x		
Mercuric sulfides				x			x		
Zinc white				x	x	x			
Alizarin crimson				x					x

Note: These assessments are for the pigment alone in linseed oil. They do not take into account the driers or other additives that some manufacturers add to their formulated paints.

Paint Making and Painting Techniques

This section discusses how to make and apply the paints you are likely to use, such as oils, watercolors, gouache, temperas, caseins, pastels, and synthetics. ✍ More unusual painting materials and techniques, such as mural paints and techniques, are also covered because they are historically important and still valid methods for those who wish to use them. ✍ We will look at safe and correct procedures for making the paints, as well as procedures for applying both homemade and commercial varieties. ✍ The traditional methods of employing these materials are emphasized, since those methods have developed successfully over many years, but other application methods are also explored.

8 Making Your Own Paints

The beginnings of modern art can actually be traced far back in human history. The abstractions of human form in Egyptian wall painting certainly influenced twentieth-century painting. But generally we think of the end of the nineteenth century as the beginning of the modern era. The pioneering efforts of a host of painters, notably Cézanne, Matisse, and Picasso, taught artists that the old rules of expression no longer applied, and that the restricting harness of tradition could be shed. One result of this new way of thinking was a burst of creative energy that has produced many important works of art in this century.

Along with new ways of making paintings, there came the idea that the "concept" of the work was most important. If it were not for the idea, the painting would have no meaning. This is surely undeniable, but there is something very discouraging about seeing an idea lose its meaning because the artist forgot, or ignored, the tradition of good craftsmanship. The idea or "the day's issue" is the basis for the work, but the painting expresses it; and if the work deteriorates so that our perception of it is altered, then the idea is changed. It is possible to look at many well-known twentieth-century paintings as little as 20 years old and see that they have changed—the color has faded or dulled; the collage materials have darkened, yellowed, or cracked; the paint has flaked—so much that the artists' original intention is undiscernible. This is an irretrievable loss.

Each painting technique has a few fundamental rules for proper physical construction. Within these restrictions, which are more or less broad depending on the medium, a host of manipulations are possible. Outside the limits, you will find that you have made a painting that will not survive even a generation.

MAKING PAINT

Making one's own paint was an activity engaged in by nearly every painter until the early part of the eighteenth century, when commercially made artists' paints became more widely available. Today, few artists understand the complexities of the process and, like their colleagues from the eighteenth and nineteenth centuries, rely heavily on the expertise of artists' paint makers for the quality of their paints. No one doubts that the manufacturers have a great deal of experience (some companies that began in the eighteenth century are still operating today) and that their products are superior. Still, we are often left to guess at some of the quality, using secondhand information. In this respect, making paints yourself is a valuable experience.

Many paint-making procedures are similar; the difference between paints is in the vehicle, the liquid part. The most desirable qualities of a well-made paint include the following:

- The consistent dispersion of pigment particles in the vehicle. The paints should be smooth, with each pigment particle separated from its neighbor and completely surrounded by a film of the vehicle.
- The even consistency of texture throughout a range of hues. The paints should be characteristic of their type; a range of hues should have similar handling, textural, and drying properties.

The difficulties of making paint in the studio are related to these fundamental requirements. Without mechanical aids, the consistent, complete dispersion of the pigment in the vehicle is hard to attain. Manufacturers use triple-roller mills (water-cooled, high-pressure, high-speed grinders) to make excellent dispersions. With practice and experience, you can nearly meet the basic requirements, though from a purely technical view homemade paints will not fully equal those made on a three-roll mill. Commercial paints are manufactured to a standard that is an *average demanded by the customer*—and up to 90 percent of the customers of a typical company are hobbyists, not professional artists.

There are several advantages to making your own paints. You have control over the ingredients. You can achieve greater clarity of hue, making paints far stronger than the average commercial type, with the fullest-strength masstones. You can also adjust the paints according to your personal needs.

☞ *CAUTION: There are some hazards associated with making paints that every artist should be aware of, although the precautions are standard and easily taken:*

- Pigments are fine powders that can easily be inhaled. Chronic ailments can result from inhaling dusts—even nontoxic dusts. Wear a dust mask when handling dry pigments, and do not handle them carelessly.
- Avoid the use of toxic pigments altogether. Even artists experienced with the processes should avoid using toxic pigments unless the following clothing and protective devices are worn: a long-sleeved smock (used only in the studio), impermeable gloves, splash goggles, and a dust mask with an organic mist filter. These items need be worn only until the paint paste is made, when the hazards of dusts become negligible.
- Some vehicles can be dangerous or contain dangerous components. Wear the appropriate protective devices specified for the particular material.

It is prudent to exercise caution by knowing all the ingredients—and their potential hazards—for a particular paint, and by taking the most effective measures to protect yourself from harmful exposures. A Material Safety Data Sheet (MSDS) for each ingredient should be consulted before using that ingredient. The MSDS can be obtained from the supplier or manufacturer of the ingredient. Do not take shortcuts with your health.

BASIC PAINT-MAKING SETUP

The following are the basic tools and materials used in the studio manufacture of artists' paints:

- Large, sturdy table with a wooden top into which nails can be driven.
- Slab, made of 6 mm ($1/4$-inch) thick tempered glass or marble, of sufficiently large size to be practical—perhaps 46×62 cm (18 inches by 24 inches) or larger.
- Piece of corrugated cardboard, to be used as a cushion beneath the slab. Cut it to the same size as the slab. It can be painted white, covered with white paper, or painted a neutral gray, so that you can better see the color of the paint.
- Four wooden cleats with double-headed nails, which are attached to the tabletop around the perimeter of the slab to hold it in place. Short stretcher bars will serve this purpose.
- Medium-grit (#120) Carborundum, for giving a frosted surface to the slab. Carborundum is the brand name for an abrasive wet-grinding powder.
- Small palette knife.
- Flexible steel spatula, 16 to 20 cm (6 to 8 inches) long.
- Flexible steel wall scraper, 8 to 10 cm (3 to 4 inches) wide, which is used to handle large volumes of paint. It must be flexible; do not buy a cheap one that bends only where it attaches to the handle.
- Glass muller with a flat face at least 9 cm ($3 1/2$ inches) across. This is the tool used to grind the paint. When buying one of these solid glass implements, be sure there are no air bubbles near the grinding surface; the glass face will eventually wear down and the pits caused by the bubbles will spoil the grinding surface.

- Empty, collapsible tubes for paint, either "studio" size, about 3 × 10 cm (1 by 4 inches), or "pound" size, about 4 × 15 cm (1½ by 6 inches) for storing the finished paint. Aluminum tubes are brittle but satisfactory; lead-tin alloy tubes should be coated with a plastic or wax film on the inside for use with sulfide pigments. Any tube used for water-based paints should be coated inside to prevent corrosion (see List of Suppliers). Small-capacity (56 to 112 g, 2- to 4-ounce) white or amber glass ointment jars with plastic caps can also be used. Plastic jars will stain and are difficult to keep clean, but are satisfactory. Metal caps will rust if the paint is water-based.
- Fabric-stretching pliers with wide jaws, for closing the filled tubes.
- Artist-grade dry pigments.
- Vehicle in which to grind the pigments, composed of a binder, a stabilizer, and other assorted ingredients, depending on the type of paint.

FROSTING SLAB AND MULLER

The first step in making paint is to prepare the slab and muller that will be used. Both must be prepared with a frosted, toothy surface so that they can properly grind pigments in a vehicle. Carborundum abrasive powder is used in this procedure. (See Box 8.1.)

PREDISPERSING PIGMENTS

Commercial manufacturers usually predisperse pigments in a liquid medium before grinding them into the paint vehicle. (See Box 8.2.) This is less important if a slow-drying vehicle like oil is used—it is sometimes unnecessary to predisperse oil paints—but crucial if a fast-drying vehicle is to be employed because the paint could dry out on the mill before it is finished. Artists who make their own paints do not generally predisperse pigments in a liquid other than the vehicle, since the quantities that are involved are not large and speed is not

BOX 8.1. HOW TO PREPARE THE SLAB AND MULLER

MATERIALS
- Table.
- Slab.
- Corrugated cardboard.
- Wooden cleats with nails.
- #120 Carborundum abrasive.
- Wall scraper.
- Small palette knife.
- Muller.
- Soap and water.
 (For more detailed descriptions of these materials, see list under "Basic Paint-Making Setup.")

METHOD
1. Place the slab, with the corrugated cardboard beneath it, on the sturdy table. Cleat it in place by nailing the wooden strips to the table around the outside of the slab.
2. Put a few tablespoonsful of Carborundum abrasive powder on the slab and mix into a loose slurry with water and a palette knife.
3. Grind the slab with the muller in a methodical manner, using a loose-wristed, circular motion. Hold the muller with one hand low on the handle, resting more on the shoulder of the muller, and use the other hand to steady the tool. Do not exert undue downward pressure or allow the muller to skip up onto its edges. Grind patiently for about 10 to 15 minutes, or until the slab is completely and evenly etched.
4. Scrape off the slurry with the wall scraper and discard it. Rinse the slab and muller thoroughly in water, and then wash them with soap. Rinse them again and let dry.

 The slab and the muller will now have the same type of graining and texture on their respective surfaces. They are ready to grind paint.

so critical. But occasionally certain pigments will be difficult to grind in the chosen vehicle without predispersion. Some techniques require that the pigments be predispersed.

The dispersion liquid is not always the same as the vehicle; it is more often the thinner for the finished paint, and is usually volatile, so that when it evaporates it leaves no residue in the paint. Any pigments that will be ground in a water-based vehicle can be predispersed in water; paints that are thinned with mineral spirits can have the pigments dispersed in mineral spirits. These two liquids cover all the paints that will be described here.

There are two possible problems to consider when predispersing pigments for grinding in oil. First, if too much thinner (mineral spirits) is used, it is possible that the resulting paint will not be like normal oil paint—its dry appearance may not resemble its wet appearance. Second, when the solvent evaporates from the film of dried oil paint, it may cause the film to shrink and crack. For these two reasons, it is probably better to predisperse pigments for oil paint in linseed oil.

If the jars used to store the predispersed paint are absolutely clean, the paste should last indefinitely. It should not be allowed to dry out; check it from time to time and moisten it with a little thinner if necessary. If the paste should dry out, remove it from the jar and grind it again. If the paste develops a mold or a strong musty odor, discard it.

☞ *CAUTION: In this and all subsequent paint-making operations, be sure to observe precautions regarding your personal health and safety. Never underestimate potential hazards. Wear a dust mask when handling dry pigments, and protect your skin with a barrier cream or impermeable gloves. Know your materials, and get a manufacturer's MSDS if necessary.*

9 Oil Paints

Oils are a popular and long-lived medium precisely because they are so adaptable. The "rules" in this chapter governing the use and application of oil paints can be stretched and bent. If you exercise common sense, oils will allow for a broad and diverse amount of manipulation, and unhampered expressive freedom. (For a discussion of painting tools and equipment, refer back to Chapter 1.)

First let's look at how to make your own oil paints, and then briefly discuss oil painting methods.

BASIC INGREDIENTS

The importance of making a good decision about what to include in an oil grinding vehicle cannot be overstated. Although oil paints are among the easiest to make, a lot can go wrong with the finished product—and the defects will not show up until it is too late to do anything about them. There is latitude in the choice of ingredients, but every one of them will have an effect on the finished product.

The best advice: Use the simplest formula at first, and make written observations about the process and the character and performance of the paints that result. After some experience, you will have a basis for judging how the vehicle can be modified to fit your personal needs. At this point you may wish to experiment, while once again taking notes. If you devise a personal paint formula, it is well worth the

effort to take good notes about how the formula developed so that the paint can be reproduced. It does no good to have worked out a terrific new paint, only to realize that the formula was arrived at haphazardly and the paint cannot be duplicated. Be aware that a complicated formula is not necessarily the best one, and again, that every ingredient will have an effect on the durability of the paint.

BINDERS

The most common binder for artists' oil paints is linseed oil. The cold-pressed variety is favored for its low viscosity and good wetting ability. It is expensive to produce and therefore expensive to buy; it is relatively rare to find it in use. Alkali-refined linseed oil is the common oil used by large- and small-scale paint manufacturers. It is less expensive than the cold-pressed variety and is more widely available.

Other oils that have a place in a vehicle, as a percentage of the total liquid, are those that are either less yellow or slower to dry than linseed oil. They are used as modifiers for the oil vehicle, and include safflower, poppyseed, and recently some modified versions of natural soybean oil. To simplify matters, limit the use of these other oils to special applications; they should not constitute more than 5 to 10 percent of the total liquid vehicle, by volume.

DRIERS

Driers are sometimes added to the vehicle in an oil paint to produce a range of hues that have similar drying rates. On an industrial scale, the addition of such potentially damaging ingredients can be more controlled than on a small scale, so it is best to leave them out.

Damar varnish has been suggested as an addition to an oil vehicle because it will impart its own rapid drying characteristics to the oil film. Its reversibility is a significant problem, however, since it can make oil films less resistant to simple solvents and overpainting. Leave varnishes and similar resins out of homemade oil paints. One suggested substitute for a drier is a faster-drying linseed oil like stand oil or sun-thickened oil as a 5 or 10 percent addition to the vehicle.

STABILIZERS

Stabilizers are the most appropriate additives to a homemade grinding vehicle. Properly used, they can give the degree of short or "buttery" consistency across a range of hues that most painters want in oil paints. Stabilizers also help to make difficult, "stringy" pigments grind into the oil a bit more easily, and help them to remain dispersed in the vehicle. Commercial producers use various inert pigments, such as aluminum stearate, alumina hydrate, and barium sulfate, as stabilizers. The small producer is more likely to use bleached white beeswax as a 1 1/2 to 3 percent concentration in the vehicle.

PIGMENTS

Any pigment listed in Table 7.1 as suitable for oil paints can be used for the studio manufacture of oils. Some are so expensive, however, that if the cost of labor is taken into account, their use in homemade paints would be much more expensive than purchasing the paint ready-made. Prices for dry artists' pigments fluctuate, so current price lists should be consulted in determining whether to use a pigment on this basis.

How difficult it is to grind a particular pigment can also be taken into account, since extra time spent on a pigment raises the labor cost of making it into a paint. Generally speaking, the synthetic organic pigments are more difficult to grind into satisfactory oil paints because of their resistance to wetting. Naturally, there are exceptions—and there are also inorganic mineral pigments that are difficult to disperse. Predispersing these pigments in mineral spirits will often make them easier to grind.

Toxicity is a factor in choosing a pigment. It is safer to eliminate those of a proven hazard, such as the lead-containing pigments, unless you are prepared to wear the necessary protective equipment.

☞ *CAUTION: Handle all pigments in the dry state with care. Do not splash them about, keep containers covered, and take all necessary precautions to guard against accidental misuse. Wear at least a dust mask if you are using large amounts of dry pigment.*

PREPARING THE OIL VEHICLE

Assuming that the simplest vehicle will be chosen for grinding, use a linseed oil and beeswax combination without any other additions (see Box 9.1). The percentage of wax can be altered to suit a particular pigment when making this grinding oil. Some pigments can be ground into the oil without the stabilizer; others will require a bit more than the 2 percent addition. The 240 ml (8 fluid ounces) of wax-oil mixture can be stored separate from the balance of the oil, with the correct percentage of wax added only when necessary. This procedure is somewhat more difficult, since the calculations can be laborious; adding too much wax to the binder will produce a paint that does not dry to a hard film.

As the oil is removed from the storage bottle, add additional clean marbles to keep its level high enough to exclude air. If a skin forms on the oil, it has begun to dry and should be discarded. A piece of polyethylene plastic or waxed paper pressed onto the surface of the oil can help prevent skinning.

BOX 9.1. HOW TO PREPARE A SIMPLE OIL VEHICLE

MATERIALS

- Cold-pressed or alkali-refined linseed oil.
- Bleached white beeswax.
- Double boiler.
- Colored glass container with tight-fitting stopper. It should hold slightly more than a quart of liquid.
- Clean glass marbles.

METHOD

1. Measure 240 ml (7 fluid ounces) oil into the top of a double boiler and heat very gently on a hot plate.
2. Into the heating oil break 28 g (1 ounce) of bleached white beeswax. Heat just until the wax melts completely, stirring to homogenize. Do not overheat, since this will cause the mixture to darken. Remove from the heat and allow to cool.
3. To the cooled oil slowly add, while stirring, 720 ml (24 fluid ounces) more oil, to bring the total volume up to 980 ml (a quart). The wax addition totals about 2 percent. Allow the mixture to homogenize for a day, and store it in a well-stoppered colored glass container. Use clean glass marbles to raise the level of the mixture in the bottle to the point where all air is excluded from the container. Kept this way, free from contact with air and away from light, this general-purpose grinding oil will keep for quite a while. It is enough to make about 25 standard studio-size tubes of oil paint. If the least amount of oil is used to make the paint, it is possible to get more tubes out of this volume of oil.

MAKING OIL PAINTS

The key to successfully making your own oil paint—and, indeed, most other paints—is to apply a systematic method patiently. Any method of grinding is acceptable, as long as it accomplishes the objective of a well-dispersed and consistent paint. If the method is also efficient and safe, so much the better.

Some paints should be placed in storage jars after grinding and before tubing, to let them rest and settle. This is a step commercial manufacturers include in their operation. Typically, mineral pigments can separate from the oil, in which case they are simply reground with more dry pigment. No further addition of oil is necessary or advised. Some pigments should be allowed to rest for at least a month, some for as long as three months, before regrinding. Be sure no air is present in the container.

Paints that are allowed to sit before they are tubed can be tested for defects. A well-made oil paint should not have agglomerations of undispersed pigment particles. A film of the finished paint should not show flocculation, a condition where the pigment particles clump together and rise to the surface of the film and can be rubbed off easily with a light swipe of a dry rag. Paints that flocculate usually do so because of a fault in formulation or from insufficient grinding, though the blame can also be laid to certain pigments, such as the phthalocyanines, which have a tendency to flocculate even when well dispersed.

A collapsible tube is best for the permanent storage of oil paint, but pharmaceutical ointment jars can be used. Again, remember that whenever air comes into contact with the exposed paint, the drying process will begin. If the jars are used, a polyethylene plastic wrap, or even waxed paper, should be pressed over the surface of the paint to exclude air.

The choice of whether to modify the character or behavior of the oil vehicle should be made after you have gained experience with the simple, general recipe given in Box 9.2 (pages 194–195).

LAYERS OF AN OIL PAINTING

The process of oil painting is actually the application of a succession of layers. With the exception of some mixed-media techniques, this process is the most complicated of all painting constructions. From first to last, the layers are the support, the size, the ground, the drawing (an optional step), and the paint (and a painting medium, if one is used). Earlier chapters of this book provide more detailed discussions of all the supporting layers. The way in which the layers are applied, and their composition, can affect the durability of the picture.

THE SUPPORT

The support for an oil painting should be durable and stable. If it is attached to an auxiliary support, fabric should be stretched well in the recommended manner. Paper supports should be heavy enough to carry their own weight plus the weight of the paint, or else should be mounted on a rigid auxiliary support. Lightweight papers should be matted when the picture is finished (see Chapter 16). Panels should be rigid and correctly braced.

THE SIZE

Oil binders dry by oxidation and are destructive to susceptible supports. Therefore, the size should be nondestructive and protect the support from the binder. It must not be a shiny coating, but a sealer. It should be correctly formulated and applied.

THE GROUND

Grounds generally must be white and provide tooth, absorbency, or roughness, or some agreeable combination of the three so that the oil paint can adhere. An oil ground must be separated from the support by a size.

The so-called acrylic emulsion gessoes are a size-and-ground combination and do not need a size to separate them from the support. In fact, sizing under acrylic emulsion gessoes is not recommended by most manufacturers.

The size and the ground together are sometimes referred to as the primer, or priming; preparing the support with a size and a ground is sometimes called "priming the support."

The ground may have a middle-value oil wash applied over it, but the ground itself should not be tinted.

THE DRAWING

After the support has been prepared, you can do a drawing to find the placement of the shapes and forms in the painting. This step is not always necessary, and depends largely on your style, intention, or approach.

Drawings are usually executed in soft pencil, vine charcoal, or—if the support is a gessoed panel—in black ink, watercolor, or egg tempera. They are then corrected or emphasized in oil paint diluted with mineral spirits. After you have done the drawing with the dilute paint, remove excess dust from charcoal or chalk drawings from the surface by flicking with a rag; excess charcoal dust in particular can muddy color mixtures in subsequent overpainting.

PAINTING TECHNIQUES

The paint itself can be applied in one layer or in several layers. The two techniques create quite different effects.

DIRECT PAINTING

A painting can be completed in one layer of paint, in one sitting, using a style called *alla prima* (Italian for "at the first"). In this approach, also called "direct painting," the broadest shapes and hues are put on in a loose, very general way with dilute paint. Application is with a large brush, rag, or any other tool. Definition is kept to a minimum, with a sense of the entire composition becoming the main objective. The painting is finished with daubs of paint you intend to leave as final statements—without further manipulation.

BOX 9.2. HOW TO MAKE OIL PAINTS

MATERIALS

- Solvent-proof barrier hand cream.
- Glass slab over corrugated cardboard cushion, held in place by wooden cleats.
- Muller.
- Artist-quality dry pigment.
 - ☞ *CAUTION: Chronic ailments can result from inhaling dusts—even nontoxic dusts. Wear a dust mask when handling dry pigments, and do not handle them carelessly.*
- Grinding oil vehicle prepared in Box 9.1.
- Flexible steel wall scraper.
- Flexible steel spatula.
- Empty, collapsible tubes for paint.
- Piece of white paper.
- Bristle brush.
- Fabric-stretching pliers with wide jaws.
- Palette knife.
- Rags.
- Mineral spirits.
- Cleansing materials.

(For more detailed descriptions of some of these materials, see pages 187–188.)

METHOD

1. Apply a solvent-proof barrier hand cream to your hands and forearms (see List of Suppliers). This will prevent the absorption of mineral spirits into your skin; most of these creams will act as a barrier against mild organic solvents for about two hours of working time, but can be washed off with soap and water.

2. Set up the slab as for making the pigment pastes: on the cardboard cushion, held in place with the wooden cleats.

3. Put a volume of artist-quality dry pigment in the center of the slab. The amount will depend on the size of the slab and how much paint you want to make.

4. Add a small amount of grinding oil vehicle to the pigment and mix the two together with the spatula. Add a bit more oil and mix again. The pigment will slowly absorb the oil and begin to form a stiff paste, but do not be deceived by the crumbly nature of the mixture into adding excess oil. Remember that linseed oil is not the perfect binder; it yellows and/or darkens and grows brittle with age. Use the least amount of oil to get the job done. While adding the oil, bit by bit, rub the paste with the spatula to ensure complete wetting of the pigment particles. A very stiff paste, the consistency of cold peanut butter, should result. Remove the paste to one corner of the slab.

5. Scrape a small amount of the paste, no more than a tablespoonful, into the center of the slab.

6. Grind out the paste with the muller, using the same circular loose-wristed motion as when you prepared the slab with the Carborundum abrasive powder. Downward pressure on the muller is not necessary; its own weight should provide the proper grinding action. Grind out the paste, working methodically, until it forms a thin film over the entire surface of the slab (Figure 9.1). Frequently scrape the sides of the muller where the paste rides up and accumulates, and grind this along with the rest. The grinding process is intended to disperse the pigment evenly in the vehicle, to be sure there is no air between the pigment particles. It is not a crushing operation—be patient. Repeat this step until the paste is smooth and no grittiness is apparent.

7. Try a drawdown with the flexible steel wall scraper to test the paint visually. Hold the scraper at a 45° angle to a piece of white paper and draw it across a volume of the paint so that a thin film is left. The film should appear smooth and without lumps of unground pigment (agglomeration) or other irregularities.

8. Check the consistency of the paint by gathering it all together in the center of the slab and observing its reaction to manipulation. It should retain brushmarks if brushed out with a bristle brush, and it should hold its form if built to a thickness

with the spatula. In other words, it should resemble commercial artists' oil paints. If the paint is too liquid, it must be reground with more pigment; return it to the paste pile and add a bit more pigment to the whole mass. If all is well, the material is oil paint. Scrape it all together and remove it to the corner of the slab opposite the pigment paste.

9. Continue in this fashion, grinding small amounts at one time, until all the paste has been made into paint. Remove the paint to the center of the slab and mix it all together with the spatula to make the general consistency uniform. You may also quickly regrind the whole batch. The paint is now ready to tube.

10. Hold the tube cap-end down. Loosen the cap to allow air to escape as the paint is added.

11. Use the palette knife to feed the paint into the open end of the tube. Hold the tube lightly in one hand, with your little finger cushioning the cap, and gently but firmly tap your fist on the tabletop. This forces the paint to settle into the tube, expels air from the cap end, and makes any small air bubbles trapped in the paint rise out. Do not squeeze the tube or bang the cap directly on the table; the result will be a burst or deformed tube.

12. Add more paint, tapping frequently to remove trapped air, until the tube is well packed and nearly full.

13. Place the tube flat on the slab and close the end by gently pressing on it with the scraper. Expel a bit of paint and the remaining air by pulling the tube out from under the scraper. Be careful not to cut the tube by pressing too hard.

14. Fold the end of the tube two or three times, using the palette knife to get a straight fold. Crimp the folded end with the stretching pliers.

15. Close the cap tightly and clean the outside of the tube with a rag dampened with mineral spirits. Label the tube with the hue, pigment, vehicle composition, and date.

16. Clean the slab, muller, and tools first with dry rags; then clean everything again, using a minimum of mineral spirits as a solvent. Wash everything with soap and water—scouring pads or scouring powder containing bleach is excellent— to clean all traces of color from the equipment. Rinse thoroughly and dry well. Once dry, the tools can be used for the next color.

17. Wash your hands thoroughly, using plenty of soap (or one of the solventless hand-cleaning creams) and a scrub brush.

FIGURE 9.1. Grinding (dispersion) pattern for making oil paint.

This approach is obviously subject to variation, and circumstances will more often than not prevent you from completing a work in a completely pure "direct" manner.

Direct painting is difficult because it forces you to make quick and definite decisions about the progress of the work while being open to change. All the issues of painting—color, shape, mass, placement, composition, and so on—must be handled simultaneously. Attempting to resolve details before knowing the compositional framework of the picture, or having too fixed an idea about what the painting should look like, can lead to a disappointing result.

INDIRECT PAINTING

Indirect painting is usually thought of as the traditional technique, since its slow and deliberate method has a long history. Indirect painting was probably a necessity in the early days of pure oil painting, because slow-drying oils and resins and the damp, cool climate of northern Europe did not combine to provide a quick-drying and easy painting system.

In this method, considerably more complex in intention and effect than the direct method, layers of opaque and transparent paint are applied in succession. Theoretically, the color effects are made by glazes (transparent layers of darker colors applied over lighter colors) and scumbles (transparent layers of lighter colors applied over darker colors).

The colors in the upper layers alter the appearance of those in the lower layers. Color resulting from this type of application has a greater luminosity than can be achieved in purely opaque direct painting, because light is not only reflected from the surface of the paint films but also travels through them and is refracted, while being reflected from the lower films. Thus, a strong orange hue can be softened and made to appear cooler by glazing over it a transparent blue; a cool, dark blue can be made warmer and lighter by scumbling over it a light orange hue.

The usual procedure is to begin by making a loose drawing on the ground. Then, using one or two colors plus a fast-drying white with a low oil content (such as flake white), lay out the composition in thin, fluid paint. The thinner is mineral spirits or gum turpentine, and in neither case should so much thinner be used that paint becomes like a watercolor glaze; this could later cause adhesion problems. Make the paint about the consistency of cream.

Establish the value range, but keep it lighter than you intend it for the final picture. If you use a drawing, make it as sharp and precise as possible. Sharpness of delineation and lightness of tone are necessary in the monochrome because glazing and scumbling will lower value and chroma, and somewhat obscure details. When you have finished the so-called underpainting, or *grisaille* (gray painting), allow it to dry for two or three days. After that you can apply local and tonal color can be applied by glazing and scumbling, using whatever means suit you.

Any combination of technical procedures and applications can be used to strengthen, clarify, or refine the underpainting. Most artists do not make big changes at this stage, but it is possible to do so if opaque painting is employed. You can make final applications of opaque paint in the direct manner. Wet-into-wet painting is possible (opaque or transparent paint applied to still-wet glazes and scumbles), as are many other manipulative effects that serve the purpose of the work. The idea of the painting should always take precedence over the technical procedures, which are merely the means to express the idea. Nevertheless, pay attention to what you're doing!

FAT OVER LEAN

Whatever technique you use when painting in oil, the traditional rule of "fat over lean" should be observed. "Fat," or more oily paint, must always be applied over "lean," or less oily paint. This is because thin oil paint applied over a glossy, oily underpainting may not adhere to the underpainting; the overpainting will also dry more quickly and is then liable to crack.

The oily underpainting will develop a skin as the paint dries from the top down (unlike paints that dry by evaporation of a solvent or thinner), so that it appears to be dry. But underneath the skin the wet paint is still expanding and contracting. In conjunction with this rule, use pigments that are low oil absorbers in the underpainting (see Table 7.1), which is the reason the white pigment of choice for underpainting in oil is lead white. Pigments that absorb a great deal of oil should be used only in the final layers of a complex indirect painting.

IMPASTO

Impasto, or thick, rough strokes of paint, must be applied with care when painting with oils. Impasto is most safely used when scattered throughout the painting in combination with thinner passages, rather than as a continuous layer. A thick layer of impasto may crack, sometimes through to the ground; this cracking can even lead to the detachment of portions of the paint from the picture.

THE USE OF PAINTING MEDIUMS

Painting mediums are used with paints to extend the color without diluting its chroma (up to a point of diminishing return), change the brushing or application characteristics of the tube paint, or make the paint into a transparent glaze or scumble without giving up its vehicle content. Numerous proprietary materials are made by every commercial paint maker to satisfy the demands of the largely amateurish marketplace. Remember, only 10 percent of the artists who buy art materials are professionals like you.

You will find that there is little need for most of these concoctions, and those few that are absolutely necessary are easily homemade. In some of the other heavy-bodied paints, the addition of various materials to the paint film will not much affect the performance of the paint. But in oil paints, as versatile and flexible as they are, these additions can be

disastrous if not carefully controlled. It is advisable to limit the use of mediums very strictly in oil painting.

Glazing mediums are necessary for those who wish to paint indirectly, and recipes for them can be found in every book on the techniques of oil painting. Your requirements should dictate the ingredients. Recipes generally contain advice to use at least three materials: an oil, a thinner, and a varnish. Damar varnish is usually the recommended varnish, gum turpentine the thinner, and a partially polymerized linseed oil (stand oil or sun-thickened oil) the oil.

Since the technique of glazing is simple but the physical makeup of an oil painting is complex, the addition of a complicated glaze medium to the structure of the work can be damaging. Damar and other varnishes are particularly susceptible to being redissolved by applications of fresh paint containing the varnish's solvent, and to being unintentionally removed during future cleaning or restoration. It is far better to use a simple glaze medium that does not contain a varnish, with perhaps 1 part mineral spirits and 2 parts linseed stand oil or sun-thickened linseed oil.

A glaze medium is mixed to a soupy consistency with the tube paint, so that the applied film is thin and transparent. It can be applied with a soft brush, a rag, or other tool to the painting on an easel—or, to avoid drips, to the painting laid horizontally on a table. Some practice, experience, patience, and a fairly good idea of the intended result are necessary to develop the technique.

Glaze mediums do not dry quickly, and additions of driers are sometimes recommended. However, driers in oil paint can cause structural damage and should therefore be avoided. Instead, use a pigment, such as a metallic umber, which acts as a drier for linseed oil. When painting with oils, accept slow drying as an attribute of the paint you have chosen. Convenience and speed are not the point, and can be found in other techniques anyway.

In any event, it is best to use as little medium as possible. The idea is to avoid yellowing or darkening, both of which can be

traced to excess oil. It is possible to use no glaze medium, in fact, with a completely dry underpainting. Most tubed oil paints contain the proper ratio of oil to pigment, so mechanically spreading the paint into a thin film, using a rag or a stiff-bristled brush, can also work very well.

SAVING OIL PAINT

Oil paint placed on a palette will develop a dry outer skin as it begins the drying process. Skinned-over oil paint that has begun to dry will lose its adhesive and binding properties, and breaking the skin and thinning the paint with a medium or diluent will not restore these properties. The paint should be scraped off the palette and discarded.

There are some tricks for saving paint left over from a day's work. Try transferring the blobs of paint to a strip of glass and immersing it in water, or pressing plastic wrap closely over each bit of paint to exclude air. You can also cover your palette with plastic wrap and put it in a freezer.

But these tricks may be more trouble than they are worth—especially since you will soon learn to judge the amount of paint you need for an average day's painting. Anyway, many artists are as likely to scrape an entire day's worth of painting onto the floor as they are to consider the picture satisfactory; so what's the point of quibbling over a flew small blobs here and there?

PAINTING OVER OLD OIL PAINTINGS

The practice of painting a new picture over an old one can work, and is economical with some kinds of painting, but it is not advisable with oil paints.

Even with laborious scraping and sanding to remove thick strokes of paint, the old image will eventually appear beneath the new. Oil paint films gradually become more transparent—they saponify, especially if painted with lead-containing pigments—as they age. Saponification, or turning to soap, produces an effect known as pentimento, and can be seen in thinly painted early works where the artist evidently had a change of mind about the placement of a form or made corrections in drawing. Many fifteenth- and sixteenth-century Dutch and Flemish paintings show evidence of pentimento. Also, an old oil painting that is very dry may not provide enough tooth or absorbency to allow fresh oil paint to adhere properly.

COMMERCIAL OIL PAINTS

Professional-grade oil paints, the best of each manufacturer's line, are made for full-time professional artists. They usually contain the finest ingredients and are well labeled for all the ingredients. The best oil paints can usually be intermixed—one brand mixed with another—without problems.

There is in fact little difference among the best products of the top manufacturers, since oil paints are relatively inexpensive to make. All the manufacturers uses the best materials they can get for their best paints because good and continuing reputations are founded on this quality. What causes one artist to prefer one brand over another is usually an intangible "quality," based on a preference for a certain texture, color range, or other subjective trait. These high-quality materials are sometimes expensive.

Student-grade paints, particularly in oil, differ only in two respects. First, the pigment content is less concentrated than in the professional grades, or is extended more than is necessary for proper color development (thus cheapening the product while also making it less expensive). Second, substitute pigments or pigment mixtures are often used in place of the more expensive genuine pigments. In the first instance, you must use more paint in order to have the same tinting strength, say, than with the professional version of the paint. In the second case, it is impossible to get the same purple by mixing a cadmium red medium with a substituted "cobalt blue hue," a "variety of ultramarine," or a "mixture of phthalocyanine and ultramarine with white" as you would get using the genuine cobalt pigment.

It is not worth the aggravation of attempting subtle color mixtures, nor is it worth the extra paint needed when using an adulterated, excessively extended pigment, to purchase student-grade materials. Student-grade paints are made for the 90 percent of the art materials market that is composed of hobbyists and "Sunday painters," not for professionals or serious students who are engaged in a professional course of study. Buy the professional grade of all paints. High price is not a guarantee of first-rate quality in a particular company's line, but at least there is some assurance of getting good value for your money.

THE CARE OF OIL PAINTINGS

A finished oil painting—most paintings, in fact—ought to receive a final coating of a protective varnish. In the conservation community there is some disagreement about the necessity for a varnish, particularly when the conservator doesn't know the original intentions of the artist concerning the final appearance of the picture.

The biggest problem with oil paintings is that they can take a long time to dry. Usually a picture of "average" thickness will require from three months to a year of drying before it can be varnished. Very thin paint will take less time, and thicker paint will take longer. During this time the picture should be stored in a dust-free environment, since dirt deposited on the surface before it has received a protective coat cannot be removed without possible harm to the painting. Unvarnished oil paintings cannot be easily or completely cleaned.

If the painting must leave the studio before it is varnished, put on a thin coat of a diluted retouch varnish as a temporary protection. Notify the client that the picture will be given its final varnish at a later date. Set the date, and be sure to follow through on that promise!

10 Water-Thinned Paints

Paints thinned with water have a long history. From the earliest times, artists decorated surfaces with pigments bound in adhesive gums from animal and vegetable sources. The expressive possibilities of water media cover the widest possible range, from the extremely controlled calligraphy of medieval manuscript illumination to the freer, more spontaneous styles associated with twentieth-century art.

The most readily apparent characteristic of water-thinned paints is that they dry very quickly. This is the reason why many artists like to use them as a sketching medium to work out ideas in advance, before proceeding to a more involved technique. Of course, watercolor paints need not be thought of as a medium to be used solely for quick studies. Many of the most important works by modern masters such as Klee were executed in watercolors.

Water paints can also be thinned to a very dilute and fluid state, allowing them to be brushed out in a freely flowing style without suffering any appreciable loss in binding capacity. Very thin applications of water paints can be controlled for tight, descriptive work. In fact, the binders for water paints are relatively weak, and the material should not be applied in thick, impasto layers. Impasto applications of watercolors will crack or separate from the support.

Watercolor paintings are normally matted for storage, but can also be kept in a portfolio (stored flat) without matting if the pictures are interleaved with a neutral barrier paper. For exhibition, matting and framing behind glazing is necessary (see Chapter 16). Gouache paintings require the same care, in storage and exhibition. For size paintings, varnishing is optional if the work is exhibited behind glass. Casein paintings can be varnished, matted, and framed.

TRANSPARENT WATERCOLOR

This familiar and popular medium is sometimes called by the French term *aquarelle,* to distinguish it from opaque techniques. The most common name for transparent watercolor is simply watercolor, not a wholly descriptive term, but a generally acceptable one.

BINDER AND PIGMENTS

The primary binder for transparent watercolor is gum acacia, or gum arabic, a slightly acidic water-soluble gum exuded from the acacia tree. Commercial watercolor vehicles are often blends of several materials in addition to the binder gum. Wheat starch binders are added (dextrin), as well as preservatives (usually less than 1 percent by volume), thickeners, plasticizers, and wetting agents. The only appropriate additive for a homemade watercolor vehicle is a plasticizer. Glycerine, for instance, will increase the elasticity of the rather brittle binder and allow dried paints to redissolve more easily. Glycerine is easily obtained from a pharmacy.

Most of the pigments used in oil painting can be used in transparent watercolor, except those that are susceptible to atmospheric impurities. For example, lead white and Naples yellow should not be used in their dry state in any case because of their toxicity. Poorly

processed grades of vermilion, which contains mercuric sulfide, can darken in watercolor. Naturally transparent pigments—the arylide (Hansa) yellows, the quinacridone reds and violets, manganese blue, viridian green—work particularly well in this medium.

PREPARING THE VEHICLE AND THE PAINT

When you are preparing the vehicle (see Box 10.1), make only enough for one working session, since the solution does not store well. Because of the laborious, even tedious grinding necessary for the production of a fine transparent watercolor, however, it may be simpler to purchase the paints. If you are up to the task, though, your patience will be rewarded.

When you are making the paint, small adjustments of the pigment-to-binder ratio are often necessary for different pigments. Experience is the best guide, but start with a 1 to 1 mixture, by volume, and work from there. (See Box 10.2.)

TOOLS AND BRUSHES

Watercolor palettes, with small indentations for holding the paints and larger spaces for mixing, are found in art supply stores; a simple china plate will also do. Palettes specifically designed for watercolors often come with sets of the paints, and are made of plastic or painted metal. Some palettes have folding covers to protect unused paints.

At least two jars for water are necessary: one for clean water used for mixing with the paint, and one to hold water for rinsing the brushes. Plastic jars with covers are best for working outdoors. Distilled water is recommended for use in areas with hard water, since it does not contain dissolved mineral salts that could affect the spreading of the paints. Most artists, however, will find local tap water sufficiently soft.

The brush of choice for most watercolorists is the pure red sable (see Chapter 1). The hair is especially soft but springy, and the brushes can hold a great deal of color but still make an exquisitely fine point. Sable brushes are very expensive, but other brushes cannot perform in the same way. It is not usually necessary to purchase more than two or three sable brushes of various sizes.

A fat, soft "mop," made of squirrel or badger hair, will also be helpful. The hair of these brushes is floppy, and they will not hold a fine point or edge, but they do hold a lot of water and paint and are indispensable for laying down washes over large areas. All brushes should be thoroughly rinsed and washed with mild soap and tepid water after use; keep the brushes in a box with a few mothballs if they are to be stored for a long time.

SUPPORTS AND GROUNDS

Transparent watercolors are most commonly painted on paper. However, thin fabrics such as silk—and other supports such as vellum, parchment, gessoed panels, and ivory—have been used. Watercolor papers should be composed of 100 percent cotton or linen rag.

BOX 10.1. HOW TO MAKE WATERCOLOR VEHICLE	
MATERIALS	METHOD
• 2 parts by volume gum arabic. • 4 parts by volume boiling distilled water. • 1 part (or less) by volume glycerine. • Small pot. • Fine-mesh cheesecloth. • Wooden spoon. • Very clean glass jar with cover.	1. Put the gum arabic in the small pot and pour the hot distilled water over it. Stir to hasten the solution. 2. Stir in the glycerine. 3. Allow the solution to cool a short time before straining it through the cheesecloth into the clean jar.

Linen is preferred because its individual fibers are longer and stronger than those of cotton, but linen rag papers are rare today. (For a more complete discussion of papers in general, see Chapter 1.)

The surface of a watercolor paper is important. It should be evenly absorbent and sized during its manufacture to prevent uncontrolled spreading and bleeding of the paint. Plain drawing papers may not be sized; one method of sizing papers is given in Chapter 3. The surface texture of a watercolor paper is controlled by the manufacturer. Most fine papers come with three distinct surfaces: rough (sometimes called "not" or "not pressed"), cold-pressed (a medium finish), and hot-pressed (a smooth finish). Your preference for one type of finish over another is personal, although traditionally the rougher surfaces have found favor because they impart a lively variation to the appearance of the picture.

Generally the heavier-weight watercolor papers are preferred because lightweight papers will wrinkle in an unpleasant way when flooded with water. Lighter papers can be used, however, if they are stretched in a rigid drawing board. Two procedures are available; the choice depends on whether you want to preserve the edges of the paper. (See Box 10.3.)

Some artists prefer to forgo the inconvenience of stretching the paper by using commercially available blocks of watercolor papers. A number

of sheets of paper are held together in a block by adhesive applied around its edges. When the picture is finished, a thin knife can be inserted between the sheet and the rest of the block to separate it.

Naturally, other papers can be used, as suits you. Rag mat board and some of the many varieties of Oriental papers may be attractive, depending on your intentions. Since the fibrous surface of the paper plays a part in holding the paint on the support, papers with glazed or shiny surfaces should be avoided.

It is the white color of the support that allows the development of a value scheme in transparent watercolor—the white shows through the transparent paint—so grounds are not necessary. If you are painting on a panel, try a glue gesso ground; it is very white and very absorbent.

PAINTING TECHNIQUES

Technical styles of transparent watercolor painting can vary tremendously, according to your wishes. You can do a careful line drawing in full detail, and then slowly build up pale washes over it to achieve the desired value range and depth of color. If your drawing of forms needs help, this method is desirable at first, since it is difficult to go back and make corrections without the changes in the picture becoming obvious.

On the other hand, it is perfectly feasible to use a direct painting method, without any preliminary drawing. In this manner you can give an image life quickly and broadly, and then refine it with a few touches here and there.

In any case, keep in mind that transparent watercolor has a luminosity and lightness unlike other techniques. This is due to the transparency of the binder, the fact that the pigments are so finely ground, and the fact that often the paper is more of a binder for the pigments than the gum itself. Do not paint too thickly, or the paint may crack.

Removal of unwanted passages of very fluid paint can sometimes be accomplished by blotting with a tissue; dried areas of paint can be lightened, but not entirely removed, by

BOX 10.3. HOW TO STRETCH WATERCOLOR PAPER

MATERIALS
- Watercolor paper.
- Tub, sponge, or water sprayer.
- Sturdy drawing board.
- Water.
- Thumbtacks or pushpins with long, thin shafts (for Method A).
- Brown paper wrapping tape with water-soluble glue backing (for Method B).

METHOD A: PUSHPINS (WHICH PRESERVE THE EDGES)
1. Dampen the paper on both sides by spraying with water, soaking the paper in a tub of water, or liberally sponging on the water.
2. Lay the damp paper on a sturdy drawing board and flatten it out. Pin it down all around the perimeter using the thumbtacks or pushpins. As the paper dries, it will shrink tight. When the painting is finished, remove the tacks. The pinholes will hardly show.

METHOD B: TAPE (WHICH DESTROYS THE EDGES)
Follow the procedure in Method A, but use brown paper wrapping tape (the kind that has a water-soluble glue backing). Tape down the edges of the paper, overlapping about 6 mm ($^1/_4$ inch) of it. The tape may not stick securely at first, so keep pressing down on it. When the picture is finished, peel away the tape after carefully dampening it to loosen the glue, or just cut the picture loose with a sharp blade. This method will most certainly destroy the deckle edge of a fine paper. Under no circumstances should masking tape be used; its adhesive can stain the paper and migrate into the image, and it will not stick easily to wet paper.

scrubbing the area with a bristle brush or a toothbrush dampened with water, followed by blotting. Beware of overmixing your colors, which can easily lead to muddying or an unpleasant opacity.

If you wish to plan ahead to leave areas of the painting white, for highlights or accents, masking is appropriate. Use small pieces of plain masking tape, one of the proprietary masking fluids, or rubber cement. These can be painted over freely. When the picture is dry, remove the mask by peeling or rubbing with a dry cloth. Some artists use a very sharp knife to pick or scrape out tiny highlights—but only heavier papers with considerable surface texture are able to stand this manipulation without it becoming obvious.

COMMERCIAL PRODUCTS

The best lines of most paint manufacturers' watercolors are well-made products. Mechanical production is less tedious than hand production, and the formulas are simple and rather standardized. An artist's preference for one brand over another is usually related to the form in which the paint comes—tubes, pans, or cakes—or to some specific handling characteristic or color range. Look for those professional grades of transparent watercolors that are fully labeled for both pigment and vehicle content.

By contrast, student-grade watercolors and hobby sets are usually variable in quality. They may contain fillers that lessen the tinting strength of the colorants, extra binding agents of questionable value and durability, and substituted pigments bearing the name of a real pigment but only imitating that pigment's hue. Or they may not be labeled at all and contain colorants not found in the best lines and that may be impermanent. Take no chances with commercial brands of watercolors; buy only the well-labeled professional grades.

Commercial producers of watercolors market a variety of auxiliary mediums to go with their products. These can be viewed as unnecessary—one of the virtues of the medium is that it is so simple—but interesting adjuncts. Winsor & Newton, for example,

sells the following mediums for transparent watercolor: Aquapasto (for giving impasto effects), gum arabic (for increasing gloss), gum water (containing plant oils, to increase gloss, transparency, and wetting), ox gall (the traditional wetting agent formerly used in commercial and homemade watercolors), size (gelatin-based, for sizing paper), Raising Preparation (a "pigmented, highly bodied" paste that can be remoistened and made sticky with your breath, used for "illumination"), two mediums (for improving flow and brilliance), and a Water Matt Gold Size (a pigmented base like the traditional bole used for gilding metallic leaf).

OPAQUE WATERCOLOR

Gouache is the name of the technique of painting with an opaque watercolor made with the same binder used in transparent watercolor. Like "watercolor," "gouache" is not really a descriptive term, but it is generally accepted as the name of a paint.

The pigmentation of opaque watercolors is the same as for transparent watercolors, but the paints are made opaque by the addition of precipitated chalk to the vehicle. Because extremely fine grinding is not necessary to produce a good gouache paint that covers well and can be applied smoothly, it is more easily homemade than its transparent cousin.

PREPARING THE PAINT

Since this is such an easy paint to make (see Box 10.4), good recordkeeping about the amounts of binder to pigment used for each color will ensure that you can reproduce successful mixtures. Custom colors can easily be prepared.

The paints can be ground to a more liquid consistency than ultimately desired, then allowed to thicken by evaporation of the water before putting them in their containers. Spreading the paints out on a smooth, nonabsorbent surface will speed the process. A clean pane of glass works well.

Test the paints by rubbing a well-dried (overnight) test patch with a soft, dry cloth.

BOX 10.4. HOW TO MAKE OPAQUE WATERCOLOR PAINTS

MATERIALS

- Vehicle prepared in Box 10.1.
- Preservative (optional): Cuniphen 2778-I (0.5 percent by weight of the vehicle) if the volume of vehicle being made makes precise calculations possible. Because gouache paints are more liquid, they can be more susceptible to attack by microorganisms.
- Artist-grade dry pigments—the same as those used in transparent watercolor.
 ☞ *CAUTION: Pigments are fine powders that can easily be inhaled. Chronic ailments can result from inhaling dusts— even nontoxic dusts. Wear a dust mask when handling dry pigments, and do not handle them carelessly. Avoid the use of toxic pigments altogether.*
- Precipitated chalk. Whiting, a coarser natural chalk, can be substituted.
- Paint-making setup (pages 187–188).
- Containers for the finished paints. The paint is liquid, so use small collapsible tubes, ointment jars, or sterilized baby food jars.

METHOD

1. Prepare the vehicle, using distilled water as the diluent.
2. Mix each pigment with the precipitated chalk in a separate container. For good opacity, mix about 1 part pigment with 1 part chalk.
 ☞ *CAUTION: Do not breathe the dust.*
3. Predispersing the pigment and chalk is not necessary, but it may facilitate grinding.
4. Rub the pigment and chalk into a smooth paste with some of the vehicle, using a stiff spatula. Each pigment will absorb a different amount of the vehicle, so as a general starting point begin with 3 parts pigment to 1 part vehicle, by volume. Adjust for each color as necessary.
5. Grind the mixture with the muller to a smooth and somewhat liquid consistency. Fill the containers, tap them down to expel air, and cap tightly. (For a more detailed description of how to do this, see Steps 10 through 15 of Box 9.2.)
6. Clean the equipment thoroughly before proceeding to the next color.

Properly bound paints should not rub off, but may stain the cloth slightly. Paints with too little binder will crumble or crack, or rub off entirely.

BRUSHES, SUPPORTS, AND GROUNDS

Sable watercolor brushes work well with gouache. Since the paint can be applied in relatively thicker layers than transparent watercolor, some artists also like to use bristle brushes.

Paper is the usual support for gouache painting, although the paint works equally well on glue-gessoed panels and rag mat boards. Since opaque watercolor is not dependent on the white of the support for light values, you can give the support a middle-tone tint of color, using either gouache or watercolor to make the tint wash.

PAINTING TECHNIQUES

Gouache painting processes are the same as for other water media, except that the paint can be built to a thicker film. This does not mean a film the thickness of an oil impasto, but rather one that can hold and retain brushstrokes and small areas of delicate impasto. Any defect that might occur because of a film that is too thick will show up as soon as the paint is thoroughly dry. Areas that have crumbled or cracked can be reworked by scraping and painting over; the paint is more easily resoluble with water than transparent watercolor, which stains the support with hard-to-remove color.

Opaque watercolor is well suited to many variations in the transparency and opacity of applied layers; a watercolor wash for the middle tone can be combined with transparent watercolor passages in the body of the work.

Furthermore, opaque watercolor can be combined with other mediums like pastel, ink, and charcoal for successful mixed-media effects. Bear in mind that gouache tends to dry lighter in value than it appears when wet (the chalk content is translucent when wet but opaque when dry). This can alter the result. Also, be on the lookout for the dominance of technical manipulations over conceptual matters. The idea of using mixed-media approaches can easily run away with the idea that supports the work. In an opaque watercolor and mixed-media painting, gouache should be the dominant technique, and all the other manipulations and additions should be subordinate.

COMMERCIAL BRANDS

A number of manufacturers produce ready-made opaque watercolors. These brands are often labeled "designers' gouache," indicating that their primary use is for applications where permanence may not be a requirement. (Designers do their work for reproduction, not posterity, although there are many who now wish the paints were more durable.) The brighter colors in these lines have been observed to fade completely in less than a year of exposure to sunlight. Use only those commercial opaque watercolors labeled with the generic name of the pigment content; avoid proprietary color names.

These paints have notoriously poor labels concerning contents, but the ASTM Subcommittee (see Chapter 7) has written a lightfastness test method and a labeling specification.

SIZE PAINTS

Size paints are sometimes called *distemper* paints. This phrase refers to the "tempering" of the pigments with the binder or vehicle, and can rightly be applied to almost any kind of paint. The name of egg tempera paints grows out of this usage, which can be misleading if you think of the entirely impermanent variety of "poster temperas" in use today.

True size paints are water-thinned paints made of artists' pigments dispersed in warm hide glue. These dry very quickly and are

particularly suited to decorative effects. Their use ranges over the centuries from Egyptian and Far Eastern wall decoration to the small, marvelously luminous paintings of Bonnard.

BINDER AND PIGMENTS

Standard-strength hide glue size is the binder. The pigments used in watercolors can be used in size paints. The same cautions about toxic and reactive pigments apply.

PREPARING THE PAINT

This paint is easy to make (see Box 10.5). Because it does not keep well, it should be made fresh for each painting session. If you are making a large volume of paint, it may be possible to use either Cuniphen 2778-I or sodium benzoate in 0.5 percent or 5 percent solutions of the vehicle, respectively. The use of preservatives can be hazardous, however, and should be avoided whenever possible. The finished paint can be made somewhat less soluble when dry by adding a couple of drops of an acrylic emulsion matte medium to the thinner used in the painting process. Do not add the emulsion to the paint itself.

BRUSHES, SUPPORTS, AND GROUNDS

Either hair or bristle brushes can be used with size paints. Hair brushes include sable, camel, and squirrel.

Size paint is brittle, so flexible supports should not be used unless they are mounted on a rigid substrate. Any ground except an oil ground will accept size paint—although acrylic emulsion gessoes may not be absorbent enough. Museum boards and very stiff papers do not require a ground. Glue-gesso grounds can be particularly attractive when used with this technique with chalk added, because the paint then becomes like a colored gesso; sizing the ground is not necessary.

PAINTING TECHNIQUES

The paint can be thinned with a great deal of water, but take care not to thin the lower layers

of the painting too much. The upper layers should not contain stronger glue than the lower layers, becaue this could cause the upper layers to crack. A problem with painting a number of successive layers in this medium is that the water content of the fresh paint can sometimes dissolve and lift the underpainting. Adding a drop of acrylic emulsion matte medium to the thinner water can lessen the effect or prevent it from occurring.

CASEIN

Casein is a protein derived from the dried curds of skim milk, a natural emulsion containing a small amount of butterfat suspended in water. The skim milk is allowed to sour, or made to sour by adding a weak acid or an enzyme (rennet). The resulting curds are separated from the whey, dried, and ground up into a white powder. Casein powder can be obtained from chemical supply houses like Fischer Scientific (see List of Suppliers). Always use the freshest powder available; aged casein will not make a very strong or reliable solution.

The casein powder is dissolved in water with the assistance of an alkaline emulsifier: ammonium carbonate, a crystalline powder that is available from your local pharmacy. (See Box 10.6.) Concentrated clear ammonia water—also available in larger pharmacies—can be used instead of the ammonium

carbonate, but be sure that it is the clear, not the cloudy, variety. Some writers recommend that the casein syrup be heated to drive off the excess ammonia gas. Heating will certainly shorten the preparation time, but to do so requires more equipment.

All the pigments used in the other water-thinned paints can be used in casein. Make only small amounts of casein at one time (see Box 10.7) and use it promptly. The solution can be stored in a cool place (but not refrigerated) for about a week before it spoils. The life of the solution can be somewhat prolonged by the addition of a preservative, if you care to make the calculations: 5 percent sodium benzoate by weight of the solution, or 0.5 percent of Cuniphen 2778-I by weight. Add the preservative after Step 3 in Box 10.6. However, unless you are making a large stock of casein for multiple uses (paint binder, gesso adhesive, general adhesive), it is generally not worth the bother to measure such small amounts of preservatives.

To make a glue gesso using casein as the binder, mix a volume of chalk and pigment filler equal to that of the casein solution prepared above. Combine them as instructed in Chapter 3. Dilute this mixture with more water until the gesso reaches a brushable consistency.

Casein gesso does not gel when it cools, does not have to be reheated, is somewhat harder than hide glue gesso, and is more water-resistant than hide glue gesso.

BOX 10.6. HOW TO MAKE CASEIN VEHICLE

MATERIALS

- 2 parts by volume of casein powder, the freshest available.
- 1 part by volume ammonium carbonate crystals or concentrated ammonia water.

 ☞ *CAUTION: Ammonia is harmful; concentrated exposures to skin can be corrosive, and inhalation of the vapors or ingestion can be severely irritating or even fatal. Wear eye protection and gloves, and handle ammonia with care. Local exhaust ventilation is also recommended.*

- 16 parts distilled water, divided equally between two containers.
- Wooden kitchen spoon.
- Large glass, heavy plastic, enameled steel, or glazed ceramic bowl in which to mix the solution. Do not use plain metal containers to make or store the casein; they can react with the solution.
- Plastic or glass jar with plastic top.

METHOD

1. To 2 parts by volume of the casein powder, slowly add 8 parts by volume of water. Add a little water at a time, stirring with the wooden spoon, to make first a thick, then thin, paste. This method, as opposed to adding the casein to the water, will help prevent the formation of lumps. Stir thoroughly to make the solution smooth.
2. With a little of the remaining water, mix 1 part by volume of the ammonium carbonate crystals into a smooth paste. Add the paste to the casein and water mixture and stir. Or add the concentrated ammonia water—1 part by volume—to the solution, and stir.

 ☞ *CAUTION: Do not inhale the vapors or handle the paste with unprotected hands.*
3. Allow the solution to rest for at least an hour, or until there is no more odor of ammonia. Stir in the remaining 8 parts of water. This is the vehicle, a clear, syrupy solution. Store it in a plastic-topped plastic or glass jar until ready to use.

BOX 10.7. HOW TO MAKE CASEIN PAINT

MATERIALS

- Casein vehicle prepared in Box 10.6.
- Paint-making setup (pages 187–188).
- Artist-grade dry pigments.
- Distilled water.
- Small containers for storing the finished paints. Ointment jars with plastic caps or baby food jars that have been sterilized work well.
- Palette.

METHOD

1. Predisperse each pigment in distilled water. Place each pigment and water paste in its own storage container.
2. Place a small volume of each paste on a palette. It is helpful to use an enameled steel palette or a plastic watercolor palette that has individual depressions to hold the paint. Or use small individual plastic or ceramic ink bowls, one for each color. To each color, add a volume of casein solution that is equal to the volume of the paste. Mix thoroughly to make the paint.
3. You can grind the pigments directly into the casein solution. Make only enough for one day's painting, because the solution will not keep well.

BRUSHES, TOOLS, SUPPORTS, AND GROUNDS

Hair or bristle brushes can be used with casein. Water is the thinner. Be sure to use plenty of water and keep the brushes moist, because dried casein paint is difficult to remove from brushes. Use a glass, enameled steel, or ceramic palette.

All supports used for other water-thinned paints can be used for casein painting: rag papers and museum board, panels, and fabrics or thin papers mounted on a rigid auxiliary substrate. Heavy rag papers can be used without mounting.

Casein gesso or hide glue gesso can be used as a ground, although no ground is necessary for white rag papers and museum boards. The ground need not be sized. A middle tone of color can be washed onto the ground with diluted casein paint or watercolor.

PAINTING TECHNIQUES

Casein can be used in thin washes like the other water-thinned paints, or opaquely. It can also be built up to a bit of an impasto. Since casein is not easily resoluble in water once it dries, its paint layers dry water-resistant, and overpainting is not a problem. Corrections can be made easily, and glazes resembling watercolor glazes can be applied over heavily painted areas without lifting the underpainting. Paints that have dried on the palette should be scraped off and discarded, as should any paint not used by the end of the day.

To make the paints even more water-resistant, add a drop or two of acrylic emulsion matte medium to the thinning water.

CASEIN AS AN EMULSIFIER

Casein can also act as an emulsifier; that is, the casein syrup can be used to emulsify other oily, waxy, or resinous materials into mixtures that are thinned with water but dry water-resistant. (See Chapter 11, which discusses tempera paints.)

The usual procedure is to mix 1 part by volume of the casein syrup with 1 part by volume of the other ingredient. Examples include:

- *Linseed stand oil.* This produces a paint that can yellow considerably.
- *Damar varnish* (5-pound cut). This vehicle dries quickly and can crack and/or yellow.
- *Venice turpentine.* This gives a paint that dries quickly with a good gloss and will not show brushstrokes.
- *Saponified wax, also called wax soap.* This paint dries quickly with a matte surface, but has films that can be soft if too much wax is used.

Once the vehicle has been assembled, the pigment and water paste are mixed into it to produce the paints. If a more waxy, oily, or resinous material than casein syrup is used in the emulsion, water can no longer be used as the thinner. Use mineral spirits instead.

To make oil paints that dry very rapidly, first make a selection of casein paints as outlined above. Then, using a palette knife, mix 1 part by volume of each casein color with 1 volume of oil color straight from the tube. These casein-oil paints can be thinned with the casein syrup, or with one of the mixed emulsions mentioned above. Casein-oil paints are particularly useful where you want to introduce crisp highlights and lights into wet oil paint. Straight casein paints can also be used, very thinly, as a fast-drying underpainting for oil paints.

COMMERCIAL BRANDS

Casein paints can be bought in tubes from one or two manufacturers in this country. Shiva, distributed by Standard Brands, is one (see List of Suppliers). Because pure casein spoils, these paints have preservatives in them, or they are solutions of casein containing other ingredients to prevent hardening or putrefying. Be sure to purchase the freshest tubes available: Ask the retailer or write the manufacturer for an explanation of the code usually found imprinted in the tube crimp. Make a test of each color to be sure it is stable. Casein paints are not addressed by ASTM Standards.

Casein-based housepaints are not made for artistic purposes, and should not be used with expectations of durability.

11 Temperas

Tempera paints employ a vehicle that is thinned with water but upon drying becomes water-resistant, making the paint a bit like casein and placing it between pure water-thinned paints and pure oil paints. In fact, before the development of the technique of oil painting as a separate process, during the sixteenth century, egg tempera was the prevalent easel painting technique. Much of the religious panel painting done between the twelfth and fifteenth centuries was executed in this delicate and subtle process, which is capable of highly detailed and complex development. Since the sixteenth century, tempera painting has enjoyed sporadic revivals. Several modern painters—Ben Shahn, Andrew Wyeth, and Robert Vickery, for instance—have helped to rekindle an interest in the technique.

PURE EGG TEMPERA

The binder in egg tempera painting is an oil-in-water emulsion, which can be defined as a suspension of a resinous, oily, fatty, or waxy material in a watery material. Milk is another example of this, with its suspended component of butterfat. There are also water-in-oil emulsions, such as butter (it has a small component of aqueous material) or a mixture of oil paints and casein. The two different materials are held in suspension with the assistance of a third ingredient, the emulsifier. Simple natural emulsions are found in eggs and in fig-tree sap, a latexlike suspension mentioned in archaic paint-making recipes.

BINDER AND PIGMENTS

Egg yolks contain a fatty material called egg oil, a watery material called albumen (which is the greater part of the white of an egg), and an emulsifier called lecithin. Lecithin is an efficient natural emulsifier often found in processed foods. Albumen is also an emulsifying agent, but its major contribution to the system is that it coagulates under heat and light, giving the binder a tough, flexible, and relatively insoluble character. Observe a frying egg to see how rapidly albumen coagulates; try washing a plate that has had dried egg sitting on it for a day to see how tough a film it makes.

All the pigments usable in the water-thinned paints can be used in egg tempera.

PREPARATION OF THE VEHICLE AND THE PAINT

The egg vehicle (see Box 11.1) does not keep and should be made fresh for each session. Some writers recommend adding a preservative (a few drops of white vinegar, or sodium benzoate). But the preservative may cause the emulsion to separate if it is not precisely calculated. Refrigeration of the vehicle is not advised.

Each pigment will require slightly more or less than an equal volume of vehicle to make a satisfactory paint. (See Box 11.2.) It is possible to grind the dry pigments directly into the vehicle, skipping the step of making a pigment-and-water paste. Leftover paint must be discarded at the end of the workday.

To test the resulting film, paint a thin strip, diluted with water as in normal applications, onto a piece of glass. After the paint dries overnight, you should be able to peel the strip off the glass with a razor blade in one continuous ribbon. Paint that crumbles or powders needs more binder. A well-made egg tempera paint should not stain a dry white cloth that is gently rubbed against some dried paint.

BRUSHES, TOOLS, SUPPORTS, AND GROUNDS

For classical egg tempera painting techniques, a fine-tipped red sable brush can produce very fine lines and subtle cross-hatchings. Larger hair or bristle brushes can be used for broader, bolder effects. A sharp knife blade is handy for scraping out errors. The technique is translucent, not opaque, and errors are hard to cover up.

BOX 11.1. HOW TO MAKE EGG TEMPERA VEHICLE

MATERIALS

- Fresh, raw chicken egg. Cennini (see Bibliography) points out that "country eggs" are fresher than "town eggs," meaning that if you get your eggs directly from your own chickens you'll be sure of how fresh they are!
- Towel.
- Distilled water. Normally, local soft water can be used (hard water should not be used), but to be on the safe side, use distilled water.
- Small glass jar or paper cup.
- Sharp knife.

METHOD

1. Crack the egg and separate the yolk from the white by passing it from half-shell to half-shell, or by using an egg separator. Discard the white, or save it to make meringues.
2. Dry the yolk by rolling it gently on a towel, or by passing it gently from hand to hand, wiping each hand clean on a towel between passes.
3. Pick up the yolk by grasping its skin between your forefinger and thumb, and hold it over a small, clean glass jar or cup. With a sharp knife, puncture the sac and allow the yolk to run out into the jar. You can squeeze out excess yolk with your fingers.
4. Mix about a teaspoonful of distilled water with the yolk. This mixture is the vehicle, which, as noted, should be made fresh for each day's painting.

BOX 11.2. HOW TO MAKE EGG TEMPERA PAINT

MATERIALS

- Egg vehicle prepared in Box 11.1.
- Artist-grade dry pigments.
 ☞ CAUTION: *Do not breathe the pigment dust.*
- Paint-making setup (pages 187–188).
- Palette.
- Small containers to hold the finished paint.
- Water. If your local water is soft, use it; otherwise, use distilled water.

METHOD

1. Prepare a pigment and water paste with each pigment, using distilled water, to the consistency of tubed oil paints.
2. For each color, mix approximately 1 volume of pigment paste with 1 volume of egg vehicle. The combination can be done directly on the palette, or separate jars can be used for each color. Watercolor palettes with depressions around the mixing surface are good for storing the prepared paints.

Although egg tempera is a relatively flexible medium compared to many of the water-thinned paints, it is rather brittle when compared to oil paints. The support should be rigid. A glue-gessoed panel, with its brilliantly white and absorbent ground, is the traditional support system. Finishing the gesso ground off to an eggshell surface is important if you want to emphasize the delicate linear quality of the medium. The ground should be perfectly smooth. Mounted papers and museum boards do not need a ground. If you prefer a paper or a fine fabric support, mount the support on a panel.

PAINTING TECHNIQUES

Painting methods will naturally vary according to your desires, but to appreciate the subtlety of the medium, you should try at least one painting in the classical style. In this well-documented method, all the ideas—the drawing, values, shapes, forms, content—are worked out in advance in a drawing on paper. Because it is difficult to remove unwanted passages from a tempera painting, you should make the preliminary drawing as complete as possible.

Transfer the outlines of the drawing to the panel. This can be done by using a proportional grid system or by using graphite transfer paper, a thin paper coated on one side with a film of graphite dust. Do not use ordinary carbon paper, because the ink will bleed through the paint.

Once you have transferred the contours of the forms, develop a monochromatic or dichromatic underpainting with thin, gradually built up layers of paint. Thin the paint with plenty of water so that it resembles a watercolor wash. With the correct proportion of binder to pigment, the vehicle will hold properly despite a great deal of thinning.

The underpainting need not be entirely monochromatic but can have varying shades of neutralized color. In the traditional approach, areas of flesh tones are underpainted in a greenish hue (specifically, green earth pigment) to emphasize cool shadows and contrast with the warm, local color of the flesh. It is possible to develop an underpainting composed entirely of hues complementary to those that will be applied later in glazes.

Overpainting is applied in thin, small, translucent strokes of cross-hatching or parallel hatching that describe the direction of turning in the form. The idea here is to build up layers of strokes that do not completely obscure the underpainting but use it, in combination with the cross-contour hatching, to model the lights and darks of the forms. This technique was developed because it is difficult to make smooth blends of color in egg tempera, especially when blending one color into another.

It is particularly important at this stage to keep the paint translucent: Be sure to thin it with plenty of water. To avoid opaque blobs of paint at the beginning or end of each stroke, load the brush with a full charge of thinned paint, then squeeze out about half with your fingers before touching it to the painting; or wipe the loaded brush on a tissue to discharge some of the paint. Do not scrub the paint on in a back-and-forth, housepainting style, but use single strokes in one direction. When painting over fresh strokes, wait a few seconds for the previous layer to dry. Of course, this approach takes a great deal of planning and control in the application process, and may not be entirely suitable to more modern, expressionist methods.

Any other application technique can be used, as long as the special character of the paint is retained. Egg tempera should be applied well thinned, so as to produce translucent films. It is not an opaque technique, but opaque effects can be achieved by building up layers of translucent applications. Finished egg tempera paintings, dried for a week or more in a normal environment, harden somewhat as the egg coagulates into a tough film. The painting can then be polished with a soft cotton cloth or nylon stocking to bring out its unique, low surface sheen. The friction of polishing will harden the painting surface and provide a little protection against dust and scratches. The paint is water-resistant but it is *not* waterproof. Do not expose the painting to excessive moisture.

EGG-OIL EMULSIONS

Egg-oil emulsion paints can be considered an intermediate step between pure egg tempera and pure oil painting. In this variation, the

character of the egg medium is considerably altered by the addition of linseed stand oil, sun-thickened linseed oil, alkali-refined linseed oil, cold-pressed linseed oil, damar or other natural resinous varnishes, or wax soaps. A whole egg is used as the emulsifier of the oily and aqueous ingredients. (See Box 11.3.)

Depending on the materials in the vehicle and their proportions, the egg-oil emulsion paints can take on some of the aspects of an oil paint while retaining the qualities of a pure egg tempera. The paint still dries quickly but can be blended more easily, and it can be painted on with slightly more impasto than the pure egg tempera. The emulsion is good, but not perfect, and may separate in the jar during manufacture of the paints, or during the painting process. Shake the bottle vigorously from time to time to be sure the mixture is thorough and stable.

If the amount of water in the emulsion is decreased, the resulting paint will be more like a fast-drying oil paint. Egg-oil emulsion paints made with the normal proportion of water can be thinned with water, but these paints made with little or no water must be thinned only with the emulsion. The yolk alone can be used to make an egg-oil emulsion, but then precise measurement of the ingredients becomes more difficult. Furthermore, the excellent emulsifying capacity of the egg white is missing from an emulsion made only with the yolk.

Ordinary (hard) tap water or eggs that are not fresh can produce emulsions that do not dry properly. Be sure all the ingredients are pure and fresh. Egg-oil emulsions begin to smell strongly as they deteriorate, and can no longer make a good, adherent paint. Discard the spoiled emulsion. Do not use a bottle in which an egg-oil emulsion has spoiled without first resterilizing it by boiling.

Paints can be tested for proper pigment-to-binder proportions in the same way as pure egg tempera paints are tested.

BRUSHES, SUPPORTS, AND GROUNDS

Bristle brushes can be used with egg-oil paints, for the quality of the paint invites a more vigorous application, and the paint is able to show off the brushstrokes with more character than pure egg tempera. Of course, hair brushes can be used with equally pleasing results.

Egg-oil emulsion paints work well on the same supports and grounds used for pure egg tempera. Some artists may be inclined to think

BOX 11.3. HOW TO MAKE EGG-OIL EMULSION PAINT

MATERIALS
- Sterilized tall glass bottle.
- Fresh raw chicken egg.
- Distilled water.
- Any one, or a combination, of the following ingredients: linseed stand oil, sun-thickened linseed oil, alkali-refined linseed oil, cold-pressed linseed oil, damar varnish (5-pound cut), Venice turpentine, or saponified beeswax.

METHOD
1. Chip a hole in the top of the egg and put its entire contents in the bottle. Cap the bottle and shake vigorously to mix the egg.
2. Fill the eggshell with the oily ingredients. Various combinations of two or more of the ingredients can be used, as long as the total volume is equal to that of the eggshell. Put the oily materials into the bottle with the egg and shake again to mix them together.
3. To the egg-oil mixture, add one or two eggshellfuls of distilled water. Shake vigorously to emulsify the oil and water mixture. This is the vehicle.
4. Following the procedures outlined in Box 11.2, combine the egg-oil emulsion with dry artists' pigments or with pigment and water pastes. The egg-oil emulsion vehicle will keep far longer than pure egg binders, provided it is stored in a cool place (but not refrigerated). Do not use preservatives.

that because the emulsion contains oily materials it must be more flexible, but this is not necessarily so. Egg-oil emulsion temperas can crack as easily as pure egg temperas when used on flexible supports, especially if the layers of applied paint are of varying thicknesses. Mount flexible supports to rigid auxiliary supports to be sure the paint will not crack.

PAINTING TECHNIQUES

Procedures used in painting with pure egg tempera can also be used with egg-oil emulsion paints. Because the paint seems to have more body, you might prefer a freer approach.

Thin the paints with water or the emulsion; they dry more quickly than pure oil paint but more slowly than pure egg tempera, depending on the type of oily ingredients used. Allow the paints to dry to touch before painting over fresh underpainting.

Pure oil paints can be incorporated into the emulsion paints to produce an egg-oil paint capable of making a thicker impasto. Squeeze paints straight from the tube, in proportions varying from 1 part oil paint to 1 part egg-oil paint, to 1 part oil paint to 2 or 3 parts egg-oil paint. Paints containing an equal proportion of oil paint should be thinned with mineral spirits. Paints in the 1 to 2 or 1 to 3 ratio should be thinned with plain emulsion—not water.

Remember also that by adding oil paint to the egg-oil emulsion, you can easily lose the special characteristics of the egg-oil paint. If you do this, be sure to follow all the rules of oil painting, especially with regard to painting oilier layers over less oily layers.

MIXED-MEDIA TECHNIQUES

Like casein paints, pure egg tempera or egg-oil tempera paints can be used in the final stages of oil painting to introduce crisp, fast-drying highlights and accent touches into still-wet oil glazes. Egg temperas can also be used as a fast-drying underpainting material for oil paints. The underpainting must be kept very thin and be painted on a very lean ground (if it is an oil ground) in order that it not interfere with the adhesion of the oil paint. Execute the underpainting broadly and rapidly, and wipe out any errors with a damp rag. The overpainting in oil should be done in glazes to retain the visual character of the underpainting. If an egg-oil emulsion is used for the underpainting, the glaze medium in the oil paint should contain the same ingredients found in the emulsion.

Finishing touches of opaque oil paint are applied on top of the glazed areas. They can be applied to wet glaze or on top of dried glaze. If the opaque touches are in egg tempera or egg-oil emulsion tempera, they should be applied to the wet oil glazes to become incorporated into the paint. These paints could crack if applied to dried glazes that contain much oil because of the continuous movement of the oily layer.

The same caution suggested for other mixed-media techniques holds true here: Mixed techniques in egg tempera and egg-oil emulsion tempera should be attempted only by painters who have a firm grasp of what they want from the painting. The work should be executed briskly, in two or three more or less transparent layers, without a great deal of manipulation. Painters who wish to apply thicker, more varying layers of paint or many more layers of paint should stay with pure oil painting.

COMMERCIAL BRANDS

George Rowney (English) and Sennelier (French) both market a tubed egg tempera in this country (see List of Suppliers). Because of the necessity of having a paint that will store well, these are egg-oil emulsion paints, although they can be thinned with water and used like pure egg temperas. Be sure to purchase by generic pigment name, and buy the dealer's freshest stock.

CARE OF THE PAINTINGS

A dilute picture varnish can be applied to the painting, but varnishing can emphasize the contrast between opaque and glazed areas (by changing the refractive index of the binder), and reworked areas can show up in an undesirable way. It is sometimes advisable to frame egg tempera paintings behind glass. Egg-oil emulsion paintings should receive the same care as works in pure egg tempera. (See Chapter 16.)

12 Encaustic

Encaustic is a hot wax painting process in which the wax-bound paints are fused together and adhered to the ground with heat applied from an external source. The process was probably developed by the ancient Greeks, and the name is derived from the Greek *enkaustikos,* "to burn in," referring to the final step. The Egyptian Faiyum-period sarcophagus portraits dating from the second century A.D., purportedly created by Greek painters or at least Greek-trained Egyptians, have remained remarkably well preserved—a testament to the durability of this medium—and are outstanding examples of a highly refined technique.

Although the process itself is simple, the equipment required to make the pictures in the past was bulky and awkward. Consequently the use of the encaustic method declined as less involved processes were developed. During the beginning of this century, when electric heating devices became more common and easy to move about, the technique was occasionally revived. Even though it is not as popular as other, more familiar, easel painting techniques, mainly because of its apparent inconvenience, encaustic now enjoys a considerable reputation. Jasper Johns is probably the best-known modern proponent of encaustic painting.

BINDER AND PIGMENTS

The binder for encaustic is simply melted, bleached white beeswax, which is combined with up to 25 percent of a resinous or oily component that acts as a hardener for the relatively soft vehicle. (See Box 12.1.) The vehicle is then mixed with dry pigments to make the paint. (See Box 12.2.) Such simplicity of formulation, along with the use of a very stable binder, produces a paint that is known for its high durability.

In comparison with oil painting, for example, encaustic pictures do not yellow or darken with age, because the the oil content is very low and the wax is colorless. And because the wax binder is virtually inert, the pictures are very resistant to chemical changes, atmospheric moisture, and other forms of decay. The only threats to encaustics are extreme heat, which could cause the paints to melt, and extreme cold, which can make the paintings brittle and subject to mechanical damage if jarred or moved carelessly.

The thinner and solvent for encaustic is mineral spirits. This liquid can be used to predisperse the pigments prior to mixing them with the wax vehicle, a particularly helpful procedure when dealing with gritty pigments. ☞ *CAUTION:* **Mineral spirits is flammable.**

All the pigments used in oil painting are suitable for encaustic. The pigments must be finely pulverized.

Repeated heating and cooling of solid cakes of encaustic paint may eventually cause the oily or resinous content to break down; they are the culprits in a deteriorating encaustic painting. If the encaustics are going to be used only occasionally, you can prolong their storage life by not adding these ingredients to the paint until you are ready to work. Follow the method in Box 12.1 for making the paints, but eliminate step 2 in the preparation of the vehicle: Make the cakes *without* the oily or resinous content. When you are ready to paint, rub the cakes on the palette to form puddles of color, and then add a small amount of the prepared liquid ingredients.

Small tin cans—tunafish cans are excellent—or those individual foil "boats" used for baking potatoes can be used for making and storing the color cakes described here. The individual containers can be placed directly on the palette and the colors melted in them. The only problem with using the cans as both storage and painting containers is that the various colors can be contaminated with one another during the painting process.

TOOLS AND BRUSHES

Bristle brushes are used for painting in encaustic; hair brushes will not stand up to the abuse of the process. Only natural bristle brushes should be used—plastic bristles will melt—and they need not be the best quality, since good brushes are as quickly ruined as cheap brushes.

The major pieces of equipment needed are the palette and the burning-in tool. The ancient Greeks used a container of burning charcoal covered by a flat metal plate. Today, use a hot plate with a variable temperature control, topped with a hollow steel box. The box can be welded from scrap steel, with the top surface at least 6 mm (1/4 inch) thick, while the sides and bottom can be thinner. A useful size is about $46 \times 61 \times 5$ cm ($18 \times 24 \times 2$ inches thick); the hollow box form allows for an air space within the palette that helps to distribute the heat evenly. Leave a small hole in one corner of the bottom of the palette to allow heated air to escape and to prevent the warping of the palette surface.

Manufactured palettes can be purchased from specialty suppliers. The palettes are made of aluminum with built-in thermostatically controlled electric heating elements, with depressions in the surface to hold the paints, and they can be quite expensive.

The least expensive alternative to both palettes described above is an electric frying pan made of aluminum, the kind with a thermostat in its handle. These can usually be found in junk stores, and you can adapt them for your use. Their only drawback is that they are quite small.

☞ CAUTION: *Do not use the frying pan for cooking food after using it as an encaustic palette.*

The other big piece of equipment is the burning-in lamp. Any heat lamp can be made to work if the heat emitted by the bulb is enough to melt the wax—but be sure that the lamp will melt the entire thickness of the paint layers, not just the top layer. Better than a simple heat lamp is an electric coil, mounted around a ceramic heatproof core that has a screw-mount base. These can be screwed into a ceramic heatproof socket and put into a bowl reflector.

BOX 12.1. HOW TO MAKE ENCAUSTIC VEHICLE

MATERIALS

- Bleached white beeswax.
- The oily or resinous ingredients: linseed stand oil (oily) *or* 3 parts 5-pound cut damar plus 1 part Venice turpentine (resinous).
- Small enameled steel saucepan, or medium-size tin can.
- Hot plate.

METHOD

1. Break the beeswax into small pieces. (Freeze it and then wrap it in a cloth and smack it with a hammer—it'll break up quite easily.) Place the wax in the small saucepan or tin can. Heat it gently until it just melts. Do not heat it until it begins to smoke.

 ☞ CAUTION: *Hot wax can cause severe burns, and the vapors can be harmful.*

2. Remove the melted wax from the heat, and stir in the oily or resinous ingredients. The proportion of the added ingredients should not exceed 25 percent of the volume of the wax. Consider the wax to be 4 parts by volume (you could have volume level markings on the inside of the can or pan): Add 1 part by volume of the oily or resinous mixture.

BOX 12.2. HOW TO MAKE ENCAUSTIC PAINT

MATERIALS

- Vehicle prepared in Box 12.1.
- Highly pulverized, artist-grade dry pigments.

 ☞ *CAUTION: Avoid breathing pigment dusts, and do not use toxic pigments.*

- Muffin tin, containing as few as six depressions or as many as a dozen, depending on the number of colors you're making.
- Hot plate.
- Spatula or stiff palette knife.

METHOD

1. Heat the muffin tin on the hot plate. Place dry pigments in the depressions in the tin, a different color for each depression. Be careful not to mix the pigments inadvertently—or do make deliberate custom mixtures, as desired. The tin should be warm, not hot.

2. Reheat the vehicle until it just melts. Pour some of the vehicle into one of the depressions, and use the spatula to mix the wax and pigment thoroughly. The consistency of the mixture should be very smooth, without lumps of pigment, and about the viscosity of thin tubed oil paint.

3. If the wax vehicle in the saucepan begins to solidify, gently reheat it. Continue pouring and mixing each individual color until all the pigments have been made into paint.

4. Allow the cakes of color to cool and solidify. They can be popped out of the tin and wrapped in paper for storage, or stored in the tin. For use in painting, they are simply rubbed on the heated palette (see the section below on tools and brushes) to make a puddle of liquid paint.

 ☞ *CAUTION: Do not use the muffin tin to make food after using it to make encaustic paints.*

☞ *CAUTION: Be sure that none of the elements is flammable—some ordinary light sockets have cardboard insulating material that can ignite, and most have plastic parts that can melt— and that the whole apparatus can be held safely by a handle.*

SUPPORTS AND GROUNDS

Although the addition of the oily or resinous component to the vehicle makes the wax binder a bit more flexible, the normal proportions given in Box 12.1 do not make the paints flexible enough to use on unmounted paper or fabric supports. A rigid panel, correctly braced at the back, is the best support for an encaustic painting. Papers, fabrics, and museum boards can be used as supports if they are mounted on a rigid panel.

Adding a larger amount of oil to the vehicle could make the paint usable on a flexible support, but then you run the risk of producing a painting that will yellow badly (the wax is transparent), or one that dries very slowly.

It may be possible to substitute one of the acrylic solution binders (Acryloid B-67MT) for the linseed stand oil, to limit yellowing.

The preferred ground for encaustic is glue gesso, because it is absorbent enough to allow firm attachment of the paint layers when they are fused and burned in when the painting is finished. Acrylic emulsion grounds may work if they are sufficiently roughened by sanding with a medium-grit sandpaper, but they can be fairly unabsorbent grounds.

PAINTING AND BURNING-IN

Set the box palette on top of the hot plate and preheat it to about 93° C (200° F). If the temperature control on the hot plate does not indicate degrees, simply heat the palette to the point where it easily melts a sample of one of the color cakes.

Lower the temperature and keep it steady at about 65° to 79° C (150° to 175° F), or at a temperature where the color sample stays liquid but does not bubble, smoke, or burn.

When the palette has reached the proper temperature, rub the various color cakes to form discrete puddles of color, or set individual containers of the wax colors on the palette and wait until the contents have melted. Add the oily or resinous content if it was omitted from the cakes for longer storage life. Then place two cans of the thinner—mineral spirits—near, but not on, the palette.

☞ CAUTION: *Mineral spirits is flammable. Keep your containers far enough from the hot plate that the contents remain cool.*

You can then use any standard painting technique, except that, because the paint dries (cools) very quickly, you should work more rapidly to get the paint to the picture before it hardens in the brush. Put the palette close to the work. You can also use wet-into-wet techniques by holding the heating lamp close to the work with your free hand. Subtle glaze effects can be obtained by thinning the paint with mineral spirits and rubbing it on briskly. Rinse your brushes frequently to keep your color mixtures clean. You can work on the painting indefinitely, since removal of unwanted areas is easy; heat the surface and scrape away the paint.

Encaustic technique seems especially suited to impasto and various kinds of knife painting, although you should be careful not to overdo it; too thick an application of the paint may crack. The paint is already endowed with an impasto "look."

You can clean your brushes and knives by warming them on the palette and then wiping them on a rag. After rinsing in mineral spirits, they can be washed like other brushes. Although clean brushes will ensure clean paints, going to a great deal of trouble to get them perfectly clean may not matter in the long run—the heat of the palette can reduce some brushes to stubble in short order.

Burning-in is accomplished by laying the picture flat on a table and passing the heat lamp back and forth across the painting, about 10 to 15 cm (4 to 6 inches) from its surface. Heat the picture until all the paint softens and fuses the layers to each other and the whole structure to the ground. Do not overheat so that the paint bubbles or burns, although this procedure can be controlled so the effects one artist might call defects another will find desirable. In fact, if the surface is heated to the proper temperature, pigments seem to float around within the vehicle. What happens is that heavier, denser pigments sink, and lighter pigments rise to the surface. Organic pigments, usually light and fluffy, are likely to float up through heavier metallic or earth pigments in a characteristic pattern. Some degree of practice is necessary to control the burning-in process.

When the initial burning-in is finished, further touches and corrections can be made, and then the painting can be given a final burning-in. At this point, some artists will spray the surface of the painting with mineral spirits and ignite it, or use a blowtorch to finish off the surface.

☞ CAUTION: *These practices are NOT recommended. In the first case there is the danger of explosion or fire, and in the second case you can vaporize the heavy metallic pigments into toxic metal fumes.*

After the final burning-in, the painting will have a soft matte surface. After a few days, it can be polished with a cotton cloth to harden the surface and produce a semigloss finish.

COMMERCIAL BRANDS

There are a couple of small manufacturers of encaustic paints—you'll pay a lot for their labor and can make your own faster and know exactly what's in them. Commercial encaustics do not conform to ASTM Standards, but should have a health label according to the law.

THE CARE OF ENCAUSTICS

Finished encaustic paintings should not be varnished with resinous finishes; the usual solvents, mineral spirits or gum turpentine, can soften the wax. The paintings can be displayed with a polished surface alone, but for the best protection, framing the painting behind glass is recommended. Avoid extremes of heat and cold, to prevent softening or cracking of the picture. Large encaustic works should be heavily framed (see Chapter 16).

13 Pastel

Pastel, like the oil and wax crayons, is sometimes thought of as primarily a drawing medium because the material is applied dry. Since it uses color, however, it is just as well to think of it as a painting medium. Pastel is, in fact, the purest of the painting techniques: The sticks of color are composed mostly of pigment, with very little vehicle added.

Although chalks dug from the ground and mixtures of colored clays with weak binders have been used since prehistoric times, the development of true pastel as a separate and distinct painting medium dates only from around the beginning of the eighteenth century. Red, white, and black chalks were used as accent hues in Renaissance drawings, and there are some works in full color dating from the early seventeenth century, but the technique was not fully realized until about a hundred years later.

Artists such as Jean-Étienne Liotard, Maurice-Quentin de La Tour, and Jean-Baptiste-Simeon Chardin were early practitioners who refined pastel painting into a highly sophisticated medium for portraiture. Édouard Manet, Pierre-Auguste Renoir, and most notably Edgar Degas exploited other possibilities of expression in pastel, producing less slickly finished works in favor of more spirited, loose constructions. Degas's work in pastel can stand by itself, apart from his other, equally formidable work, as a monumental achievement. He experimented with pastel more than any other artist before him, and stretched its limits far beyond its established boundaries.

Most artists prefer to purchase their pastels ready-made, but they are easy to make. Artist-grade pigments are simply combined with the binder; the lighter tints of the various hues are made by combining a white pigment or inert filler with the full-strength colors. As in all the other paint-making processes, you can make up special colors that are not available commercially. It is easy to make very large pastel sticks if you wish to work with big sweeps of color.

Artist-grade dry pigments used for the water-thinned paints are appropriate for pastel. During and after the painting process, fixative is sprayed on, so that the particles will not be brushed off. Fixative can be made in the studio too.

☞ *CAUTION: Avoid the toxic pigments, especially since you are apt to inhale the dust during the painting process.*

Pastels are usually matted and framed behind glass for exhibition. For storage, they should at least be matted to protect their fragile surfaces. (See Chapter 16.)

PREPARING THE BINDERS

Good pastel binders can be made of gum acacia or gum tragacanth (the traditional pastel binder). (See Box 13.1.) Each of these ingredients requires a slightly different method of preparation, and each in turn is made as a stock solution to be diluted further for making the pastels.

BOX 13.1. HOW TO MAKE TWO KINDS OF PASTEL BINDERS

MATERIALS

- Wooden spoon.
- Small pot.
- Dry binder (gum arabic *or* gum tragacanth).
- Distilled water.
- Hot plate.
- Fine-mesh cheesecloth.
- 1 large, clean glass jar with cover, and 5 smaller clean glass jars with covers, for storing the various vehicle strengths.
- Denatured ethyl alcohol or grain alcohol (for Method B).
- Second large, clean glass jar (for Method B).

METHOD A: GUM ACACIA (GUM ARABIC)

1. Combine 1 part by volume of powdered or lump gum with 2 parts by volume of boiling distilled water in the small pot.
2. Remove from heat, and stir to dissolve the gum.
3. Allow the solution to cool, then strain it through fine-mesh cheesecloth into the large glass jar. This solution will keep for a few days in a cool place. It may be refrigerated if necessary, but will have to be warmed before use. A preservative can be used, but is not necessary if all the vehicle is to be used at once to make a complete set of colors.

METHOD B: GUM TRAGACANTH

1. Put 1 part of the powdered gum into a clean glass bottle and moisten it with a very little bit of denatured ethyl alcohol or grain alcohol. Add 25 to 35 parts of distilled water, cap the bottle, and shake the mixture.
2. Allow the solution to sit overnight, by which time it will have formed a gel— a colloidal solution. Warm the gel in a water bath (place the bottle in a pot of water on a hot plate) to complete the solution.
3. Pour the warmed solution through a cheesecloth strainer into a second clean glass jar. The solution will keep as long as the gum acacia, but it need not be refrigerated. Preservatives are not necessary.

VEHICLE STRENGTHS

Both solutions made in Box 13.1 are stock vehicles that can be used full strength to make the pastels, but for some pigments they are far too strong and will make sticks whose very hard consistency makes them inconvenient to use. Whichever binder you choose, reduce the vehicle to five different strengths with additional distilled water, as follows:

1. Divide the stock solution in half. Label the reserved stock *#1*.
2. To the *second* part of *#1*, add 2 parts water. Divide it in half again and label the reserved portion *#2*.
3. To the *second* part of *#2*, add 2 parts water. Divide it in half again and label the reserved portion *#3*.
4. To the *second* part of *#3*, add 2 parts water. Divide it in half again and label the reserved portion *#4*.
5. To the *second* part of *#4*, add 2 parts water. Label it *#5*.

The pastel chalks are made with these various strengths of vehicles. Since identically named pigments can vary in texture and particle size from supplier to supplier, it is difficult to give precise instructions as to which strength of binder is appropriate for which pigment. However, you will rarely need the stock solution, #1. The weakest vehicles, #4 and #5, will generally bind the organic pigments sufficiently, although some varieties will need #2. Vehicles #2 and #3 will bind the natural and manufactured mineral pigments, although some need only #5 or, in a few

cases, water alone. It is a simple matter to make a test stick and take notes to remember how the color was made.

MAKING PASTELS

A surprisingly small volume of pigment will make quite a large number of sticks, depending of course on the pigment being used. (See Box 13.2.) For instance, 60 ml (2 oz.) of arylide (Hansa) yellow, a relatively inexpensive pigment, can be reduced with about 120 ml (4 oz.) of precipitated chalk without losing any of the chroma of the straight pigment. This volume of pigment can be made into 10 to 15 sticks of full-strength pastel, *not counting any reductions with white to make the tints.* If a stick of bright yellow pastel purchased in an art supply store costs, on the average, about 50 cents to a dollar (or more depending on the pigment), you can readily see the savings involved in making your own pastel sticks.

White pastels can be made of one single kind of pigment, or a combination of the pigment and a chalk filler, or a single chalk filler, or a combination of chalk fillers, depending on the consistency you desire in the resulting chalk. Kaolin and precipitated chalk will produce smoother chalk sticks; blanc fixe, a precipitated barium sulfate, will produce smoother sticks; natural calcium carbonate (whiting) will produce harder or coarser chalks. Likewise, the selection of the variety of filler chalk will affect the consistency of any colored pigments that are added to it to make tints. The possibilities are endless.

Although the operation is very simple, it is smart to take written notes of the ingredients used and their proportions when making pastels. This is true when making any kind of paints, but perhaps even more so with making pastels. Such a variety of combinations can be made that it will be impossible to duplicate successful results without some written record of the recipe.

TOOLS AND SUPPORTS

Ordinarily, no tools other than your fingers (used for blending) are necessary for painting in pastels. That's fine, as long as you do not use hazardous pigments that could be absorbed through your skin. Some artists prefer to use a rolled paper stump or chamois cloth for blending, rather than their fingers. Short-bristled brushes are useful for scrubbing off mistakes, especially when the pastel has been built into a thickness; a small sharp knife blade can also be used, as can a kneaded rubber or vinyl eraser.

Any permanent, toothy support can be used for pastel, although too rough a surface might not work well, and fabric supports will not work unless they are mounted. Mounted fabrics can have a very thin ground applied— so as not to obscure the weave—and some smooth-surfaced supports, like hardboards, should have a toothy ground. Papers made especially for pastel are available; they have a textured coating applied to the surface, which is ideal for pastel painting. But it is easy to make your own pastel papers, using ground pumice powder and a little thin glue. (See Box 13.3.)

Colored papers can be used for pastel supports, but they should be pigmented or dyed with permanent colorants, and should be made of permanent, acid-free materials. It is better to give a rag paper support a thin, even wash of watercolor paint.

PAINTING TECHNIQUES

In pastel, as in other techniques, the use of the material is governed by your artistic needs. Most artists try to avoid overblending pastel in a careless manner, which can result in a smudged or blurry appearance. Separated strokes of color can blend optically with one another to produce mixtures of hues, and layers of color that do not obscure each other can be built up in this way.

Once the tooth of the support has been completely filled in by applications of the chalk, subsequent layers of color will not adhere well unless the ground is reexposed. A very slight impasto may be possible, but heavier applications will eventually fall off the support, especially if the picture is subjected to rough handling.

BOX 13.2. HOW TO MAKE PASTELS

MATERIALS

- Mortar and pestle. It is easier to mix the pigments with this equipment than with a grinding setup, because you are making a dry dough instead of a liquid. Large porcelain or ceramic mortars and pestles can be obtained from restaurant supply houses or chemicals suppliers.
- Vehicle. Use one of the stock vehicles recommended in Box 13.1, and reduce it to the recommended strengths.
- Artist-grade dry pigments. For the white pastels, use titanium or zinc white, or plain precipitated chalk, or whiting (calcium carbonate). For the filler, used to make light tints, use whiting to produce harder chalks, and precipitated chalk or kaolin (China clay) to produce softer chalks. Barium sulfate can also be used.
- Newspapers and trays for drying the sticks. Cover a hardboard panel with several layers of newsprint.
- Several bowls and cloths.
- Soap and water.

METHOD

1. Make the white pastel dough first, because it will be used to reduce the full-strength colors to tints. Make a lot of the white. Begin by placing a volume of dry, white pigment in the mortar. If the pigment is a fine powder, which it should be, proceed to Step 2. If it is somewhat coarse, grind with the pestle to separate the lumps.

 ☞ *CAUTION: **Do not breathe the dust.***

2. Add a bit of the selected vehicle. Grind the mixture, and add some more vehicle. Continue grinding and adding small amounts of vehicle until the mixture is a smooth, doughy paste. It should be very smooth and of the consistency of bread dough, or a slightly moist lump of clay.

3. Remove the dough from the mortar and divide it in half. Reserve half to make tints; to keep it moist while the white sticks are being made, place it in a bowl and cover the bowl with a damp cloth.

4. Separate the dough into smaller lumps and use the flat of your palm to roll each out into a stick about 1 cm ($^1/_2$ inch) in diameter and 7.5 cm (3 inches) in length, or whatever size you prefer. If you want a stick with smooth and regular contours, use a piece of stiff cardboard or a small block of wood to roll out the sticks.

5. Put the sticks of white pastel on a layer of newsprint, on a tray, and set them aside to dry. They may be dried near a source of gentle heat, but too rapid drying may cause them to crack. However, if you are making a test stick to check the vehicle strength, set the tray in the sun or on a radiator.

6. To make full-strength colored sticks, select a pigment and repeat Steps 1 through 5. Reserve half of the full-strength dough, as in Step 3.

7. To make a half-strength tint of a full-strength color, combine the colored dough with an equal portion of the reserved white dough. Mix them together thoroughly so that there are no streaks of color evident. Divide the mixture in two and reserve half as in Step 3. Make the half-strength sticks as in Steps 4 and 5.

8. To make quarter-strength sticks, combine an equal portion of the white dough with the reserved half-strength dough. Reserve half as in Step 3.

9. Continue as above, making weaker and weaker tints if desired, until the white dough is no longer tinted by the remaining colored dough. Usually three or four reductions are enough, although some stronger pigments can be reduced by as much as 80 or 90 percent before they no longer have a coloring effect.

10. Clean up all the equipment with soap and water, and proceed to the next color. If you have made a huge batch of white dough, begin with a new colored dough; otherwise, make some more white first.

11. Some sticks will form a surface crust when dry. Simply scrub the stick on a rough surface to break through the crust.

BOX 13.3. HOW TO MAKE PASTEL PAPER

MATERIALS

- Paper. Any smooth-surfaced, acid-free artists' paper will do. Attach to a board as if you were stretching watercolor paper.
- PVA emulsion glue or other white glue.
- Water.
- Ground pumice powder, available in a well-stocked pharmacy.

METHOD

1. Thin 1 part of glue with 10 parts of water, and brush it liberally over the surface of the stretched paper.
2. Sprinkle the ground pumice powder evenly over the surface of the stretched paper.
3. Pick up the support, holding it horizontally and face up, and give it a good shaking back and forth and side to side—as though you were flouring a greased baking pan—to distribute the powder evenly.
4. Tilt the support and shake off any excess powder that has not stuck to the glue.
5. Allow the glue to dry.

Mixed-media techniques with pastel are attractive. Combined with water-thinned paints, they can produce exciting images. They can also be combined successfully with the temperas, casein, oil, resin-oil, acrylic solution, acrylic emulsion, and alkyd paints.

As with any other mixed-media technique, you should have some idea of which medium will be dominant and which will be used for accents or supporting touches.

COMMERCIAL BRANDS

There are myriad brands of pastels on the market; probably the best-known are Rembrandt and Sennelier. Although no brand is "better" than another, each brand has its own special characteristics, so many artists have a personal favorite. Pastels are especially susceptible to fading since the lighter tints are so reduced with chalk: some colors did better than others in a lightfastness test, and brand name is no assurance of quality in this regard. ASTM Standards do not yet cover pastels.

FIXATIVES

A fixative is applied as a final weak film and is used to adhere the particles of pastel to each other, and somewhat to the support, to prevent their being jarred loose or falling off. A fixative must be sprayed on; it is not applied as a measurable layer or coating. Too heavy an application of fixative can change the refractive index of the paints, causing a drastic change in the look of the work—and the idea—and making those passages painted with opaque strokes transparent and darker. Fixatives can be applied during the painting process as well as at the end, in order to prevent movement of painted layers as further applications of color are made.

Your choice of fixative is important. It should be weak in strength, as colorless as possible, and very fast-drying. Commercial spray fixatives in art supply stores are usually solutions of acrylic or vinyl resins in alcohol, mineral spirits, toluene, or combinations of these solvents. They should be used with caution, especially if the label indicates the presence of toluene, for most of the solvent vapors are harmful, if not toxic. ☞ *CAUTION: An organic vapor mask should be worn when spraying fixatives, or good cross-ventilation of air should be provided.*

PREPARATION OF HOMEMADE FIXATIVES

Homemade fixatives are a less expensive alternative to the commercial brands. The shellac solution described in Box 6.2 can be used. For those who might object to the slight yellowing shellac can cause—it is really negligible in the dilution suggested for fixatives—try the alternative in Box 13.4.

SPRAY EQUIPMENT

Since fixatives should be sprayed, not brushed, consider the equipment available for spraying. The old-fashioned mouth atomizer works well, but puts you very close to potentially harmful spray mists. An alternative to this is the commercial spray solution, a self-contained solution of resin and solvent with an inert propellant. These can become expensive if you intend to use a lot of fixative. Also, the pressure in the can is reduced with use, so that the final bursts of spray may be more like spurts of globs than mists.

Another alternative is to use one of the small devices that have a container of inert propellant attached to a reservoir into which anything that can be sprayed is placed—you only need replace the can of propellant when it runs out. The best alternative is a compressed-air sprayer or an electric sprayer—especially if you want to do spray varnishing too. See the section on spray varnishing in Chapter 16 for a further discussion of spraying equipment.

14 Synthetics

The synthetic paints make use of binders made from resins synthetically derived from petroleum. These resins are twentieth-century industrial innovations adapted to artists' materials. The artists' materials market is very small: The principal research and development of these resins is still conducted by the producers of the raw materials, who have relatively specific industrial applications as their motivation.

If you want to experiment with the synthetic binders by preparing your own paints from the raw materials, contact manufacturers of the ingredients for advice. Artists' paint manufacturers hold their formulas as trade secrets and will not divulge them. Raw materials chemists who specialize in coatings formulation can offer suggestions, but not guarantees—and their recommendations are often for relatively short-lived industrial applications.

In spite of what you might think about the prices of art materials and the profitability of selling them, only a few manufacturers of artists' materials have the financial resources and expertise to develop the synthetic resins with specific art products as the end result. Most of the development has involved an attempt to improve on the performance and durability of traditional mediums, or to provide new effects not usually possible with the traditional paint systems—principally oils. Even after more than 50 years of continuous use and development, during which time certain of the synthetic paints have become very popular, we should really consider them experimental systems. Fifty years is not a long time when measured against the history of art.

The synthetics are by no means a replacement for other kinds of paints, although certain aspects of their performance—drying time, clarity, flexibility, convenience—can be seen as definite improvements. These materials should be thought of as separate entities, with individual sets of problems and possibilities. Unlike the oil paints, each brand of synthetic paint has its own character—that is, Winsor & Newton's acrylic emulsion paint is different from Liquitex's, which is different from Golden's. None is "better" than another, though some may be better for specific applications.

See Chapter 16 for instructions on the care of paintings made with synthetics. Paintings of acrylic solution and alkyd should be varnished; acrylic emulsion paintings should be protected with an acrylic solution varnish.

ACRYLIC SOLUTION PAINTS

An acrylic resin dissolved in a solvent serves as the binder for these paints. They perform similarly to oil paints, though they do not yellow and are somewhat more brittle.

BINDER

The binder for the acrylic solution paints is an acrylic resin—a solution of polymers, the principal monomer being an ester of acrylic acid. There are over 20 different acrylic solutions produced by Rohm and Haas, the main supplier, only a couple of which are dissolved in a solvent considered safe for normal artistic use without adding the burden of restricting and uncomfortable protective equipment.

Acryloid B-67MT is supplied as a solution of 45 percent solids in mineral spirits and is compatible with alkyds and alkyd-oil mixtures, aliphatic hydrocarbon solvents, and other paint system liquids. Its main industrial use is for plastic coating, or for inks and lacquers. The binder is a rapid drier and forms films that are clear, nonyellowing, reasonably flexible, and adhesive.

The binder comes as a rather heavy syrup. It is sometimes necessary to thin it a bit in order to be able to grind a paint easily by hand. Mineral spirits can be used for this purpose. It is not necessary to add more than 1 or 2 parts by volume of mineral spirits to 20 parts of the resin solution.

PIGMENTS

All the pigments compatible with acrylic solution resins, listed in Table 7.1, can be used with these paints. Generally, all pigments that can be used in oil are used in acrylic solution paints.
☞ *CAUTION: Do not use the toxic pigments in the dry state.*

PREPARATION OF THE VEHICLE

Other than a slight thinning, if necessary, no further preparation is needed. The procedures, materials, and methods for making these paints are exactly the same as for making oil paints, although, obviously, the vehicle is different. You are advised to predisperse the pigments in mineral spirits, since speed is important when making these paints. Too much time spent trying to get a pigment well dispersed in the acrylic syrup may leave a hopelessly gummed-up slab and muller. Although the paints are simple to make, this problem can be significant if you are attempting to make a lot of it. The solvent, mineral spirits, is volatile enough so that the paints begin to assume their tube consistency almost as soon as they are ground. They must be placed in air-free storage (tubes or jars) immediately. Of course, you can grind the paints to liquid, with an excess of solvent in the vehicle, and then allow them to reach the proper viscosity before packaging them.

EQUIPMENT, SUPPORTS, AND GROUNDS

The same tools, brushes, and other equipment and accessories used in oil painting can be used with the acrylic solution paints. The techniques used in preparing the surface and applying the paint vary slightly from those used when working with oils.

All the grounds so far discussed (oil, glue gesso, and acrylic emulsion) can be used with the acrylic solution paints; the paint's adhesion is very good. Lack of flexibility can be a problem, however, so the best supports are rigid, or flexible supports mounted on a rigid backing.

Since there is no problem with the oxidation of the acrylic resin affecting the integrity or durability of the support—as there is with linseed oil—it is possible to use these paints on unprimed supports. The support itself should be stable and white. Morris Louis's veil paintings of the 1950s—strikingly brilliant, thin transparent washes of Magna (acrylic solution) paints on unprimed cotton duck—are an excellent example of this technique. Of course the support (or any ground applied to it) can have a middle-tone wash of the paint applied to it. Beware of stain painting on unprimed supports, however: See Chapter 3 on grounds and why they should be used.

PAINTING TECHNIQUES

The acrylic solution paints behave very much like oil paints, and can be manipulated for a comparable range of effects. They have a slightly different brushing quality from oils, and may not seem quite as viscous. The dried paint films are more transparent than linseed oil's and are not yellow, so the colors seem more saturated and brilliant. Thickly painted passages of the paints will normally take less than two days to dry.

One difficulty with acrylic solution paints is that the films remain soluble in mineral spirits or gum turpentine after drying. This characteristic poses problems in overpainting, because subsequent applications of paint can dissolve and muddy the underpainting.

To overcome this problem, it is necessary to isolate the underpainting with a retouch varnish made of an acrylic solution that is not soluble in mineral spirits. Acryloid A-21 is soluble in n-butyl alcohol and forms a tough film good for this purpose. Once the isolating varnish is dry, overpainting will not lift previously painted layers.

☞ *CAUTION: n-butyl alcohol should be considered flammable and harmful. Its vapors can be very irritating.*

COMMERCIAL BRANDS

Bocour Artists Colors, Inc. (now owned by Zipatone), makes the best-known version of an acrylic solution paint, called Magna, which has been on the market since about 1946. This gives it the distinction of being one of the first commercially available synthetic paints. The Magna paints come in the usual collapsible tubes and are offered in a good range of colors, although not nearly as extensive as the range found in oil paints. There is also a proprietary isolating varnish, two painting mediums— glossy and matte—and a gel medium for making the paints very viscous. The Magna paints are oil-miscible, but mixing them with oil paints will contribute the faults of oil—slow drying, yellowing, eventual embrittlement— unless the mixtures contain a preponderance of the acrylic resin.

Maimeri, an Italian company, has had its Restoration Paints marketed in this country by C.B. International in New Jersey. (See List of Suppliers.) These paints are ground in a "resinous gum," with "completely volatile solvents." From the description of their use and performance, it can be deduced that, although they may not be strictly acrylic resins, they perform the same way. The color range is rather limited to those pigments that have a certifiable degree of lightfastness (certified by Maimeri, that is); the solvent is mineral spirits or gum turpentine.

Lefranc et Bourgeois, a French company now owned by a consortium (Colart International, which also owns Charbonnel, Paillard, and Winsor & Newton), has begun marketing a conservation paint based on Acryloid B-67MT.

The color range is rather limited to those pigments that have a certifiable degree of lightfastness (certified by Lefranc); the solvent is mineral spirits or gum turpentine (see List of Suppliers).

ALKYD PAINTS

These paints use an oil-modified alkyd resin as a binder. Their performance is quite similar to that of oil paints, but they maintain their flexibility and do not yellow.

BINDERS AND PIGMENTS

Alkyd resins, as explained in Chapter 4, are made by reacting a polybasic acid with a polyhydric alcohol and an oil or a fatty acid. Typical combinations might include phthalic anhydride (the polybasic acid), ethylene glycol or glycerine (the polyhydric alcohols), and soybean, linseed, or safflower oils (the fatty acids or oils). These resins have had industrial applications in coatings technology for a long while—housepaints, deck paints, automobile paints—but only recently have they found use in durable artists' materials. The alkyds used for artists' paints are called "long-oil alkyds" because they have more than 60 percent oil content, usually in the range of 60 to 70 percent, depending on the type of oil. The oil content is essential if the alkyd binder is to form a stable, tough film because the alkyd resin by itself is considered too brittle. Curiously, artists and artist's paint makers call these oil-extended binders "oil-modified alkyds," but the raw materials manufacturers call them "unmodified alkyds." They also produce alkyds that have rosin or phenol-formaldehyde additions—for better hardness and water resistance—which are not for artists' paints, and these they call "modified alkyds."

Alkyd binders come from the manufacturer already prepared as a paint vehicle, at about 50 to 70 percent solids content. The solvent preferred for artists' paints is mineral spirits. A variety of alkyds modified by soybean, linseed, or safflower oil, reduced with mineral spirits, are available from Reichhold Chemicals (see List of Suppliers) under the trade name Beckosol.

The 10-000 series, unmodified long-oil alkyds, are best for artists' paints. Two that may be used for homemade artists' paints are Beckosol 10-045, P-296-70 (65 percent soybean oil, reduced in mineral spirits) and Beckosol 10-051, P-381-70 (65 percent linseed oil, reduced in mineral spirits).

Another additive, appropriate for manufacture on a commercial scale but not feasible for homemade paints, is a drier. Driers are used with commercial artists' paints to ensure a relatively consistent drying rate among a range of colors, but cannot normally be added in the minute quantities as required for home production. A 1 to 2 percent wax stabilizer can be incorporated into the vehicle using the method given for oil paints in Box 9.1.

All the pigments appropriate for oil paints can be used for alkyd paints.

PREPARATION OF THE VEHICLE AND THE PAINT

The binder as it comes from the supplier might have to be thinned slightly. Use a very small amount of mineral spirits—no more than 1 part in 20 of the alkyd binder.

The methods, materials, and procedures for making oil paints are the same for alkyd paints as well. The pigments can be predispersed in mineral spirits, but the vehicle does not dry out as quickly as the acrylic solution vehicle. The oil content of the vehicle slows the drying process.

EQUIPMENT, SUPPORTS, AND GROUNDS

The tools, brushes, and other equipment used with oils are used with alkyd paints. The supports and grounds used for oil paints are appropriate for alkyd paints. Oxidation of the alkyd resin seems not to affect the durability of the support, so that unprimed, white supports (mounted papers or museum boards, for instance) can be used. Once again, however, be aware that alkyd resins reportedly do yellow, albeit not as much as oils. A middle-tone wash of alkyd color can be used to modify the color of the support or the ground.

PAINTING TECHNIQUES

The performance of alkyd paints is so similar to that of oil paints that you can easily use oil painting procedures. Alkyd paints dry more quickly than oil, usually overnight; different colors dry at different rates in homemade versions. Glazing and other indirect techniques can be used without waiting as long as you have to wait with traditional oils. You can use wet-into-wet techniques for direct effects. The paints are relatively nonyellowing (but linseed oil-modified alkyds *do* yellow), and resemble dried oil paint more closely than acrylic solution paints. Oil paints can be judiciously mixed with alkyds to slow drying time or alter viscosity, but too much oil paint can make alkyd colors yellow as the oil ages.

COMMERCIAL PRODUCTS

Winsor & Newton markets an alkyd resin-based paint. It remains to be seen whether it will make significant progress in the marketplace. The principal difficulty seems to be a misconception about the nature of the product—the name "alkyd" may not inspire distrust, but it certainly is not attracting hordes of customers.

Think of these paints as oils, for that is really what they are if they contain more than 50 percent oil in the binder. Check the label on a can of oil-based deck paint sometime—industrial paints are better labeled for contents than artists' paints!—and see how much alkyd resin is in the vehicle. Another problem with the artists' alkyds is that they are expensive (Winsor & Newton has to import them).

A number of auxiliary materials are offered with the commercial brands of alkyds, which can also be used with oil paints. Winsor & Newton makes Liquin, a thin, translucent gel; Oleopasto, a stiff, translucent gel; and Wingel, a clear gel. All these mediums are more thixotropic than the paints—they are stiff, but flow easily when brushed out. The mediums can be mixed with the paints to produce impasto or glaze effects with little risk of cracking and yellowing, according to the manufacturer. When mixed with oils, the alkyd mediums will speed the drying of the oil paints.

The binder for these paints is an acrylic resin emulsified in water, and the paints are thinned with water. They perform quite differently from oil and the other synthetics.

BINDERS

Artists' paints based on acrylic emulsion binders are by far the most popular of the synthetics, mainly because of their convenient and easy cleanup, but also because of their versatility and flexibility. The binder is an acrylic resin emulsified with water; of the more than 30 Rhoplex emulsions made by Rohm and Haas, Rhoplex AC-34 seems to be the most popular. When a thin film of the translucent, milky white liquid is painted out, it dries rapidly as the water evaporates and the resin coalesces into a relatively clear, tough, water-resistant layer. The dried films are not as clear as oil, acrylic solution, or alkyd films, but they are nonyellowing and do not get brittle as they age.

The formulation of an acrylic emulsion vehicle is the most complex of all the synthetic vehicles. The vehicle is not always a straight acrylic emulsion, but often contains other kinds of emulsions in addition: Combinations of acrylic emulsions (AEs), acrylic plus polyvinyl acetate emulsions (PVAEs), or even two different AEs plus a PVAE, depending on the specific requirements of the manufacturer. The terms "co-polymer" (two polymers) and "ter-polymer" (three polymers) seen on some labels make reference to this practice.

In addition to the varieties of binders, a commercial vehicle can contain some or all of the following ingredients:

- *Dispersants and surfactants,* which improve the wetting of the pigments by the vehicle and inhibit pigment flocculation.
- *Defoamers,* which inhibit foaming of the vehicle.
- *Preservatives,* which prevent the growth of molds.
- *Glycols,* which provide freeze-thaw stability and flexibility.
- *Thickeners,* which increase the viscosity of the vehicle.
- *pH balancers,* which adjust the alkalinity of the emulsion.

These additives are let into the emulsion in precise proportions, depending on the pigment type being dispersed. Deviation from rather standard formulas can produce bad paints, which can "rock up" in the tube, or emulsions that "break," or separate.

PIGMENTS

Pigments cannot be loaded into an acrylic emulsion vehicle to the extent that they can in other paints, because of the character of the emulsion (particles suspended in a liquid). It is for this reason, combined with the translucent rather than transparent nature of the film itself, that colors in oil, alkyd, or acrylic solution vehicles may seem richer and higher in chroma than the same colors in acrylic emulsion paints. (When the acrylic emulsion paints dry, their chroma improves.) Furthermore, some pigments cannot be used in the acrylic emulsion because of their inability to form stable paints. A typical pigment list for a line of acrylic emulsion paints might contain the following colors:

- *Reds:* quinacridone reds, cadmium reds, naphthol reds, iron oxide reds.
- *Oranges:* cadmium orange.
- *Yellows:* cadmium yellows, arylide (Hansa) yellows, iron oxide yellows.
- *Greens:* phthalocyanine green, chromium oxide opaque.
- *Blues:* phthalocyanine blue, ultramarine blue, cerulean blue, cobalt blue.
- *Purples:* quinacridone violets.
- *Blacks:* ivory black (relatively "cool"), mars black or iron oxide black (relatively "warm").
- *Whites:* titanium white, zinc and titanium mixtures.

PREPARATION OF THE VEHICLE AND THE PAINT

Because of the difficulties of adding small but precise volumes of a large number of important ingredients, there can be no assurance that acrylic emulsion vehicles put together in a

studio will perform as expected. The precision necessary is possible only if large volumes of vehicle are being prepared, and even then lack of experience will often lead to a poor result. If the paint made under such circumstances does not exhibit immediate defects, it may show effects of early deterioration—flocculation, for instance—after a work is completed. For this reason, recipes or instructions for making acrylic emulsion paints must be adjusted individually for each pigment, and the kind of latitude possible in making other paints is not permissible here if you want to be assured of good quality.

A basic acrylic emulsion vehicle (which should not be assumed to be suitable for all pigments) *might* contain the following ingredients:

- *Binder:* 1180 parts
 Rhoplex AC-34, 19.4 l (5 gallons); 93.70 percent of the vehicle.
- *Glycol:* 64 parts
 Propylene glycol, used to slow the drying time of the vehicle, 480 ml (1 quart); 5 percent of the vehicle.
- *Thickener:* 16 parts
 Methocel (Dow Chemical), 120 ml (4 fl. oz.); 1.25 percent of the vehicle.
- *Surfactant:* 1 part
 Nacconal NRSF (Allied Chemical), a wetting agent, 3.75 ml ($^1/_8$ fl.oz.); 0.05% of the vehicle.

To 3.81 l (1 gallon) of the binder, stir in the glycol. Add this mixture to the remaining 15.21 l (4 gallons) of binder. Next add the thickener while stirring until the mixture is uniform and smooth. Mix the surfactant with a teaspoonful of water and add it to the emulsion while stirring. Making this large amount of vehicle can present storage problems; you may prefer to make smaller amounts using the recommended percentages of the various ingredients.

This vehicle does not contain pH balancers to counteract the extreme alkalinity of the binder, nor does it contain preservatives, dispersants, or defoamers. Mix the pigments into the vehicle on a slab, using only a palette knife, because the paints will dry too quickly with the heat of the friction caused by grinding with a glass muller. Store the finished paints in glass jars with plastic covers. Using pigments predispersed in water will help in getting a good dispersion, but do not be discouraged by paints that do not resemble commercial-quality products; this is not a commercial product.

If you wish to experiment with acrylic emulsion paints, contact the chemistry departments of the major suppliers of coatings emulsions—Borden Chemical, Rohm and Haas, and Union Carbide—for suggested formulations. Literature on artists' materials containing recipes, including this one, should be consulted with healthy skepticism. As remarkable as they are, the acrylic (and vinyl) emulsion paints are not cure-alls for every painting problem, nor are they miracle paints that can be stretched beyond limits—and the limits are only now becoming known. Much of the published literature is occasionally overenthusiastic.

TOOLS AND BRUSHES

Brushes and tools used in oil painting can be used with the acrylic emulsion paints, provided they are kept scrupulously clean. If the paint dries in the bristles, it is nearly impossible to remove without using strong solvents that can damage the brush. Brushes in use should be kept in a jar of water near the palette and promptly and thoroughly washed with warm water and mild soap when the day's painting is over. Bristle brushes can soften and lose their snap and spring with prolonged soaking in water; some artists prefer to use the newer nylon filament brushes, which retain their lively feel. In an emergency, you may be able to get dried acrylic emulsion paint out of your brushes with either household ammonia or rubbing alcohol.

The conventional wooden palette is difficult to use, since the paint dries rapidly. A plate-glass palette is much easier to keep clean. Clean it continually during the painting session, not just afterward, because dried bits of paint can interfere with pure color mixtures.

The usual assortment of scrapers, painting and palette knives, and containers that accompany conventional oil painting are also used with

the acrylic emulsion paints. Keep in mind that water can cause metal knives and containers to rust. Plastic knives and glass or plastic jars, with plastic caps, can be substituted.

SUPPORTS AND GROUNDS

Because of the very adhesive and flexible nature of the binder, acrylic emulsion paints can be used on a great variety of supports. Among these are rigid panels such as aluminum, plywood, and hardboards; interior plaster and plasterboard walls; and rag cardboard, paper, and the usual fabric supports. The supports should be stable and durable.

Although the paint is adhesive enough to stick to plain support surfaces, a ground should be used to provide a white surface that is evenly toothy and absorbent. An acrylic emulsion "gesso" primer is the recommended ground. It may be washed over afterward with a neutral or colored middle tone. Neither acrylic emulsion grounds nor paints should be applied over oil-painted surfaces, either oil grounds or old oil paintings. The bond between these two different types of films may not be sufficiently stable to ensure the work's survival.

PAINTING TECHNIQUES

Painting methods for acrylic emulsion paints are flexible. The effects of direct and indirect painting can be used with results comparable to those in oil paint, the major difference being that the drying time for the paint is quick—about 20 minutes for an "average" layer—and ideas can be developed or changed sooner. In fact, the drying time may be too fast for those used to working wet-into-wet in oil. Two suggestions: Use a very light misty spray of water to keep the paint film wet, or mix a retarder gel with the paint to make it dry more slowly. Do not use too much gel.

Traditional water-thinned paints— transparent and opaque watercolors, and temperas—can be imitated in this medium, although the actual characteristics and appearance of the original material cannot

be duplicated. When thinning the acrylic emulsion paints to imitate other water-thinned techniques, be careful not to use too much water. As with oil painting, it is possible to overthin the binder. The result is a paint that lacks enough binder to hold the pigment to the support. Mix a little of the gloss or matte medium into the paint to improve the adhesion of the thinned-out color.

In contrast to oil paint, the rule of "fat over lean" need not be observed in acrylic emulsion painting techniques. The paint merely loses its water content through evaporation— the acrylic resin coalesces into a porous, continuous film—and there is little oxidation or polymerization. It is therefore possible to develop a wider range of texture effects with the paint, using the various auxiliary mediums and additional inert additives.

The development of collage is perhaps most easily accomplished with the acrylic emulsion paints. *Collage,* the technique of making a composition by gluing various unrelated materials to a picture surface, can be successful here because of the strongly adhesive and durably flexible nature of the binder. You might use bits of paper, newspaper or magazine fragments, and colored fabrics. Other inert materials such as sand, sawdust, pieces of wood, and so forth, can also be added to the paint films, but these additions should be judicious.

All the materials to be added to acrylic emulsion paintings should be known to be pure and clean, and as durable as the paints themselves. The known durability of the paints will not keep materials like newsprint from disintegrating and perhaps altering the original color or compositional intention of the work. Also consider the weight of the additions being made to the painting: An abundance of sand or wood scraps will certainly be too heavy for a canvas or linen support. Well-braced rigid supports are best for mixed-media collage compositions that contain built-up layers of different materials or materials that are unusually heavy.

To be sure that the added materials will adhere to the support, coat them well with the gloss or gel mediums described below.

Powdery materials (sand, sawdust) should be mixed with a little medium to ensure adhesion; coat both sides of added papers or fabrics before sticking them onto the painting, then give them a further overcoating to be sure they are stuck down well.

Of course, the development of a personal technique will dictate the direction of experiments with collage and mixed media. Just keep trying many different approaches, and bear in mind that most artists are concerned with producing a permanent record of their activities.

AUXILIARY MATERIALS

The auxiliary mediums and other additives that come with most lines of acrylic emulsion paints are used to alter the working properties of the straight paint. Some are very effective glues.

GLOSS MEDIUMS

These are slightly thickened emulsions that can be added to the paint to increase its brilliance and transparency. They are useful in achieving interesting glaze effects, and can also be used as a collage adhesive.

MATTE MEDIUMS

Matte mediums are less transparent, have poorer adhesive properties, and show a flat finish when dry.

GEL MEDIUMS

These are very thick versions of the emulsion, with about the same body as the tube paints. The gels are added to the paints for the same glaze effects you get with the gloss and matte mediums, but with considerably greater textural or impasto possibilities. Adding a gel medium to the paint reduces its tinting strength and somewhat lengthens the drying time. The gels are also excellent adhesives.

MODELING PASTE

This is a combination of the emulsion with inert bulk filler such as marble dust. The paste can produce thickly textured areas of impasto that should be built up in layers, and can even be carved when it dries. Its use should be restricted to rigid supports, since it can be quite brittle; adding a little of the gel medium to it will increase its flexibility.

RETARDER

This jellylike mixture in a tube can be mixed sparingly with the paint to slow drying. Too much retarder may inhibit drying altogether, and produce soft, easily damaged paint films.

VARNISHES

Acrylic emulsion varnishes are available in matte and gloss finishes. They should be used only as an integral part of the painting, *not* as a final coating. It is now generally recognized that dried acrylic emulsion films are quite porous to water and susceptible to accumulations of dust and dirt. An emulsion varnish will not provide surface protection for the work; furthermore, it is not removable with simple solvents.

To varnish an acrylic emulsion painting, use an acrylic solution varnish.

COMMERCIAL PRODUCTS

In the early 1950s, Permanent Pigments introduced the first commercial line of acrylic emulsion paints under the name Liquitex. Binney and Smith, Inc., now owns the company (it, in turn, is owned by Hallmark Cards), and both the oil paints and acrylic emulsions are called Liquitex. Other popular brands are sold by Bocour (Aquatec), Golden (Golden), Grumbacher (Hyplar), Hunt (Speedball), Martin/F. Weber (Permalba), and Utrecht Linens (New Temp).

Major European manufacturers Winsor & Newton (Colart International) and George Rowney have also marketed their acrylic emulsion paints here. A host of other manufacturers, large and small, foreign and domestic, have saturated the market with this profitable material (see List of Suppliers). All the paints are water-thinned, come in collapsible plastic tubes or plastic jars (in a slightly thinner consistency

than the tubed paint), and are accompanied by a large variety of related mediums and modifiers. In the early years, some of the binders exhibited erratic behavior—separation, uncontrolled drying—but most commercial preparations are now considered reliable. The only caution concerning the use of these materials is one that has been offered in earlier books, and still seems prudent now: Brands should not be indiscriminately mixed. Each may use a slightly different formula for its product.

☞ *CAUTION: It has been reported recently (1992) that one of the reaction products made in the formation of certain methacrylate resins and acrylic emulsions is formaldehyde, a highly toxic substance formerly used as a preservative. Some manufacturers add a form of ammonia to remove the formaldehyde and render the emulsion safe; therefore, the odor of ammonia in some acrylic emulsions is a good sign. It does NOT follow, however, that the lack of an ammonia odor in other acrylic emulsions is a bad sign!*

PVA EMULSION PAINTS

Polyvinyl acetate emulsions, familiar as the common "white glue" used as a household adhesive and recommended as a size, have been used in artists' paints. They can occur as a co-polymer with acrylic emulsions and have been used alone in some experimental applications. The published literature does not supply conclusive information about the durability of paints whose sole binder is a PVA emulsion.

Lefranc et Bourgeois (Colart International, through Koh-i-Noor—see List of Suppliers) has marketed Flashe, a water-thinned "vinylic" paint that behaves quite like traditional gouache, although it is not resoluble in water once it dries. The term "vinylic" refers to the source of all acrylic resins, the vinyl group, and does not indicate whether this paint is a vinyl emulsion or an acrylic emulsion. Until there is independent confirmation of the manufacturer's claim for its performance, its use should be restricted to applications where permanence is not expected.

PVA SOLUTION PAINTS

There were some early experiments using the straight PVA resin dissolved in solvents such as alcohol or toluene, conducted by Alfred Duca in the 1930s and 1940s. Aside from the potential health and safety hazards associated with the solvents, the resins themselves form soft and easily damaged paint films without considerable modification. Independent testing of paints using PVA resins has never been conclusive, and early claims for their excellence—although not entirely unwarranted—should be taken with caution.

15 Mural Paints and Techniques

Mural painting is distinct from easel painting in several ways. Murals are usually executed for architectural spaces—rooms, public halls, walls, floors, ceilings, and exterior walls—and thus must be planned to fit the design requirements of the particular space. Because the paintings must usually be viewable from all angles, they must be free from surface glare and reflections or other elements that could interfere with the perception of the work. The paintings usually cover a relatively large expanse, and although murals need not be complicated—full of figures in involved situations—they sometimes are. The total impact of the design and composition must transcend intricacies in specific areas.

Murals present an added set of technical difficulties related to permanence. Public spaces, and even some private ones, have hard-to-control environments, and the technique chosen should be able to withstand more than the usual stresses to which an easel painting is exposed. Also, murals intended for exterior exposure must not be vulnerable to even more stressful exposures: wind, rain, strong and variable ultraviolet light, heat, cold, and the abrasive action of windblown dust, dirt, and pollutants.

Most contemporary interior mural paintings are not done in the traditional *fresco buono* (affresco) method because of the rather delicate nature of the painting's surface. Instead, *secco* techniques are sometimes used. (We will talk more about the various types of fresco later on.) However, it is more convenient, less expensive, and less technically involved to choose one of the easel painting techniques: acrylic or vinyl emulsion, acrylic solution, alkyds, casein, resin-oil, or one of the temperas.

Exterior murals must be done in more resistant techniques, depending on the nature of the exposure: mosaic, colored cement, glazed ceramics, porcelain enameled steel, acrylic emulsions, or the silicate paints.

PLANNING A MURAL

Unless you are free to do anything—in your own home, for instance—it is usually necessary to work with others on a mural project. The client, other artists, artisans, interior designers, and architects are ordinarily consulted during the planning of new construction. Engineers and landscape architects might have to be included for the planning of exterior decorations. At the very least, the client must be satisfied if you are doing work in an existing structure. It is therefore essential that everyone involved have an understanding of the work, and that all are capable of working together.

A series of studies—drawings or color work—is generally the beginning point. These studies should be done to scale, so that their appropriateness to the setting can be judged, and they should take into account the surroundings and the viewer's distance from the work. After the studies have been

approved, they can be scaled up by means of the grid system to a full-size cartoon, and transferred to the surface being decorated.

Any of the intermediate steps—site selection, and wall, ceiling, or floor surface preparation—between the acceptance of the design and the execution of the work will depend on the type of technique chosen.

INTERIOR MURAL PAINTS

As touched on later in this chapter, various kind of paints can be successfully used for interior murals: oil paints, alkyds, and the acrylic solution and acrylic emulsions paints. However, the classic technique of fresco painting excels at meeting the special requirements of interior mural decoration—principally that the mural be free of surface glare and easily seen from many viewpoints.

Although fresco is primariy used for interior painting, it can also be used outdoors under certain circumstances. These are briefly outlined here as well.

FRESCO

Fresco is the Italian word for "fresh," and it properly refers to mural paintings executed on fresh wet lime plaster. Sometimes the term *buono fresco (fresco buono)* or *buona fresco* is used to distinguish the fresh technique from *secco,* painting on dry lime plaster, and *mezzo,* painting on half-dry lime plaster.

The fresco technique of interior and exterior wall painting has its beginnings in the eastern Mediterranean Minoan civilization. Wall decorations in India date from 200 B.C.

During the Renaissance, some of the masterpieces of Western art were executed in Italy, and it is there that we can see frescoes from all periods since Roman times. Giotto, Massacio, Fra Angelico, Piero della Francesca, Michelangelo, and Raphael were masters of the technique, and their work exemplifies the classical and traditional approaches to fresco.

Fresco is a catalytic medium. That is, dry pigments predispersed in plain water are brushed onto and absorbed into the plaster-coated wall. They become part of the wall, which undergoes a complex chemical change to convert back to its original form while locking the pigments within its matrix. Only those pigments that are resistant to an alkaline binder can be used in fresco; and in the case of exterior application, the pigments must also resist an acidic environment. This rather limits the artist's palette.

The actual procedures for painting in fresco are simple. It is the preparation that is expensive and time-consuming. Artisans competent in wall construction and plastering must be hired if the artist cannot do the work, and they must understand the special nature of fresco plaster. Often apprentices or assistant artists are needed to help with the execution of the work.

THE SITE

When planning a fresco, you must consider the interior spaces and architectural embellishments. Aspects such as lighting, the viewpoint of the audience, the size of the work, and the scale of the space present problems.

For interior spaces, you should point out to the client that polluted city atmospheres may shorten the life of a fresco, since the pigments are not protected by a covering film or layer of vehicle. An enclosed and controlled environment is best for fresco, although planners in the countryside, where the air might be cleaner, may not need to worry so much about this problem.

Exterior sites are much more difficult, exposed as they are not only to pollutants, but to wind, rain, and dust. A protected courtyard wall, a wall with a slight divergence from the vertical, or walls with protective overhangs might be made to work, but you should not make claims for the life of the painting.

PREPARING THE WALL

If you can start with new construction and have a fresco wall built from scratch, so much the better. It is more usual to have to build up

the wall over existing construction. The wall must be absorbent and toothy, to provide a key for the plaster, and its structure must not contain any impurities that can later leach out and discolor the painting. New constructions and renovations should be done well in advance of the painting, to allow the structure to settle. Cracking is almost inevitable in both cases, and repairs should be made to the wall, not to the lime plaster ground.

Exterior Walls

The fresco plaster cannot be applied over concrete or cement substrates because dissolved mineral salts will effloresce through the coatings. Smooth wooden walls, rarely encountered outdoors, and other wooden structures should have an exterior lattice of fir or spruce applied, to which a wire screen lath can be nailed as a key for the plaster.

Brick walls are excellent, provided they are carefully prepared. The cement mortar between the bricks should be pointed and repaired, with all loose particles removed and replaced. Any soft or crumbly bricks must be cut out and replaced, as must bricks that show efflorescence, mold, or any surface growths. Smooth and even brick walls should be given a tooth by going over the entire surface with a hammer and chisel to chip, score, and texture the surface. The entire wall must then be washed repeatedly with clear water: Wash twice while scrubbing to remove loose particles (use a stiff bristle floor brush), then rinse twice.

Interior Walls

Ideally, there should be an air space between an interior wall that backs onto an exterior exposure; the inside of the exterior wall should be coated thoroughly with a waterproof asphalt-based paint. The space provides an insulating pocket of dead air—it is even better if the space can be filled with fiberglass or foam insulation—and the coating prevents atmospheric moisture from affecting the lime plaster wall. Walls that back on other interior spaces do not necessarily need the insulating space.

New or old plaster and plasterboard walls should be removed. It is best to build the lime plaster on a stud framing with lattice or wire screen lath attached. To save the mess of tearing down a wall, you can build a stud wall in front of, and slightly separated from, existing interior walls. Standard construction techniques should be used to ensure that the wall is sound. There should be both sills and top plates, and the studs should be spaced at 40 cm (16 inches) on center. Although it need not be a bearing wall, supporting the ceiling above, bearing wall construction will be sounder than any shortcuts. Allow this kind of new construction to settle before plastering.

SUPPORT, GROUND, AND BINDER

The plaster, or mortar, for fresco serves as the support, the ground, and the binder for the painting. It must be prepared with particular care, of the purest and cleanest ingredients, to prevent any problems as it dries and ages. The plaster is applied in three or four coats of varying composition, with the last coat being richest in lime.

The different coatings of lime plaster, in order of application, are:
1. The rough coat. Also called the rough-cast or scratch coat and, in Italian, *trullisatio* or *trusilar*.
2. The brown coat. In Italian, *arricciato* or *arriccio*.
3. The sand coat. In Italian, *arenato*. This coating is sometimes left out.
4. The painting coat. In Italian, *intonaco*.

Slaked Lime

The plaster binder for all of these coats is made from a base of roasted calcium carbonate, called, variously, quick lime, calcium oxide, or high-calcium lime. This caustic alkali may be found in building supply stores. Take care that it is the purest available, and that it does not contain clays, gypsum, mica, or metallic salts that can later cause efflorescence. It should be bought in powder form and handled with care.

☞ *CAUTION: Quick lime is caustic and can cause burns once it is mixed with water.*

The calcium oxide is converted to lime putty for the mortar by a process called *slaking*. Water is mixed with the calcium oxide powder, and the mixture is allowed to age. (See Box 15.1.) Since the character and performance of slaked lime improves with age, the time needed to prepare and cure it sufficiently is the principal drawback in making a proper fresco ground. It can take as long as two years for the slaked lime to age to a good consistency, and the best slaked lime has been allowed to age for 25 years or more. You may be able to locate a ready commercial source for slaked lime; be sure, however, that the substance is made of the purest calcium oxide.

Additives to the Lime

To strengthen the wall, the different coatings of lime plaster are reinforced by diminishing amounts of filler materials. The lower layers have more filler in proportion to lime, while the upper layers are richer in lime. Likewise, the lower layers of plaster should contain coarser filler; the upper layers, finer filler.

Filler materials include the following, arranged in order from coarse to fine:

- *Crushed brick, crushed unglazed clay tile, or coarse sand:* The average particle size should be about 1.5 to 3 mm ($1/16$ to $1/8$ inch) in diameter.
- *Coarse marble meal:* The average particle size should be about 0.75 to 1.5 mm ($1/32$ to $1/16$ inch) in diameter.
- *Fine sand or marble dust.*

None of the filler materials should have any impurities that could cause efflorescence. The sand should be river sand, not beach sand (which can contain dissolved salts), and it should be thoroughly washed. The brick and tile pieces and the marble meal and dust should also be thoroughly washed.

To wash the coarse fillers, spread them on a screen outdoors and rinse them with water from a hose. The screen should be fine enough to prevent the filler from being washed away. Rinse several times, and spread the material out on a clean tarpaulin to dry. Store it in bags indoors where it will not pick up any organic impurities from the ground. To wash finer filler such as sand and marble meal or dust, stir it in a bucket into a very

loose slurry with water. Allow it to settle, and pour off the water. Repeat this procedure until the water is absolutely clear. Spread the filler out to dry; store in bags indoors. When it is mixed with the lime putty, the filler must be not only very clean but completely dry. A film of water around the particles of sand, for example, could prevent the complete integration of the putty with the sand.

As noted earlier, the proportion of coarse aggregate to fine adhesive materials in the mortar decreases with successive layers (see Box 15.2), producing a sound construction analogous to that of an oil painting ("fat over lean").

The application of each coating of lime plaster should proceed once the previously laid layer has set, but before the surface has dried to a crust. (See Box 15.3.) A crust will normally form within 6 to 10 hours of application, depending on the relative humidity of the environment. If you will not be able to apply the next coating before a crust forms, provide a mechanical key for the new layer by applying the lower coat roughly or by scratching a key into it with the metal comb.

Before the initial application of the rough coat, and between each succeeding application of the other coatings, the wall should be thoroughly wetted with water, either by brushing it on with the plastering brush or by liberally spraying it with the hose. Allow the water to soak into and disappear from the surface of the wall before applying the mortar.

BOX 15.2. HOW TO MIX THE LAYERS OF LIME PLASTER

MATERIALS

- Wooden trough.
- Hoe.
- Wooden lime pit (see Box 15.1).
- Screen.
- Clean, soft water, with no dissolved minerals or metallic salts.

 Note: Make sure your tools are clean, so as not to contaminate the lime.

FOR THE ROUGH COAT:

- 1 part lime putty.
- 3 parts filler: crushed brick, crushed unglazed clay tile, or marble meal.

FOR THE BROWN COAT:

- 1 part lime putty.
- 3 parts filler: coarse sand.

FOR THE SAND COAT:

- 1 part lime putty.
- 2 parts filler: fine sand or marble dust.

FOR THE PAINTING COAT:

- 1 part lime putty.
- 1 part filler: fine sand or marble dust.

METHOD

1. To make a proper mixture of the ingredients for each of the coats, first combine them while they are dry. Use a wooden trough and a hoe to make the initial mix, making sure that the various materials are fully incorporated with one another.

2. When the cover is removed from the lime pit and the putty is exposed, you will often find that a crust has formed on the surface of the putty. Scrape off the crust and remove bits and pieces of it before mixing with the filler by straining it through a screen. Next, hoe the strained putty with the filler thoroughly until you have a dry mixture in which there are no lumps or separate agglomerations of one or the other material.

3. After the dry mixture is made, add a little water and hoe again. Continue adding water, a little at a time, and hoeing until the mortar reaches a plastic consistency that can be troweled onto the wall.

PREPARATORY CARTOONS

Only the most accomplished and self-assured artists can use an improvisational approach to painting in fresco. So much energy and expense go into preparing the wall that few are willing to risk spoiling the effort; large or obvious mistakes cannot be painted over with any guarantee of success. The prudent artist will prepare sketches, drawings, and tonal studies of the project, all subject to approval by the client, and a final color sketch showing the artist's conception in its final form, in scale with the surface to be covered. For the color sketch, it is wise to use a water-thinned paint and only those pigments that can be used in fresco.

Since approval for the idea must be obtained before the project can begin, the sketch should be ready before the wall is built. The final small-scale color study is enlarged by means of the proportional grid system into a full-size line drawing called a *cartoon*. (Cartoons look like outline drawings in a children's coloring book.) Brown wrapping paper, white butcher's paper, or smaller pieces of paper taped together can be used for the cartoon. The cartoon need not include every detail of the composition, but it should show all the major design elements and their proper placement within the picture. Charcoal, conté crayon, or soft pencil can be used to make the cartoon drawing, and when it is finished the whole picture can be divided with heavier lines into sections to estimate what will take a day to paint.

The lines of the drawing are then gone over with a pounce wheel, which pierces the paper at regular intervals. An ordinary finishing nail or large pin can be used for this, but the pounce wheel will perforate the paper more efficiently and is the easiest tool to use. The effect is to produce a stencil that can be transferred to the wall.

When the cartoon is finished and perforated, hang it over the damp painting coat on the wall by means of tape or small tacks through its upper edge. When you then pounce (tap) a cheesecloth bag full of crushed charcoal against the drawing, the charcoal dust goes through the perforations and is deposited on the wall. This leaves a faint outline of the cartoon—a dotted line—which is a guide to the painting that will follow.

If the wall cannot be completely covered in one day's painting, then the entire wall is not covered with the painting coat. By the same reckoning, the entire cartoon will not have to be transferred—only those sections that are going to be painted. Some artists prefer to see the whole idea at once as it is developed, and this is difficult if the wall is so large that it cannot be painted in a day. A way around this problem is to pounce the cartoon onto the sand coat before the painting coat is applied. Excess charcoal should be dusted off the sand coat before you begin to apply the painting coat, so that the charcoal will not interfere with the adhesion of the painting coat. You will then have to pounce the part of the cartoon for that day's painting on the newly laid painting coat.

If the cartoon is transferred to the painting coat, transfer only those sections marked on the cartoon as suitable for a day's painting. Try to make these divisions as inconspicuous as possible, perhaps running the dividing line along edges of shapes. A line through a large flat area of color will make it very difficult to match color mixtures during the painting—especially from one day to the next.

PIGMENTS FOR HOMEMADE FRESCO PAINTS

The lime plaster is an alkaline ground. Since it is also the binder for the paint, it becomes intimately mixed with the pigments. Therefore, only those pigments resistant to alkaline systems can be used in fresco. A palette can consist of one or more pigments from each hue section below, depending on your intentions or the requirements of the design.

- *Reds:* Indian red; light red oxide (English red); mars red; naphthol AS-TR red (PR7); Venetian red; cadmium reds, but test first for resistance to the lime; quinacridone magenta, scarlet, and red.

- *Oranges:* cadmium orange, but test first; benzimidazolone orange (P062). Oranges can also be mixed from reds and yellows.
- *Yellows:* raw sienna; mars yellow; yellow ochre; arylide (Hansa) yellow; cadmium yellows, but test first; titanium yellow.
- *Greens:* chromium oxide, opaque; viridian (chromium oxide, hydrous); green earth; cobalt green; green gold; light green oxide; phthalocyanine green.
- *Blues:* cobalt blue; both varieties of cerulean blue; ultramarine blue, but it can turn white in the presence of calcium; phthalocyanine blue, alpha form (PB 15/74160), 74100 may bronze: see the pigment list, Table 7.1 (pages 166–167).

BOX 15.3. HOW TO APPLY LIME PLASTER

MATERIALS

- Clean, well-aged lime putty.
- Hose and a source of clean water.
- The various fillers.
- Wooden mixing trough and hoe.
- Buckets for measuring the ingredients.
- Mortarboard for holding the mortar.
- Trowel for throwing the mortar, about 10 × 25 cm (4 by 10 inches) with a handle. The size will be determined by the area of wall to be covered.
- Perfectly straight length of 2- by 4-inch (5 × 10 cm) lumber, the length determined by the size of the wall.
- Metal comb for scoring the plaster.
- Wide, soft-bristled plastering brush.
- Wooden float for smoothing the surface of the mortar, about 15 × 30 cm (6 by 12 inches).
- Metal float for polishing the mortar.

METHOD: THE ROUGH COAT

1. If the wall is brick, soak it thoroughly with water. Allow the water to soak into the wall. If the wall is a stud wall with wooden lath, soak the lath with water. If the wall is a stud wall with a wire screen lath, there is no need to soak it.
2. Mix the rough coat's dry ingredients in the wooden trough, and then add enough clean water to make a stiff paste. Mix thoroughly.
3. Beginning at the bottom of the wall and working toward the top, use the trowel to throw the mortar at the wall from a distance of about 30 to 60 cm (a foot or two) and at a slight sideways angle to the wall. The mortar is slapped on from this distance, to force it into the mechanical key and to rid it of air bubbles; the angle of application will keep bits of the mortar from splattering back into your face.
4. Build the rough coat to a thickness of about 6 mm ($^1/_4$ inch).
5. Level the surface of the wall with the length of straight lumber, but do not make the surface too smooth. Scratch the wall with the metal comb in an overall random pattern to provide a key for the next layer.
6. Spray the wall with water before the plaster sets. It will set in about 20 to 30 minutes.

METHOD: THE BROWN COAT

1. While the rough coat is setting, clean out the trough and mix the brown coat materials.
2. Wait until the standing water on the wall has disappeared, but begin application of the brown coat before the wall dries out. It is possible but not absolutely necessary to apply the brown coat in two steps: in a thin, even layer of brown coat mixture thinned with water, followed immediately by a richer layer of brown coat of normal consistency. The application of two layers will ensure better adhesion.
 Trowel on the brown coat(s) evenly and smoothly.
3. Build the brown coat to a thickness of 1.2 to 1.8 cm ($^1/_2$ to $^3/_4$ inch). Some accounts recommend that the thickness

- *Purples:* mars violet; cobalt violet, cobalt oxide variety, but test first; dioxazine purple; quinacridone violet. (Purples can be mixed.)
- *Browns:* mars brown; burnt sienna; raw umber. (Browns can be mixed.)
- *Blacks:* ivory black; mars black; carbon black.
- *Whites:* titanium white; zinc oxide; slaked lime putty; Bianco Sangiovanni (Saint John's White)—the traditional white fresco pigment. Bianco Sangiovanni can be made in your studio; see Box 15.4.

Although this list of pigments is rather limited by comparison to those in other mediums, it is still quite large. To avoid having to make too many choices, you can use a palette consisting of a few basic low-chroma

of the rough coat and the brown coat combined be 2.5 cm (1 inch); others say they can be of equal thickness, for a combined total of 3.75 cm (1$^1/_2$ inches). Experience indicates that thinner walls, and thinner layers within the wall, present fewer adhesion problems; on the other hand, thicker walls can be more stable.

4. It should not be necessary to level the brown coat with the straightedge. Scratch it with the metal comb, as before, to give it a key.
5. Spray the wall with water after the plaster sets, but before the crust forms.

METHOD: THE SAND COAT

1. While the brown coat is setting, clean out the trough and mix the sand coat materials.
2. Wait until the standing water on the wall has disappeared, but begin application of the sand coat before the wall dries out. The sand coat may also be applied in two steps like the brown coat. Trowel the mortar on evenly and smoothly.
3. Build the sand coat to a thickness of 9 mm to 1.25 cm ($^3/_8$ to $^1/_2$ inch).
4. Before the wall sets, give it a smooth finish with the wooden float; lightly splatter the wall with the plastering brush dipped in water. Dip the float in water to keep it from sticking to the wall, and scrub it over the sand coat with a circular motion, holding it flat against the wall, until the surface is smooth.

5. You can allow the wall to dry before you apply the painting coat, since there is usually some further preparatory work to be done before painting can begin. Spray the wall with water before proceeding with the painting coat.

METHOD: THE PAINTING COAT

1. Fresco paints will be absorbed into and held by the lime only when the painting coat is fresh and damp. Therefore, only as much painting coat as can be covered by a day's painting (say, 6 to 10 hours) can be applied at one time. Any unpainted areas of the painting coat must be cut out of the wall at the end of the day, and a new application of fresh lime made before the next painting session.
2. Spray the sand coat with several applications of water.
3. Mix the painting coat ingredients in a clean trough.
4. After the water has been absorbed into the plaster, trowel on the painting coat to a thickness of no more than 3 mm ($^1/_8$ inch). Cover only those areas of the design surface that can be painted in one day.
5. Finish the painting coat surface with a wet wooden float. To make a finer surface, polish the mortar with the metal float using the circular motion and holding the float flat against the wall, as with the wooden float. After the painting coat has been finished off, the painting can begin.

hues at first. Brighter colors can be harder to control in a massive composition. Mixing fresco pigments is a very simple process; see Box 15.5.

TOOLS AND BRUSHES

Both bristle and hair brushes can be used for fresco. Because of the scale of most frescoes, it is advisable to have a supply of large brushes with longer hairs and bristles than are employed in easel painting. The plasterer's brush can be used for wetting the wall and making washes.

Palette and painting knives can be used for mixing large batches of paint; a plastic palette knife is helpful for making the cuts when removing a section of the painting coat that cannot be painted in one day. A putty knife is handy for helping in the removal of painting coats, and can also be used for mixing large batches of color.

Mix the colors to be used in each day's work in various glass or ceramic containers—jars, cups, and so on—that can be cleaned out or easily discarded. These containers serve as the equivalent of a palette. A water sprayer filled with distilled water can be used to wet colors in your mixing pots to keep them from drying too quickly, and also to spray the wall.

PAINTING TECHNIQUES

If all the ideas of the composition are worked out beforehand, you should be able to begin work immediately after the wall has been completed and the cartoon transferred. If you are inclined to change your approach to paintings in midstream, you must be able to do so within the time limits imposed by the drying lime plaster. Painters with a clear idea of the intent and arrangement of the work can probably make small adjustments as they go along, but it is certainly easier, and far less nerve-wracking, to have a well-thought-out plan of action to rely on.

To begin, allow the painting coat to dry out for about half an hour, until it is set to a

BOX 15.4. HOW TO MAKE BIANCO SANGIOVANNI PIGMENT

MATERIALS

- Aged slaked lime.
- Paint-making setup (pages 187–188).
- Distilled water.

METHOD

1. Form small cakes of aged slaked lime, and allow them to dry completely.

2. Crush the cakes and grind them on the slab with the muller and some distilled water into a paste. Form cakes and allow them to dry completely. Repeat the process until the cakes no longer hold together in a solid lump.

3. Grind the cakes with water into a loose paste to make the white paint.

BOX 15.5. HOW TO MAKE FRESCO PAINTS

MATERIALS

- Distilled water.
- Artist-grade dry pigments.
- Paint-making setup (pages 187–188).
- Glass, ceramic, or plastic jars with plastic screw-on covers, for storing pure pigment pastes.

METHOD

1. Grind each pigment separately in distilled water to a creamy consistency rather like sour cream.

2. Store the paints in the jars. Pour a bit of distilled water over the top of the creamy pastes to keep them from drying out.

consistency that will hold the indentation left by your fingertip pressed gently into it. There should be no water standing on the surface of the wall.

Transfer the cartoon by pouncing. Start the painting at the top of the wall and work downward, to avoid splashing finished areas with drips and splatters. Proceed as you would with transparent watercolor, by washing on transparent tones of color over broad, general areas. This approach will unify the composition from the beginning, but it is by no means a rule. Allow washed-over areas of paint to sink into the plaster before applying overpainting. Overpainting can proceed with additional washes of thin color, leaving the bare wall as the white or highlight areas. Then gradually deepen the color tones until the final effect is reached.

More direct applications of color can be made by mixing paints—color with color or colors with white—separate from the painting. When white admixtures are made with color, the result is somewhat like what occurs in gouache: The mixtures appear translucent when they are wet, but dry much lighter. This effect should be taken into account. The lightening of the tone is more apparent with the lime putty white and Bianco Sangiovanni than with the titanium white.

Bianco Sangiovanni is oxidized lime putty, which is why it no longer has a binding effect. But the lime putty white is the pure slaked lime used to make the wall; it acts not only as a pigment but also as a binder. When lime putty whites are used, either alone or in mixtures with color, it is possible to build up a slight impasto. This most emphatically does *not* mean the impasto used in oil painting.

As the painting continues, try to resolve the image quickly and conclusively. Again, as in transparent watercolor, areas that are worked over excessively tend to lose vitality and luminosity. Furthermore, remember that you are working on a damp ground that can be disturbed by too much brush activity. Keep the color harmonies simple and broad at first—using complementary colors for shadow areas, for instance, rather than going

immediately to darks and lights. Reserve the detail touches and small corrections for the end of the painting. Final accents of straight color and whites or light colors can be applied only when the complete idea is realized.

When the painting coat begins to dry out, painting must stop for the day. Paint that seems to go on dry, as though it were being drawn rapidly from the brush (as paint sometimes goes on an unsized glue-gesso ground), is a sign that the plaster is drying out. The drying out can be delayed for a while by spraying the wall with a bit of distilled water, but paint must not be applied to the dried surface: It will not stick.

Any areas that have not been painted must be cut out of the wall. Score the edge of the cut along a line in the design that is inconspicuous—a contour separating two distinct color areas, for instance—so that the painting can begin the next day without delays caused by having to attempt a color match. Dividing a large, flat area of color will pose numerous problems. Use the plastic palette knife or putty knife to make the cut deep enough to penetrate the painting coat completely, and slightly undercut the line to provide a key for the next day's application of fresh plaster. Scrape away the excess painting coat with the putty knife.

When replastering the next day, wet the edges of the cut with a liberal spray of distilled water, so the new plaster will adhere to the old. Put on the new mortar carefully, to avoid splashing the painting. Corrections in the painting, if kept to small areas, can be made in paints like egg tempera or casein, or with a variation of the *fresco buono* technique called *secco*.

As the wall continues to dry, the paint will become slightly lighter in value. The wall will take at least a month to dry completely, depending on the relative humidity of the surroundings. When you are making small corrections in a different medium, it is advisable to wait until the wall is completely dry so that color matches can be more accurate.

The cycle of damp and dry conditions in the atmosphere may produce cracks in the wall, but

should not cause deterioration of the painting. The greatest dangers to the life of a fresco are related to pollution and efflorescence.

Secco

Secco is the Italian word for "dry," and refers to the process of painting on a dry lime plaster wall. Technically, there is no such thing as *fresco secco*, since this phrase is a contradiction in terms, but the phrase is often used.

Secco can be executed in any number of different kinds of paints on a fresco wall, the principal difference between it and *fresco buono* being that the paint has its own binder and sits attached to the surface of the wall. In *fresco buono*, the wall itself is the binder and the pigments become a part of it, making for a more durable structure. *Secco* techniques, subject to greater stresses than relatively smaller easel paintings, can suffer a proportionately greater number of defects.

A technique that perhaps gives rise to the notion of a *fresco secco* is the following: A regular fresco wall is built up to the sand coat layer. Instead of a painting coat finish, the wall is given three or four coats of a dilute lime putty paint—slaked lime putty diluted with distilled water to the viscosity of a latex house paint. (See Box 15.6.) Each coat is applied as soon as the preceding coat is set but not bone dry. The paints are made by grinding the pigments in lime water and applied to the wall using the fresco painting process. Although the effect is like *fresco buono,* the pigments lie on the surface of the wall and are quite likely to chip or flake off as the wall ages, or if moisture penetrates the wall.

Other paints can be used on a dry fresco wall, such as egg tempera, egg-oil emulsion tempera, casein, and size paints. All these paints should be thinned well with water and built up slowly; heavy applications of impasto will fail. Acrylic emulsion paints can also be applied to a fresco wall. They too should be thinned and slowly built up, and they can produce more opaque effects and greater impasto with less chance of failure.

Acrylic solution and alkyd paints can be used for *secco* painting, but the work will rapidly begin to lose the special optical quality of a mural paint: rather dry-looking, light and somewhat narrow value ranges, minimum surface irregularities, and little surface reflection. If the paint is applied as it should be, in layers containing the correct proportion of binder to pigment, these paints will soon develop a reflective surface. Because the fresco surface is absorbent—but not necessarily evenly absorbent—the painting can end up with a disagreeably uneven appearance, which to be corrected must be varnished. And of course the problem is compounded by varnishing.

Oil paints have also been used for interior murals, but, again, the fresco wall is unevenly absorbent and can produce a spotty effect. The optical and technical characteristics of oil paint are not compatible with the desired effect of a mural paint. Furthermore, oil paints

BOX 15.6. HOW TO MIX SECCO PAINT

MATERIALS

- Slaked lime putty.
- Distilled water.
- Fresco pigments.
- Paint-making setup (pages 187–188).
- Two small plastic buckets.

METHOD

1. Make a lime water by mixing 1 part of slaked lime putty with 4 parts distilled water in a small plastic bucket. Allow the lime putty to settle and drain off the water into the second bucket. Allow the drained water to settle again.

2. Grind the fresco pigments in the settled lime water. Make corrections to a large area of the wall by cutting out that section of the wall and then replastering and repainting it; some writers recommend cutting out the sand coat along with the painting coat, and reapplying both. Corrections to large areas of the wall should be made within 24 hours of the original plastering.

present complicated technical problems (such as yellowing and embrittlement) that make their use on such a scale on a plain wall formidable and ill-advised.

When artist and client agree that a more reflective and robust paint is suitable, *marouflage*—the technique of attaching a painted fabric support to a wall with an adhesive—can help reduce the drawbacks outlined above. The painter's task is simplified a bit—you can do the work in your studio, without the assistants needed for fresco work—but the installation can be complicated. If the wall is large, a good bond between the fabric and the wall will be hard to achieve. The use of white lead in oil, the traditional adhesive for marouflage, will guarantee a good bond but will also make the work difficult, if not impossible, to remove from the wall if conservation problems appear. The white lead adhesive will also deteriorate beneath the fabric, if the wall is subject to damp and dry cycles, producing cracks and tears in paint and fabric.

Better yet, just execute the paintings on standard supports, rigid or flexible, and then attach them independently to the wall. Of course, the work is no longer a mural, but just a very large picture.

Fresco Panels

If the problems of working at the site cannot be surmounted or if there are logistical difficulties, fresco paintings can be done on small panels that are then attached to interior walls. You can nail together lumber stock 3.75 × 5 cm (1 1/2 by 2 inches) to form a framework for the structure, with the 3.75 cm (1 1/2 inch) dimension forming its depth. Brace the rear of each corner with angle irons in order to keep the panels square. Then nail a wire screen lath to the rear of the frame, and add cross-bracing to large frames; the cross-bracing is behind the lath. Then build the fresco wall within the frame and bring it flush with the front of the wooden surrounds (Figure 15.1). The painting proceeds as in the classical technique.

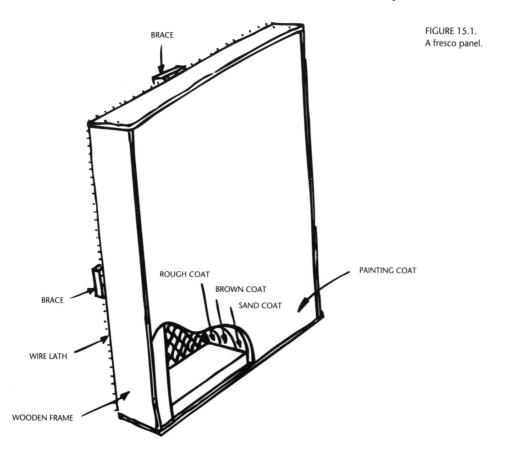

FIGURE 15.1.
A fresco panel.

BRACE

ROUGH COAT

BROWN COAT

SAND COAT

PAINTING COAT

BRACE

WIRE LATH

WOODEN FRAME

Fresco panels are excellent practice for those who are unfamiliar with the technique. As finished products they are also good, although if the panels are large, they can be very heavy and thus may be difficult to install. Steel hangers should be attached to the upper perimeter of the panel. These are then hung on steel rails built into the wall. Such custom work can be expensive, but perhaps no more so than for any other mural process.

EXTERIOR MURAL PAINTS

The problems of durability and resistance to mechanical damage are magnified when the mural is exposed to outside atmosphere. Even in relatively pollution-free environments, exterior mural paints are subjected to abnormal stresses. Intense exposure to ultraviolet light and windborne particles are especially destructive. If glossy paints are used, adhesion of the ground and paint to the support is made difficult if there are any openings, however tiny, through which water vapor can penetrate.

THE SITE

If possible, the site and its orientation should be given major consideration. A wall facing northeast will not only be out of the direct rays of the sun but will be sheltered from the prevailing winds. Overhangs or parapets will provide some protection from rain; particularly choice sites are cloisters or other galleries open to the outside but sheltered by a covered walkway. Since moisture is the biggest problem, apart from exposure to ultraviolet light, try to arrange the execution of the mural in late spring, when dry weather is more constant and predictable.

THE WALL

You can use a plain brick wall for an exterior mural, but first go over it thoroughly to remove any broken or crumbly bricks; bricks with surface efflorescence, mold, old paint, or other organic growths; and any crumbly mortar. A solution of 1 part household bleach to 3 parts water will eliminate mold and mildew. The wall should be scoured with a wire brush and thoroughly washed with water, and all the mortar repointed and brick repaired. You can paint directly on the brick if you do not mind the textural interference the brick and mortar will cause.

The wall should be primed with at least two coats of a PVA emulsion adhesive (1 part adhesive to 5 parts water) to buffer against the alkaline constituents present in all masonry walls, to lessen the absorbency of the surface, to make it more evenly absorbent, and to isolate the wall from the painting as far as possible. It is not wise to attempt to seal the surface completely, since blistering of applied paints can easily occur; the PVA emulsion is porous, and at the recommended dilution it will allow water vapor to be absorbed and expelled from the brick. A less textured surface can be applied to a brick wall, which gives it something of the character of a plaster wall. A cement mixture containing proportions of Portland cement (a hydraulic cement made of pulverized hydraulic calcium silicates), fine clean river sand, and slaked lime putty can be troweled on the wall in two layers, flattened and smoothed, primed, and painted. The mixture is called *stucco.* Two kinds of stucco can be made, one for hard brick or concrete walls (see Box 15.7) and one for soft brick or concrete (see Box 15.8).

Whether the stucco is hard or soft, avoid applying either when there is danger of frost. If there is any crumbled or powdery areas in the stucco when it has dried, they must be cut out and replaced.

PIGMENTS

Pigments chosen for outdoor application must have the highest lightfastness rating. They must also be resistant to alkaline supports, grounds, and vehicles, and to acidic atmospheres. The palette is slightly more limited than for indoor frescoes.

- *Reds:* Red iron oxides (mars, burnt sienna); quinacridone red and scarlet.
- *Oranges:* (Oranges can be mixed from reds and yellows.)

- *Yellows:* Titanium yellow; yellow iron oxides (mars, raw sienna, yellow ochre).
- *Greens:* Phthalocyanine green (PG7); green gold; chromium oxide green, opaque; and light green oxide.
- *Blues:* Phthalocyanine blue, alpha type (PB15/74160); cerulean blue; cobalt blue; and manganese blue.
- *Purples:* Quinacridone violet; mars violet. (Purples are easily mixed.)
- *Browns:* Brown iron oxides.
- *Blacks:* Mars black.
- *Whites:* Titanium white, rutile (nonchalking) type.

SYNTHETIC EMULSION PAINTS

Acrylic emulsion paints can be used for exterior mural decoration. Industrial varieties will not have the durability of those made by artists'

BOX 15.7. HOW TO MAKE HARD STUCCO

MATERIALS

- Hose and source of clean water.
- Wooden trough.
- Hoe.
- Shovel.
- Very clean, washed river sand.
- White Portland cement.

METHOD

1. Mix 1 part dry Portland cement with 3 parts dry sand. Mix enough for two coats; divide in half.
2. Add enough water to half the mixture, a little at a time, while thoroughly hoeing, until the stucco reaches a puttylike consistency. Reserve the second half of the mixture, in its dry state, to use for the second coat.

3. Chisel a key onto the support if there is an insufficient texture to hold the stucco; most hard walls will need to be chiseled. Spray the wall with water until it is soaked, and wait until there is no standing water on its surface.
4. Apply the first coat with a trowel or wooden float, starting at the bottom and working up, to a thickness of about 6 mm ($1/4$ inch). When it has set, but before it has dried, scratch it all over to give it a key.
5. Apply the second coat when the first coat is dry, using the wood float to get a smooth surface, to the same thickness as the first coat. A light spray of water can be given to the first coat before the second is applied, but do not apply the second coat to standing water.

BOX 15.8. HOW TO MAKE SOFT STUCCO

MATERIALS

- Same materials and equipment as for the hard stucco prepared in Box 15.7.
- Slaked lime putty.
- PVA adhesive.

METHOD

1. Mix 1 part dry Portland cement, 1 part slaked lime putty, and 5 parts dry sand. Mix enough for two coats; reserve half.
2. Add enough water to half the mixture, a little at a time, while thoroughly hoeing,

until the stucco reaches a puttylike state. Reserve the second half of the dry mixture for the second coat.
3. A key need not be chiseled onto the support, but it should be given an application of PVA adhesive (1 part adhesive to 5 parts water). One coat should be enough. Allow the primer to dry.
4. Apply the first and second coats of soft stucco as in the instructions for hard stucco.

paint manufacturers. Claims of "high performance exterior paints" mean that they may last as long as seven to ten years—hardly high performance where our expectations are concerned. There is no reason to adopt a fatalistic attitude about this situation, however. Spend the money and use the best artists' paint for exterior murals. Do not mix brands.

You can apply the paint over a PVA emulsion priming, without the application of a ground, but it is better to have a white reflective surface if the colors are to be fully developed. An acrylic polymer emulsion gesso ground, or a thin layer of acrylic emulsion titanium white paint, can be applied to the PVA emulsion priming. A stucco surface made with white Portland cement may be white enough so that a ground is not needed.

To protect the paints from ground moisture, which will rise by capillary action, start the painting at least 60 cm (2 feet) above ground level. Develop preliminary sketches, color studies, and cartoons as in fresco painting. You can square up the wall with chalk snap lines, and pounce the cartoon onto the surface.

Use hair and bristle brushes to paint. If the wall is large, choose large brushes. The paint can be applied straight but will penetrate the wall better if it is thinned with up to 4 parts of clean water for the first coat. In order to maintain coherence in the design, you will need to work the image as broadly as possible at first, reserving the details for later application. A slight impasto can be built up, but remember that projections from the plane of the wall will collect a surprising amount of dirt.

The porous synthetic emulsion paints should not be varnished in exterior applications. A sealed surface can develop blisters that will eventually crack open, and the varnish will be degraded quickly by ultraviolet light—it can bloom or craze over its surface and obliterate the image. A glaze of acrylic emulsion matte medium, thinned 2 to 1 with water, can be applied over the work and will provide some protection for a limited time. The mediums have been known to bloom on excessive exposure to moist atmospheres, however, and they probably should not be used. Any bloom that occurs in the paint films themselves may be overpowered by the colorants present. But again, so much depends on the exposure conditions that predictions for durability are not reliable.

EXPERIMENTAL EXTERIOR PAINTS (SILICATE PAINTS)

The silicate paints, first develoved in the nineteenth century in Germany and perfected by the chemist Adolf Wilhelm Keim, are based on solubilized sodium, potassium, or lithium silicate. The potassium silicate paints that Keim developed (from earlier work with sodium silicates by von Fuchs) were further improved in the 1930s. These paints were ultimately developed as industrial coatings, primarily "zinc-rich" paints for protecting equipment and structures outdoors. They are used mainly on nonabsorbent substrates, as distinct from the normally absorbent bases for mural paints.

A great deal of speculation about the durability of the silicate paints has been generated in literature on artists' materials; Mayer and Wehlte offer more or less cautious endorsements of the medium. Conservators and paint chemists who deal with artists' paints are a bit more cautious in their opinions, and some have condemned the technique as not as durable as once thought. The paints have been in use for only about 40 years in varying conditions of exposure, and they were certainly not developed specifically for artistic use. Any recommendations are provisional.

The chemical process by which silicon ester binders work is essentially catalytic—that is, the binder, containing ethyl silicates and ethyl alcohol, remains stable and inert until a catalyst, a mixture of water and hydrochloric acid, is added. When the catalyst is added, a reaction occurs that causes the alcohol to evaporate and the silica to form a colloidal gel.

The reaction is not reversible and cannot be inhibited once the catalyst is added.

When the binder is exposed in thin films outdoors, atmospheric moisture and continuing reactions within the colloidal silica contribute to the gel's further reduction to pure silica. Pure silica is the dioxide form of silicon, a nonmetallic element occurring in nature in both amorphous and crystalline forms, especially in quartz and agate rocks. In other words, the binder is reduced once again to its natural form, and in doing so will lock within its crystalline matrix pigments, which are dispersed in it.

Although the silica forms a layer, its film is very porous—even more porous than those made by the emulsion paints. The paints on a porous wall look like those applied in a fresco technique, which is to say that the vehicle is nearly undetectable and what you see is the wall and the color. The films, therefore, are subject to mechanical wear and tear, and can be scraped off by abrasion or worn off by abrasive particles like those that might be blown against the wall by wind.

Survival of the paints depends on the nonreactive characteristics of the inert silica and the resistance of the pigments. The problem with the fresco technique as applied outdoors is that the substrate (the lime plaster wall) can react with modern acidic atmospheres and deteriorate. If the silicate binders are as inert as claimed, they ought not to react even under such extreme conditions of atmospheric pollution as are often found in urban areas. Unfortunately, it is too early to tell about the survival rate of paintings in the silicate binder. Only the actual passage of time will indicate the durability of murals painted with the silicates.

Nevertheless, if you wish to try the technique you can use one of the methods recommended by Union Carbide's Coatings Materials Division (Old Ridgebury Road, Danbury, CT 06817) in publication F-41629C, "Ethyl Silicates." This paint is used in industrial applications and may not be suitable for artistic use. Remember that the manufacturer cannot accept responsibility for the use or potential misuse of its products, and assumes no legal liability for such use.

All the silicate paints and their derivatives discussed in this chapter should be considered experimental materials until such time as controlled, scientific testing is conducted to determine their durability and performance characteristics as artists' materials.

PREPARATION OF SILICATE VEHICLE AND PAINT

There are three methods for preparing the vehicle; they use the same materials. (See Box 15.9.) The pigments used for silicate painting are all those recommended for fresco, since they must be resistant to the alkali ground of white Portland cement.

Mixing the pigments with the vehicle is the most difficult aspect of the process. The pigments must be combined with the vehicle directly before painting, but the binder is highly volatile, making grinding on a slab an unsatisfactory method of dispersion. Two methods are suggested. (See Box 15.10.)

☞ CAUTION: *The materials can be dangerous.*

For all methods, use approximately the following proportions of vehicle to pigment, by volume: 80 parts vehicle to 3 to 5 parts pigment. Remember that pigments can vary tremendously in volume-to-weight ratios. By weight, the proportions are 10 parts vehicle to 3 to 5 parts pigment.

A small proportion of the pigment volume can be replaced by "micronized" mica (hydrous potassium aluminum silicate) to improve the stability of the mixture. The mica flakes will hold the pigments in suspension in the vehicle.

OTHER TYPES OF SILICATE PAINT

This variety of silicate vehicle described so far—ethyl silicate—is the one most often discussed in relation to fine arts painting. Some others deserve investigation for their potential application. Samples are available from E. I. Du Pont de Nemours and Company, Inc. (see List of Suppliers).

BOX 15.9. HOW TO PREPARE SILICATE VEHICLE

MATERIALS

- Ethyl silicate 40.
 ☞ CAUTION: Ethyl silicate 40 is flammable (flash point is 32° C, 90° F) and harmful. Do not breathe the vapors; use with cross-ventilation and wear a vapor mask.
- Ethyl alcohol in 80 percent solution.
 ☞ CAUTION: Ethyl alcohol is flammable. Do not breathe the vapors.

 To make an 80 percent solution of ethyl alcohol, reduce 80 parts of 100 percent ethanol with 20 parts of distilled water. Ever Clear brand of grain alcohol is 90 percent ethanol, and available in some liquor stores.
- Hydrochloric acid in 0.3 percent solution.
 ☞ CAUTION: Hydrochloric acid is dangerous. Wear splash goggles, acid-proof gloves, and either an air-supplied respirator or an organic vapor mask. A fume hood or direct local exhaust should be used when handling HCl.

 To make a 0.3 percent solution, reduce 1 part of chemically pure HCl with 120 parts distilled water in a glass container.
 ☞ CAUTION: ADD THE ACID TO THE WATER so that the acid is immediately diluted. Adding water to acid can result in splashed, undiluted acid—which could burn you.
- Store the solution in an amber-colored glass bottle with a plastic cap. HCl deteriorates in light and will corrode metal caps.
- Distilled water.
- Wide-mouthed glass jar with a plastic cover.
- UCAR Silicate ESP-X, an experimental variety of ethyl silicate available from Union Carbide (for Method C).

METHOD A

1. Mix 80 parts of the ethyl silicate with 18 parts ethyl alcohol and 2 parts 0.3 percent HCl, in that order, in the glass jar. Allow to stand, covered, for 8 to 12 hours.
2. Add 5 parts distilled water. (Here the acid is already dilute, so it's not dangerous to add the water to it rather than vice versa.)

 This solution should be used within 8 hours of mixing, although Mayer reports that 2 hours is enough of a wait and may be better. It has a higher silica content than the solution described in Method B. After the binder is made and the pigments are combined with it, it will slowly begin to thicken as the reaction begins.

 This thickening cannot be stopped, nor can it be delayed by thinning the binder. If the paints made with the silicate vehicle thicken to a point where they cannot be brushed out in thin layers, they must be discarded.

METHOD B

1. Mix 15 parts ethyl silicate, 8 parts 80 percent ethyl alcohol, and 2 parts 0.03 percent HCl (dilute 1 part of the 0.3 percent solution of HCl with 10 parts distilled water), in that order, in the glass jar.
2. Allow to stand, covered, for 8 to 12 hours.

 This solution may be used after the first rest period, without further additions of distilled water. It has less silica content than the solution made by Method A.

METHOD C

An experimental variety of ethyl silicate made by Union Carbide, called UCAR Silicate ESP-X, is available for evaluation. It is called a one-package system because no additions need be made to the solution to activate the hydrolysis.

1. Add the pigments to the solution. As the vehicle is exposed to air, the solution will immediately begin to gel.
2. Once complete gelation has occurred and the paints can no longer be brushed out into thin layers, discard the solution.

BOX 15.10. HOW TO MAKE SILICATE PAINT

MATERIALS
- One of the vehicles prepared in Box 15.9.
- Artist-quality pigments resistant to an alkaline binder.
- Glass jar with tight-fitting cap (for Method A).
- Deep, narrow mortar and pestle (for Method A).
- Can with cover (for Method B).
- Stick or wooden spoon (for Method B).

METHOD A
Use a deep, narrow mortar and a pestle to disperse the pigment. This type of mortar will inhibit rapid evaporation. Store the finished paint in a glass jar with a tight cap.

METHOD B
1. Place the vehicle in a can.
2. Sprinkle in the pigment while stirring vigorously with a stick or wooden spoon. The paint should be like a smooth syrup.
3. Cover the can and discard the stick.

Polysilicate 48 Solution, Technical

This is a lithium silicate dispersed in an aqueous and therefore nonflammable vehicle. Du Pont recommends it as an excellent binder in inorganic coatings on concrete, glass, and aluminum. It can be loaded with more pigment than the ethyl silicates; it is not sensitive to moisture; and it will improve hardness when used as an additive to PVA emulsion vehicles. It is *toxic* by ingestion and irritating to the skin and eyes. Avoid skin and eye contact by wearing gloves and goggles, and wash thoroughly after handling.

Preparation of the vehicle is simple: Open the container, disperse pigments using any of the three methods recommended for the ethyl silicates, and paint before gelation occurs.

Potassium Silicate, Electronics Grade #200

This is a hydroscopic mixture of potassium carbonate and pure silica sand, supercooled to form potassium silicate glass. The potassium silicate glass is then dissolved in hot water to form a clear solution. As the water content of the solution evaporates on application—the reaction can be speeded up by heating the solution or films of the solution—the usual gelation and eventual film forming occurs. Du Pont recommends it as an excellent binder in mortars and as a binder for roofing granules, but makes no recommendations specifically regarding paint coatings. The material, however, seems to meet all the requirements for paint application if used like the ethyl or lithium silicates: in thin films on porous cement walls.

☞ *CAUTION: The solutions are alkaline, and may irritate the skin; the dried flakes of the potassium silicate glass are capable of causing eye injury. Avoid skin and eye contact by wearing goggles and gloves, and wash thoroughly after handling.*

Preparation of the vehicle, dispersion of pigments, and use are the same as recommended for the ethyl silicates.

Ludox Colloidal Silica, HS-40 Percent

This is a water-based colloidal dispersion of silica particles that has many industrial applications: high-temperature binder for refractory cements, paper and film coatings, antisoil coatings, adhesion promoter, wetting promoter, reinforcing agent for latex emulsion coatings and adhesives, and binder for pigments and decorative coatings on bricks. Other proprietary forms of colloidal silica are used extensively in artist's paint manufacturing as reinforcing agents and wetting promoters, primarily in the acrylic emulsion paints.

Ludox is unlike the other silicates mentioned in that it does not have a crystalline structure. The silica particles are spheres, dispersed in an alkaline medium (not as alkaline as the other silicates), and the film-forming capability is achieved by the fact that the particles repel each other in the alkaline medium—they are given a negative electric charge by the medium. Gelation occurs, as in the other silicates, when the water evaporates from the vehicle; gelation of Ludox can also occur if the pH is altered, or if a water-miscible organic solvent is added.

☞ *CAUTION: Ludox HS-40 percent is alkaline and can cause some skin irritation. Avoid skin and eye contact by wearing goggles and gloves, and wash thoroughly after handling. The dried silica particles can cause pneumoconiosis, a lung disease. Do NOT spray the liquid; use a fine-particle respirator.*

Preparation of the vehicle, dispersion of pigments, and use are the same as recommended for the ethyl silicates.

TOOLS AND BRUSHES

Brushes with long bristles or hairs can be used with silicate paints. The binder is hard on brushes, so use medium-quality rather than expensive ones.

The various containers used to hold the made-up paint should be disposable—cans or glass jars are best—since once the paint is exposed to the air, it begins its irreversible drying process. Any leftover paint should be discarded at the end of the day's work, certainly within 8 hours.

Two separate containers holding amounts of vehicle should be on the site. One is used to store brushes when they are not in use—do not allow the paint to dry on the brushes. The other container of vehicle can be used to thin the paint. Do not thin the paint too much, and do not attempt to thin a paint that has begun to gel.

At the end of the working day, clean all tools with alcohol before washing them out with soapy water.

SUPPORTS AND GROUNDS

Stucco surfaces, bonded to brick or concrete, are the best for the silicon ester paints. Prepare them as for painting in acrylic emulsion paints, applying a hard stucco to hard brick or concrete and a soft stucco to crumbly brick or concrete. The substrate should be cleaned prior to the application of the stucco.

PAINTING TECHNIQUES

Make the vehicle and a supply of fresh paint each day. Two application methods are suggested: You can apply the paint in thin glazes, as in the fresco or watercolor processes; or you can apply the paint more opaquely, with glazes over the opaque films.

The frescolike applications using paint that has been thinned with the plain uncolored vehicle seem to work well, provided the paint is ground well enough so that flocculation or streaking does not occur. If the grinding method used does not give a good, smooth paint, it is better to use the more substantial application.

To apply the paint more opaquely, do not thin it with the clear vehicle. Glazing, if desired, should be done so that thinner paint overlies thicker paint, in order to ensure adhesion. "Thicker paint," incidentally, means as thick as opaque watercolor, not as thick as oil paint.

In both methods, it is necessary to wait a few minutes for lower layers of paint to set before applying glazes or overpainting. Thin films will dry in about one hour. Complete curing of the paints, and the binder's conversion to pure silica dioxide, will take several weeks, depending on the moisture content of the atmosphere.

SILICATE PANELS

Smaller panels for practice or the production of portable silicate paintings can be made the same way such panels are made for fresco. Use a hard stucco built up on a wire screen lath that has been attached to a supporting wooden frame. (Refer back to Figure 15.1.)

OTHER EXTERIOR MURAL TECHNIQUES

Although these are not painting methods, the following mural techniques are particularly appropriate for exterior use. In outdoor applications, any paint is destined to fail sooner or later, and these techniques offer a reasonable alternative where more durable mediums are sought.

SGRAFFITO

This method is more adaptable to flat, two-dimensional designs than it is to free-flowing, naturalistic, or spatial compositions. It consists of a two-, three-, or even four-layer wall built of different-colored mortars, through which is scratched a design that reveals the different layers. This is like the ancient Chinese technique of colored lacquer carving. The design can be bold and graphic, utilizing planes of color, or essentially linear. The name of the process comes from the Italian *sgraffiare,* meaning "to scratch." The technique itself dates at least from the thirteenth century.

Build the wall of stucco plaster, made with white Portland cement, clean sand, and slaked lime putty (if needed). Next apply a rough coat to the keyed wall, to a thickness of about 1.25 to 1.85 cm (½ to ¾ inch). Before it is set, apply a thin film of color to it using the fresco technique. Only pigments usable in fresco—that is, alkaline-proof pigments—can be used. When this layer has dried, apply a second coat of stucco to a thickness of about 5 cm (2 inches). This layer may also be colored.

When the second layer is set, but before it dries, incise it to reveal the lower layer. You can use any tool that will incise or cut away the top layer of the wall. As in fresco, only sections of the wall that can be completed in a day can be worked at one time.

To use more than two colors, apply and individually color more layers of this cement, but the total thickness of the wall should not exceed 6.25 cm (2½ inches). Since the process then becomes more complex, smaller sections must be worked individually so there is time to complete each one before the cement dries.

Sgraffito can be combined with other graphic techniques using paint, although there is the problem of durability if the mural is outdoors.

MOSAIC

Mosaic uses small units of variously colored materials, set in a mortar, which together form a design. The technique dates at least from about 1750 B.C. in Babylon, although it reached its height during the Byzantine Empire, A.D. 476–1453.

Simple designs, subordinate to the surrounding architectural elements, can be executed in mosaic, but some remarkably naturalistic works have also been done, particularly by the Byzantines. Mosaic is used on floors, walls, ceilings, and even in small framed supports. Interesting modern examples of mosaic can be seen in some New York City subway stations, where they have survived nearly 50 years of exposure to truly filthy environments.

The mosaic units are called *tesserae,* from the Latin word for both the technique and the units, *tessellatus.* The units can be pieces of colored stone, marble, glazed or plain ceramic tile, or glass. Other materials can be used indoors, but only these will be impervious to outdoor conditions. Colored glass is of particular interest, since when it is fractured the broken side (as opposed to the smooth front and back) present a sparkling, very reflective surface.

The tesserae are most often cut into regular pieces about 3 to 6 mm (⅛ to ¼ inch) on a side and perhaps as thick. Stones, naturally, will vary in size, and there is no rule saying that the units must all be of the same size or even of the same shape.

There are two ways of setting the tesserae: placing them directly into damp mortar on the wall, or presetting them (as described below) before applying them to the wall. As in all mural techniques, a complete plan of action should be worked out in advance.

Simple mosaics, or those in which you wish to improvise without a plan, can be carried out directly; artists who wish to design a more complex picture will prefer presetting the tesserae.

To preset the tesserae, the artist constructs shallow trays of plywood with wooden surrounds and fills them to a depth of about 1.6 mm (1/16 inch) with fine sand. The tesserae are laid in the sand face up, with a distance of about 3 mm (1/8 inch), more or less, between each unit. The sand keeps the tesserae from moving around.

Once the tray is full and the design has been approved, a piece of muslin soaked in a water-soluble glue (or heavy paper brushed with the glue) is pressed and smoothed over the design, with care taken to be sure each tessera comes into contact with the cloth. The whole is allowed to dry, and then it is lifted and set into place in the damp mortar. A stucco or fresco wall can be used, and it can be white, gray, or some color that fits with the design. The entire design of the mosaic can be laid out in advance this way, using a large warehouse floor, for example, then cut into sections, carried to the site, and applied to the wall, much like the installation of bathroom tile.

Before the wall has set, the tesserae must be pushed into the mortar using a flat wooden block and a hammer; they are not set too evenly, as some surface variation is desirable, but deeply enough to become securely held by the mortar. When the wall has set and dried, the muslin is gone over with a damp sponge to loosen the adhesive and the cloth is stripped from the wall. The artist inspects the work for defects; loose tesserae can be knocked out and reset.

Another method of presetting, used less often, has the artist glue the tesserae face down on a paper or cloth support. This then is carried to the site and installed as described above. The difficulty with this method is that you must work with the imagery in reverse, although artists who do much printmaking will be used to working with reversed images.

PORCELAIN ENAMEL

Porcelain enamel uses colored *frits* fused by high heat to a metal substrate, forming a glossy, glasslike, and impervious surface. Frits resemble powdered glass, but also contain in addition to the colorant a flux (to lower the melting point of the frit) and a refractory (a material that balances the flux and stabilizes the mixture).

Frits are made by melting the ingredients together, cooling them, and milling them into a powder, but the color of the dry frits is not always an indication of the final color after the frits are finally fired. Frits are sold through enameling materials suppliers.

Cloisonné is an example of a delicate form of porcelain enamel in which the colored shapes are separated by thin brass or copper wires. Some old street signs and modern stove surfaces are made of porcelain-enameled metal.

Anyone with a ceramics kiln that is capable of reaching a temperature of at least 1082° C (2000° F) can produce these products, although it is sometimes more convenient to send the material to a professional enameler for fusing. Suppliers sell iron or steel sheets of various sizes onto both sides of which has been fused a base coat of cobalt oxide—in black or gray—and a second coat of opaque white of tin oxide or titanium dioxide. You then apply the frit, thinning the colored paste with water as desired, or mixing the powdered colored frit into a paste with water and then thinning it. The paste is allowed to dry to an even, powdery layer and then fired to fuse the color to the base. Since each color should be fired to a specific temperature in the neighborhood of about 815° C (1450° to 1550° F), it is usually necessary to refire after each application of a different frit. This complication can be frustrating if you have to wait for the work to be returned from the enameler's, or if the workers in the factory do not have a clear understanding of the artistic purposes of the work.

The major difficulty with the standard application procedure is that the powdery layer of frit, once dry, cannot be overpainted to

make corrections without disturbing or muddying the underpainted layer. It is also difficult to build up layers of colors in the free-flowing, brushy technique that today's artists might prefer. If the frits are ground in a watercolor vehicle composed of gum acacia, water, and glycerine, this difficulty is somewhat relieved. As an added benefit, the colors will appear more as they will after firing. The binder will be destroyed in the firing long before the frits are fused into enamel layers.

Aluminum, copper, steel, or iron sheets, prepared with the base coat of cobalt and a white ground and of various sizes, can be had from suppliers. If they are custom-designed with interlocking flanges, it is possible to put together large works from several smaller components panels. Because very large panels may warp during firing, it is better to work with several smaller panels, even though it is impossible to avoid the visual disruption caused by the divisions between them. The panels can be hung on an exterior wall using special clips—a standard construction procedure today. Consult an architectural engineer about the various methods employed.

If colorants that are permanent in strong light exposures are used, the enameled panels will be as durable as mosaic tiles. Their only susceptibility is to scratches, chips, and cracks that could develop as the result of mechanical stresses to the metal substrates caused by temperature changes. Cracks or chips can allow moisture to come into contact with the metal interior, leading to rusting or oxidation, which in turn can cause the enamel to blister or powder. Enameled metal panels installed in exterior situations should be inspected frequently for these defects, especially at the edges. They must be repaired immediately by painting or removal and refiring.

Part Three

Picture Protection and Restoration

All finished works of art are vulnerable to gradual decay. ✍ This is true even if you have chosen high-quality materials and applied them wisely. ✍ However, there are steps you can take to protect finished works: varnishing or other surface protection, matting and framing, and proper storage. ✍ In this section you will learn how to apply varnish and fixative, how to make several kinds of mats, how to build your own frames, and how to build storage racks and sturdy crates for shipping artworks. ✍ You will find out how to document and photograph your work. ✍ You will also get a glimpse of the techniques used by professional conservators to preserve damaged works on paper, fabric, and wood.

16 Picture Protection

All pictures, well-crafted or not, will inevitably suffer deterioration as a result of exposure to atmospheric conditions, ultraviolet light, or the vicissitudes of aging. Mishandling, improper storage, or other forms of negligence can also contribute to the untimely demise of a work of art. Fortunately, it is possible to slow the deterioration of the work by careful framing and matting, proper surface protection, and good storage and display conditions.

VARNISHING

A final varnish is a protective surface coating. It should be clear, nonyellowing, elastic enough to absorb the movements of the support and paint layers without cracking, and reversible. Even the cleanest of storage or display conditions will not prevent the eventual accumulation of dirt on the picture's surface. Some yellowing, embrittlement, and loss of transparency are also inevitable over the course of many years.

The varnish should be removable with mild solvents that will not harm the paint layers beneath it. Finally, the varnish should have an appropriate degree of surface reflectivity for the work. Too glossy a varnish will make the work hard to see, and too matte a surface will not provide good protection for the work.

Some types of paintings do not require, or traditionally receive, a varnish coating. These include the water-thinned paints (opaque and transparent watercolor, size), casein, the egg and egg-oil emulsion temperas, encaustics, and pastels. Usually the water-thinned paints are matted and framed behind glass. The tempera paints can be varnished, but this often changes the refractive index of the paint and alters the appearance of the picture; simple polishing of the temperas is recommended. Encaustic paintings are usually polished to a semigloss finish with a soft cloth and do not require varnishing, but they can be given a coat of paste wax soap. Pastels are never varnished; they are given a light spray of a weak fixative merely to hold the pigment particles in place. Murals, indoors or out, are not usually varnished either.

Paintings in oil, resin-oil, acrylic emulsion, acrylic solution, and alkyd vehicles should be varnished. The acrylic emulsion, acrylic solution, and alkyd paints can be varnished as soon as they are completely dry, usually within a few days or at most a week. Oil and resin-oil paintings must be allowed to dry thoroughly before they are varnished. A painting of "average" thickness will dry in about six months, and thicker paintings will take a year or longer, all depending on the conditions in which the paintings are stored. Because oil paintings dry from the top layer down toward the support, a dry surface does not mean that the painting is completely dry. If you suspect that an oil painting is not dry enough to support a final varnish coating without causing it to crack, an application of a light retouch varnish will provide temporary protection.

A simple solution varnish such as damar or mastic in gum turpentine is the usual finish for oil paintings, although it has been established that damar grows brittle and yellows as it ages far more rapidly than the newer acrylic solution or ketone resin varnishes. The following are newer synthetic alternatives to the traditional varnishes.

- Liquitex's Soluvar (a solution of n-butyl methacrylate and iso-butyl methacrylate resins in mineral spirits).
- Golden's MS/UVLS (a solution similar to Soluvar with an added ultraviolet light inhibitor).
- Daniel Smith's picture varnish with UV absorber (again similar to Soluvar and Golden's MS/UVLS).
- Winsor & Newton's artist's picture varnish or Griffin picture varnish (a ketone resin solution in mineral spirits).

Most commercial preparations are supplied in liquid and spray-can form, and can be had in, or adjusted to, gloss or semigloss finishes. For a summary of surface coatings for various types of pictures, see Table 16.1 (pages 285–288).

Varnishing should be done in a warm room on a dry day. Atmospheric humidity can contribute to the formation of *bloom* behind the varnish film. Bloom is a whitish or cloudy haze that obscures the image and is generally believed to be caused by moisture trapped beneath the varnish; warm, dry conditions will help prevent bloom.

The room in which the varnishing is to be done should be swept or vacuumed to lessen the possibility that airborne dust will settle on the freshly varnished surface. Sweep or vacuum the night before varnishing day, to allow dust to settle—there is always some dust left hanging in the air. All the tools used in varnishing should also be very clean, and free of water moisture. For further instructions on varnishing, see Box 16.1.

SEMIGLOSS AND MATTE FINISHES

A semigloss or matte surface finish might be appropriate for a particular work. Commercial varnishes with these finishes are available from various manufacturers, or you may apply a very thin beeswax coating to the surface of a glossy varnish.

Use a beeswax and water emulsion or a beeswax and mineral spirits paste, depending on the solubility of the paint layers. Apply the paste to a completely dry varnish with a stiff brush or soft cotton cloth pad. The wax can be warmed slightly to help it spread. Use a short, circular motion to apply the paste with the pad, and be sure that the film is very thin and even. When the wax coating has hardened, you can polish it to a low sheen with a clean cotton cloth or nylon stocking.

A wax coating on the surface of a picture is likely to attract dust, and can be easily scratched or damaged. The wax is more easily removed and replaced than the varnish coating in case of damage, however, and it also provides some protection for the varnish.

A reminder: Acrylic emulsion paintings should *not* be varnished with the glossy or matte varnish mediums that are supplied as auxiliaries for the paints. These films cannot be easily removed or separated from the paint films, and they are as porous and susceptible to damage as the paint films themselves. Use an acrylic solution varnish to coat these paintings.

SPRAY VARNISHING

Spraying a varnish coating can be more efficient than brushing it on, particularly if a large number of works are to be varnished at one time. The technique is significantly different from brushing and requires practice.
☞ *CAUTION: Spray varnishing can be a health AND fire hazard, because large amounts of resin and solvent are put into the air in a fine particle and vapor mist. Appropriate ventilation is a must, preferably direct forced-air. A powerful window fan with explosion-proof grounding, correctly placed to draw out the offending mists, can work, but you should also wear an organic vapor respirator, eye protection, gloves, and a long-sleeved smock or overalls.*

Three types of apparatus can be used for spray varnishing:

1. Small spray packs that have a reservoir for the varnish and an attached, replaceable propellant can. These operate like the traditional mouth atomizers, by external mixing, and are suitable for small pictures and the application of fixatives. As the propellant runs out and the pressure decreases, these devices can begin to spit out globs of varnish in an erratic manner, giving an unsatisfactory finish to the painting. Be sure to have replacement cans of propellant handy.

2. Electric compressors. The most common type of electric spray compressor has no reservoir for compressed air, but usually provides a fairly steady pressure for spraying medium-size and large works. These work on the principle of external mixing, like the spray packs.

 Electric compressors with large air tanks for holding a reserve of pressurized air are powerful enough to spray large amounts of varnish for a sustained period. The air reservoir ensures even pressure; the pressure lines should have an oil trap to keep moisture out of the system. The cost

BOX 16.1. HOW TO APPLY VARNISH TO A PAINTING

MATERIALS

- Bristle brush 6 to 8 cm (2 1/2 to 3 inches) wide. Special varnishing brushes that have fairly long bristles of mixed varieties and that taper to a very thin edge are available. They have short, comfortable handles. Ordinary artists' bristle brushes can be used to varnish small paintings, but they will not hold a substantial amount of varnish.
- Painting to be varnished.
- Table.
- Cup or a can to hold the working varnish.
- Clean white cotton rags.
- Kneaded eraser.
- Mineral spirits.
- Soft-hair dusting brush.
- Varnish thinner.
- Varnish, in the correct dilution with its thinner. Ordinarily, the heavy, syrupy condition of the varnish as it is sold or homemade is too thick to be manipulated easily into a thin, even film. A dilution of 3 or 4 parts thinner to 1 part varnish will usually produce a solution that is more workable. You will have to experiment with various proportions in order to find the correct dilution. Consider applying 2 or 3 thin coats of varnish rather than

one thick coat. This is a rule of thumb every housepainter understands.

METHOD

1. Lay the painting flat, face up, on a table. Position it so that you can see light reflected from its surface. This positioning will help you to determine whether the picture has received an even coating of varnish.
2. If the picture is thoroughly dry, dust it gently with the soft-hair brush. The kneaded eraser can be used to pick up particles of dirt not removed by dusting.
3. Further surface dirt can be removed by gently wiping the painting with a clean white rag slightly dampened with mineral spirits. Be particularly careful with oil paintings less than one year old or those with delicate glazed passages, and also be on the lookout when cleaning acrylic solution paintings.

 Check the rag frequently for traces of color. Color on the rag can show a number of conditions: the painting is not thoroughly dry; the paints have been thinned too much, with no painting or glaze medium, so that they are underbound; or the manufacturer of the paint had a formulation problem with a particular pigment that is known to flocculate.

of these compressors can be justified only if you have a huge amount of work to varnish or if there is another use for the tool, such as for airbrush painting.

3. Electric sprayers that work by centrifugal force. This type of sprayer does not work by compressed air or with external mixing, but by an internal mixing mechanism. A rapidly spinning plate at the end of a hollow rod picks up the liquid, draws it up the inside of the rod, and hurls it out of the nozzle in a fine spray. These sprayers are designed for use with water-based, nonflammable mixtures, but with caution

can be used with varnishes thinned with mineral spirits. Do not use them to spray lacquers or any solution containing solvents stronger than mineral spirits.

The preparation of the work for spray varnishing is the same as the preliminary work done for varnishing with a brush. Do not place the work to be varnished on a table, however, but hang it vertically on a wall or easel. Mask the surrounding area with brown paper or plastic sheeting to protect it from overspray. Position the setup so that overspray is drawn out of the room by the exhaust system, either to the rear of the setup or to the side.

4. Pour some varnish solution into the cup or can. This is the working varnish and should be kept separate from the stock supply. Close the stock bottle and put it away to avoid confusing solutions.

5. Load the varnish brush, then discharge it against the inside of the container so that it holds a minimum amount of varnish. A dripping brush is too full.

6. Begin application at one corner of the painting. Cover a small patch at a time, say two or three brush widths. Brush on each patch first in one direction, then in a direction perpendicular to the first. Feather the edges of each patch so that you can blend into the next area. Work quickly (but don't be sloppy!) so that the surface receives as thin and even coating as possible.

7. Working quickly and deliberately, since the varnish will set quickly, proceed in a systematic way across the surface of the painting. Check the work against the light from time to time to be sure that all parts of the surface are receiving an equally thin coating.

Brushstrokes should not be evident because most varnishes level out quite readily. If brushstrokes are evident, a feather-light pass with the tip of the brush will remove them.

8. After the entire painting has been varnished, allow it to sit for about 10 minutes before removing it from the table. If it is lifted to a vertical position too soon, the varnish may sag or run. After 10 minutes, the painting can be removed from the table and leaned against a wall, face in, to finish drying. (The acrylic solution, ketone resin, or silicone varnishes can dry more quickly than damar or mastic solutions.)

Dust in the air cannot settle on the surface of a painting leaning face-in against a wall, but be careful not to stir up any dust on the floor in the vicinity of the painting.

9. Discard any working varnish left in the cup or can. Working varnish should be considered contaminated and should not be returned to the stock bottle.

10. The next day, when the varnish is dry, check to see whether there are any sunken-in areas, where the varnish has been absorbed into the picture and the surface looks dull and flat. If so, revarnish the entire picture to remove these patches. It may be necessary to give the picture two or three thin coats of varnish in order to even out the appearance of the surface.

A sprayed varnish must be diluted more than a brushed varnish, and thus will contain more thinner. Test various dilutions before spraying to find the proper mix for the varnish being used. Because of the dilution with the thinner, a sprayed-on varnish will dry more quickly than a brushed-on varnish. Usually two or three coats, with sufficient drying time in between, are necessary to achieve a satisfactory finish.

Test the spray device on scrap paper before proceeding to the work to see what kind of spray pattern is produced, and to discover how far from the surface you must hold the sprayer in order to produce a thin, even film. Holding the sprayer too close to work will cause the varnish to puddle, sag, drip, or run. The optimum distance is about 20 to 30 cm (8 to 12 inches), depending on the force of the spray and the pattern.

Start spraying at the top. Spray off one edge of the work and spray all the way across the top, off the other side. The return stroke should overlap the previous stroke by about half. Be sure to carry each stroke beyond the edge of the painting in order not to form any puddles. Keep the sprayer moving, and keep your hand at a constant distance from the surface of the painting. Continue spraying back and forth across the work, depositing a thin film of varnish, until the entire surface is covered.

FIXATIVES

Fixatives are applied to pastel paintings, and also to charcoal or graphite drawings if desired, to hold the particles of colorant immobile. A fixative must be applied as a very light, dilute spray so that it does not form a layer or film. Carelessly applied fixatives can completely alter the appearance of the picture by changing the refractive index of the pigments.

Prepared fixatives can be purchased in spray cans. There are two types: workable fixatives, which allow the relatively easy erasure and further application of the mediums, and nonworkable fixatives, which are harder to work over.

☞ CAUTION: *Many commercial fixatives contain solvents that are fire and health hazards. Also use caution when using one of the homemade fixatives suggested in Boxes 6.2 and 13.4.*

Clean conditions and surroundings are essential when you apply fixatives. Since spraying solvents and resins is a hazard, be sure to follow the precautions given under "Spray Varnishes" earlier in this chapter.

Lay the work face up on a tabletop or the floor. Hold the spray device vertically over the piece so that it will operate properly, and discharge the fixative so that it floats down to settle on the surface of the work. This method is preferable to spraying against the work hung vertically, since the force of the spray is often enough to dislodge the particles of colorant. One light coat of fixative should be enough to hold the particles in place.

Pastel painters who apply intermediate touches of fixative as they work on their paintings, in order to prevent smearing as they overpaint with successive layers of pastel, may find that the particles are fairly well fixed by the time the painting is finished. In this case, a final fix can be applied to the work hanging vertically, using the same procedure as for spray varnishing. This is a more convenient way to apply fixatives. Remember, do not apply a thick coating of fixative!

MATTING

A mat is the most popular protective housing for works of art on paper. It provides some protection for the work, in storage and while on exhibit, and it can also be an aesthetic addition to the work.

In the past 15 years, high-quality mat boards have become widely available. Boards made of 100 percent rag fibers (usually cotton) or purified lignin-free and acid-free wood pulp, treated with an alkaline buffer to absorb atmospheric acidity, can be obtained in many art supply stores or by mail order (see List of Suppliers). These materials are often called "acid-free" or "museum-quality" mat boards. To be truly high-quality materials,

museum-quality mat boards should contain an extra reserve buffer of the alkaline material—say, calcium carbonate or magnesium carbonate—that has been incorporated during manufacture, and they must not contain lignin.

Colored paper-covered pasteboard has long been found in framing shops, where an appeal to the customer's taste can take precedence over a concern for longevity. These boards can be distinguished from high-quality mat boards by looking at the core of the material. It is usually white or cream-colored, contrasting with the paper covering. These boards are of low quality and deteriorate rapidly, and their failure can damage the work of art.

Several manufacturers offer colored mat boards of acid-free construction in which the color is a pigment, not a dye, and which can be identified by observing the color of the core. The coloring is continuous throughout the thickness of the board—there is no paper covering. The color selection in these products is relatively limited, but quite adequate for most needs. Be sure that the manufacturer certifies the contents of the board as being of museum quality; do not rely on the word of the retail salesperson.

Museum board comes in varying thicknesses, or plies: 2-, 4-, 6-, or 8-ply boards are the most common. Each ply is approximately 1.5 mm ($^1/_{16}$ inch) thick. The boards are also available in two common sizes: 75 × 100 cm (30 × 40 inches), and 100 × 150 cm (40 × 60 inches). It is generally wise to use the thicker boards for larger works.

PREPARING AND CUTTING MATS

As you handle the artwork and measure, cut, and hinge the mat, cleanliness is essential for a professional-looking product. Your hands should be thoroughly washed. Do the job in a clean environment.

Any pencil marks or light smudges on the visible portions of the mat must be erased with a vinyl eraser, which should not harm the surface of a good-quality rag mat board. Ordinary pink rubber erasers can be too abrasive. If there are any eraser crumbs, dust them away from the work area with a soft dust brush. This sort of cleanup should be done before the artwork is placed in the mat.

There are many kinds of mat cutters, depending on how much you want to spend. Most of these tools hold a sharp blade at either 45° or 60°, enabling you to cut a beveled opening in the mat board. The Dexter mat cutter is an example of this tool. Some mat cutters not only hold the blade at an angle, but also provide a runner guide that ensures a perfectly straight cut, and a heavy pressure bar to hold the mat stable while it is being cut. The Logan cutters or C & H mat cutter are examples (both available from Daniel Smith, Inc.). The more work the tool does, and the more precise its operation, the more expensive it is. Be sure that all cutting blades are very sharp, since dull blades will tear, not cut. Have an ample supply of replacement blades for the cutter.

Another important tool you will need for matting is tape. At this time there are no pressure-sensitive tapes (masking tapes, cellophane tapes) recommended for this job. The adhesives in these tapes tend to dry out over time, cannot be removed safely without strong solvents, and can stain or discolor the work and the mat.

A thin linen tape using a water-soluble adhesive is available in various widths in some art supply shops or framing studios, or through mail order (see List of Suppliers). This type of tape is strong and stable, and the glue is easily reversible. Some conservators object to its use because it can be too strong for the work and because its sharp edges can damage fragile papers. It is, however, excellent for hinging the backboard of the mat to the window.

Small patches made from water-cut Japanese rice or mulberry papers are an alternative to using the linen tape. Buy archival Japanese papers from conservation suppliers to be sure of getting a quality material. Japanese paper is favored because it is long-fibered and therefore both strong and flexible.

Make the hinges by moistening the paper with a small brush dipped in distilled water,

and then gently separating the fibers along a straightedge; tearing or cutting the paper is not recommended because both can shorten the fibers and reduce the strength of the hinge. Then attach the hinges to the mat and the work using a cooked starch paste or methyl cellulose paste, both of which are reversible water-thinned glues.

A traditional mat is like a book, hinged along the side or top, whichever is longer. The front has a window opening through which the work is viewed. The back is solid, and provides support for the work. Most important, the window separates the work from the glazing used in the frame.

If the artwork has a border, the window mat can overlap the paper around its edges to hold it down securely (a T-hinge is used for hanging). If the image extends to the edges of the paper, the window should not overlap the work (a V-hinge is used).

The width of the border around the window is determined by convention or aesthetics. Large works might require a large border 7.5 to 15 cm (3 to 6 inches) in width; a small work may require a narrow border. Whatever your choice, it is the usual practice to make the top and two side borders the same dimensions and the bottom border slightly larger—for instance, the top and sides might be 7.5 cm (3 inches) wide, and the bottom 10 cm (4 inches) wide, as in the example in Box 16.2. These proportions provide a visual balance to the look of the work. If all the borders are the same width, the visual illusion will be that the work is sliding out of the bottom of the mat. Naturally, this convention is ignored if the needs of the work dictate a different arrangement.

Using water-cut, feathered-edged rice paper for the hinges may seem like an unnecessary bother because of the added task of making the adhesive to attach them, but they are far superior in strength and gentleness to the linen tape. If the artwork is on a heavy, strong piece of paper, however, the disadvantages of making hinges from linen tape are less worrisome.

Matted works that are not to be immediately framed need protection from possible damage— the open window of a mat will not protect the

MATERIALS

- 2 pieces of 4-ply museum board for each mat you plan to make.
- Scrap mat board to act as padding.
- Mat cutter.
- Mat knife. This simple tool, also called a utility knife, consists of a metal handle holding a rather heavy single-edged blade. It is used for cutting the boards to size, but can also be used for cutting levels if you have a very steady hand.
- Marking gauge. This is a carpenter's tool, like a sliding T-square, used for making repeat measurements of a set distance. The tool consists of a shaft divided like a ruler into 1 mm ($1/16$ inch) markings fitted with an adjustable sliding stop that can be fixed at any measurement with a thumbscrew. One end of the shaft has a holder into which a pencil can be inserted.
- Steel T-square and a steel ruler. Both should be marked with divisions every 1 mm ($1/16$ inch).
- Tape for hinging and hanging: linen tape with water-soluble adhesive, or patches of a long-fibered Japanese paper.
- Distilled water.
- Cooked starch paste or methyl cellulose paste.
- Blotter or absorbent scrap paper.
- Bone folder or smooth, short plastic rod. This is used to fold the hinges, and to smooth tiny surface defects in the mat.
- Very fine sandpaper or garnet paper. Used to clean up ragged cuts.
- Vinyl plastic eraser. An eraser is handy for removing light smudges and stray pencil marks. The vinyl erasers are gentle and do not leave crumbs.
- Soft dust brush, the kind used in drafting.
- HB pencil. A hard pencil like this will leave only faint marks on the mat, which are easy to erase. A hard pencil can also make depressions in the mat. If you have a heavy hand, it would be better to use a 4B pencil even though the marks will be darker.

BOX 16.2. HOW TO CUT AND HINGE A MAT

METHOD FOR CUTTING THE MAT

1. Measure the image. For this example, imagine that a drawing 25 × 20 cm (10 inches high and 8 inches wide) on a piece of paper 30 × 25 cm (12 by 10 inches) is being matted using 4-ply rag mat board. Since there is plenty of extra paper around the image, the mat will be used to cover the paper to within 3 mm ($^1/_8$ inch) of the edge. Adding 6 mm ($^1/_4$ inch) to each of the image's dimensions (2 × 3 mm) gives the size of the opening for the window: 25.6 × 20.6 cm (10$^1/_4$ by 8$^1/_4$ inches).

2. Determine what border widths are satisfactory for the image. In this example, let 7.5 cm (3 inches) for the sides and top and 10 cm (4 inches) for the bottom be appropriate. Add 17.5 cm (7 inches) to the height of the window opening (7.5 + 10, or 3 + 4 inches) and 15 cm (6 inches) to the width of the window opening (7.5 + 7.5 cm, or 3 + 3 inches) to give the outside dimensions of the mat: 43.1 × 35.6 cm (17$^1/_4$ by 14$^1/_4$ inches). Try it; it's not as complicated as it sounds.

3. Cut two pieces of the 4-ply museum board to exactly the dimensions determined in Step 2. Use the T-square to be sure that all markings on the board are square and true. Use a padding of scrap mat board beneath the good pieces to preserve the knife blade. Be sure that the mat knife is very sharp. One piece of mat board will be the backboard; set it aside in a clean place.

4. Use the marking gauge to mark the borders of the window mat on the backside of the mat. Set the stop at 7.5 cm (3 inches) and mark the top and sides, then at 10 cm (4 inches) for the bottom. Hold the stop firmly against the edge of the board and press down lightly with the pencil end of the gauge. Slide the gauge along the board and a line 7.5 cm (or 10 cm) from the edge of the board will be inscribed, parallel to the edge. With practice, it is not necessary to inscribe the full length of each line; mark just the corners where the lines intersect.

5. Cut out the window. If you are using the hand-held type of mat cutter, first check the blades to be sure they are sharp. Guide the tool carefully along a straightedge held firmly against the marking lines. A mat-cutting machine will have a weighted bar to hold the work firmly, and a sliding track to make sure the cut is straight. Set the blade depth adjustment so that the blade will extend about 1.5 mm ($^1/_{16}$ inch) below the cut to be sure of making a clean cut with no ragged edges. Also allow each cut to extend about 1.5 mm ($^1/_{16}$ inch) beyond each corner mark to be sure the corners are fully and cleanly cut through. Although it is possible to cut window mats with 90° angle edges, it is more common to use beveled edges. A bevel is cleaner-looking and does not allow the mat to cast a shadow on the image. The bevel can be 30°, 45°, or 60°.

6. Set the scrap piece from the window aside and check the edges and corners of the cut for ragged bits of torn mat. If there are any, a gentle pass with the fine garnet paper will smooth them out. Turn the mat over to the front side and lightly burnish the inside edges of the window with the bone folder or plastic rod. This will prevent any sharp edges from damaging the work of art.

7. Lay the window mat face down and place the backboard beside it. Since the longest part of the mat in this example is the side, the two pieces will be hinged together like a book. (If the longest edge were the top, the two would be hinged there.) Cut a length of linen tape just slightly shorter than the length of the side, moisten it, and assemble the mat. When the adhesive dries, fold the mat closed. Set it aside in a clean place.

METHOD A: USING T-HINGES

1. A T-hinge is used to hang works whose edges are covered by the window mat. Lay the work face down on a clean surface,

BOX 16.2. HOW TO CUT AND HINGE A MAT, CONT'D.

and prepare the hinging materials. To make the hinge, use either water-cut archival-quality Japanese paper or the linen tape; the Japanese paper is preferred. Each hinge consists of two pieces of paper or tape, one smaller than the other. The smaller is attached to the back of the artwork and forms the stem of the T. The larger piece forms the crosspiece of the T.

2. Prepare the smaller tabs first. For a work of the size in the example, there need be only two hinges. Larger works may require more, depending also on the weight of the work. Lay the small tabs on a blotter or absorbent piece of scrap paper and apply cold archival-quality methyl cellulose glue (the consistency of heavy cream), or cooked starch paste, to half the width of the tab. When the blotter has absorbed excess moisture from the tabs (a few seconds), place them in position on the back of the work, on the top edge, close to the corners. Overlap the edge of the work with enough of the tab to ensure that it will hold the work securely. Allow the adhesive to dry; this may take more than an hour.

3. Position the work on the backboard so that it is properly located beneath the window, and hold it in place with a light weight cushioned with clean blotting paper or clean scrap paper; or use your very clean finger. If the work is on heavy paper, a weight will not be needed. Open the window.

4. Prepare the larger crosspiece tabs of the hinges. These should be longer and wider than the smaller tabs. Apply adhesive to the entire surface of the tabs. Place them over the loose ends of the smaller tabs to stick them to the backboard. The large tabs should be centered over the smaller tabs and at a distance from the top edge of the work that is at least equal to the thickness of the work. A correctly hung work will hang freely on the tabs, allowing it to expand and contract as it reacts to changes in the atmosphere, but will be held securely in the mat. When the adhesive dries, close the mat.

METHOD B: USING V-HINGES

1. If the image extends to the edges of the page, it is necessary to "float" the work in the window mat so that the window does not cover the edges of the work. An inverted V-hinge, like a modified and reinforced stamp-hanging hinge, is employed here. Cut the mat as before, being sure to make the window large enough that it does not cover any edge of the work. Assemble the mat.

2. Position the work in the window of the closed mat. Lightly weight it in place if it is so fragile that it will shift.

3. Open the mat. With a pencil, carefully mark on the backboard the position of the upper two corners of the work. Remove the weight, if used, and turn the work over so that the upper corners of the work are now above the pencil marks. Weight it in place. Erase the pencil marks.

4. Prepare two small and two larger tabs as for a T-hinge. Apply adhesive to the entire surface of each of the smaller tabs. Immediately position the tabs on the back of the artwork, near the corners, and stick them to both the work and the backboard. About half of each hinge should be attached to the back of the work, and half to the backboard.

5. Apply adhesive to the entire surface of each of the larger crosspiece tabs. Place the crosspieces over the part of the hinges that are attached to the backboard, with the top edge of each just a bit away from the edge of the work. The crosspiece should not show when the work is viewed from the front. Allow the adhesive to dry.

6. When the tabs have dried, turn the picture right side up, pivoting it on the hinges, and close the mat.

surface of the work from harm. A slip sheet of acid-free glassine (a stable, smooth-surfaced, semiopaque paper) can be placed between the surface of the work and the window opening. The matted work should then be stored flat, in a closed portfolio or print storage box until it is framed. The work can also be slipped into an envelope made of Mylar, a clear form of polyester sheeting, for storage. Mylar is stable in light, but to keep the encapsulated matted work in a portfolio, use an uncoated, archival Mylar.

DOUBLE MATS

Pastels and works with high impasto present a special problem for the framer. The surfaces are either very sensitive to damage (pastel) or are so thick that they will extend above the plane of a single mat. A double mat is one solution; it can be made of 8-ply museum board, or two 4-ply or 6-ply mats glued together.

If you use an 8-ply board, proceed as outlined in the section on mat cutting. Be sure that the cutting blades are stiff enough to do the job without wandering off the marked lines;

thick mat board has a way of causing thin blades to wander. If you are using built-up 4- or 6-ply boards, following one of the two methods outlined in Boxes 16.3 and 16.4. The first method uses PVA emulsion glue. (See Box 16.3.) The second method uses double-faced polyester transparent tape from 3M (product #415; see List of Suppliers). Testing has shown that this tape has good aging properties. This tape cannot be used on the artwork itself, but it is good for double matting. No other pressure-sensitive tapes should be used. (See Box 16.4.)

Since you cannot tape the boards together and then cut the window out with any assurance of accuracy, it will be necessary to cut the window openings in each board separately. There is opportunity to experiment with various configurations: both bevels aligned so that it appears there is only one; separated bevels; or a regular bevel on one mat and a 90° cut on the other. Those who do not have a great deal of experience cutting mats or those who are using a hand-held mat cutter will find that trying to make two cuts appear as one is extremely difficult.

BOX 16.3. HOW TO MAKE A DOUBLE MAT WITH PVA EMULSION GLUE

MATERIALS

- All the mat-cutting tools from Box 16.2.
- 3 pieces of musuem board.
- PVA emulsion glue.
- Piece of paper.
- Sheet of hardboard.
- Weights.
- Material for hinges, as in Box 16.2.

1. Cut the three pieces of museum board exactly the same size. One will be the backboard, and two will be glued together to form the double-thick window mat.
2. Brush PVA emulsion glue on the face of one of the window boards. Be sure the coating of glue is thin and even, and that it covers the board to its edges. Position the second window board on top of the

glue-covered board, being absolutely sure that the edges align perfectly. Use gentle pressure all over the surface of the boards to make sure they have adhered to each other. Clean up the edges to catch any drops of glue that have squeezed out. Cover the boards with a clean sheet of paper and then a piece of hardboard, and weight them down until the glue has dried thoroughly.

3. Proceed with the window cutting as in Box 16.2. Be sure that the blades being used in the mat cutter are very sharp, and that they are stiff enough to prevent them from wandering off the guidelines.
4. Assemble the window mat and backboard as in Box 16.2 and hang the work with T-hinges or V-hinges, as required.

BOX 16.4. HOW TO MAKE A DOUBLE MAT WITH DOUBLE-FACED POLYESTER TAPE

MATERIALS

- All the mat-cutting tools from Box 16.2.
- 3 pieces of museum board.
- Double-faced polyester transparent tape from 3M, product #415. (Do not use any other kind.)

METHOD

1. Cut the mats using sharp blades, align them, and check their appearance. Remove the top mat.

2. On the back of the top mat, place strips of the double-faced tape around the perimeter of the board, about 1.5 mm ($^1/_{16}$ inch) from the edge, and around the inside perimeter of the window, about 1.5 mm ($^1/_{16}$ inch) from the edge.

3. Peel the protective film off the tape, and carefully align the two boards; press on them to be sure they stick together.

4. Assemble the window mat and backboard as in Box 16.2 and hang the work with T-hinges or V-hinges, as required.

BOX 16.5. HOW TO CONSTRUCT A SINK MAT

MATERIALS

- All the mat-cutting tools from Box 16.2.
- 2 pieces of museum board, and additional strips to serve as filler.
- Material for T-hinges, as in Box 16.2.
- PVA emulsion glue or double-faced polyester transparent tape from 3M (product #415).
- Wide linen tape.

METHOD

1. Cut two pieces of museum board to a size appropriate for the proportions of the work.

2. Cut the window opening in one piece. Since works cannot be floated in a sink mat, the window edges should overlap the edges of the work by about 3 mm ($^1/_8$ inch) on each side.

3. Make enough T-hinges to support the work comfortably. Attach the smaller stem tabs to the back of the work, leaving at least half the tabs showing and free of adhesive.

4. Position the work on the backboard, place the window over the work, and adjust the location of the work and the window. Gently weight the work, if necessary, and remove the window and set it aside.

5. Attach the work to the backboard by gluing the crosspiece tabs over the smaller stem tabs to form the T-hinges.

6. Figure out the number of thicknesses of mat board that will be needed to equal the thickness of the work.

7. Cut a strip of mat board that will fit the right side of the backboard, extending flush along the side of the board from top to bottom, and just a hair from the right edge of the work (about 1 mm). Be sure the filler is exactly flush with all edges of the backboard and does not touch the work. Cut as many other strips as are needed to achieve the correct thickness of the filler to the same size as the first strip.

8. Use either PVA emulsion glue or double-faced polyester tape to assemble the strips into a block. Place the block in position and attach it to the backboard. Be careful to check the alignment of the block with all edges of the backboard.

9. Use the methods in Steps 7 and 8 to assemble and attach a filler block for the left side of the mat. The filler block should not touch the work.

10. Assemble the bottom filler in the same manner as the side fillers, and attach it to the backboard below the work and

SINK MATS

A sink mat is an alternative to double matting and is especially useful for mounting works with high impasto or those that are in general thicker than an ordinary sheet of paper. Works done on thin hardboard, canvas board, or museum board can be mounted in sink mats with ease.

A sink mat is constructed of 4- or 6-ply museum board like a standard mat, except that the space around the work is built up to the thickness of the work with filler boards. (See Box 16.5.) The filler boards support the heavy work, which would otherwise put a strain on the hinges used to hold it in the mat. The window board of a sink mat is attached to the built-up filler boards.

SINK MOUNTS

It is occasionally desirable to mount a work of art on a backboard but forgo the use of a window mat, which can disrupt the visual impact of the work. In this arrangement, the work hangs freely from the backboard, which provides a visual border around the work, and the whole is placed in a frame. It is not recommended that an object be mounted this way for storage (unless the work is framed in storage) because

between the two side fillers. It should be flush with the bottom of the backboard and the insides of the two side fillers, and the same distance away from the work as the other fillers.

11. The top filler does not support the work. It is constructed in the same manner as the others, but is narrow enough so that it does not cover the hinges. It should be flush with the insides of the side fillers and the top edge of the backboard.

12. When all the fillers have been put in place, attach the window board to the top of the filler boards along the longest side of the mat. Use wide linen tape.

13. Insert the work and close the mat. If you wish to remove the work from the mat, open it and tilt it until the work slips out.

14. If you want to avoid the possibility of dropping the work, make a lifting tab: Glue a length of rice paper to the inside of the backboard, where it will be hidden by the work; it should be long enough to extend out from underneath the work when the object is put in place. Do not glue the free-hanging end, and use only enough glue on the other end to ensure firm attachment. The tab will be hidden by the window mat, and can be used to lift the work out of the sink (Figure 16.1).

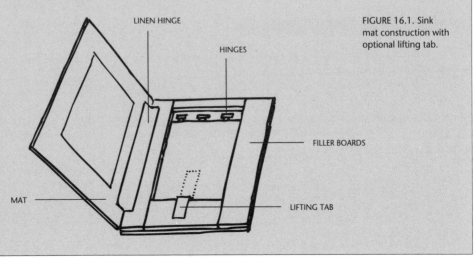

FIGURE 16.1. Sink mat construction with optional lifting tab.

LINEN HINGE

HINGES

FILLER BOARDS

MAT

LIFTING TAB

it is necessary to have protection for the front of the work. A spacer in the rabbet of the frame keeps the work from coming into contact with the glazing material.

Without the added rigidity of the window mat, the backboard is likely to buckle in the frame. Six- or 8-ply museum board should be used. In addition to the 8-ply mount, insert a piece of hardboard 3 mm ($^1/8$ inch) thick, cut to size behind the backboard.

In the frame, the backboard of the work should be isolated from the hardboard by a barrier paper. Acid-free glassine with an added alkaline buffer will work, or use two-ply buffered mat board.

1. Determine the position of the artwork on the backboard.
2. Use V-hinges for hanging the work.
3. Assemble the frame.
4. Insert the glazing into the frame rabbet.
5. A product called Frame-Space, made of a clear plastic, which can slip onto the edges of the glazing and simultaneously act as a spacer to keep the work from touching the glazing, can be used (see List of Suppliers). Or attach spacers made of thin strips of museum board the same color as the backboard, or of wood to match the frame, to the inside of the rabbet. They should provide from 3 to 12 mm ($^1/8$ to $^1/2$ inch) of space between the glazing and the surface of the free-hanging work, depending on the depth of the frame. (See the following section on framing for details and illustrations.)

FRAMING

A frame provides additional protection for works of art, and it can also be considered a visual "stop" for the edges of the image. It is especially necessary to frame works that will be handled a great deal, or those that will be moved to exhibitions. The more substantial the frame, the more protection it will give the work.

STRIP FRAMES

A strip frame is often used for temporary exhibition purposes or in storage situations. This construction consists of little more than thin strips of wood tacked around the perimeter of the painting with small brads. Sometimes the wood is left plain, sometimes it is varnished or painted, and sometimes it is stained and has a decorative beading at the front edge.

Lightweight strip framing can be attractive if done well, but it has several disadvantages. If the painting is the least bit out of square, strip framing will often emphasize rather than hide the problem. The method of attaching the strips to the frame, by hammering brads into the stretchers or strainer, can damage the painting or the chassis. Because there is little room at the back edge of the strips for hanging apparatus, screw eyes or strap hangers must be attached to the chassis; this arrangement can put undue strain on the painting. Finally, the strips do not offer any protection for the front edge of the painting.

BOX FRAMES

The box frame is the preferred and standard method of framing paintings and matted works on paper. It consists of a rigid framework of wood or metal constructed with corners mitered at a 45° angle. The inside of the frame has a rabbet, usually about 6 mm ($^1/4$ inch) deep, to hold the work. A frame is constructed to provide an independent structure in which the picture can be protectively suspended.

A table saw, for making the rabbet in the frame stock, and a miter box, for cutting the 45° mitered corners, are the major pieces of equipment you need to make frames. If you do not have a table saw, it is often possible to convince a local mill or lumberyard to rabbet the frame stock to the required dimensions. Hardwoods like maple or oak are recommended because of their strength, although semihard woods like poplar are easier to work with. It is easier and more convenient, but also more expensive, to purchase ready-made frame stock.

Few frame shops will sell their stock at retail, but several distributors of stock have established thriving and reliable mail-order businesses (see List of Suppliers). These concerns will supply a wide variety of styles, in different woods and metals (mostly aluminum), and even chop

the frames—that is, cut the components to the correct size for the work in question, with mitered corners. You then need only assemble and finish the frames.

CHOOSING AN APPROPRIATE FRAME PROFILE AND GLAZING

Select a frame profile that complements your work. Take into consideration the style of the art: An ornate, carved, and gilded frame might be acceptable when placed around a nineteenth-century painting but might look silly with a contemporary work. There are hundreds of frame profiles to choose from.

Whether the artwork is matted or on stretched fabric or a panel, the procedure for cutting the frame is identical except for the amount of space to be added (see Step 1 in Box 16.6). Instructions for the two types of assembly of the frame follow the directions for cutting.

For works that are framed behind glass, use single-weight window glass. Glass does not provide much protection from ultraviolet light, however.

Acrylic sheets from Rohm and Haas (Plexiglas UF-3 and UF-4) shield works from up to 95 percent of UV radiation, at the slight cost of some illumination. These sheets can also have a slight yellow cast.

Plastic glazing is lighter in weight than glass, and much less liable to break—particular advantages if the work is to be shipped. But plastics are easily scratched, and can develop strong static electrical charges—so strong that pastel and charcoal can be drawn right off the surface of the work. Plastics can be treated and cleaned with antistatic solutions to relieve the electrical charge, but very delicate works should be put behind regular glass.

Partial filtering of ultraviolet can be obtained from styrene plastic glazing such as KSH-UVF from Westfall Framing (see List of Suppliers), but this product is recommended only for temporary use.

Nonglare glass is not recommended because, for it to work, it must be pressed against the surface of the work. A product called Denglas is clear and need not be placed directly against the surface of the work. It is expensive, but also provides some ultraviolet filtering (see List of Suppliers).

LABELING THE WORK

Pictures should have a descriptive label attached to the back of the dust cover or frame, never directly to the work itself. The label should provide complete identification of the artist and the work. The label is a record of the picture and can be a help to those who might, in the future, have to clean or repair it. The label should have the following minimal information about the work:

- The artist's name. Some artists provide address and telephone number.
- The title, date, and dimensions of the work (height preceding width).
- A complete listing of the materials used in the work, including brand names. The type of support, ground, paint(s) and other ingredients in the paint layers, and the kind of varnish or surface coating, should be given.

STORING ARTWORKS

Clean and controlled storage conditions make it possible to keep work in good shape for immediate exhibition or sale. Museum facilities are beyond the capacity of most artists, and except for rare, valuable, or exceedingly delicate objects, they are not really necessary. A spacious closet, or the corner of a studio set aside exclusively for storage, can be made into a suitable area if certain basic requirements are met.

CLEANLINESS

It is essential that your storage space be clean, and kept that way. Dust and dirt in the air can settle on the surfaces of artwork and eventually cause damage. Flies, moths, and other insects can also damage works. If the storage is in an open area such as the corner of a studio, cover the objects. Maintain a regular program of vacuuming—better than sweeping—and dusting.

BOX 16.6. HOW TO CONSTRUCT A FRAME

MATERIALS

- Artwork to be framed.
- Frame stock.
- Table saw.
- Miter box and backsaw.
- Two corner clamps, used for holding the assembled joints until the glue has set.
- Carpenter's square, for checking corners.
- Fine sandpaper or garnet paper.
- Strap clamp.
- Small drill. When you are working with hardwoods, it is necessary to drill pilot holes for the nails. Soft or semihard woods can be nailed without drilling the pilot holes. A thin, sharp awl will work here; a small brad, the diameter of the ones being used for the frame, chucked into an inexpensive hand-operated drill, will also work.
- Nail set. This is for setting the brads below the level of the wood. If you use very small finishing nails, another nail will work as a nail set.
- Tack hammer.
- Selection of small brads and finishing nails.
- Screwdriver.
- Accurate tape measure.
- Brad pusher with brads. This device consists of a sliding sleeve enclosing a magnet. A brad is held in the sleeve by the magnet, and the tool is used for pushing brads into the frame.
- Strong wood glue. The yellow aliphatic carpenter's wood glues are far superior in this application to the white PVA emulsion glues.
- Brass or steel mending plates, drilled to accept screws. These are sometimes called Z plates, for their shape, and can be fabricated or purchased. They are used to hold unmatted works in the frame. A proprietary product called All-Flex (see List of Suppliers) can be used for this.
- Putty for filling nail holes. Putty, or spackle, can be painted to match the color of the frame, or you can buy putties to match different colors of wood.
- Shellac. The white residue left from making shellac fixative is good for sealing the insides of the frames.
- Cork cushions. Cut a wine-bottle cork in half lengthwise, then make 3 mm (1/8 inch) slices of the halves so that small disks are left. These are used between the painting and the inside of the rabbet, for works that are not matted.
- Brown paper, to be used as a dust barrier on the rear of framed, matted works. It is not archival—not used in museums—but does not come into contact with the matted work. If you are concerned about this, use an archival glassine or tissue as a dust barrier.
- Sponge or water sprayer, and water.
- Sharp razor blade.
- Picture wire of a gauge appropriate to the weight of the work. Braided steel picture wire is good but can embrittle with age. Heavy-gauge copper wire is better—it is more malleable—but also more expensive. Fishing line is *not* recommended.
- Screw eyes or strap hangers. Screw eyes can put a strain on the frame and split the wood. Hangers are small metal plates with one or two screw holes and a freely moving metal loop. They are more secure hanging devices that do not put too great a strain on the frame members.
- Thin, sharp awl.
- Narrow strips of wood, mat board, or some other suitable material to serve as spacers between the glazing and the frame (only if the artwork is to be floated without a window mat).
- Archival-quality stiffening backboard.
- Glazing and its appropriate cleaner.

METHOD FOR CUTTING THE FRAME

1. Measure the work. If the work is on stretched fabric or a panel, add 6 mm (1/4 inch) to each dimension to allow a 3 mm (1/8 inch) space between the inside rail of the frame and the outside edge of the work. If the work is matted, add

3 mm ($^1/_8$ inch) to each dimension. These spaces will allow the work to move within, and independently of, the frame. If, for example, a painting on linen measured 41×51 cm (16 by 20 inches), the inside dimensions of the frame would then be 41.6×51.6 cm ($16 ^1/_4$ by $20 ^1/_4$ inches).

2. Measure and cut the frame stock. Measure accurately and mark all cutting lines to be sure of getting a precise 45° angle; be sure to measure from the inside of the rabbet, not the outside of the frame. Check the miter box for accuracy, and make sure your backsaw is very sharp. The cuts should be clean and smooth. Any slightly ragged edges can be smoothed with fine sandpaper or garnet paper.

3. Use the corner clamps to assemble two adjacent sides of the frame, and check the joint for accuracy. Separate the joint slightly and coat the end of one rail with glue. Reassemble the joint and close the clamp tightly. Wipe away any glue that oozes out of the joint. Allow the glue to set. Check one corner, or all four, by laying out the frame members and using the carpenter's square. Then, use a strap clamp—or a homemade version of one—to assemble and glue the entire frame at once.

4. If necessary, drill pilot holes for the finishing nails. Make the holes slightly smaller than the diameter of the nails. At least two nails should be used in each joint, though a large or heavy frame will require as many as four or five. Insert the nails at a slight angle to the sides of the frame to draw the joint tight. Countersink the nails and set the assembly aside to dry.

5. Assemble the other two sides of the frame, using Steps 3 and 4, unless the strap clamp has been used. When both corners are dry, assemble the complete frame in the same manner. Lay the frame flat in a safe place until all the glued joints are completely dry.

6. Inspect the frame corners for open joints, cracks, or splits. Fill the nail holes with putty, as well as any small openings or cracks.

7. Unfinished stock should be sanded smooth, using a sanding block to ensure that all corners and edges will remain sharp and square. An electric orbital sander is good for this, but use a piece of museum board beneath the sandpaper to keep the sandpaper from rounding off edges and corners. The outside of the frame can be painted, or given a coat of polyurethane varnish, or rubbed with linseed oil and then waxed, or just waxed. If you use wax, use a good-quality paste wax. Shellac or varnish the rabbet, but do not paint or wax it.

METHOD FOR ASSEMBLING THE FRAME: MATTED WORKS

1. Lay the completed frame face down on a clean surface.

2. Clean the glazing. Acrylic or styrene glazing should be cleaned with a plastic cleaner and a soft, lint-free cotton cloth to avoid scratching the surface. Glass can be cleaned with a glass cleaner. Newspapers make excellent lint-free glass cleaners (but do not them use on plastic glazing). Cheaper than a commercial glass cleaner is a very mild solution of ammonia and water. Mix 1 part household ammonia with 20 parts water and use it in a sprayer.
☞ *CAUTION: Ammonia can be a health hazard. Do not breathe the vapors, and label the sprayer carefully.*

3. Lay the glazing in the frame. If the work is to be floated without a window mat, now is the time to insert the spacers. Very thin wooden strips, at least 6 mm ($^1/_4$ inch) thick and as wide as the rabbet—generally 6 mm ($^1/_4$ inch)—may be tacked to the inside of the rabbet with small brads. They may be finished the same as the frame, in order to be as inconspicuous as possible.

BOX 16.6. HOW TO CONSTRUCT A FRAME, CONT'D.

The spacer will keep the work from touching the inside of the glazing. Thick museum board, the same color as the backboard, can also be used; nail it in place. The spacers should be removable—they should not be glued in place (Figure 16.2). Framespace, made by Frame-Tek, can also be used as a spacer between the backboard and the glazing (see List of Suppliers).

4. Put the work in the frame. If the work is floated, stand the frame upright to keep the free-hanging edge of the work from swinging out and touching the glass. It may be necessary to do this anyway, if the surface of the work is too dusty and fragile.

5. Insert a stiffening backboard behind the matted work. The backboard should be the same size as the mat backboard, and made of archival materials: another piece of museum board; archival foam-core board; archival corrugated cardboard (see List of Suppliers)—but never ordinary corrugated cardboard! You could also use a sandwich of tempered hardboard 3 mm (1/8 inch) thick, faced with an archival barrier paper (Figure 16.3).

6. If the work is not floated, but is in a regular mat, use the brad pusher to insert the brads into the rabbet to hold the work into the frame. Gently press down on the back of the work with one hand and guide the brads in at a slight downward angle. Space the brads every 5 cm (2 inches) around the edge of the work, with extra brads close to each corner.

7. Cover the back of the frame to keep out dust; the covering will also slow the picture's reaction to atmospheric stresses.

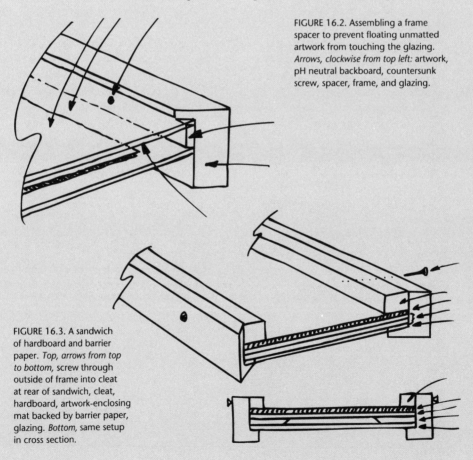

FIGURE 16.2. Assembling a frame spacer to prevent floating unmatted artwork from touching the glazing. *Arrows, clockwise from top left:* artwork, pH neutral backboard, countersunk screw, spacer, frame, and glazing.

FIGURE 16.3. A sandwich of hardboard and barrier paper. *Top, arrows from top to bottom,* screw through outside of frame into cleat at rear of sandwich, cleat, hardboard, artwork-enclosing mat backed by barrier paper, glazing. *Bottom,* same setup in cross section.

Cut a sheet of brown wrapping paper larger than the back of the frame. Wet the paper with a damp sponge or a light spray of water. Lay a thin bead of glue around the back edge of the frame. Place the paper over the frame and stretch it tight. When the glue dries, trim the excess paper off with a sharp razor blade to make a neat edge; as the paper dries, it will stretch tight.

8. Attach the hanging hardware to the frame. As a rule of thumb, the screw eyes or strap hangers can be placed at a point about one-third the distance from the top to the bottom of the frame. This will allow the frame to hang away from the wall at a slight angle.

9. Attach the hanging wire. Stretch the wire taut between the two hanging points—it will stretch a little more when the work is hung, so it is important that it be tight as possible. (This is when screw eyes reveal themselves to be inferior to strap hangers: When the wire is stretched, screw eyes can split the frame.) Use a lock twist on the wire to keep it from slipping off the hangers (Figure 16.4).

METHOD FOR ASSEMBLING THE FRAME: WORKS ON STRETCHED FABRIC AND PANELS

1. Lay the frame down on a clean surface.
2. Attach a dust cover to the back of the picture if it is a stretched fabric on a chassis. The cover should be made of stiff cardboard or foam-core board—it will prevent dirt and dust from settling in the rear of the picture between the chassis and the back of the fabric, and it will also prevent mechanical damage to the rear of the work. Cut the cover about 1.25 cm ($^1/_2$ inch) smaller than the dimensions of the work, and attach it to the back of the chassis with flathead screws and countersunk washers. Fome-Cor board (from Monsanto) is available in 3, 4.5, and 9 mm ($^1/_8$, $^3/_{16}$, and $^3/_8$ inch) thicknesses.

3. Place the work in the frame. Notice the space between the inside of the rabbet and the edge of the picture. The little half-disks of cork are ideal for filling this space because they absorb shocks. Using the blade of the screwdriver, jam the disks into the space between the frame and the picture at even intervals.

4. Attach the mending plates to the back of the frame, using flathead or panhead wood screws. The plates should be bent down in the Z shape so that they exert pressure on the back of the work to hold it in the frame. There should be no need to use screws to hold the plates to the back of the work—the pressure of the plates against the chassis should be sufficient— but there is no harm done if screws must be used, as long as you take care with their installation. Use at least two plates on each side of the frame.

5. Attach the hanging hardware and wire to the back of the frame.

FIGURE 16.4. The Gordian lock twist for the hanging wire. *Top arrow,* the lock twist. *Bottom arrow,* pull the wire taut before lock-twisting the other end.

LIGHT

Many works are sensitive to continued exposure to light, which can cause fading, cause chroma or color changes in pigments, or otherwise degrade the picture and its support. The storage area, therefore, should have minimal lighting, preferably low-wattage incandescent lights or dim north daylight.

Oil paintings, as usual, are the exception. Linseed oil has a tendency to yellow as it ages, and yellowing seems to be accelerated when the paintings are kept in the dark. Oil paintings should therefore be exposed to a minimum amount of diffuse natural light. The yellowing caused by the dark is reversible: Just expose the picture to some sunlight or other natural daylight for a few days.

Works that are on exhibit need to be given a rest once in a while. Sensitive paintings should not be continuously exhibited but rotated, on a regular basis, with those in storage.

HEAT AND HUMIDITY

It is not so much high or low heat or humidity that causes damage to works of art; it is the constant changes in these two atmospheric qualities—which act always in concert—that cause the damage. Rapid change in relative humidity and temperature can cause a support or paint layer to crack, especially if the work is aging and brittle. Even relatively slow changes in atmospheric conditions, because they occur on a cyclical schedule, can stress an object.

Museums strive to keep both exhibition and storage spaces at a stable temperature and relative humidity. The optimum values can vary, according to the type of object, but the normal range for temperature is 18° to 21° C (65° to 70° F) and for relative humidity, 55 to 70 percent moisture.

Without completely separate storage facilities, insulated, heated, humidified or dehumidified, and monitored, you cannot hope to meet these ideal conditions. But you can choose a more or less stable environment—say, an interior closet away from radiators and forced-air heating registers—and provide at least a good environment for the work.

Temperature can be monitored with a simple thermometer, and relative humidity can be kept track of with humidity indicator strips from Multiform Desiccants (see List of Suppliers).

STORING PAINTINGS

Paintings on fabric or panels should be stored off the floor in racks, standing vertically on one edge. In an ideal situation each painting has a separate compartment, so that paintings of different sizes can be stored without damaging one another. Practically speaking, this arrangement is often impossibly expensive or inconvenient. Place a large stiff piece of corrugated cardboard between each pair of paintings. The idea is to keep each painting physically separated from the others.

Paintings on fabrics that have been removed from their chassis can be stored by thumbtacking them at the upper edges to large pieces of corrugated cardboard. The paintings are easily handled in this manner, and can be stood in the racks with the rest of the work.

To protect the surfaces of the paintings in the racks, attach a dust cover. Cut a piece of brown wrapping paper large enough to cover the work, and thumbtack it to the back of the chassis. Fold it over the top edge of the chassis and allow it to hang freely in front of the work.

Paintings on fabric should never, as a general rule, be rolled, either for storing or for shipping. Whether the paintings are rolled face-in or face-out, this practice places great stress on painted films, no matter how thin or flexible the films may appear. Gigantic paintings that must be shipped, however, can be rolled, as long as they are not kept rolled up for too long a period of time. Build a cylinder of the largest diameter possible, preferably out of wood. Roll the painting face-out onto the cylinder, after first covering the face with archival glassine to protect it from scratches. Pack the painting carefully, ship and unpack it promptly, and unroll it as soon as possible after its arrival.

STORING WORKS ON PAPER

Art on paper supports is usually fragile or susceptible to mechanical damage, and so should be carefully stored. Matting all paper works will certainly provide a measure of safety, and a slip sheet of archival glassine placed between the window opening and the surface of the work will keep dust and dirt from touching the surface. As a further precaution, a covering flap cut from museum board can be hinged to the mat and folded over the front of the window.

The matted works should be stored flat, in a portfolio. Arrange the pictures in the portfolio so that they cannot damage one another, and limit the number of works in one stack. Hinged portfolios can place a strain on a large stack of matted objects by squeezing them along the edge of the portfolio's hinge. Better and safer, though more expensive, are specially made print and drawing storage boxes constructed of archival buffered board. When these close, they do not exert any pressure on the objects inside. The boxes can be homemade using linen tape and 8-ply museum board; line the box with glassine or Mylar to act as a moisture barrier. Commercial varieties come in an array of standard sizes (see List of Suppliers), and some come with clasps and carrying handles so that they can double as portfolios as well as storage containers.

Large shallow-drawered print storage cabinets can be used to store drawings or other works on paper that have not been matted. Do not overfill the drawers, and be sure to place a slip sheet between each work and the next.

Works on paper should never be rolled, either for shipping or storage, unless they are gigantic. In that case, use the method suggested for rolling huge paintings.

PHOTOGRAPHING PICTURES

Having a record of your work is important, and keeping a file of color slides or prints or black and white prints is a valuable aid in documentation. For insurance purposes, proving the condition of a picture prior to its damage is essential. When you are making initial contacts with clients, agents, dealers, galleries, or employers, having a high-quality photographic portfolio can be an advantage; final judgments about your work will usually be made from the actual object, but first impressions more often come from viewing a photographic portfolio.

If you have a basic understanding of the operation of a 35mm single-lens reflex camera and a light meter, making prints or slides of your work is not difficult. Because it is not a difficult process, artists can overlook details; this may be one reason why some artists seem to be satisfied with less than acceptable reproductions of their work. Once you see that a photograph of a painting, while not a perfect replica of the color, can be better than you thought, you may begin to pay more attention to how that good photograph was made. Many artists needlessly hire professional photographers to do work they can learn to do as well, at much less cost. You should keep in mind that the photography of works of art is a mechanical process not dependent on an outside aesthetic. The art provides the aesthetic, and the photograph must merely reproduce it as perfectly as possible. There is an art to creative photography too, but don't let "art" get in the way of good, efficient record keeping.

EQUIPMENT

The following selection of equipment is the minimum needed for the job.

The camera should be, as noted, a 35mm single-lens reflex, with adjustable aperture and shutter speed. In most cases a normal 50mm focal-length lens is all that you need, although a telephoto lens or a 2x magnifying extension that fits between the lens and camera body is useful for making detailed closeups of a portion of a picture.

Other camera sizes can be used if you want better, less grainy resolution of the image: 5 × 7, 8 × 10, or 11 × 14 formats are possible. These cameras, and the film, can be very expensive. The 35mm format is most

commonly used because few people expect to see perfect resolution, and they would rather make the final judgment based on the actual work anyway. For the highest-quality color and sharpness (if you were publishing a catalog of your work, for instance) a large-format camera is recommended.

A cable release screws into the shutter release button, allowing you to make a shot without touching the camera body. On long exposures, a cable release is useful in preventing any movement of the camera from spoiling the picture.

A professional tripod with adjustable legs and center post prevents movement of the camera during long exposures. Tripod light stands are adjustable in height; attached bowl reflectors accept photoflood or tungsten photography lamps. Although it is possible to make good pictures using daylight, the amount and quality (color rendering) of the light can be extremely variable. For more consistent results, you can develop an operating scheme, using artificial light, that can become almost automatic after a while.

Tungsten and photoflood lamps both put out a constant light in a predetermined strength and color rendering quality, although the strength deteriorates with time and the light output diminishes.

The tungsten lamps should be rated at 3200° K and the photoflood lamps at 3400° K, abbreviated 3200 K and 3400 K. The figures refer to the color temperature of the light in degrees Kelvin (an absolute measure of temperature). Since these lamps are not very costly, it is advisable to have fresh lamps on hand; after about five hours of use, their output will diminish noticeably. Use the worn-out lamps as auxiliary lighting in your painting studio.

Many 35mm cameras today have through-the-lens metering systems, which can be useful though not very accurate. For more precise results, a simple hand-held light meter is recommended.

Color filters are used to balance the color of the film to match the light being used to illuminate the picture. The filters are not expensive and are easily screwed onto the front of most lenses; some lenses may require a special mounting ring. Consult Table 16.2 to see which filters might be necessary. In any case, conditions can be arranged so that color filters are unnecessary.

Pictures that have highly reflective surfaces can be difficult to light and photograph without picking up specular reflection (appearing as glaring whitish areas on the picture). Polarizing filters, which screw to the front of a lens, can eliminate most of the glare. They do not alter the color of the reproduction, but they do lower the amount of light reaching the film, making longer exposures necessary.

Finally, you will need a carpenter's level and an accurate tape measure.

FILMS

The selection of films shown in Table 16.2 (page 289) can be used to make color slides or color prints, or black and white prints, with a 35mm camera. Note the film speed, shown by the ISO number (International Standards Organization)—the lower the number, the more light required, or the longer the exposure required, to make a good photograph. Also note the filters that may be required, depending on the light source. A complete listing of films for 35mm cameras and other camera sizes can be found in the Eastman Kodak publication *Kodak Color Dataguide,* available in most camera stores.

Always check the data sheet supplied as a package insert with each film, since the ISO speed can be different from the assumed speed, depending on the factory batch. The data sheet will give the corrected speed for that roll of film.

Color films should be stored under refrigeration, although most films are not that sensitive to heat. Refrigeration will extend the life of the film. Put the film in a plastic bag and store in a refrigerator to be sure of its stability. Then allow the film to come to room temperature before using it—remove it from the refrigerator about two hours prior to use.

COLOR CONTROL

Also in the *Kodak Color Dataguide* are two pages of interest to artists who want to control the color rendering of their prints. Color slides can be processed only to the level of quality at which they were photographed—the photo lab cannot adjust for photographer error—but prints can be adjusted if the Gray Scale and Color Control Patch standards are used. The Gray Scale is the guide for value adjustment, and the Color Control Patches are used for color.

For the first exposure of each roll of film, take a photograph of a picture with the *Dataguide*'s Gray Card, Gray Scale, and Color Control Patches placed beside it, in the same lighting used on the picture. These control standards can then be used by the printer to adjust the color balance of the prints made from that roll, ensuring better color rendition and thus better color reproduction.

PRINTING

All Kodak color films can be processed by Kodak or by local laboratories. Other films can be processed by local labs. If you have a working relationship with a local printer, it is possible to get better prints than you can get from a mass processor like Kodak. Remember, though, that with slides, what is photographed is what is printed: No adjustments or improvements can be made.

Be patient with the printer. Only you really know how the prints should look in comparison to the actual work. It probably will be necessary to go back to the laboratory the first few times until the desired quality is achieved. Usually the Color Control Patches and Gray Scales will help a great deal.

MAKING THE REPRODUCTION

Assuming that you will make the photographs inside under artificial light, the most convenient arrangement is to set aside a corner of your studio for photography. You can block off the windows with shades to prevent daylight from spoiling the color balance of the film, or you can photograph the works at night.

Not all pictures fit the 35mm format perfectly. There is always some background showing around the edges of the slide or print image, a condition that can be distracting to someone looking at the reproduction. Masking the image, by cropping the print or by using an opaque silver or black slide-masking tape, can be tedious and time-consuming.

Instead, make the background behind the subject as plain and nonreflective as possible. The best solution can be chosen from these alternatives:

- Paint the wall against which the works are to be photographed with a flat black latex housepaint.
- Buy a large roll of flat black photographic paper. The paper comes in widths up to about 3.6 m (12 feet) and can cover large areas of the background.
- Use a large piece of black velvet to cover the wall behind the picture. Black velvet will absorb nearly all light striking it, and is the least reflective of the background coverings suggested here.

The black background will make masking the slide or cropping the print unnecessary.

Some device should be provided for holding the work perfectly vertical and level while it is being photographed. You can set up an ordinary painting easel to do the job, or remove the vertical member from an adjustable easel and attach it to the wall. Paint the easel with flat black latex paint. It is possible simply to put nails in the wall to hold the work, although getting the work level in this case is sometimes a bother. Be sure to allow plenty of room on either side of the picture-holding area for a variety of lighting arrangements.

Every artist develops a method of photographing artwork, and there are so many variables in possible conditions (lighting, film type, and so on) that there can be no single perfect method. Nevertheless, it is helpful to consider a representative case: making a color slide of a painting, in an indoor studio, using artificial light. (See Box 16.7.) No filter is required.

BOX 16.7. HOW TO PHOTOGRAPH A PAINTING

MATERIALS

- Painting to be photographed.
- 35mm camera with Kodak's Ektachrome 64T (tungsten) film, ISO speed 64.
- Carpenter's level.
- Light meter.
- Tripod.
- Easel, painted with flat black latex paint.
- Two 3200 K lamps on stands.
- Kodak Gray Card.

METHOD

1. Set the painting up on the easel. If the work is framed behind glass, remove it from the frame; photographs made through glass may show specular reflections from the glass, or reflections of the camera and photographer. Use the carpenter's level to make sure the picture is perfectly level and exactly vertical. For proper illumination of the object, it is necessary to get an even wash of light across its surface. Since the lighting will be from either side of the work, place it on the easel so that its narrowest dimension is vertical.

2. Attach the camera to the tripod and adjust it to a vertical position to conform to the arrangement of the picture. Place the tripod and camera on a line with the exact center of the picture, far enough away from it so that the image fills the viewfinder of the camera comfortably. The plane of the back of the camera must be parallel to the plane of the picture to avoid distortion at the edges of the reproduction known as *parallax* (when straight vertical or horizontal lines appear to curve). Adjust the height of the camera so that the lens points directly at the center of the picture. You can do this visually, but to be more accurate, and to avoid parallax, make this quick calculation: Divide the height of the picture by 2. Add the distance measured from the bottom of the picture to the floor. This total will give the required height of the center of the camera lens.

3. Position the light stands to either side of the painting, one on each side and each about the same distance away from it. They should be placed so that they are at an angle of 45° to the line running from the center of the picture to the camera, and their height should be the same as that of the camera.

4. Turn on the lights and check to see that the picture is evenly lit. Use the light meter to take a number of readings of the light reflected off the picture at various points on its surface. Adjust the distance of the lights from the picture accordingly, to get an evenly lit picture.

5. Use the meter to figure the f-stop setting for the camera. Set the meter at ISO 64 (the speed of the film) and take readings at several points on the picture's surface. Since most pictures have both dark and light areas, and therefore are not equally reflective at all points across their surfaces, average the readings. It will be helpful to take a reading in the same light from the Kodak Gray Card, held close to the picture's surface. In both cases, hold the meter not more than 15 cm (6 inches) from the surface of the card or picture, and do not allow any cast shadows to interfere with the reading. Choose the setting indicated by the meter that allows the f-stop to be set as small as possible with the shutter speed set $1/10$th of a second or faster. A very small aperture will allow you to record very fine details, but too slow a shutter speed may throw off the color balance of the film.

6. Check the camera to be sure the ISO setting matches that of the film. Adjust the f-stop and shutter speed according to the meter reading. Focus carefully and shoot.

Photographers commonly bracket exposures by taking two more shots with the aperture set a half-stop higher and a half-stop lower than the original setting. Some photographers suggest two additional exposures a full stop higher and lower than the original, for a total of 5 exposures. Bracketing will ensure at least one acceptable reproduction of the picture, and possibly a few.

If taking so many shots of each picture seems like an awful expenditure of film—you can get only 7 theoretically perfect slides from a 36-exposure roll—consider this: It is more trouble to set up the studio to reshoot a set of slides because an entire roll was either underexposed or overexposed. Furthermore, when shooting in this manner, you get 5 slides of each picture, and it is always helpful to have an extra set. Shooting slides or prints from the original picture is often preferable to having copies made from the slide. (Copies from a color negative are usually acceptable—that is, after all, how the original print was made—but having duplicate negatives is also desirable.)

LABELING SLIDES AND PRINTS

When the slides have been returned from the processor, label them immediately. The information on the label should include the artist's name, the title and date of the work, the dimensions of the work (height preceding width), the medium or technique, an indication of the top of the work (so the viewer can orient the slide correctly in a projector), and a notice of copyright, if desired. The same information should be put on a label and then stuck on the back of each print. Do not write on the back of the actual print because the writing may be visible from the front.

STORING SLIDES AND PRINTS

Light will fade most color photographic reproductions. Store prints and slides in the dark. Mylar polyester slide sheets with small pockets for individual slides, with three-holed margins for insertion into three-ring binders,

are good, and the slides can be looked at without being handled. Polyester envelopes for prints are also available, with the three-hole margins.

The three-ring binders can be kept in a box with other records about the work, to keep them from getting dusty. All this is just a matter of organization. Once a system is established, none of it is difficult or time-consuming.

TRANSPORTING ARTWORKS

The more a work of art is handled, the more likely it is to be damaged. Transporting a work can be significantly hazardous unless the work is properly protected.

ASSEMBLING A CRATE

Crates must be custom-built to accommodate the individual pictures properly, but the carpentry involved is no more complicated than that used to make strainers or bracing for panels. (See Box 16.8.)

A crate is essentially a suspension system in which the picture floats, so it must be made slightly larger in every dimension than the work it is to hold, in order to make room for the added packing materials. As a rule, add 10 cm (4 inches) to length, 10 cm (4 inches) to width, and 10 to 13 cm (4 to 5 inches) to the depth of the work, to arrive at the interior dimensions of the crate. Thus a painting 40 × 50 × 5 cm (16 by 20 by 2 inches) thick will require a crate with interior measurements of 50 × 60 × 15 cm (20 by 24 by 6 inches). Remember to take into account the thickness of the wood when calculating the dimensions of the lumber for purchase.

PACKING THE CRATE

Before packing the picture, check to see that it is snug in the frame, and that there are no loose wires, hanging apparatus, or other dangling parts that could damage the work. The wire should be removed or taped down. Cover glass—but not acrylic or styrene—with closely spaced strips of masking tape to hold it in case it breaks.

BOX 16.8. HOW TO CONSTRUCT A CRATE

MATERIALS

- Handsaw.
- Hammer.
- Slotted screwdriver.
- Flathead wood screws and washers.
- Carpenter's square.
- Staple gun.
- Electric drill with bits. The drill bits should have the same diameter as the shaft of the flathead wood screws used to fasten the top of the crate.
- Plywood 1.25 to 1.89 cm ($^1/_2$ to $^3/_4$ inch) thick. Plywood forms the flat sides of the crate. Thinner plywood can be used for small crates, but thicker plywood should be used for large crates.
- White pine, yellow pine, or fir boards. The boards are nominally 2.5 cm (1 inch) thick, but usually measure about 1.89 cm ($^3/_4$ inch) thick. They come in various widths—5, 7.5, 10, or 15 cm (2, 3, 4, 6 inches)—and since they are used to build the collar of the crate, choose the width equal to the correct depth for the crate. Also obtain some lengths of 2.5 × 5 cm (1 × 3 inch) boards to use for bracing the flat sides of the crate, and for battens inside the crate.
- Strong carpenter's wood glue.
- Masking tape.
- Selection of flathead wood screws and countersink washers.
- Selection of flathead nails. Longer nails can be used to assemble the collar of the crate. Shorter nails are used to attach the bracing to the plywood sides, and the plywood to the bottom of the crate.
- Cushioning materials. These are used to float the work in the crate, and should be light, strong, and bulky but compressible. The choices include Bubble-pak (cells of air sealed in plastic, available in rolls, forming a strong and lightweight cushioning), Kimpak (multilayered paper packing that is strong and soft), and foam lining used as cushioning under wall-to-wall carpeting (an open-cell foam, thin and soft, and relatively inexpensive).
- Brown wrapping paper.
- Waterproofing materials, for making the interior of the crate water-resistant. Some writers advise against the use of plastic, since it can trap moisture and cause condensation inside the crate, but plastic is acceptable if the wrapping is not airtight. Thin plastic sheets can be obtained in rolls. A water-resistant paper for lining crates is available from Glas-Kraft or a local paper distributor (see List of Suppliers). It is a laminate of paper and a water-resistant core material.
- Corrugated cardboard (inexpensive) or foam-core boards (expensive).

METHOD

1. Cut the wood for the collar and sides to the proper dimensions.
2. Assemble the collar using nails through butt joints. For very secure joints, use glue.
3. Attach the bottom of the crate to the collar with nails. Glue if desired.
4. Put the top of the crate in place and drill holes for the screws. Attach the top with flathead wood screws and countersunk washers. Mark the top of the crate and the collar at each screw head so that the top of the crate can be realigned properly.
5. If the crate is large enough to require bracing, cut and attach bracing struts with nails—and glue, if desired.
6. Disassemble the crate and carefully check the interior for protruding nails or splinters. Remove them by filing them down or cutting them off.

The outside of the crate should be clearly marked to identify its contents. Use arrows to indicate "Up," for the crate should always be standing on edge to relieve strain on the picture planes inside. Use the words "Works of Art" and "Fragile," and the symbols of a broken wine glass and an umbrella, to show that the contents are fragile and should be kept dry. If the work is to be shipped overseas, use the phrase "Use No Hooks" and the symbol of a hook with an X through it to indicate restrictions on crane use at the port. For more about packing crates, see Box 16.9.

CRATES FOR MORE THAN ONE PICTURE

A crate for more than one picture of the same size can easily be built. Use 1.89 cm (³/4 inch) plywood for the collar, and make the crate any depth necessary. When packing, follow all the steps outlined in Box 16.9 through Step 6. Repeat Steps 2 through 6 for each picture. Then, instead of using battens to hold the work inside the crate, you can cut sheets of Bubble-pak plastic cushioning to fill up the empty space.

BOX 16.9. HOW TO PACK A CRATE

MATERIALS

- Waterproof paper or plastic sheeting.
- Glue, or stapler and staples.
- Corrugated cardboard.
- Masking tape.
- Kimpak paper packing or foam carpet padding or Bubble-pak plastic cushioning.

METHOD

1. Line the inside of the crate with the waterproof paper or the plastic sheeting. Cut two pieces to fit the top and bottom covers and one long strip to fit around the inside of the collar. Use glue or short staples to attach the liner—be sure the staples are completely flush with the inside of the crate.
2. Cut corrugated cardboard to fit the bottom of the crate.
3. Wrap the painting in brown paper to protect it from dust. Use masking tape to hold the paper.
4. Make pads for the corners of the painting. Use either Kimpak paper packing or foam carpet padding cut into long strips and rolled into tubes. Then fold the pads diagonally over the front of the painting at each corner and staple them to the back of the frame.

 An alternative to corner padding, but one that takes up more room in the crate, is to make an envelope for the painting out of the Bubble-pak plastic cushioning. Cut a piece of corrugated cardboard large enough to fit the front of the painting and attach it to the frame sides with masking tape. Next cut a length of Bubble-pak cushioning that will fold over and enclose both sides of the painting. Enclose the work in the Bubble-pak cushioning and tape it in place. However, to prevent condensation, do not make this enclosure airtight.

5. Place the picture face down inside the crate, and adjust its position so that there is an equal amount of space all around the picture between it and the inside of the collar. Fill this space with rolls of Kimpak, Bubble-pak, or foam padding. Stuff all the spaces firmly until the work is snugly padded and cannot move around inside the crate.
6. Cut another piece of corrugated cardboard to fit on top of the picture and place it in the crate.
7. If there is a space left between the cardboard and the inside of the top cover of the crate, prepare two battens to hold the package tightly. The battens should be screwed to the inside of the crate's collar.
8. Attach the cover of the crate.

One crate can hold many pictures of different sizes, although the construction is likely to be more complicated and the resulting box quite heavy. Each picture should have its own individual space within the crate.

SHIPPING

The size and weight of the crate will determine which carrier can handle the shipment. Smaller packages can be shipped by the United States Postal Service (USPS) or a private carrier, United Parcel Service (UPS). Both USPS and UPS have weight and size restrictions and will limit the amount of insurance coverage they will allow on the object. They may also place restrictions on the contents if it is a one-of-a-kind work of art. An advantage of these carriers is that they deliver to the door.

Common carriers—ordinary freight trucking companies—will handle larger crates, but sometimes refuse to carry works of art. Insurance coverage is reasonable, however, and it is possible to convince the carrier that the crate is substantial and will prevent damage to the work. Common carriers will sometimes deliver to the door for an additional charge, but often require the recipient to pick up the shipment at a central distribution point.

Some common carriers specialize in shipping works of art, and provide the special handling occasionally needed by these objects. Workers for these companies have experience packing and handling art objects, and their trucks do not carry any other kinds of freight; some of these carriers will even ship uncrated work in specially padded vehicles. The rates for these shipments can be substantially higher than those charged by ordinary carriers, but the handling of the work is of the highest professional standards.

Whichever service you choose for shipping, be sure to be aware of the following variables: packing or crating requirements, size and weight restrictions, insurance limitations, and delivery arrangements. Always make sure that the recipient of the shipment understands what arrangements have been made for delivery of the work.

TRANSIT STORAGE

Sometimes the work being shipped must be stored for a day or two before delivery can be made. If this is a possibility, it is wise to find out what kind of storage facilities are being used. A warehouse with a controlled environment—at the very least the space should be heated—is preferable to a shed or open loading dock somewhere. Remember that works of art are fragile and can be damaged by rapid changes in atmospheric conditions.

TABLE 16.1. VARNISHES AND COATINGS FOR PICTURES

Key: EX = Excellent; G = Good; F = Fair; P = Poor; NT = Not tested; NR = Not recommended

COMMON NAME	Damar	Mastic	Sandarac
TYPE	Natural resin	Natural resin	Natural resin
APPLICATION			
Oils	x	x	NR
Acrylic solutions			
Acrylic emulsions			
Alkyds	x		
Water-thinned			
Temperas	x		
Encaustics	x		
Pastel (fixative)			
Murals (surface coatings not recommended)			
METHOD OF APPLICATION			
Brush	x	x	
Hand-rub			
Spray	x	x	
CAUTIONS			
Ventilation	x	x	
Goggles	x	x	
Respirator	x (if poor ventilation)	x (if poor ventilation)	
Gloves			
Coveralls	x	x	
REVERSIBILITY	G; over time becomes F	G; over time becomes F	
SOLVENT	Gum turpentine and stronger	Alcohol and stronger	
DURABILITY			
Interior	EX	G	
Exterior	P	P	
Rigid support	EX	EX	
Flexible support	G	F-P	
RESISTANCE TO:			
Water	G	F	
Acid	F	F	
Alkali	F	F	
Pollutants	G	F	
Ultraviolet light	P	P	
Mechanical damage	P	P	
Oxidation	P	P	
POSSIBLE DEFECTS	Bloom, cracking, yellowing, mechanical damage	Bloom, cracking, mechanical damage	
ESTIMATED LIFE	20 years, in ideal conditions	Less than 20 years, in ideal conditions	
OTHER COMMENTS	Not considered a reliable surface coating	Less reliable than damar	Not recommended

TABLE 16.1. VARNISHES AND COATINGS FOR PICTURES, CONT'D.

Key: EX = Excellent; G = Good; F = Fair; P = Poor; NT = Not tested; NR = Not recommended

COMMON NAME	Shellac	Bleached White Beeswax	Acrylic Solution
TYPE	Natural resin	Natural wax	Synthetic resin
APPLICATION			
Oils		x (after the varnish)	x
Acrylic solutions		x (after the varnish)	x
Acrylic emulsions			x
Alkyds		x (after the varnish)	x
Water-thinned		x	x (thinly)
Temperas		x	x (thinly)
Encaustics		x	x (very thinly)
Pastel (fixative)	x (fixative only)		x (weak dilution)
Murals (surface coatings not recommended)			
METHOD OF APPLICATION			
Brush		x (if in paste form)	x
Hand-rub		x (preferred)	
Spray	x (fixative only)	x (thin the paste form)	x
CAUTIONS			
Ventilation	x	x (only if sprayed)	x
Goggles	x	x (only if sprayed)	x
Respirator	x (if poor ventilation)	x (only if sprayed)	x (if sprayed)
Gloves			
Coveralls		x (only if sprayed)	x (if sprayed)
REVERSIBILITY	G	G	G
SOLVENT	Alcohol	Mineral spirits	Mineral spirits
DURABILITY			
Interior	G	EX	EX
Exterior	P	G	F
Rigid support	EX	EX	EX
Flexible support	P	G	G-EX
RESISTANCE TO:			
Water	P	EX	G-EX
Acid	F	F	G
Alkali	F	G	G
Pollutants	F	EX	G
Ultraviolet light	P	EX	F-G
Mechanical damage	P	P	G
Oxidation	P	EX	G-EX
POSSIBLE DEFECTS	Severe yellowing, bloom, darkening	Melts or sags (heat); brittle (cold); easily scratched	May craze
ESTIMATED LIFE	Short life	More than 20 years in ideal conditions	More than 20 years in ideal conditions
OTHER COMMENTS	Use only as a fixative when better synthetics are not available	Excellent surface coating over a varnish	Reliable surface coating if the correct resin is used; most commercial products are reliable

TABLE 16.1. VARNISHES AND COATINGS FOR PICTURES, CONT'D.

Key: EX = Excellent; G = Good; F = Fair; P = Poor; NT = Not tested; NR = Not recommended

COMMON NAME	Vinyl Solution	Ketone Resin
TYPE	Synthetic resin	Synthetic resin
APPLICATION	NR	
Oils		x
Acrylic solutions		x
Acrylic emulsions		x
Alkyds		x
Water-thinned		
Temperas		x
Encaustics		
Pastel (fixative)		
Murals (surface coatings not recommended)		
METHOD OF APPLICATION		
Brush		x
Hand-rub		
Spray		x
CAUTIONS		
Ventilation		x (if sprayed)
Goggles		x (if sprayed)
Respirator		x (if poor ventilation)
Gloves		
Coveralls		x (if sprayed)
REVERSIBILITY		Surface G; over time becomes F
SOLVENT		Mineral spirits
DURABILITY		
Interior		EX
Exterior		F
Rigid support		EX
Flexible support		EX
RESISTANCE TO:		
Water		EX
Acid		F
Alkali		F
Pollutants		G
Ultraviolet light		EX
Mechanical damage		G
Oxidation		G-EX
POSSIBLE DEFECTS		Slight craze if mechanically damaged
ESTIMATED LIFE	Not recommended	More than 20 years in ideal conditions
OTHER COMMENTS	The solvents for vinyl solutions are very hazardous	Tested by the manufacturer; seems reliable so far

TABLE 16.1. VARNISHES AND COATINGS FOR PICTURES, CONT'D.

Key: EX = Excellent; G = Good; F = Fair; P = Poor; NT = Not tested; NR = Not recommended

COMMON NAME	Silicone	Petroleum microcrystalline
TYPE	Synthetic resin	Synthetic wax
APPLICATION		
Oils	x	x
Acrylic solutions	x	x
Acrylic emulsions	x	x
Alkyds	x	x
Water-thinned		x
Temperas		x
Encaustics		x
Pastel (fixative)		
Murals (surface coatings not recommended)		
METHOD OF APPLICATION		
Brush		x (diluted)
Hand-rub		x (preferred)
Spray	x (only)	x (very diluted)
CAUTIONS		
Ventilation	x	x (if sprayed)
Goggles	x	x (if sprayed)
Respirator	x	x (if poor ventilation)
Gloves	x	
Coveralls	x	x (if sprayed)
REVERSIBILITY	NT	G
SOLVENT	Trichlorotrifluoroethane	Mineral spirits
DURABILITY		
Interior	NT	EX
Exterior	NT	G
Rigid support	NT	EX
Flexible support	NT	G
RESISTANCE TO:		
Water	NT	EX
Acid	NT	F
Alkali	NT	F
Pollutants	NT	G
Ultraviolet light	NT	G
Mechanical damage	NT	F-G
Oxidation	NT	EX
POSSIBLE DEFECTS	NT	Very soft films; easily damaged
ESTIMATED LIFE	Unknown	More than 20 years in ideal conditions
OTHER COMMENTS	Expensive; tested only by the producer, and developed for conservators	Adhesive wax for conservation; possible use as a surface coating (with a hardener added) over varnishes

FILM	ISO FILM SPEED	TYPE	OPTIMAL LIGHT SOURCE	FILTER REQUIRED		
				Daylight	Photofloods (3400 K)	Tungsten (3200 K)
Kodak Ektar 100	100	Prints	Daylight	No filter	85B	85
Kodak Vericolor HC Professional	100	Prints	Daylight	No filter	85B	85
Kodachrome 40 Type A Professional	40	Slides	Photoflood 3400 K	85	No filter	80A
Fujichrome 50	50	Slides	Daylight	No filter	80B	80A
Fujichrome 64T Professional	64	Slides	Tungsten 3200 K	85B	81A	No filter
Kodachrome Ektachrome 64T Professional (EPY)	64	Slides	Tungsten 3200 K	85B	81A	No filter
Kodak Ektachrome 100 Professional	100	Slides	Daylight	No filter	80B	80A
Kodak Ektachrome 160T Professional	160	Slides	Tungsten 3200 K	85B	81A	No filter
Kodak Plus-X Pan	125	B&W prints	The color temperature of the light source does not affect the performance of B&W film.			
Kodak Tri-X Pan	400	B&W prints	The color temperature of the light source does not affect the performance of B&W film.			

TABLE 16.2. 35MM COLOR SLIDE AND PRINT FILMS

Notes:
1. ISO = International Standards Organization.
2. *Always* check the package insert: The ISO speed for that individual roll of color film may differ from the speed printed on the box. Furthermore, the ISO speed will be different from the rated speed, according to the filter used. Your best solution is to use a film rated for the lighting you choose, so that you will not need to rely on filters.
3. Buy fresh rolls of color film. Store them in a refrigerator until you use them, and allow them to come to room temperature before loading the film into the camera. Process the exposed film promptly.
4. It is possible to have slides or prints made from any type of film, even if it is primarily designed for one purpose. To go from prints to slides, the printer will copy your print using a slide film or will use a Vericolor print film to make a slide from the color negative; to go from slides to prints, the printer will use a Vericolor internegative film to make a print negative from the slide, and then make the print.

17 Conservation and Restoration

It is not my purpose here to instruct you in *restoration,* the art and science of the repair of artworks, or *conservation,* the art and science of the preservation of artworks.

Conservators, as they are known in this country, are professionals who have received highly specialized training and have considerable experience. If you are so inclined, you can play a part in conservation by using quality materials and durable processes, but you should not practice art conservation without training. *This chapter is not a guide for the do-it-yourselfer.* Probably more paintings have been irreparably damaged by amateurs—painters who thought they knew what they were doing—than successfully treated by professionally trained conservators. But it is useful, at least, for you to be aware of the kinds of harm paintings can suffer, and how these ills are treated. For those artists who might be interested in pursuing conservation as a profession, the end of this chapter lists the few professional training and internship programs in the United States and Canada.

All works of art are different, and each is therefore treated as an individual case in a conservation studio. Some general procedures are followed in many cases, but to generalize where conservation practices are concerned can be dangerous: It can lead to assumptions about treatment methods. The following discussion of the damage that pictures may sustain, and the methods of treating that damage, is presented in the most general way, with the understanding that several types of defects or injuries may occur at once in a work, and that the conditions may alter the method of treatment.

INSPECTION OF THE WORK

All works of art that are to undergo restorative or preservative treatment must be thoroughly inspected. The conservator takes color and black-and-white photographs of both sides of the work—the obverse, or front, and reverse, or back—both before and after treatment. Next he or she carries out a complete visual inspection under normal light, and notes the condition of the support and design layers. If necessary, the work is also inspected under other kinds of light: infrared, ultraviolet, and X-ray. Each of these can reveal information about the paint and support.

In museums, a chemical analysis of the paint is often done to determine the authenticity of the work, or to place it in a historical context. All the information gathered from these inspections is recorded in writing in a separate file for each work, from which an individual plan for treatment can be developed. Only after consultation with the owner, including an explanation of suggested treatment, is treatment attempted.

If the picture's condition is at all fragile, it is sometimes useful to consolidate it before beginning treatment. Consolidation effectively stabilizes the design layer by immobilizing it under a reinforcing covering. The covering is usually small patches of very thin but strong mulberry paper applied as a patchwork over the fragile front surface of the work, using a reversible glue. The mulberry paper can be further reinforced by a covering of thin muslin. In all cases it is necessary to determine the solubility of the paint layer before consolidating it.

Oil paint, for instance, cannot be consolidated with an adhesive that needs a strong aromatic solvent to remove it, since these solvents can affect the paint layer. A water-soluble glue may be used in this case, if there is no danger of loosening the ground from the support.

DAMAGE TO SUPPORTS

The type of damage that affects a work depends, in part, on the kind of support used. Paper, wood, and fabric are each susceptible to particular forms of disrepair.

PAPER SUPPORTS

Inherent faults in the paper can derive from its constituent materials, in which case not much can be done to restore the work. A cheap, acidic paper can be stabilized so that it will change little in the future, but it cannot be returned to its original state.

MOLD

Mold is characterized by brownish or gray-greenish spots or stains on the paper. Caused by too humid an environment, mold stains—also called foxing—can be treated by removing the work to a dry place and exposing it to circulating air and sunlight for a day to kill the organism. The artwork is sometimes placed in a closed container containing a fungicide, whose slow evaporation eventually kills the mold.

STAINS

Water stains or discolorations caused by atmospheric pollutants can sometimes be treated by bleaching the work with hydrogen peroxide vapors in a closed environment.

ACIDIC PAPERS

These can be deacidified with a proprietary mixture called Wei T'o® (available from Conservation Materials, Ltd.; see List of Suppliers). The solution, in three forms, is a dispersion of a buffering agent in volatile organic solvents. The solvents carry the buffer

into the paper fibers, where it converts to magnesium carbonate, an alkaline reserve, by reacting with the water vapor and carbon dioxide in the air. The solution can be applied to the paper by brushing, spraying, dipping, or roll-coating.

INSECT DAMAGE

Silverfish, cockroaches, termites, and woodworms all eat paper, and particularly enjoy animal glue sizes and vegetable gum binders. In such cases an insecticide is applied, and the work is removed to a safer environment.

TEARS

If a paper support is torn, the conservator can make a patch of a paper that is thinner than the paper on which the work was done. The patch has feathered edges, made by water-cutting and separating the fibers around the edges of the patch. The conservator then attaches the patch with a weak reversible glue to the reverse of the object. Tests must be made to determine that the solvent for the glue does not affect the support paper or the design mediums.

CREASES, WARPS, AND WRINKLES

These are caused by careless handling, folding, rolling, and so on. Depending on the nature of the mediums used in making the work, these physical defects can be reduced by exposing the object to a humidified atmosphere, by pressing under a moderate weight, or a combination of the two.

WOODEN SUPPORTS

Wooden supports—especially those of solid, thick panels—present special problems to the conservator.

WARPING

This is caused by uneven tension between two faces of the work, or by uneven graining between the two faces. If the support is a grained structure such as a thick, solid wooden panel

and the design layer is not in fragile condition, the panel can sometimes be straightened by exposure in a humidity chamber. When the work is removed from the chamber and dries out, the warp eventually reappears. The reappearance of the warp may be prevented or lessened by attaching a felt-lined aluminum channel brace around the perimeter of the support.

Occasionally the conservator decides that attempting to remove the warp will cause more damage than leaving it alone.

Cradling, the practice of attaching slotted braces to the rear of the panel running parallel to the grain, with smaller movable braces placed into the slots and running perpendicular to the grain, is rarely used today—it is one of those techniques that, though ingenious for its time, was discovered in many cases to have caused more damage than it prevented.

CRACKS

These splits in the wood, sometimes called checks, can accompany warping, but can also be the result of the support's reaction to atmospheric changes. Sometimes the conservator fills the splits with an epoxy or other inert consolidant in order to stabilize the structure. These visual interruptions in the design layer can be lessened by in-painting over the filler, a technique discussed later in this chapter.

INSECT HOLES

Boring insects can honeycomb a support and leave it in a very weakened state. Treatment with an insecticide kills the insects. The conservator then infuses the channels and holes with a wax or epoxy consolidant to stabilize the structure.

TRANSFERRING

Occasionally the support is so deteriorated that the paint films are actually supporting the panel. Although this occurs more often with pictures on textile supports, it is occasionally true with paintings on wooden supports too. In this case, the design layer can be transferred to another support.

First the conservator consolidates and immobilizes the paint layer with a covering of reversible adhesive (made with a solvent that will not affect the design layer) and thin rice paper. In some situations a muslin covering is used for added strength.

The support is turned over and placed on a padded surface—if the paint has high impasto, the surface can be a reverse mold of the picture, to preserve the configuration of the surface projections. The conservator then carefully planes the panel off the rear of the painting, down to the reverse of the ground; if the ground has deteriorated, even it is sometimes removed.

While the paint layer is still immobilized, the conservator then attaches it to a new ground and support. Because of the delicacy and extreme risk of this operation, it is used only under the most unusual circumstances.

FABRIC SUPPORTS

The defects of fabric supports result from exposure to light and atmosphere. Embrittlement and general weakening are inevitable for the commonly used cotton duck and linen. Treatment of this kind of deterioration is usually accomplished by first stabilizing and consolidating the face of the picture, then attaching a new support to the back of the old.

The operation is called *lining;* when an old lining is stripped from the back of a support and a new lining is applied, the procedure is called *relining.*

The new lining material has traditionally been new, smooth linen, of a weight similar to that of the old material. In the last two decades or so, the more stable synthetic fabrics, such as woven fiberglass or woven polyester sailcoth, have gained prominence. More recent developments make the use of light but very rigid honeycombed panels possible. These include cast polyester on an aluminum honeycomb, or an aluminum panel on an aluminum honeycomb.

The procedure for lining begins with the usual close inspection of the picture, followed by stabilization and consolidation of the design layer if necessary. The conservator then removes the picture from the auxiliary support and

carefully cleans the back of it. Loose threads around tears are trimmed, but the original stretching edge of the picture is left intact.

The conservator prepares a strainer and stretches a new lining material (if it is a fabric) tightly on the frame. Next she or he makes a wax and resin adhesive. This kind of adhesive is strong and penetrating but easily removed by gentle heating and/or the application of mild solvents.

The new support is placed face down on a release paper surface, which will not allow the adhesive to stick. The wax and resin adhesive is brushed into the rear of the new support and then spread out and forced into and through the fabric by gentle remelting with an iron. The temperature of the iron is set as low as possible, but warm enough to melt the adhesive.

The painting is likewise placed face down on a release paper surface, padded to prevent the flattening of thick paint, and the same wax and resin impregnation is carried out. The temperature of the iron is kept at its lowest setting to prevent the burning of the paint layers.

When the back of the old picture has cooled, the conservator aligns the new adhesive-coated support over it, and the two are stuck together using gentle heat and pressure. The conservator then removes the strainer from the lining and restretches the newly backed picture on its original chassis—although sometimes a new chassis is used.

A more recent method of lining uses a vacuum hot table, a table covered with seamless aluminum sheeting, heated from beneath by a series of electric elements. Suspended over the table is a frame holding a loosely stretched rubber blanket and a vacuum system connected to a vacuum pump. Newer lining tables are bigger, and do not use the suspended rubber blanket; instead, the vacuum system is incorporated into the perimeter of the table itself, and the rubber blanket has been replaced with a thick, transparent sheet of polyester film.

The picture is prepared in the usual way, but the new lining material is not stretched on a strainer. Rather, the adhesive is applied to both the picture back and lining, and the two are aligned and stuck together by hand. Release paper is placed on the hot table, and the lining

and picture are placed face up on the paper. Strips of corrugated cardboard may be placed around the perimeter of the picture to act as channels to draw off excess adhesive. The table is then warmed just enough to melt the adhesive.

As the table is heating, the conservator puts the clear polyester film over the surface of the table. If the artwork is large, the whole table is used; if not, small-diameter sausagelike tubes of sand-filled fabric can be placed around it, on top of the plastic film, to seal the film to the surface of the table.

A seal around the edge of the table is engaged, and the vacuum pump is turned on. Air is pumped from beneath the covering, to a pressure not higher than about 11.25 kg/2.5 cm^2 (25 pounds per square inch), and the soft plastic film conforms to the surface irregularities of the picture. Then the conservator turns off the heating elements, and the picture is quickly cooled with fans while the vacuum continues to work.

When all has cooled, the conservator removes the plastic film, discards the cardboard, and takes the picture off the table. It is then restretched on a chassis—a new one if necessary, the original if possible. Naturally, the process of lining varies from practitioner to practitioner and depends on the condition of the work.

DEFECTS OF PAINT FILMS

Paint films themselves are also subject to degradation as a result of age or faulty application. A few problems are noted here.

CHECKING

If the paint binder oxidizes completely or becomes brittle, either from stresses internal to the paint or from stresses external to the paint (atmospheric changes), cracks that follow the weave of a fabric support or the grain of a wooden support will appear.

POWDERING

The complete loss of the paint binder may leave pigment particles on the surface of the picture that can easily be knocked off.

This particularly dangerous condition can be caused by excessive use of a thinner as you are painting.

CLEAVAGE

An area of the paint film may crack through completely to the ground, or the paint and ground may lift completely from the support. This can be caused by any number of things: poor-quality mediums or paints, moisture in the ground, or mechanical damage.

BLIND CLEAVAGE

This is a blisterlike condition similar to cleavage except that the paint may not be cracked on the surface. What cannot be seen may be dangerous for the life of the picture.

CUPPING

Small islands of paint crack through expansion of the support and then are pushed together when the support shrinks. When the flakes are pushed together, their edges can be raised above the plane of the picture, resulting in a cuplike profile.

CRACKING

This defect is also called *crackle* or *craquelure*. If the paint film or the ground loses its plasticity, many different types of cracking can occur. The damage can be caused by careless handling of the picture—rolling, for instance—or can come from the cyclical expansion and contraction of the support. Each condition can cause a separate and distinctive type of crack; traction cracks and alligatoring are examples.

FLAKING

This can be caused by mechanical damage or atmospheric fluctuation, resulting in the dislodging of small chips of paint. This is a dangerous condition, since the whole picture may be in jeopardy.

WRINKLING

This condition is also called reticulation. It can be caused by an excess of binder or vehicle in the paint film, by an inferior binder, or (in oil paints) by the artist's excessive use of a drier. Short of softening the film with very active solvent vapors, there is not much that can be done about this condition.

BLOOM

This is more often a defect of the varnish layer, where moisture has become trapped between it and the paint film. The symptoms are a bluish- or grayish-white veil over the picture that obscures the image. It can be treated by drying the picture or, more commonly, by removing the varnish and revarnishing.

FADING

This can be caused by overexposure of the picture to ultraviolet light, but it is also often the result of the artist's using inferior and impermanent pigments or other colorants. Other color changes can be caused by reaction of colorants to atmospheric conditions, or other colorants or mixtures of colorants.

Short of extensive retouching, which is usually advised against, there is *nothing* to be done about faded or changed colors.

CLEANING

Once the picture has been inspected, photographed, consolidated (if necessary), and lined (again, if necessary), it can be cleaned. This is a most delicate procedure, since the wrong use of the wrong material or method can easily destroy the picture.

Usually it is necessary first to remove any facing materials or excess lining adhesive. If no analysis of the paint film has been conducted, an inconspicuous corner of the work can be checked to see what effect various solvents have on it or the varnish layer, if any. On the basis of observation and experience, the conservator selects solvents to be used in the cleaning.

It is critical at this point that he or she choose only those solvents that will remove surface dirt. A different set of solvents may be required for the varnish, if that is also dirty or yellowed and is to be removed later. The conservator also selects solvents or mixtures of solvents that act as restrainers (also called "checks"); these solutions can instantly counter the action of the cleaning mixture and stop any damage to the picture if anything should go wrong during the cleaning.

Cleaning is a tedious process. No friction or vigorous mechanical methods are used. Solvents theoretically do all the work. Cotton or foam swabs are used to clean small sections of the picture at a time, and the swab is carefully examined to note the appearance of color, which could indicate that the paint film is being attacked. The conservator discards and replaces each swab as soon as it becomes dirty. The restrainer is wiped over each section of the surface that has been cleaned to stop any further solvent action, and once the cleaning operation is completed, the restrainer is used to buffer the entire surface of the work.

Naturally, different kinds of paints and paint and support systems require different approaches, and each work is treated as an individual case. There is no set system of cleaning that can be applied to all situations. This is why the diagnosis and treatment of the ills of art objects is work for the trained professional conservator.

REPAIR AND IN-PAINTING

Tears, holes, and lost areas of paint can be repaired by filling and leveling the voids with reversible putty mixtures such as stiff glue gesso. Depending on the medium, it is sometimes necessary to isolate the paint film from repair operations with a thin coat of reversible varnish; sometimes it is not possible to isolate the picture in this way.

Once the voids in the picture plane have been filled, they can be treated to become less obtrusive. The process is popularly known as *retouching*, but is also called *in-painting*. There is a great deal of disagreement about just what in-painting should accomplish. Some say it should be instantly recognizable as the work of another hand, but also very subtle, so as to do nothing to either add to or subtract from the artistic merits of the work. Others argue that in-painting can be entirely lost in the body of the work, indistinguishable from the original. The conservator's approach to this task can be determined by how extensive the damage is. It would be foolhardy and dishonest to try to replace—in the style of the artist—large areas of the missing image, but it might not be so bad to do this if the damage is confined to tiny, isolated spots.

A reversible paint is used for in-painting, so that it can later be removed. The paint is rarely the same as that which was used to execute the original work, so that its removal will not affect the picture. Only those areas in which paint is lost are in-painted; original paint is not covered. Once the in-painting is completed, the conservator gives the entire picture a thin coating of a reversible spray varnish—if varnishing is compatible with the medium and/or the desires of the artist—and if the artist's label has informed the conservator what her desires are!

ARTIST AS CONSERVATOR

Again, let me reiterate that the overview of conservation methods contained in this chapter should *not* be construed as instructions on how to repair paintings. It is reasonable for you to consider attempting conservation treatment on your own paintings, but not on anyone else's!

You should advise your clients that if there is a physical problem with a painting, you should be given an opportunity to inspect it before the client goes to a conservator. You might be able to determine what went wrong and how to fix it—especially if there is a good label.

At least, if you are confronted with a deteriorating painting that is only five or ten years old, you might stop and think a moment about quality materials and sound technique. That might be the most positive result of an unsettling experience.

It is unfortunate for the future of our cultural heritage that conservation training is not more actively supported in this country. In fact, there are only four professional conservation programs in the United States and Canada that provide scientifically based training. Several other small institutions offer additional training as internships to those who have completed the professional programs. There are also small schools that operate on the basis of apprenticeships; many fine conservators in this country were trained by apprenticing with well-known and respected conservators.

In an apprenticeship program, however, it is possible to learn a great deal about how one person treats art objects, but very little about the science of materials.

The following academically supported programs provide sound training. Artists can make very good conservators, and interested aspirants are encouraged to write for more information. Be aware that the entrance requirements are stringent, and the competition for a limited number of spaces is very stiff.

Conservation Center of the Institute
 of Fine Arts
14 East 78th Street
New York, NY 10021

Buffalo State College
Art Conservation Department
230 Rockwell Hall
1300 Elmwood Avenue
Buffalo, NY 14222

Program in the Conservation of Artistic &
 Historic Works
Winterthur Museum/University of Delaware
303 Old College
University of Delaware
Newark, DE 19711

Queens University
Art Conservation Programme
Kingston, Ontario
Canada K7L 3N6

Each of these programs has slightly different admissions requirements, but generally they include one or two undergraduate courses in chemistry, a strong background in art history, and demonstrable manual dexterity (studio arts experience). Proficiency in a foreign language is also desirable.

The following program offers internships to graduates of accredited conservation programs:

Center for Conservation and
 Technical Studies
Harvard University Art Museums
32 Quincy Street
Cambridge, MA 02138

The American Institute for Conservation of Historic and Artistic Works, Inc. (AIC), 1400 16th Street, N.W., Suite 340, Washington, DC 20036, is the professional society to which many conservators belong. Anyone can be a member of the AIC merely by paying the annual dues; only trained conservators who can demonstrate their competence before an examining board may be Fellows of the AIC. This distinction is useful when seeking the services of a professional conservator, or when recommending one to a client. The AIC has also published a Code of Ethics and Standard of Practice that is a valuable reference for those considering entering the profession. In addition, the AIC has been lobbying to have conservators certified by a licensing board.

The International Institute for Conservation of Historic and Artistic Works (6 Buckingham Street, London, WC2N 6BA, England) is the international group of which the AIC is the American arm. The IIC publishes *Studies in Conservation,* a technical journal to which members of the AIC and IIC submit articles. Some of these articles are of interest to artists.

When seeking advice about conservation, or sending a client to a conservator, begin with the local museum. If the museum does not have a conservator on staff, write to the AIC.

Glossary

Many of the words defined here are used in a nonstandard way by artists. I have attempted to reduce the technical language to the minimum, but in some cases its use is unavoidable.

The abbreviation P/CD means *Paint/Coatings Dictionary*.

Acrylic Emulsion A water dispersion of polymers or co-polymers of acrylic acid, methacrylic acid, or acrylonitrile. Paints made with the acrylic emulsion as a binder have a variety of other ingredients added to control the performance of the paint. Acrylic emulsions dry by evaporation of the water and film coalescence; the dried layer is consequently filled with voids and is quite porous.

Acrylic Solution A solution of acrylic resin in a volatile solvent. Paints made with an acrylic solution binder resemble oil paints more than those made with an acrylic emulsion binder. Acrylic solutions dry by evaporation of the solvent and form continuous, solid films.

Acute Hazard A hazard producing a symptom of injury immediately, or after a short period of exposure.

Additive Color Color that results from the mixture of two or more colored lights, the visual blending of separate spots of transmitted colored light (as in color television), or by the visual blending of flickering hues (as in tree leaves seen from a distance).

Agglomeration A condition of paint in which individual pigment particles cluster into undispersed lumps. The spaces between the particles are filled with air.

Aliphatic Hydrocarbons Petroleum-distilled solvents with generally higher boiling points than those of aromatic hydrocarbons, composed primarily of paraffinic and naphthenic hydrocarbons (P/CD).

Alkyd Synthetic resin formed by the condensation of polyhydric alcohols with polybasic acids (P/CD).

Allergenic Capable of causing an allergic reaction. It is a term used in ASTM D4236, the voluntary health labeling standard of the American Society for Testing and Materials for artists and the artists' materials industry.

Anhydrous Free from water.

Archival Refers to a material that meets certain criteria for permanence such as lignin-free, pH neutral, alkaline-buffered, stable in light, and so on. The term will be more precisely defined in a new ASTM Standard for artists' papers, but a constantly changing environment may negate standards for durability and permanence.

Aromatic Hydrocarbons A class of organic compounds with an unsaturated ring of carbon atoms (P/CD), considered generally more volatile and active solvents than aliphatic hydrocarbons.

Binder The nonvolatile adhesive liquid portion of a paint that attaches pigment particles and the paint film as a whole to the support.

Canvas Any closely woven cloth. Paintings may be referred to as "canvases."

Cartoon A planning device in mural painting, often a full-scale line drawing of the design, without color or tone.

Casein A natural protein obtained from cow's milk.

Chassis Another name for the auxiliary support on which a textile is stretched. Also called a stretcher or a strainer.

Chroma The relative intensity or purity of a hue when compared to grayness or lack of hue.

Chronic Hazard A hazard producing a symptom of injury only after prolonged exposure.

Collage A technique of picture making in which the artist uses materials other than the traditional paint, such as cut paper, wood, sand, and so on. The items are glued to the painting support and incorporated into the design or composition.

Colloid Solution A gel-like solution, as compared to the more common liquid or syrupy types.

Colour Index An internationally recognized reference text used for the identification of colorants according to type (dye, pigment), hue, chemical composition, or process of manufacture, published by the British Society of Dyers and Colourists and the American Association of Textile Chemists and Colorists.

Combustible Referring to any liquid with a flash point between 38° and 65° C (100° and 150° F).

Co-polymer A polymer in which the molecule is of more than one type of structural unit.

Cradle Originally, a system of attached and immovable battens interleaved with sliding battens, the whole screwed and glued to the rear of a solid wooden panel to keep it from warping or splitting. Today the word may refer, incorrectly, to any auxiliary support for the back of a panel.

Direct Painting A style or technique of painting in which the final image is achieved with as little manipulation of the painting surface as possible.

Dispersion Applied to paint, a smooth, homogeneous mixture of heterogeneous ingredients; the process of dispersal, in which pigment particles are evenly distributed throughout the vehicle.

Drier A material that accelerates or initiates the drying of an oil paint or oil by promoting oxidation. "Top driers," which cause the surface of a film to dry before the interior, can be most harmful to paint films. "Through driers" can cause the whole film to dry at once, and so are safer.

Drying Oil An oil that, when spread into a thin layer and exposed to air, absorbs oxygen from the air and converts into a tough, leathery film.

Emulsion A liquid system in which small droplets of one liquid are immiscible in, but thoroughly and evenly dispersed throughout, a second liquid (P/CD).

Encaustic Literally, "to burn in." A painting technique in which the binder is melted wax: The wax carries the pigment to the support, where it cools and hardens. The paint is melted into the support with a heat lamp to increase its adhesion.

Explosive Referring to any liquid with a flash point below −12° C (10° F).

Extremely Flammable Referring to any liquid with a flash point around −7° C (20° F).

Flammable Referring to any liquid with a flash point between −7° and 38° C (20° and 100° F).

Flash Point The lowest temperature at which a liquid gives off vapors that can be ignited by an open flame or spark.

Flocculation A condition of paint in which individual pigment particles cluster into lumps. The spaces between the particles are filled with vehicle, unlike in agglomeration, where the spaces are filled with air. The lumps may project above the surface of a spread-out film of paint.

Fresco A painting technique in which the pigments are dispersed in plain water and applied to a damp plaster wall. The wall becomes the binder, as well as the support for the paint. Also called affresco.

Frit A powdered, colored material that when fired at high temperature fuses into a continuous film, as hard and brittle as glass, that is often a different color from the original powder.

Gesso A white ground material for preparing rigid supports for painting, made of a mixture of chalk, a little white pigment, and glue. Also called glue gesso or Italian gesso.

Glaze A very thin, transparent colored paint applied over a previously painted surface to alter the appearance and color of the surface.

Gouache A technique of painting with opaque watercolor.

Grissaille A monochromatic painting, usually gray, which can be used under colored glazes.

Ground The coating material, usually white, applied to a support to prepare it for painting.

Gum A plant substance, like some saps, that is soluble in water.

Hue The perceived color of an object, identified by a common name such as red, orange, yellow, green, blue, or purple.

Hygroscopic Absorbing or attracting moisture from the air.

Indirect Painting A style or technique of painting in which the final image is built over an underpainting by means of transparent or semiopaque applications of paint that do not completely obscure the underpainting.

Impasto A style of paint application characterized by thick, juicy slabs of color.

Imprimatura A thin, transparent veil of paint, or a paint-tinted size, applied to a ground to lessen the ground's absorbency or to tint the ground to a middle tone.

Key A toothy ground that allows succeeding applications of paint or a drawing material to grip the surface mechanically; a basis for attachment other than adhesiveness.

"Lacquer Thinner" A widely misused term referring to any kind of mixture of various aliphatic and/or aromatic solvents used to dilute or dissolve lacquers.

Lake A dye that has been chemically or electrically attached to a particle and hence does not bleed or migrate.

Latex A dispersion in water of a solid polymeric material.

Levigating A method of water-washing pulverized pigments or sand to clear the particles of dissolved salts or organic matter.

Lightfast Resistant to fading or other changes due to light. A lightfast substance has passed a test in which it is exposed to a known amount of light over a measured period of time under specified conditions.

Lignin An acidic adhesive material found in wood that acts as a binder for the wood fibers.

Marouflage A technique for attaching, with glue, mural-size paintings on paper or fabric to a wall.

Masstone The top tone or body color of a paint seen only by reflected light.

Mat A stiff paperboard with a window cut out of the center, attached to a backboard. A mat forms a protective sandwich for a work of art by separating it from direct contact with the glass that covers it and the frame that surrounds it. Archival mat board is sometimes called museum board.

Matte Flat; nonglossy; having a dull surface appearance. Also spelled matt.

Migration The action of a pigment or dye moving through a dried film above or below it.

Monomer A material with low molecular weight that can react with similar or dissimilar materials to form a polymer.

Mosaic The technique of making a picture out of small units of variously colored materials (bits of glass, stone, ceramic tiles) set in a mortar.

Museum Board High-quality, multi-ply paperboard that is made of cotton rags or buffered cellulose to ensure its chemical stability and neutrality.

Palette The surface on which a painter's colors are mixed; also, the range of colors a painter uses.

Pentimento A condition of old paintings, particularly oil paintings in which lead-containing pigments have been used. The upper layers of the opaque paint become transparent, revealing earlier layers.

Pigments Particles with inherent color that can be mixed with a transparent adhesive binder to form paint. Also called colorants.

Plasticizer The ingredient added to the vehicle that allows the paint either to flow or to be easily redissolved.

Polymer A series of monomers strung together in a repeating chainlike form. A polymer is usually thought of as two monomers, but it could be more.

Precipitate An inert particle to which dyes can be laked.

Preservative A material that prevents or inhibits the growth of microorganisms in organic mixtures.

Primer *See* ground.

Radial Sawing A method of sawing boards in which the saw cuts are perpendicular to the growth rings of the log; also "quarter-sawing."

Refraction The bending of light rays from one course in one medium to a different course as they pass through another medium of a different refractive index.

Refractive Index The numerical ratio of the speed of light in a vacuum to its speed in a substance.

Relative Humidity The amount of water vapor in the air, shown as a percentage of the maximum amount the air could hold at a given temperature.

Resins A general term for a wide variety of more or less transparent, fusible materials. In a broad sense, the term is used to designate any polymer that is a basic material for paints and plastics. Resins dissolve in inorganic solvents, but not usually in water (P/CD).

Saponification The process in which a paint binder, under moist and alkaline conditions, becomes transparent or discolored.

Scumbling The technique of applying a thin, semiopaque or translucent coating of paint over a previously painted surface to alter the color or appearance of the surface without entirely obscuring it.

Sgraffito A technique in which the surface layer of a design is incised or cut away to reveal a ground of contrasting color.

Silicate A material, such as sand, that is composed of a metal, oxygen, and silicon.

Sinking-in A condition in which the surface of a painting appears dull in spots, and color matching with wet paint is difficult. Sinking-in can occur if oil paint is thinned too much with mineral spirits or with gum turps, or if the ground is too absorbent or too unevenly absorbent. It can occur with other paints also.

Size A material applied to a support as a penetrating sealer, to alter or lessen its absorbency and isolate it from subsequent coatings.

Specular Reflection Mirrorlike reflection, such as the apparently white reflections from a colored glass bottle.

Strainer A type of wooden chassis for textile supports that has rigid, immovable corners.

Stretcher A type of wooden chassis for textile supports that has expandable corners.

Stucco A surface finish composed of Portland cement, lime, sand, and water.

Subtractive Color Color resulting from the absorption of light.

Support The basic substrate of the painting: paper, cotton duck, linen, panel, wall, and so forth.

Tangential Sawing A method of sawing boards in which the saw cuts run at a tangent to the direction of the growth rings of the log.

Tempera A technique of painting in which water and egg yolk or a whole egg and oil mixture form the binder for the paint.

Thermoplastic Capable of being repeatedly softened by heat and hardened by cooling (P/CD).

Thermosetting Having the property of setting into a relatively infusible state when heated (P/CD).

Thixotropic Referring to a material that is thick and viscous while at rest but will flow if brushed, stirred, or shaken, resuming its viscous state when the agitation stops.

Toner An unlaked dye that can bleed or migrate through dried paint films.

Tooth A random, small-grained but even texture. Tooth provides for the attachment of succeeding layers of paint or drawing material.

Transmittance Of light, that fraction of the light that is not reflected or absorbed, but passes through a substance (P/CD).

Undertone The color of a paint seen when it is viewed in transmitted light or when the paint has been spread into a transparent glaze film; it may be very different from the masstone.

Value The relative lightness or darkness of a hue. Black is low value; white is high value.

Varnish Generally, a more or less transparent film-forming liquid that dries into a solid film after application.

Vehicle The entire liquid contents of a paint, including the binder and any additives (solvents, driers).

Vinyl Resin Any resin formed by the polymerization of compounds containing the vinyl group, derived from ethylene.

Volatile Evaporating rapidly or easily.

Watercolor A technique of painting using a binder made from a water-soluble gum. Watercolor paints can be transparent or opaque.

List of Suppliers

This reference list is organized as follows:
1. First I have listed, one chapter at a time, important materials that have been mentioned in the text, along with at least one source for each.
2. In a separate, alphabetically arranged list on pages 306–312, I have listed the addresses and other information about the sources.

This is by no means a comprehensive list, but a starting point. My mention of a product or a company is not an endorsement of it. You must decide whether the product or service is appropriate for your intended use.

LISTINGS BY CHAPTER

CHAPTER 1: BASIC TOOLS AND EQUIPMENT FOR THE ARTIST

Drawing Materials
Art supply stores

Brushes
Langnickel
Grumbacher
Isabey
Liquitex
Raphael
Simmons
Strathmore Paper
Utrecht Manufacturing
Winsor & Newton

Papers
Art Supply Warehouse
New York Central Art Supply
Pearl Paint

Shiva
Strathmore Paper
Utrecht Manufacturing

ColorpHast pH Indicator Strips
Conservation Materials

Wei T'o® Deacidification Solutions
Conservation Materials
TALAS

CHAPTER 2: SUPPORTS

Solid Wood Panels
Local specialty hardwood mills
Some local lumberyards

Die Boards
Eggers Plywood Company
Some local specialty hardwood mills

Plywood
Local lumberyards

Museum Board
Andrews/Nelson/Whitehead
Art materials supply shops
Process Materials
Strathmore Paper

Chipboards and oriented strandboards (such as Aspenite)
Local lumberyards

Hardboards
Local lumberyards
Masonite Corporation

Cored Boards
Fine Arts Stretchers and Services
Process Materials

Stretcher Cleats and Crossbar Cleats
Grumbacher

Cotton Duck
Art materials supply shops
Fredrix Artists Canvas
Selwin Textile Company
Utrecht Manufacturing
Winsor & Newton

Linen
Fredrix Artists Canvas
Selwin Textile Company
Utrecht Manufacturing
Winsor & Newton

Polyester and Polyester/Cotton Blends
Fredrix Artists Canvas

Polypropylene
Fredrix Artists Canvas (Tara Materials)

Ready-Made Stretcher Bars
Art materials supply shops

Heavy-Duty Ready-Made Stretcher Bars
Some art materials supply shops
Utrecht Manufacturing

Custom Stretcher Bars
Lascaux/Fine Arts Stretchers, Inc.
I.C.A. Spring Stretchers
James J. Lebron
Starofix (Luca Bonetti)
Le Franc et Bourgeoise

Titanium White, Zinc Oxide, Precipitated Chalk
See Pigments

CHAPTER 3: SIZES AND GROUNDS

Hide Glue
Art materials supply shops
Benbow Chemical Packaging
Grumbacher
Utrecht Manufacturing

Be Square #175 Microcrystalline Wax
TALAS

Methyl Cellulose
Conservation materials
Dow Chemical (Methocel K4MS)
TALAS

Acryloid Acrylic Solutions
Rohm and Haas

Rhoplex Acrylic Emulsions
Rohm and Haas

PVA Emulsions
Borden Chemical (Elmer's Glue)
Hardware stores (Elmer's Glue)

Barrier Creams and Hand-Cleaning Creams
Handi-Clean Products (Doktor Handi-
 Clean)
Lab Safety Supply (Cover-Derm)
Mentholatum Company (Barracaide)

Barium Sulfate
See Pigments

Alkyd/Oil Primers
Winsor & Newton

Acrylic Emulsion Primers ("Gesso")
Grumbacher
Hunt Manufacturing
Liquitex
Martin/F. Weber

CHAPTER 4: BINDERS

Linseed Oils
Grumbacher
Liquitex
Utrecht Manufacturing
Welch, Holme and Clark
Winsor & Newton

Safflower, Poppyseed, Soybean, and Walnut Oil
Welch, Holme and Clark

Beeswax, Carnauba Wax
Benbow Chemical Packaging

Gum Acacia (Gum Arabic)
Benbow Chemical Packaging
Winsor & Newton

Casein
Benbow Chemical Packaging
Fischer Scientific
Kremer Pigmente

Vinyl Resins
Borden Chemical

Acrylic Resins
Rohm and Haas

Alkyd Resins
Reichhold Chemicals

Silicates
Du Pont
Union Carbide

CHAPTER 5: SOLVENTS
AND THINNERS

Glycerine
Local pharmacies

*Protective Devices: Masks, Gloves, Goggles,
 Barrier Creams*
Lab Safety Supply

CHAPTER 6: VARNISHES, BALSAMS,
DRIERS, PRESERVATIVES,
AND RETARDERS

Damar Resin
Art materials supply shops
Benbow Chemical Packaging
Utrecht Manufacturing
Kremer Pigmente

Mastic Resin
Benbow Chemical Packaging
Kremer Pigmente

White shellac solution
Hardware stores
Kremer Pigmente (also in powder form)

Acrylic Resins in Solution and Emulsion
Rohm and Haas

Ketone Resin Varnishes
Winsor & Newton

Venice Turpentine, Driers, and Retarders
Art materials supply shops
Grumbacher
Liquitex
Winsor & Newton
Kremer Pigmente

Preservatives
Conservation Materials

CHAPTER 7: PIGMENTS

Blue Wool Textile Fading Cards
TALAS

Colored Gels
Edmund Scientific

Munsell Book of Color
Munsell Color

Natural Color System
Scandinavian Colour Institute

Retail Pigment Suppliers
Bocour
Benbow Chemical Packaging
Grumbacher
Perma-Color
Winsor & Newton
Kremer Pigmente

Uniform Color Scales
Optical Society of America

*Wholesale and Raw Materials Suppliers of
 Pigments*
American Cyanamid
American Hoechst
Blythe Colours
Ciba-Geigy
Du Pont
Ferro
Harmon Colors

Harshaw
Hercules
I.C.I. Americas
Kohnstamm
Mearl
Mineral Pigments
Pfizer
Reckitts Colours
Reichard-Coulston
Sandoz
Shepherd Chemical
Sun Chemical
Whittaker, Clark and Daniels

CHAPTER 8: MAKING YOUR OWN PAINTS

Glass Mullers
Benbow Chemical Packaging

Empty Paint Tubes
Daniel Smith, Inc.
Pearl Paint
Teledyne-Wirz

CHAPTER 9: OIL PAINTS

Oil Paints
Blockx
Bocour
Daniel Smith
Gamblin
Grumbacher
Holbein
Hunt
Lefranc et Bourgeois
Liquitex
Maimeri
Martin/F. Weber
Old Holland
Rowney
Schmincke (a resin-oil paint)
Sennelier
Shiva
Standard Brands (The Art Store)
Talens
Turner Colour Company
Utrecht Manufacturing
Winsor & Newton

CHAPTER 10: WATER-THINNED PAINTS

Transparent and Opaque Watercolors
Bocour
Grumbacher
Holbein
Hunt
Lefranc et Bourgeois
Liquitex
Rowney
Turner Colour Company
Utrecht Manufacturing
Winsor & Newton

CHAPTER 14: SYNTHETICS

Acrylic Solution Paints
Bocour
Maimeri Restoration Paints (blend of synthetic and natural resins)

Acrylic Emulsion Paints
Bocour
Chromacryl
Golden
Grumbacher
Holbein
Hunt
Lascaux
Liquitex
Martin/F. Weber
Rowney
Standard Brands (The Art Store)
Shiva
Utrecht Manufacturing
Winsor & Newton

Alkyd Paints
PDQ
Talens
Winsor & Newton

CHAPTER 16: PICTURE PROTECTION

Spray Packs
Art materials supply shops
Conservation Materials
Precision Valve

Mat-Cutting Tools
Art materials supply shops
Daniel Smith, Inc.
Light Impressions (Dexter, C & H)
Westfall (Alto Ez)

Marking Gauges
Hardware stores

Hinging and Hanging Tape
Conservation Materials
Daniel Smith, Inc.
Light Impressions
TALAS
Westfall Framing

Glas-Kraft Waterproof Paper
Glas-Kraft

3M #415 Double-Faced Polyester Tape
Conservation Materials
TALAS

Museum Board
Andrews/Nelson/Whitehead
Art materials supply shops
Light Impressions
Process Materials
Strathmore Paper
Westfall Framing

Plastic Framing Spacers
Frame Tek (Framespace)

Styrene Glazing
Westfall Framing

Ultraviolet-Filtering Plexiglass
Rohm and Haas

Denglas
Denton Vacuum

Acid-Free Corrugated Cardboard
Process Materials

Fome-Cor
Monsanto

Humidity Indicator Cards (product #5B015H01)
Multiform Desiccants

Mylar Film
Du Pont

Print Storage Boxes
Light Impressions
Hollinger
TALAS

Bubble-Pak
Sealed Air Corporation

Kimpak
Kimberly and Clark

NAMES AND ADDRESSES

Alvin
Box 88
Windsor, CT 06095

American Cyanamid Company
Pigments Division
Bound Brook, NJ 08805

American Hoechst Corporation
Industrial Chemicals Division
P.O. Box 2500
North Somerville, NJ 08876
 and
129 Quidnick Street
Coventry, RI 02816
 (Organic Pigments)

American Society for Testing and
 Materials
1916 Race Street
Philadelphia, PA 19103-1187

Andrews/Nelson/Whitehead
31-10 48th Avenue
Long Island City, NY 11101

Art Supply Warehouse
360 Main Avenue (Route 7)
Norwalk, CT 06851

Artransport, Inc.
2706 South Nelson Street
Arlington, VA 22206

Benbow Chemical Packaging, Inc.
935 Hiawatha Boulevard
Syracuse, NY 13208
Catalogue available.

Best Moulding Frames
P.O. Box 10616
Albuquerque, NM 87184

Blockx (Belgian)
U.S. distributor:
Pentalic Corporation
132 West 22 Street
New York, NY 10011
Brochures and 4-color printed color chart;
minimal technical information.

Blythe Colours, Ltd.
Cresswell
Stoke-on-Trent STI I 9RD
England

Bocour Artist Colors, Inc.
Zipatone, Inc.
150 Fence Lane
Hillside, IL 60162
Brochures; minimal technical information.

Borden Chemical Division,
 Borden, Inc.
Thermoplastics Division
511 Lancaster Street
Leominster, MA 01453

Chromacryl (Australian)
U.S. distributor:
Chroma Acrylics
40 Tanner Street
Haddonfield, NJ 08033
Brochures and color charts; minimal technical
information.

Ciba-Geigy Corporation
444 Saw Mill River Road
Ardsley, NY 10502

Cities Service Company
Columbian Chemicals Division
3200 West Market Street
Akron, OH 44313

ColArt International
3, Avenue Laënnec
72018 Le Mans Cedex
France

Conservation Materials, Ltd.
240 Freeport Boulevard
P.O. Box 2884
Sparks, NV 89431
Catalogue available.

Daniel Smith, Inc.
Fine Artists' Materials
4130 First Avenue South
Seattle WA 98134
Catalogue available; excellent technical
information.

Denton Vacuum, Inc.
8 Springdale Road
Cherry Hill, NJ 08003

Dick Blick
Box 1267, Route 150 East
Galesburg, IL 61401

Du Pont, *see* E.I. Du Pont de Nemours
 and Company, Inc.

Dow Chemical Company
Dow Chemical U.S.A.
2020 Dow Center
Midland, MI 48640

Edmund Scientific
101 E. Gloucester Pike
Barrington, NJ 80007
Catalogue available.

E.I. Du Pont de Nemours and
 Company, Inc.
Tatnall Street Building
Wilmington, DE 19898

Eggers Plywood Company
Two Rivers, WI 54241
 and
Eggers Hardwood Products Corporation
Neenah, WI 54956

Ferro Corporation
Color Division
4150 East 56 Street
Box 6550
Cleveland, OH 44101

Fezandie and Sperrle, *see* Benbow
 Chemical Packaging, Inc.

Fine Arts Stretchers and Services, Inc.
 (U.S. distributor for Lascaux)
1064 62 Street
Box 380
Brooklyn, NY 11219

Fischer Scientific Company
711 Forbes Avenue
Pittsburgh, PA 15219

Flex-Fast, Inc.
Box 4176
Greenwich, CT 06830

Frame Tek
2134-C Old Middlefield Way
Mountain View, CA 94043

Fredrix Artists Canvas, Inc.
Tara Materials, Inc.
Box 646
Lawrenceville, GA 30246
Catalogue and samples available.

Gamblin Artist's Oil Colors
P.O. Box 625
Portland, OR 97207

George Rowney and Company, Ltd.
P.O. Box 10
Bracknell RG12 4ST
Berkshire, England
U.S. distributor:
1085 Cranbury S. River Rd.
Jamesburg NJ 08831
*Good technical information; extensive
catalogue.*

Glas-Kraft
Railroad Street
Slatersuill, RI 02876

Glidden
Durkee Division, SCM Corporation
Pigments and Colors Group
3901 Glidden Road
Baltimore, MD 21226

Golden Artist Colors, Inc.
Box 91, Bell Road
New Berlin, NY 13411
Excellent technical information.

M. Grumbacher, Inc.
Englehard Drive
Cranbury, NJ 08512
Good technical information; extensive catalogue.

Handi-Clean Products, Inc.
301 Swing Road
Greensboro, NC 27402

Harmon Colors
Specialty Chemicals Division
Allied Chemical Corporation
P.O. Box 14
Hawthorne, NJ 07507

Harshaw Chemical Company
1945 East 97 Street
Cleveland, OH 44106

Hercules, Inc.
910 Market Street
Wilmington, DE 19899

Holbein (Japanese)
U.S. distributor:
Hopper-Koch, Inc.
13 Lexington Green
Ridgewood Estates
South Burlington, VT 05401

Hollinger Corporation
3810 South Four Mile Run Drive
P.O. Box 6185
Arlington, VA 22206

Hunt Manufacturing Company
1405 Locust Street
Philadelphia, PA 19102
Good technical information; catalogue available.

I.C.A. Spring Stretchers
344 South Professor Street
Oberlin, OH 44074

ICI Americas, Inc.
Specialty Chemicals Division
Wilmington, DE 19897

Isabey
LaBrosse et Dupont
12, Rue Leon-Jost
75017 Paris, France
Also available from:
La Brosse et Dupont
623 South State Street
Appleton, WI 54911

Inter-Society Color Council, Inc.
c/o Office of the Secretary
Shelyn Incorporated
1108 Grecade Street
Greensboro, NC 27408

Kimberly and Clark
2001 Marathon Avenue
Neenah, Wl 54956

Kremer Pigmente
 (Kremer Pigments, Inc.)
61 East 3rd Street
New York NY 10003
 and
Farmühle
D-7974 Aichstetten, Germany
Wide variety of unusual pigments and other raw materials; extensive catalogue.

H. Kohnstamm and Company, Inc.
161 Avenue of the Americas
New York, NY 10013

Lab Safety Supply Company
3430 Palmer Drive
Janesville, WI 53547-1368
Extensive catalogue available.

A. Langnickel, Inc.
253 West 26 Street
New York, NY 10001

Lascaux
Alois K. Diethelm AG
CH-8306 Bruttisellen
Switzerland
U.S. distributor:
Fine Arts Stretchers and Services; see above
Very good technical information; color charts.

James J. Lebron
31-56 58 Street
Woodside, NY 11377

Lefranc et Bourgeois (French)
U.S. distributor:
Koh-I-Noor
100 North Street, P.O. Box 68
Bloomsbury, NJ 08804-0068
Very good technical information; color charts.

Light Impressions
439 Monroe Avenue
P.O. Box 940
Rochester, NY 14603

Liquitex
Binney and Smith Artist Materials
1100 Church Lane
P.O. Box 431
Easton, PA 18042
Excellent technical information; catalogue available.

Maimeri (Italian)
U.S. distributor:
C.B. International
84 Maple Avenue
Morristown, NJ 07960
Good technical information; catalogue available.

Martin/F. Weber Company
2727 Southampton Road
Philadelphia, PA 19154-1293
Fair technical information; general catalogue.

Masonite Corporation
29 North Wacker Drive
Chicago, IL 60606

Mearl Corporation
41 East 42 Street
New York, NY 10017

Mentholatum Company, Inc.
Buffalo, NY 14213

Mineral Pigments Corporation
7011 Muirkirk Road
Beltsville, MD 20705

Monsanto Company
800 North Lindbergh Boulevard
St. Louis, MO 63166

Multiform Desiccants, Inc.
1418 Niagara Street
Buffalo, NY 14213

Munsell Color
Macbeth, Division of Kollmorgen
 Corporation
2441 North Calvert Street
Baltimore, MD 21218

New York Central Art Supply
 Company
62 Third Avenue
New York, NY 10003
*Extensive catalogue; special papers
catalogue.*

Niji
Yasutomo and Company
500 Howard Street
San Francisco, CA 94105

Old Holland
Oudt Hollandse Olieverwen
 Makerij N.V.
Nijendal 36
Driebergen, Holland
Available at:
David Davis Fine Arts
539 La Guardia Place
New York, NY 10012
*Fair technical information; handmade
color charts.*

Optical Society of America
1816 Jefferson Place NW
Washington, DC 20036

Pearl Paint Company, Inc.
308 Canal Street
New York, NY 10013
Extensive catalogue.

Perma Colors
Division H. Mark McNeal
 Company, Inc.
226 East Tremont
Charlotte, NC 28203
Catalogue available.

Pfizer Minerals
Pigments and Metals Division
235 East 42 Street
New York, NY 10017

Precision Valve Company
P.O. Box 309
Yonkers, NY 10702

Process Materials Corporation
301 Veterans Boulevard
Rutherford, NJ 07070
Excellent technical information.

Raphael (French)
U.S. distributor:
Dismart, Inc.
22 West 21 Street
New York, NY 10010

Reckitt's Colours, Ltd.
Morley Street
Hull HU8 8DN
Yorkshire, England

Reichard-Coulston, Inc.
15 East 26 Street
New York, NY 10010

Reichhold Chemicals, Inc.
525 North Broadway
White Plains, NY 10603

Robert Simmons, Inc.
45 West 18 Street
New York, NY 10011

Rohm and Haas
Independence Mall West
Philadelphia, PA 19105

Rowney, see George Rowney and
Company, Ltd.

Sakura of America (Japanese)
30470 Whipple Road
Union City, CA 94587

Sam Flax, Inc.
111 Eighth Avenue
New York, NY 10011

Sandoz Colors and Chemicals
Atlanta, GA 30336

Scandinavian Colour Institute
Riddargatan 17
Postadress Box 14038
S-104 40 Stockholm, Sweden

H. Schmincke and Company
GMBH and Co. KG
Otto-Hahn-Strasse 2
4006 Erkrath-Unterfeldhaus
Dusseldorf, Germany
Available at:
Sam Flax, New York
Good technical information and catalogue.

Sealed Air Corporation
2030 Lower Homestead Avenue
Holyoke, MA 01040

Selwin Textile Company, Inc.
15 West 38 Street
New York, NY 10018

Sennelier
8, rue du Moulin à Cailloux
SENIA 408
94567 ORLY Cedex, France
Available at:
David Davis Fine Arts, Pearl Paint Company

Shepherd Chemical Company
4900 Beech Street
Cincinnati, OH 45212

Shiva-Delta Technical Coatings, Inc./Shiva
2550 Pellissier Place
Whittier, CA 90601

Siphon Art (Dorland's Wax Medium)
Ignacio, CA 94947
Available at:
New York Central Art Supply

Standard Brands Paint Company
4300 West 190th Street
Torrance, CA 90509-2956

Starofix
Luca Bonetti
154 West 18 Street
New York, NY 10011
Good technical information; catalogue.

Strathmore Paper Company
Westfield, MA 01085

Sun Chemical Corporation
Pigments Division
411 Sun Avenue
Cincinnati, OH 45232

TALAS
Division, Technical Library Service, Inc.
213 West 35 Street
New York, NY 10001-1996

Talens (Dutch)
U.S. distributor:
Sakura of America (see above)

Teledyne-Wirz
Fourth and Townsend Streets
P.O. Box 640
Chester, PA 19016

Turner Color Works Ltd (Japan)
2-15-7 Mitsuyakita
Yodogawa-Ku
Osaka 532 Japan

Triad Paint and Chemical Corporation
810 Evergreen Avenue
Brooklyn, NY 11207

Union Carbide Corporation
Chemicals and Plastics
270 Park Avenue
New York, NY 10017

Utrecht Manufacturing Corporation
33 35th Street
Brooklyn, NY 11232

Welch, Holme and Clark
1000 South Fourth Street
Harrison, NJ 07029

Westfall Framing
P.O. Box 6607
Tallahassee, FL 32314

Whittaker, Clark and Daniels, Inc.
1000 Coolidge Street
South Plainfield, NJ 07080

Winsor & Newton, Inc. (English)
U.S. office:
11 Constitution Avenue
P.O. Box 1396
Piscataway, NJ 08855-1396
Excellent technical information; extensive catalogue.

Bibliography

American Society for Testing and Materials. 1993 Annual Book of ASTM Standards, Section 6, Vol. 06.02, *Paint—Tests for Formulated Products and Applied Coatings.* Philadelphia: American Society for Testing and Materials, 1992.

Billmeyer, Fred W., Jr., and Max Saltzman. *Principles of Color Technology,* 2nd ed. New York: Wiley, 1981.

Cennini, Cennino. *The Craftsman's Handbook (Il Libro dell' Arte),* trans. Daniel V. Thompson, Jr. New Haven, Conn.: Yale University Press, 1933; Dover reprint.

Chaet, Bernard. *An Artist's Notebook.* New York: Holt, Rinehart and Winston, 1979.

Chieffo, Clifford T. *The Contemporary Oil Painter's Handbook.* Englewood Cliffs, N.J.: Prentice-Hall, 1976.

Cohn, Marjorie B. *Wash and Gouache.* Cambridge, Mass.: Fogg Art Museum, Harvard University, 1980.

Constable, W. G. *The Painter's Workshop.* London: Oxford University Press, 1954; New York: Dover, 1980.

Crown, David A. *The Forensic Examination of Paints and Pigments.* Springfield, Ill.: Charles C. Thomas, 1968.

Doerner, Max. *The Materials of the Artist and Their Use in Painting,* rev. ed., trans. Eugen Neuhaus. New York: Harcourt, Brace, Jovanovich, 1984.

Gettens, Rutherford J., and George L. Stout. *Painting Materials: A Short Encyclopaedia.* New York: D. Van Nostrand, 1942; Dover, 1965.

Harley, R. D. *Artists' Pigments c. 1600–1835,* 2nd ed. London: Butterworth-Heinemann, 1982.

Hiler, Hilaire. *The Painter's Pocket Book of Methods and Materials,* 3rd rev. ed. London: Faber and Faber, 1970.

Howie, F., ed. *Safety in Museums and Galleries.* London: Butterworth-Heinemann, 1988.

Hunter, Dard. *Papermaking: The History and Technique of an Ancient Craft.* New York: Knopf, 1947. Dover reprint, 1978.

Hurvich, Leo M. *Color Vision.* Sunderland, Mass.: Sinauer Associates, 1981.

Jensen, Lawrence N. *Synthetic Painting Media.* Englewood Cliffs, N.J.: Prentice-Hall, 1964.

Kay, Reed. *The Painter's Guide to Studio Methods and Materials.* Englewood Cliffs, N.J.: Prentice-Hall, 1983.

Keck, Caroline K. *A Handbook on the Care of Paintings.* New York: Watson-Guptill, 1965.

Koretsky, Elaine. *Color for the Hand Papermaker.* Boston: Carriage House Press, 1983.

Kühn, Hermann. "Artists' Colors," in *CIBA Review* (1963/1), pp. 3–36. Switzerland: CIBA, Ltd.

———. *Conservation and Restoration of Works of Art and Antiquities,* Vol. 1, trans. Alexandra Trone. London: Butterworth-Heinemann, 1987.

Laurie, Arthur. *The Painter's Methods and Materials.* New York: Dover, 1967.

Le Blon, J. C. *Coloritto,* with an introduction by Faber Birren. New York: Van Nostrand Reinhold, 1980.

Levison, Henry W. *Artists' Pigments: Lightfastness Tests and Ratings.* Hallandale, Fla.: COLORLAB, 1976.

Long, Paulette, ed. *Paper—Art and Technology.* San Francisco: World Print Council, 1979.

Massey, Robert. *Formulas for Painters.* New York: Watson-Guptill, 1967.

Mayer, Ralph. *The Artist's Handbook of Materials and Techniques,* 5th rev. and updated ed. New York: Viking-Penguin, 1991.

———. *A Dictionary of Art Terms and Techniques.* New York: HarperCollins, 1981.

———. *The Painter's Craft.* New York: Penguin Books, 1976.

McCann, Michael. *Artist Beware.* New York: Lyons and Burford, 1992.

———, and Gail Barazani, eds. *Health Hazards in the Arts and Crafts.* Washington, D.C.: Society for Occupational and Environmental Health, 1980.

Mora, Paolo and Laura, and Paul Philippot. *Conservation of Wall Paintings.* London: Butterworth-Heinemann, 1984.

Overheim, Daniel R., and David L. Wagner. *Light and Color.* New York: Wiley, 1982.

Paint/Coatings Dictionary. Philadelphia: Federation of Societies for Coatings Technology, 1978.

Patton, Temle C., ed. *The Pigment Handbook, Vol. 3: Characteristics and Physical Relationships.* New York: Wiley-Interscience, 1973.

Permanent Pigments. *Enduring Colors for the Artist.* Cincinnati: Binney and Smith, Inc., 1975.

Rainwater, Clarence. *Light and Color.* New York: Golden Books (Western Publishing Company), 1971.

Rossol, Monona. *The Artist's Complete Health and Safety Guide.* New York: Allworth Press, 1990.

Ruhemann, Helmut. *The Cleaning of Paintings: Problems and Potentialities.* New York: Praeger, 1968. Hacker reprint, 1982.

Smith, Merily A., and Margaret P. Brown. *Matting and Hinging of Works of Art on Paper,* 2nd rev. ed. Consultant Press, 1991.

Society of Dyers and Colourists and the American Association of Textile Chemists and Colorists, *The Colour Index,* 3rd ed. Research Triangle Park, N.C., 1975.

Stolow, Nathan. *Conservation and Exhibitions: Packing, Transport, Storage, and Environmental Considerations.* London: Butterworth-Heinemann, 1987.

Sward, G. G., ed. *Paint Testing Manual,* 13th ed. Philadelphia: American Society for Testing and Materials, 1972.

The Tate Gallery. *Paint and Painting.* London: Winsor & Newton/The Tate Gallery, 1982.

Thomas, Anne Wall. *Colors from the Earth.* New York: Van Nostrand Reinhold, 1980.

Thomson, Garry. *The Museum Environment,* 2nd ed. London: Butterworth-Heinemann, in association with The International Institute for Conservation of Historic and Artistic Works, 1986.

Verity, Enid. *Color Observed.* New York: Van Nostrand Reinhold, 1980.

Wehlte, Kurt. *The Materials and Techniques of Painting,* trans. Ursus Dix. New York: Van Nostrand Reinhold, 1982.

Wilcox, Michael. *Blue and Yellow Don't Make Green.* Perth, Western Australia: Artways, 1987.

Williamson, Samuel J., and Herman Z. Cummins. *Light and Color in Nature and Art.* New York: Wiley, 1983.

Woody, Russell. *Painting with Synthetic Media.* New York: Reinhold Publishing, 1965.

Index

Italic page numbers indicate illustrations and tables.

Mediums:
 for acrylic emulsion paints, 232
 for oil paintings, 197–98
Meglip, 102
MEK (methyl ethyl ketone), 88, *95*
Mercuric chloride, *112*
Metallic pigments, 123, 138
Metallic points, 24
Metals, painting on, 31
Metal support panels, *55–57*
Methyl alcohol (methanol), 87, *93*
Methyl butyl ketone (MBK), *95*
Methyl cellulose, *77*
 as size, 45, *55, 58*
Methyl ethyl ketone (MEK), 88, *95*
Methyl isobutyl ketone (MIBK), *96*
Microcrystalline wax, *75*
Migration:
 of pigments, 116
 of toners, 124
Mineral oil, *73*
Mineral pigments, 123
Mineral spirits, 43, 86, *90,* 197
 as dispersion liquid, 189
 and encaustic, 215
 safety notes, 33
 as solvent, 81, 226, 227
Mixed-media techniques, 206, 214,
 223, 231–32
Modeling paste, 232
Mold, damage to paper, 291
Mosaic, 253–54
Mounting textiles to panels, 38–40
MSDS (Material Safety Data Sheet),
 83, 187
Mullers, 187, 188
Munsell, Albert H., *Book of Color,* 122
Mural paintings, 234–55
 care of, 258
Museum boards, 29–30, *55–59,* 263
Mylar, 267

Naphtha, VM&P, 86, *90*
Naples yellow, 200
National Bureau of Standards (NBS),
 paint standards, 132
n-Hexane, 87, *92*
Nondrying oils, 63, *72–73*
Nontoxic materals, seals of approval,
 135–36, *136*
"Not" papers, 19
Nylon filament brushes, 230

Oil crayons, 23
Oil grounds, 47, 48, *56, 58*
 gesso emulsions, 53–54
 preprimed fabrics, 35–36
Oil-in-water emulsions, 210
Oil-modified alkyds, 227
Oil of cloves, 106
Oil paintings, 193–98, 276
 care of, 199
 painting over, 198
Oil paints, 190–92, 194–95
 and acrylic emulsion primers, 49
 and egg-oil emulsions, 214
 for interior murals, 244–45

leftover, to save, 198
 varnishing of, 258
Oil pastels, 23
Oleoresins. *See* Balsams
Opacity of pigments, 124–25
Opaque watercolor painting, 204–6
Optical Society of America, color
 system, 122
Orange pigments, *147–51*
 for acrylic emulsion paints, 229
 for exterior murals, 246
 for fresco, 240
 hazardous, *178–79*
Organic pigments, 123–24
Oriented strand board, 30
Ozokerite, 64, *75*

Paint films:
 defects of, 293–94
 waxes and, 64
Painting knives, 17, *17*
Paint-making, 186–89
 acrylic emulsions, 230
 casein, 208
 egg-oil emulsions, 213
 egg tempera, 211
 encaustic, 217
 for fresco, 242
 oils, 190–92, 194–95
 opaque watercolors, 204–5
 pastel sticks, 219, 221, 222
 secco, 244
 silicates, 249, 251
 size paints, 206, 207
 transparent watercolors, 202
Paints, 114
 encaustic, 215–18
 making. *See* Paint-making
 pastels, 219–24
 standards, 132–38
 synthetics, 225–33
 temperas, 210–14
 water-thinned, 200–209
Paint sticks, 23
Palette cups, 18
Palette knives, 17
Palettes, 14
 for acrylic emulsion paints, 230
 for casein paints, 209
 color selections, 120–21
 for encaustic paints, 216
 for watercolors, 201
Panels:
 fresco, 245–46
 hide glue size, 43
 for linings, 292
 for silicate paintings, 252
 supports, 27–33, 44, 193
Paperboard support panels, 29, *55–57*
*Papermaking: The History and
 Technique of an Ancient Craft,*
 Hunter, 19
Papers, 33, *58–59,* 59n
 cold-pressed, 19
 damage to, 291
 for drawing, 18–22
 handmade, 19

hide glue size, 43–44
 hot-pressed, 19
 for oil paintings, 193
 for pastels, 221, 223
 pH testing, *21*
 storage of artworks on, 277
 for watercolors, 201–3
Paris white, 50
Partitive color system, 119
Pastels, 23, 219–24
 fixatives for, 262
 mats for, 271
 protection of, 258
Pearlescent pigments, 140
Pencils:
 colored, 24
 graphite, 22
 pastel, 24
Pens, for inks, 25
Pentimento, 198
Perilla oil, *72*
Perkins, William, 114
Permanence:
 of exterior paints, 248
 of inks, 25, 26
 of papers, 19–20
 See also Lightfastness
"Permanent" materials, 115, 125, 127
Petroleum microcrystalline, *288*
Petroleum products as solvents, 86–87
pH:
 of binders, *69–80*
 of papers, 20–21
pH neutral board, *55–57*
Photographing of artworks, 277–81
Phthalocyanine colors, 115, 116, 121
 extension of, 124
Pigment Handbook, The, 116
Pigments, 114–24, 140, *141–83*
 for acrylic emulsion paints, 229
 for acrylic solution paints, 226
 for alkyd paints, 227–28
 for casein paints, 207
 dispersion in vehicles, 186–87
 for egg temperas, 210
 for encaustic, 215
 for exterior murals, 246–47
 for fresco, 235, 239–42
 for grounds, 47
 for oil paints, 191
 opacity of, 124–25
 for pastels, 219
 for silicate paints, 249
 for size paints, 206
 for special effects, 138–40
 standards for, 115–16, 132–38
 tests for, 125–31
 for transparent watercolors, 200–201
Pinney, Zora Sweet, 128
Plant gums, 61, 64, *76*
Plant oils as retarders, 106, *111*
Plaster, for fresco painting, 236–38
Plastic glazing, 271
Plexiglas, 67
Plywood support panels, 28–29, *55–57*
 bracing of, 31
Pollock, Jackson, 31